THE AHMANSON FOUNDATION

has endowed this imprint
to honor the memory of

FRANKLIN D. MURPHY

who for half a century
served arts and letters,
beauty and learning, in
equal measure by shaping
with a brilliant devotion
those institutions upon
which they rely.

The publisher gratefully acknowledges the generous
support of the Chairman's Circle of the University of
California Press Foundation, whose members are:

Anonymous
Jeanne and Michael Adams
Stephen A. and Melva Arditti
Gene A. Brucker
Richard E. Damm and Sara Duryea Damm
William Deverell
Mary Dingman
Sonia H. Evers
Adele M. Hayutin
Lata Krishnan and Ajay Shah
John Lescroart and Lisa Sawyer
Judith and Kim Maxwell
Susan McClatchy
Muriel and Martin Paley
Kenneth and Frances Reid
Ralph and Shirley Shapiro
Judy and Bill Timken

The publisher also gratefully acknowledges the generous
support of the Art Endowment Fund of the University
of California Press Foundation, which was established
by a major gift from the Ahmanson Foundation.

THE ARTS OF CHINA

THE ARTS OF CHINA

 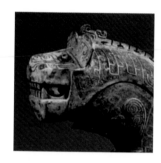

中

UNIVERSITY OF CALIFORNIA PRESS BERKELEY LOS ANGELES LONDON

FIFTH EDITION, REVISED AND EXPANDED MICHAEL SULLIVAN

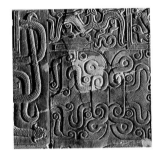

University of California Press, one of the most distinguished university presses in the United States, enriches lives around the world by advancing scholarship in the humanities, social sciences, and natural sciences. Its activities are supported by the UC Press Foundation and by philanthropic contributions from individuals and institutions. For more information, visit www.ucpress.edu.

University of California Press
Berkeley and Los Angeles, California

University of California Press, Ltd.
London, England

The details on the title page spread, left to right, top to bottom, are from figures 2.4 (p. 18), 2.25 (p. 30), 2.24 (p. 30), 3.5 (p. 51), 6.21 (p. 147), 3.30 (p. 63), 4.35 (p. 92), 3.31 (p. 63), 5.13 (p. 113), 5.34 (p. 127), 9.23 (p. 245), 5.4 (p. 104), 8.5 (p. 212), 7.41 (p. 200), 10.19 (p. 271), and 10.25 (p. 275). The chapter opening details are as follows: chap. 1/fig. 1.7 (p. 8), chap. 2/fig. 2.22 (p. 28), chap. 3/ fig. 3.19 (p. 59), chap. 4/fig. 4.26 (p. 85), chap. 5/fig. 5.23 (p. 121), chap. 6/fig. 6.40 (p. 160), chap. 7/fig. 7.34 (p. 196), chap. 8/fig. 8.18 (p. 223), chap. 9/fig. 9.17 (p. 240), chap. 10/fig. 10.22 (p. 273), chap. 11/fig. 11.37 (p. 316). Full credit information appears in the captions for the listed images.

Library of Congress Cataloging-in-Publication Data

Sullivan, Michael, 1916–
 The arts of China / Michael Sullivan. — 5th ed. rev. and expanded.
 p. cm. — (An Ahmanson-Murphy fine arts book)
 Includes bibliographical references and index.
 ISBN 978-0-520-25568-5 (cloth : alk. paper) — ISBN 978-0-520-25569-2 (pbk. : alk. paper)
 1. Art, Chinese. I. Title.
 N7340.S92 2008
 709.51—dc22 2008017957

Manufactured in Canada

17 16 15 14 13 12 11 10 09 08
10 9 8 7 6 5 4 3 2 1

The paper used in this publication meets the minimum requirements of ANSI/NISO Z39.48-1992 (R 1997) *(Permanence of Paper)*.

To Khoan

CONTENTS

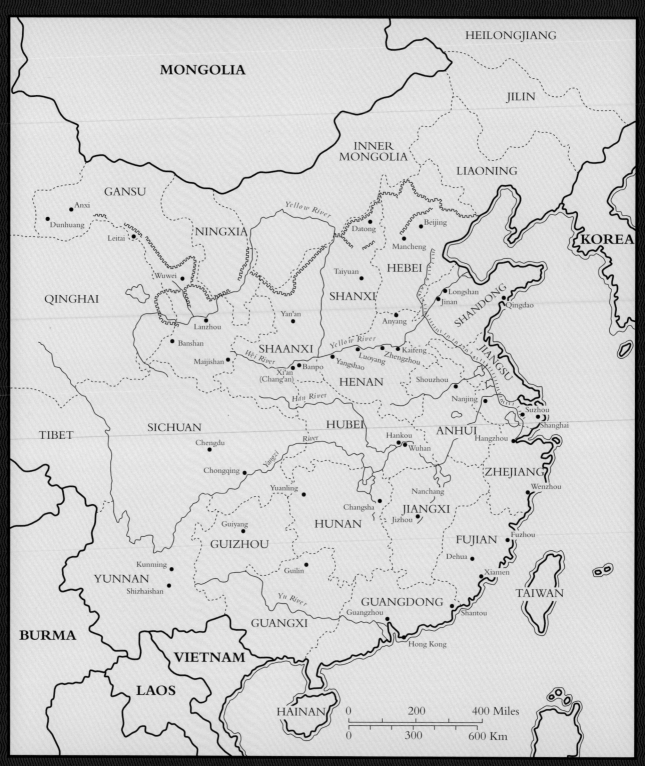

MODERN CHINA

PREFACE TO THE FIFTH EDITION

For the fifth edition of this book I have made some corrections and additions to bring it up to date, while the early chapters have been revised and recast to take account of our better understanding of Bronze Age China. There is also more about the senior art of calligraphy, Chan art, and recent developments in Chinese art.

In the more than fifty years since this book was first published, as *An Introduction to Chinese Art* (1951), other approaches to the writing of Chinese art history have been adopted by several Western authors. One has been to treat the arts of painting, sculpture, ceramics, and so on in separate chapters; the other, more radical, to present art as primarily an illustration of political, social, and economic forces, stressing the context rather than the art itself.

I have chosen not to go down either of those paths, keeping to the traditional dynastic framework, for two reasons: Chinese people see their history in terms of the succession of the dynasties, and it is essential for the Western reader, perhaps approaching Chinese culture for the first time, to have a sense of the sweep of Chinese history as the Chinese themselves see it. Moreover, the arts of each of the major dynasties, and of the periods of breakdown and confusion between them, have a distinct character of their own.

I should like to express my thanks to all those who have provided us with new illustrations, or with color where there was formerly black and white, among them Zhang Ying at the Palace Museum, Beijing, Freda Murch and Robert Bernell in Beijing, the National Palace Museum and Mr. Wei Dewen in Taipei, Professor Liu Zhengcheng of Peking University, Rosemary Scott in London, Nick Ball in Chongqing, and all those institutions and individual collectors named in the captions to the illustrations. Without their generous help and cooperation this edition would not have been possible.

I owe more than I can express to a group of young men and women, now or until recently studying for a doctorate at Oxford University, who have helped me with my research, with their companionship, and in a hundred different ways. They include Dr. Hiromi Kinoshita, Dr. Josh Yiu Sifu, Dr. James Lin, Dr. Wang Hsien-ch'un, Celine Lai, Tam Ka-chai, Deng Fei, Chen Xin, and Jiang Qiqi.

Finally, as always, I would like to acknowledge my debt to Deborah Kirshman, Sue Heinemann, Eric Schmidt, and Lynn Meinhardt at University of California Press, Amy Klatzkin, my editor, and Nicole Hayward, who designed this book.

CHRONOLOGICAL TABLE
OF DYNASTIES AND MODERN REPUBLICS

XIA			**c. 2000–c. 1650 B.C.**
SHANG			**c. 1650–c. 1050**
ZHOU	WESTERN ZHOU	c. 1050–771	**c. 1050–256**
	EASTERN ZHOU	771–256	
	Spring and Autumn Period 770–476		
	Warring States Period 475–221		
QIN			**221–207**
HAN	WESTERN HAN	202 B.C.–A.D. 9	**202 B.C.–A.D. 220**
	XIN	9–25	
	EASTERN (LATER) HAN	25–220	
THREE KINGDOMS	SHU (HAN)	221–263	**221–265**
	WEI	220–265	
	WU	222–280	
SOUTHERN	*Six Dynasties* — JIN	265–316	**265–581**
	EASTERN JIN	317–420	
	LIU SONG	420–479	
and	SOUTHERN QI	479–502	
	LIANG	502–557	
	CHEN	557–587	
NORTHERN	NORTHERN WEI (TOBA)	386–535	
DYNASTIES	EASTERN WEI (TOBA)	534–543	
	WESTERN WEI (TOBA)	535–554	
	NORTHERN QI	550–577	
	NORTHERN ZHOU (XIANBI)	557–581	
SUI			**581–618**
TANG			**618–906**
FIVE DYNASTIES	LATER LIANG	907–922	**907–960**
	LATER TANG (TURKIC)	923–936	
	LATER JIN (TURKIC)	936–948	
	LATER HAN (TURKIC)	946–950	
	LATER ZHOU	951–960	
	Liao (Khitan Tartars) 907–1125		
	Xixia (Tibetan Tangut) 990–1227		
SONG	NORTHERN SONG	960–1126	**960–1279**
	SOUTHERN SONG	1127–1279	
	Jin (Jurchen Tungus) 1115–1234		
YUAN (MONGOLS)			**1260–1368**
MING			**1368–1644**
QING (MANCHUS)			**1644–1912**
REPUBLIC			**1912–1949**
PEOPLE'S REPUBLIC			**1949–**

REIGN PERIODS
OF THE MING AND QING DYNASTIES

MING	1368–1644		QING	1644–1912
HONGWU	1368–1398		SHUNZHI	1644–1661
JIANWEN	1399–1402		KANGXI	1662–1722
YONGLE	1403–1424		YONGZHENG	1723–1735
HONGXI	1425		QIANLONG	1736–1795
XUANDE	1426–1435		JIAQING	1796–1821
ZHENGTONG	1436–1449		DAOGUANG	1821–1850
JINGTAI	1450–1457		XIANFENG	1851–1861
TIANSHUN	1457–1464		TONGZHI	1862–1873
CHENGHUA	1465–1487		GUANGXU	1874–1908
HONGZHI	1488–1505		XUANTONG	1909–1912
ZHENGDE	1506–1521			
JIAJING	1522–1566			
LONGQING	1567–1572			
WANLI	1573–1620			
TAICHANG	1620			
TIANQI	1621–1627			
CHONGZHEN	1628–1644			

BEFORE THE DAWN OF HISTORY

To admirers of Chinese art, the three decades that followed the establishment of the People's Republic in 1949 were a time of bewilderment and frustration as they watched the Chinese apparently repudiating, and even at times destroying, their cultural heritage. For years, as China carried out its gigantic social and political revolution, its doors were shut to almost all but the most uncritical admirers. While the lot of the masses improved beyond belief, art and the artist suffered, particularly during the ten terrible years from the Cultural Revolution to the death of Mao Zedong in 1976.

Yet even at the worst of times, while artists and scholars were imprisoned or sent down to farm and factory, the archaeological work never ceased. Indeed, in the years of Mao's rule, China did more to excavate, protect, study, and display its cultural heritage than ever before. If this was politically justified by Mao's insistence that the past must serve the present—and to do so it must be visible—it more truly reflects the sense of history that the Chinese have always felt and that not even the Cultural Revolution could destroy. For now, as always, the Chinese look upon their history as a deep reservoir from which they draw strength, not as a luxury but as something essential to the vitality of their culture.

Nor have the old legends been forgotten. One of these legends concerns the origins of the world. In far-off times, it runs, the universe was an enormous egg. One day the egg split open; its upper half became the sky, its lower half the earth, and from it emerged Pan Gu, primordial man. Every day he grew 10 feet (3 m) taller, the sky 10 feet higher, the earth 10 feet thicker. After eighteen thousand years Pan Gu died. His head split and became the sun and moon, while his blood filled the rivers and seas. His hair became the forests and meadows, his perspiration the rain, his breath the wind, his voice the thunder—and his fleas our ancestors.[1]

A people's legends of their origins generally give a clue to what they think most important. This one is no exception, for it expresses an age-old Chinese viewpoint, namely, that man is not the culminating achievement of creation, but a relatively insignificant part in the scheme of things—hardly more than an afterthought, in fact. By comparison with the beauty and splendor of the world itself, the mountains and valleys, the clouds and waterfalls, the trees and

flowers, which are the visible manifestations of the workings of the *Dao* (the "Way" of the Daoist philosophers), he counts for very little. In no other civilization did the forms and patterns of nature, and man's humble response to them, play so big a part.

We can trace the germs of this attitude into the remote past, when in north China nature was a kinder master than it is now. Half a million years ago, in the time of *Homo erectus pekinensis* (Peking man), that region was comparatively warm and wet; elephants and rhinoceroses roamed a more luxuriant countryside than the barren hills and windswept plains of recent times. Within this area, forming the modern provinces of Henan, Hebei, Shanxi, and Shaanxi, was born a uniquely Chinese feeling of oneness with nature that, in the course of time, was to find its highest expression in philosophy, poetry, and painting. This sense of communion was not merely philosophical and artistic; it had a practical value as well, since the farmer's prosperity, and hence that of society as a whole, depended upon his knowing the seasons and attuning himself to the "will of Heaven," as he called it. Agriculture ultimately became a ritual over which the emperor himself presided, and when at the spring sowing he ceremonially plowed the first furrow, not only did he hope to ensure a good harvest thereby, but also his office itself was further ennobled by this act of homage to the forces of nature.

This sense of attunement is fundamental in Chinese thinking. Man must attune himself not only to nature but also to his fellow men, in ever-widening circles starting with his family and friends. Thus, in the past the highest ideal was always to discover the order of things and to act in accordance with it. As the history of Chinese art unfolds in the following pages, we will find that its characteristic and unique beauty lies in its expression of this very sense of attunement. Is that one reason why Westerners, often with no other interest in Chinese civilization, collect and admire Chinese art? Do they sense, perhaps, that the forms that the Chinese artist and craftsman have created are *natural* forms—forms that seem to have evolved inevitably by the movement of the maker's hand, as an intuitive response to a natural rhythm? Chinese art does not demand of us, as does Indian art, the effort to bridge what often seems an unbridgeable gulf between extremes of physical form and metaphysical content, nor will we find in it that preoccupation with formal and intellectual considerations that so

often makes Western art difficult for the Asian mind to accept. The forms of Chinese art are beautiful because they are in the widest and deepest sense harmonious, and we can appreciate them because we too feel their rhythms all around us in nature and instinctively respond to them. These rhythms, moreover—this sense of inner life expressed in line and contour—are present in Chinese art from its earliest beginnings.

CHINA IN THE STONE AGE

Every lover of Chinese art today is familiar with the magnificent painted pottery of the Neolithic period, although not until 1921 was positive evidence found that China had actually passed through a Stone Age at all. In that year the Swedish geologist J. Gunnar Andersson (1874–1960) and his Chinese assistants made two discoveries of immense importance. The first was at Zhoukoudian, southwest of Beijing, where deep in a cleft in the hillside Andersson picked up a number of flint tools, indicating that the area had been occupied by very early man. He himself did not excavate, but his find led to further excavations and to the eventual discovery by Dr. Pei Wenzhong of fossil bones that, with the exception of late Java man, *Pithecanthropus erectus,* were the oldest human remains yet discovered. The bones were those of a hominid, *Sinanthropus pekinensis,* who lived in the middle Pleistocene period. The remains in the cave, 55 yards (50 m) thick, represent occupation between about 700,000 and 200,000 B.C. Peking man made stone tools, chiefly of veined quartz, from flakes struck off a larger pebble. He had fire and ate grains and his fellow men, breaking open their bones to suck out the marrow.

In recent years, far older remains have been discovered. The fossil teeth of an ape-man found in 1965 in the Yuanmou district of Yunnan are dated to 1.7 million years ago.[2] In 1964, in deposits on an open hillside in Lantian county, Shaanxi, paleontologists discovered the cranium of a hominid believed to be at least 100,000 years older than Peking man, and so roughly the same age as Java man, *Pithecanthropus robustus.* More recently, in 1984, the skeleton of a primitive man of the middle Pleistocene, c. 260,000 years old, was found in Jinniushan, southern Liaoning. Jinniushan man, with a brain larger than that of contemporary primates, is related to early *Homo sapiens.*

Gradually, in the late Pleistocene, the evolution of early

humans in China gathered pace. In recent years, remains of *Homo sapiens* have been found in many areas. Upper Cave man at Zhoukoudian (c. 25,000 B.C.) had a wider range of stone tools than his ancestors; he probably wore hides sewn together, and his wife adorned herself with stone beads drilled and painted with hematite, the earliest known intentional decoration in the history of Chinese civilization. Finely fashioned microliths (tiny stone implements) have been found in many desert sites in Ningxia and the Ordos region, different types of blades and flakes being fashioned for different purposes. Further south, in the region of northern Henan that was to become the last seat of the Shang dynasty, thousands of microliths were discovered in a habitation site in 1960; other rich remains have been found far to the southwest, in Sichuan, Yunnan, and Guizhou. Although the dating of these scattered sites and their relationship to each other are by no means clear, their distribution suggests that the Upper Paleolithic culture, shaping imperceptibly into the Mesolithic, was spread widely across ancient China.[3]

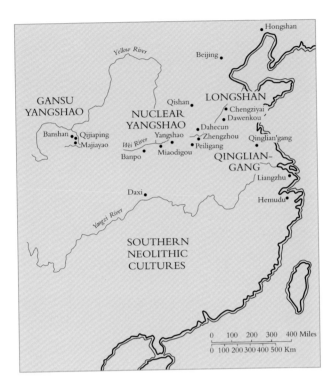

MAP 1.1 China in the Neolithic period

THE NEOLITHIC CULTURES OF CHINA

The people of Mesolithic China had been hunters and fishermen. The "Neolithic revolution" came when the ancestors of the Chinese race settled down and began to build villages and to learn the arts of farming, horticulture, and pottery making.

For a long time it was thought that Chinese Neolithic culture originated in the "nuclear area" of southern Hebei and northern Henan, and that it radiated out from there. But as more and more Neolithic sites are discovered, the picture becomes more complicated, and it is now clear that Neolithic communities flourished more or less simultaneously in various parts of China (map 1.1) and that each area had its own way of life and distinctive crafts.

As we move around China, we find the earliest settlements yet discovered, at Yuchanyao in Hunan and Aohan Banner in Inner Mongolia, which may date as early as 8000 B.C., whose inhabitants lived in little houses and huts in a community surrounded by a ditch or a moat. Then came Peiligang, a village site near Luoyang in Henan. Here were found house floors, evidence of the domestication of animals, many burials, and crude pottery, some of which is ornamented with scratched designs (fig. 1.1). By carbon-14 dating, archaeologists have put the Peiligang settlement around 6000–5000 B.C. Thereafter in various sites there appear larger houses, rows of attached houses, the beginning of rice cultivation, finely polished stone tools, the use of jade for ornaments and for ritual purposes, and the first defensive walls, leading to the creation of walled towns, the earliest of which yet discovered, at Lixian in Hunan, dates to around 4000 B.C.[4]

An early stage of the Chinese Neolithic civilization was in fact the first to be discovered, if only by chance. The Chinese government had hired J. Gunnar Andersson to search for oil and minerals in northern Henan, where in 1921 he found, at the village of Yangshao, simple burials furnished with the marvelous painted pottery that has given the name "Yangshao culture" to a major phase in Chinese prehistory lasting from about 5000 to 3000 B.C. In 1923 Andersson, noting the resemblance between the Yangshao pottery and that of the ancient Near East, went westward to Gansu in search of linking sites and there found, at Banshan, graves with rather similar pottery. Since then, how-

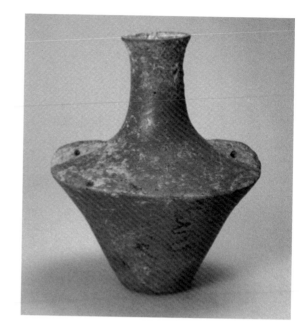

FIGURE 1.1 Jar with small "ears" for lifting. Red pottery. Ht. 17.8 cm. Excavated in Changgexian, Henan. Peiligang culture. Neolithic.

FIGURE 1.2 Banpo, Shaanxi. Part of the Neolithic village after excavation. Now a museum.

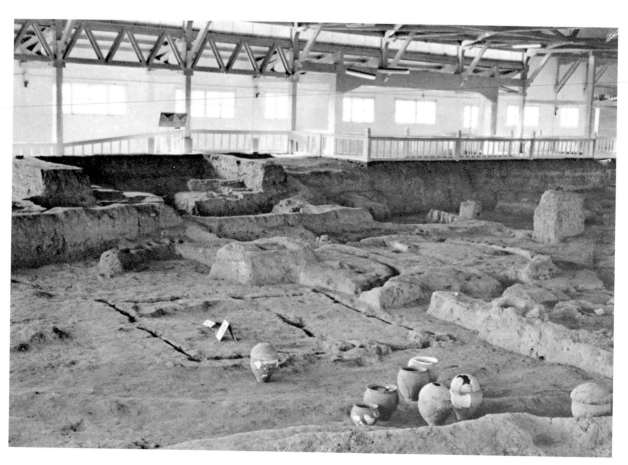

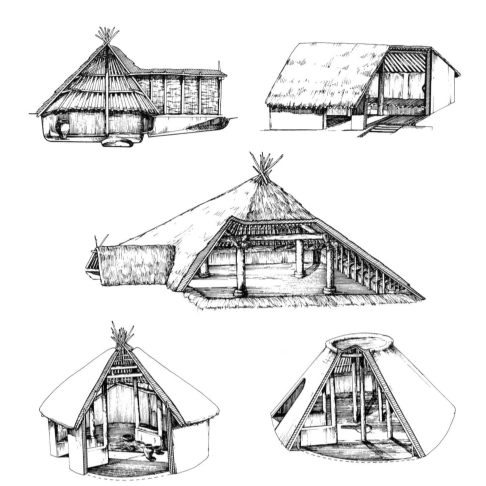

FIGURE 1.3 Banpo, Shaanxi. Neolithic houses, reconstructed. After *Xi'an Banpo* (1963).

ever, Chinese archaeologists have found so many "painted pottery" sites in different parts of north China that possible connections with western Asia are hardly discussed.

The most important discoveries of the Yangshao culture occurred in the 1950s and 1970s, when archaeologists unearthed a group of Neolithic villages and a cemetery at Banpo (fig. 1.2), just east of Xi'an, and another at Jiangzhai, farther to the east. The Banpo villages cover two and a half acres; four separate layers of houses have been found in a cultural deposit 10 feet (3 m) thick, representing many centuries of occupation spanning the fifth millennium B.C. The earliest inhabitants lived in round wattle-and-daub huts with reed roofs and plaster floors and an oven in the center, the design perhaps copied from an earlier tent or yurt. Their descendants built rectangular, round, or square houses with

a framework of wooden planking, sunk about three feet (1 m) below ground level and approached by a flight of steps (fig. 1.3). A further advance in the domestic architecture of late Stone Age China is marked by the three-room houses excavated at Dahecun near Zhengzhou, Henan, the plaster walls of which were actually baked to give them a hard and durable surface.

The Banpo potters made both a coarse gray or red pottery and a fine red ware burnished and then painted in black with geometric designs and occasionally with fishes and human faces (fig. 1.4). They seem not to have known the potter's wheel, but made their vessels by coiling long strips of clay. From clay they also made spindle whorls and even hairpins, but the finer objects such as needles, fishhooks, spoons, and arrowheads were made of bone. Part of the

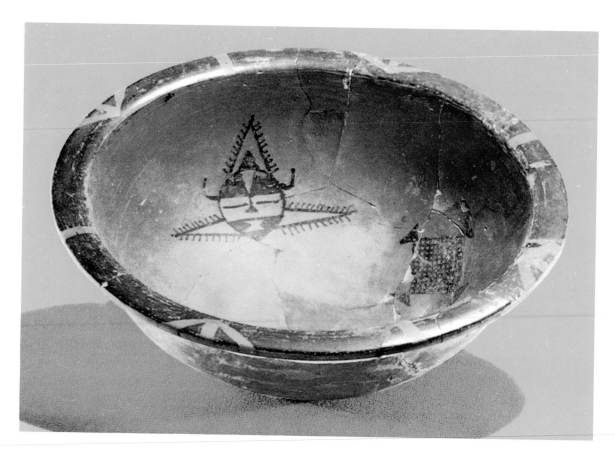

FIGURE 1.4 Bowl. Pottery decorated with masks and nets in black slip. Diam. 44.5 cm. Excavated at Banpo, Shaanxi. Early Yangshao culture. Neolithic. Historical Museum, Beijing.

villages of Banpo and Dahecun have been roofed over and preserved as museums of Chinese Neolithic culture.

The painted pottery found first by Andersson and later unearthed at many other sites in Henan and Gansu has not been matched in quality or beauty by any Neolithic wares discovered since. It consists chiefly of funerary urns (fig. 1.5), wide and deep bowls, and tall vases, often with loop handles set low on the body. Though the walls are thin, the forms are robust, their generous contours beautifully enhanced by the decoration in black pigment that was clearly executed with a crude form of brush. Some of the designs are geometric, consisting of parallel bands or lozenges con-

taining concentric squares, crosses, or diamonds. The lower half of the body is always left undecorated; it may have been set in the sandy ground to prevent it from overturning. Many vessels are adorned with sweeping wavelike bands that gather into a kind of whirlpool; others make use of the stylized figures of men, frogs, fish, and birds. Shards found at Majiayao in Gansu (c. 2500 B.C.) reveal a sophisticated brush technique, in one case depicting plants each of whose leaves ends in a sharp point with a flick of the brush—the same technique that was to be used by the Song artist, three thousand years later, in painting bamboo. Naturalistic motifs, however, are rare, and the majority of

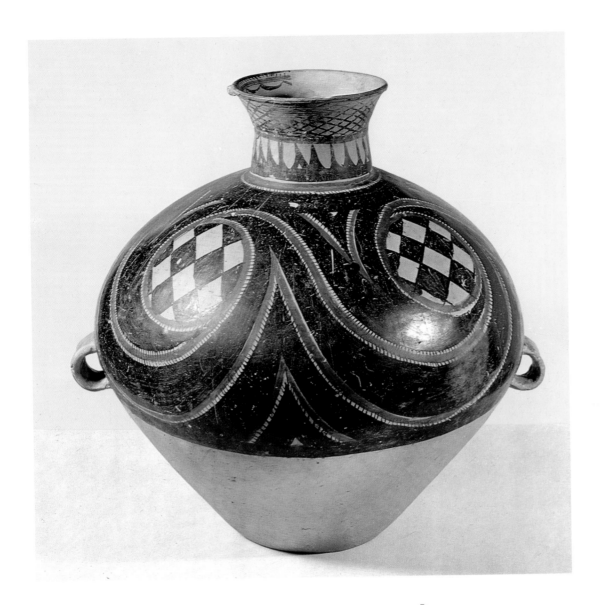

pieces are decorated with geometric or stylized patterns whose significance is still a mystery.

Until recently it was thought that the Yangshao culture, with its painted pottery, was more or less directly superseded by a totally different culture centered on Shandong and represented by the burnished black pottery of Longshan. But under the impact of a succession of new discoveries, this simple picture has given way to a more complex and interesting one. First, the beautiful painted pottery from Neolithic sites at Majiayao and Banshan in Gansu (c. 2400 B.C.) is now known from carbon-14 analysis to be as much as two thousand years *later* in date than the painted

FIGURE 1.5 Funerary urn. Pottery decorated with red and black slip. Ht. 40 cm. Excavated at Banshan, Gansu. Yangshao culture. Neolithic. Ostasiatiska Museet, Stockholm.

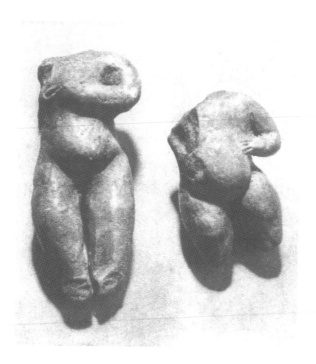

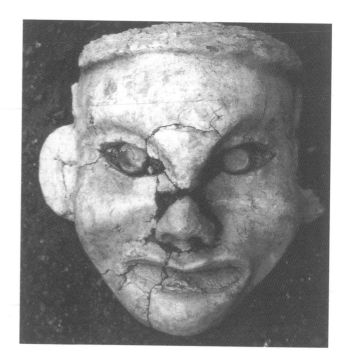

pottery of the Yangshao village of Banpo, which has yielded a carbon date as early as 4865 B.C. plus or minus 110 years. This evidence suggests a movement of the nuclear Yangshao influence westward from the North China Plain.

Many years ago Japanese archaeologists working in what was then called Manchuria (Liaoning) discovered remains of the Hongshan culture, related to the Yangshao but having some marked differences. Recent excavations at the Hongshan sites have revealed stone tombs—one with an outer "wall" of clay cylinders more like those that surrounded much later Japanese tombs of the Tumulus period than anything yet found in China—as well as ritual stone platforms, a round stone object that appears to be an altar, and, most remarkable, robustly modeled "Venus" figures of clay (fig. 1.6), a painted clay head with eyes of jade (fig. 1.7), which may have been used in a fertility rite, and jade creatures that Chinese archaeologists, for want of a better name, call "pig-dragons" (fig. 1.8). The Hongshan culture is now dated to around 3500 B.C.

Moving south, we come to the Neolithic civilization of Shandong and northern Jiangsu (about 4300 to 2400 B.C.), which, as K. C. Chang put it, "is variously christened

the Qinglian'gang Culture or the Dawenkou Culture, depending on whether the initiative had come from the archaeologists in Jiangsu or from those in Shandong."[5] In ancient times this area was warmer than it is today, its lakes and marshes full of alligators. The early Dawenkou people produced elegant pottery decorated with swirling patterns in red and white, distantly related to the Yangshao, of which the bowl in fig. 1.9 is a typical example.

Continuing our southward journey, we come to the Majiabang culture of southern Jiangsu and northern Zhejiang, related to the Dawenkou and dated to about 5000–3000 B.C. Its people were rice farmers who lived in timber houses near the water; they had domesticated the pig and the water buffalo and hunted alligators, elephants, and deer. Their tools and weapons were made of wood, bone, and stone. Although they had plenty to eat and their pottery was varied in shape and decoration—some of it incised with primitive signs or "characters"—their ceramic techniques were rudimentary, for they seem not to have had kilns, but baked their pots over an open fire.

South across Hangzhou Bay lies Hemudu in Yuyaoxian, which in more recent times has been an important center

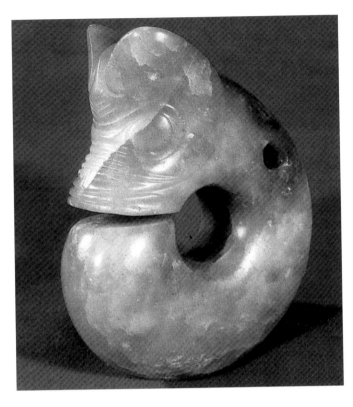

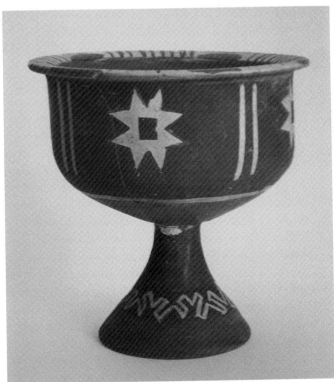

FIGURE 1.6 (OPPOSITE LEFT)
Naked women. Clay. Ht. 7.8 and 5 cm.
Excavated at Dongshanzui, Kezuo
county, Liaoning. Hongshan culture.
Neolithic. Historical Museum, Beijing.

FIGURE 1.7 (OPPOSITE RIGHT)
Pottery mask, with eyes of jade.
Excavated at Dongshanzui, Kezuo
county, Liaoning. Hongshan
culture. Neolithic. Historical
Museum, Beijing.

FIGURE 1.8 (ABOVE)
"Pig-dragon." Jade. Ht. 11 cm.
Excavated at Dongshanzui, Kezuo
county, Liaoning. Hongshan culture.
Neolithic. Liaoning Provincial
Museum, Liaoyang.

FIGURE 1.9 (LEFT) Painted *dou*.
Ht. 26 cm. Excavated in Shandong.
Dawenkou culture. Neolithic.

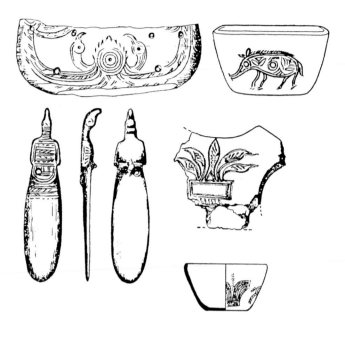

of the ceramics industry. Here were found the remains of a large village, at least as old as Banpo, built of timber on piles at the waterside, the posts and beams skillfully joined with mortise and tenon. These villagers too cultivated rice. They made a thick pottery burnished black, some of which they decorated with pretty flowers and plants incised in the clay before firing (fig. 1.10). Particularly remarkable was the find in 1977–78 of a red lacquered wooden bowl, the earliest example of the lacquer craft so far discovered in China.

The latest phase of the Neolithic in eastern China has long been associated with Longshan, the site in Shandong discovered in 1928 by Dr. Wu Jinding and dated between about 2600 and 1900 B.C. Most famous among the ceramic wares of the Longshan people is a delicate pottery made of dark clay burnished black and of incredible fragility, being often laminated in layers as fine as a few hundredths of an inch, or half a millimeter, thick. The shapes are elegant, while the decoration, consisting chiefly of raised bands, grooves, and milled rings, gives it a somewhat metallic, machine-made look (fig. 1.11). It must have been difficult to make, let alone use, for in the succeeding Bronze Age the tradition died out completely. Discoveries at Weifang in Shandong show that this "black pottery culture," as it was long called, also produced a white pottery of vigor and originality, illustrated here by the extraordinary *kui* pitcher in fig. 1.12, which seems to imitate a vessel made of hide bound with thongs. The Longshan people practiced scapulamancy, that is, divination by interpreting cracks formed by heat applied to animal shoulder blades—a custom long thought to have originated in the Shang dynasty.

A more southerly relative of the Longshan culture was first discovered at Liangzhu and later in other sites in the lower Yangzi Valley. Like the much earlier Hemudu, these people made their houses and tools of wood; they produced highly burnished black pottery and tools and ritual objects of jade, a stone that was to play an important part in Chinese life. Liangzhu burial customs were completely different from the modest Yangshao graves. At Huiguanshan, for example, was found a graveyard on a high terrace approached by flights of stairs and furnished with a drainage ditch, while the huge funerary platform at Mojiaoshan, some 30 feet (10 m) high, had at its center a timber building possibly used in funerary rites.

FIGURE 1.10 (ABOVE) Decoration on ivory and black pottery. Zhejiang. Hemudu culture. Neolithic.

FIGURE 1.11 (RIGHT) Stem cup. Black pottery. Ht. 19.2 cm. Excavated at Weifang, Shandong. Longshan culture. Neolithic.

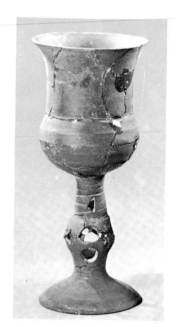

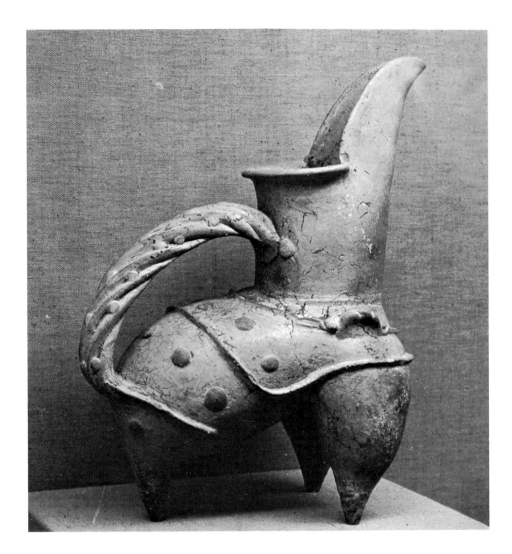

FIGURE 1.12 *Kui* pitcher. Grayish-white pottery. Ht. 29.7 cm. Excavated at Weifang, Shandong. Longshan culture. Neolithic.

JADE

By the Neolithic period, rough stone tools made by striking flakes off a larger pebble had given way to finely polished stones, of which the most precious was jade. Although early Chinese texts speak of jade from several places in China, for many centuries the chief source has been the riverbeds of the Khotan region in central Asia, and Western scholars came to the conclusion that jade did not exist in its true state in China proper. Recent discoveries, however, lend support to the ancient texts, for a jadeitic stone used today by Beijing jadesmiths has been traced to Nanyang in Henan and Lantian in Shaanxi. However, the true jade (*zhen yu*) prized throughout history by the Chinese is nephrite, a fibrous mineral rich in magnesium, as hard as steel, and of peculiar toughness. In theory it is pure white, but even small amounts of impurities will produce a wide range of colors from green and blue to brown, red, gray, yellow, and even black. In the eighteenth century, Chinese jade carvers discovered in Burma a source of another mineral, jadeite, composed of interlocked granular crystals, whose brilliant apple and emerald greens have made it deservedly popular for jewelry both in China and abroad.

Because of its unique qualities, jade has since ancient times been regarded by the Chinese with special reverence. In his dictionary the *Shuowen jiezi*, the Han scholar Xu Shen (c. A.D. 100) described it in words now well known to every

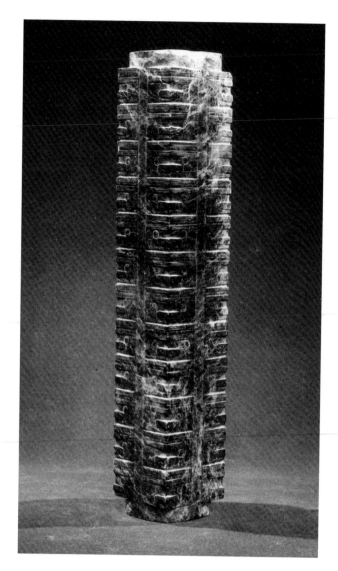

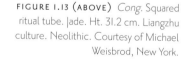

FIGURE 1.13 (ABOVE) *Cong.* Squared ritual tube. Jade. Ht. 31.2 cm. Liangzhu culture. Neolithic. Courtesy of Michael Weisbrod, New York.

FIGURE 1.14 (TOP RIGHT) Drawing of mask decoration on a jade *cong.* Liangzhu culture. Neolithic. After *Wenwu,* no. 1 (1988): 1–31, fig. 20.

student of Chinese art: "Jade is the fairest of stones. It is endowed with five virtues. Charity is typified by its luster, bright yet warm; rectitude by its translucency, revealing the color and markings within; wisdom by the purity and penetrating quality of its note when the stone is struck; courage, in that it may be broken, but cannot be bent; equity, in that it has sharp angles, which yet injure none."[6] Although this definition applies essentially to true jade, the word *yu* may include not only nephrite and jadeite, but also other fine stones such as serpentine, tremolite, hornblende, and even marble.

The hardness and toughness of jade make it difficult to carve. To work it one must use an abrasive. Possibly the Neolithic craftsmen used a substance harder than modern carborundum. It has even been suggested that the abrasive was diamond dust, although no diamonds are found in China proper today. Howard Hansford demonstrated that it is possible, given time, to drill a hole in a slab of jade using only a bamboo bow drill and builder's sand mixed with water.[7]

Jade weapons such as axes, ornaments (bracelets and rings), and ritual objects have been found in graves chiefly in east and northeast China, among the earliest being the so-called "pig-dragon" rings of the Hongshan culture that I mentioned earlier. Rich finds from graves of the later Liangzhu culture in the Lake Tai region include many jade

bi, a disk with a hole in the center, and *cong* tubes (see fig. 1.13), circular inside and squared on the outside, one of which is 15 ¾ inches (40 cm) long—a marvel of the jade-worker's craft, dated between 2700 and 2200 B.C. Some of these *cong* are decorated with zoomorphic masks that seem to anticipate the *taotie* motifs cast on the ritual vessels of the succeeding early Bronze Age (see fig. 1.14). By the late first millennium B.C. these *bi* and *cong* had become associated with Heaven and Earth, and they continue to bear these symbolic meanings today. But what they and the masks meant to the Liangzhu people, and what role they played in their burial rites, is not known.

WRITING

A much-debated question is when the Chinese first developed the system of writing that was to become, in the art of calligraphy, the highest expression of Chinese culture. The answer depends on what we mean by *writing*. Recognizable forms of Chinese characters have not yet been found in Chinese Neolithic sites, but marks painted with a brush on pottery from Yangshao and other sites in central China are thought to be numerals, or potters' or owners' marks, while drawings such as that incised on the gray Dawenkou pottery (fig. 1.15) seem to show a sun disk, a crescent moon, and a mountain. Such devices are precursors of the pictographs and ideographs of the early Bronze Age. But of the writing of symbols connected in some sort of grammatical structure, however primitive, there is as yet no sign.

Even the simplified picture I have given may suggest something of the richness and variety of late Stone Age culture in China, which, in its later phases, merges imperceptibly into the Bronze Age. It is now known that the Chinese Neolithic people experimented with simple metal technology—witness the cast copper knife 4 inches (10 cm) long found at Majiayao (c. 3000 B.C.), copper awls from Sanlihe and part of a copper vessel from Wangchenggang, southern Henan (both of the Longshan culture of about 2500 B.C.), and copper tools and knives from Qijiaping, Gansu (datable to about 2000 B.C.). Scattered and few though these finds are, they show that the transition to a fully developed bronze culture was more gradual than was formerly thought.

FIGURE 1.15 Incised motif on the side of a pottery vessel. Dawenkou culture. Neolithic. Ju County Museum, Shandong.

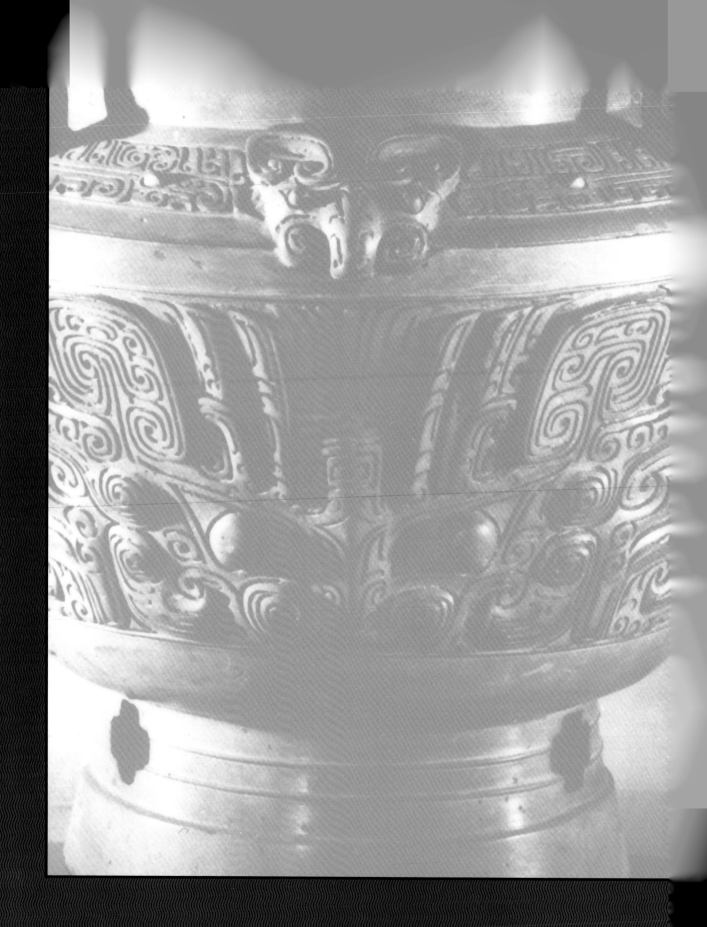

THE EARLY BRONZE AGE
Shang and Western Zhou

For centuries, farmers living in the village of Xiaotun near Anyang in Henan have been picking up peculiar bones found lying in the fields after rainfall or during plowing. Some are polished and shine like glass; most have rows of oval notches in their backs and T-shaped cracks; a few have marks on them that look like primitive writing. The farmers would take these bones to Anyang and neighboring towns and sell them to apothecaries, who often ground off the marks before reselling them as "dragon bones," a potent ingredient in restoratives. In 1899 some of the inscribed bones fell into the hands of the noted scholar and collector Liu Ou, who recognized the writing as an older form of the archaic script already known from the ritual bronzes of the Zhou dynasty. Soon other scholars, notably Luo Zhenyu and Wang Gouwei, took up the study of what were, in fact, fragments of the archives of the royal house of Shang, the existence of which had hitherto not been proved, though Chinese historians had never doubted it.[1]

The bones were traced to Anyang. The farmers began to dig deeper, and before long there began to appear on the antiques market in Beijing and Shanghai magnificent bronze vessels, jades, and other objects whose exact place of origin was kept secret. For nearly thirty years the farm-ers and dealers' agents, working at night or during the idle winter months, continued their indiscriminate pillaging of Shang tombs. Finally, in 1928, the Chinese National Research Institute (Academia Sinica) began an important series of excavations at Anyang that were to provide the first definite archaeological evidence that the Shang dynasty had actually existed and was not, as some Western writers had come to suspect, a pious fabrication of the backward-looking Chinese. By 1935 more than three hundred graves had been discovered, ten of which, of enormous size, were undoubtedly royal tombs.

These discoveries posed more problems than they solved. Who were the Shang people, and where did they come from? How was it that their earliest remains revealed a culture of such sophistication, particularly in their bronze techniques? If the Shang had existed, then perhaps remains would be found of the even earlier Xia dynasty.

The Chinese traditionally believe that they are descended from Huangdi, the Yellow Emperor, who lived for a hundred years. He succeeded Fuxi, who first drew the magical diagram *ba gua* (the "eight trigrams"), from which the art of writing is descended. Shen Nong, the Divine Farmer, invented agriculture and discovered the use of medicinal

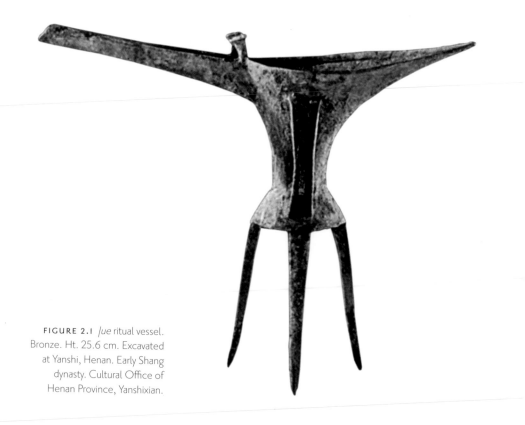

FIGURE 2.1 *Jue* ritual vessel. Bronze. Ht. 25.6 cm. Excavated at Yanshi, Henan. Early Shang dynasty. Cultural Office of Henan Province, Yanshixian.

herbs. Then came Yao and the filial Shun, the ideal rulers, and finally Yu the Great, who founded the Xia dynasty. In these legendary figures the Chinese personified all that they held most sacred: agriculture, good government, filial piety, and the art of writing. Now it is believed that all these personages were invented or took on these roles at a much later date. Yu, Yao, and Shun appeared first in late Zhou literature. Huangdi was probably invented by the Daoists.

Until 1950 our knowledge of early bronze culture in China was derived almost wholly from the remains of the Shang at Anyang, founded by King Pan Geng around 1320 B.C. and finally conquered by the armies of the Zhou in about 1050 B.C. At Anyang the bronze culture was at its height; metalworkers were producing sacrificial vessels of a quality that has been equaled nowhere in the world—the culmination, clearly, of centuries of development. The oracle bones gave the names of eighteen kings before Pan Geng, and, according to tradition, the Shang had moved their capital five times before finally settling at Anyang. If traces of these earlier capitals could be found, the gap be-

tween the late Neolithic and the mature bronze culture of Anyang might be closed.

In the 1950s Chinese archaeologists began looking for the beginnings of a true Bronze Age culture in the area of northern Henan and southern Shanxi traditionally known as the Waste of Xia. They found over a hundred sites, of which the richest is Erlitou, between Luoyang and Yanshi. It yielded what appeared to be a palace on a terrace, ceramic crucibles, bronze artifacts (some inlaid with turquoise), and objects of jade. They divided the Erlitou culture period, as it is now called, into four stages, covering the period roughly between 1900 and 1600 B.C. From the third stage comes the simple but elegant vessel for heating and pouring wine called a *jue* (fig. 2.1), one of the earliest ritual bronzes yet discovered in China and ancestor to the bronzes of the mature Shang dynasty.

Scholars are now debating whether all four levels at Erlitou should be assigned to the Xia dynasty (long thought to exist only in myth) or only the upper two. But until written evidence is found—and so far there is none—no site

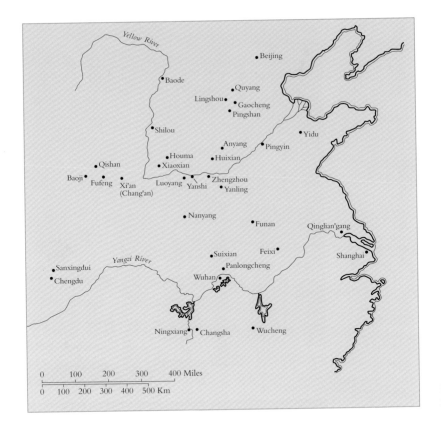

MAP 2.1 Ancient China, with major Shang and Zhou sites

can be called "Xia" with any certainty.[2] Even Erlitou may not mark any sudden advance in Chinese culture, for, as we saw in chapter 1, metal technology and the building of walled towns were already established in north China before 2000 B.C. Recently Chinese archaeologists have been calling the third millennium B.C. the Stone-Copper Age, but perhaps in light of the most recent discoveries Stone-Bronze Age or Proto-Bronze Age might be more appropriate. What is certain is that bronze working developed from primitive beginnings in several areas and that there is no need to look for its origins outside China.

By about 1500 B.C. the Bronze Age culture was widely spread over northern, central, and eastern China, as map 2.1 shows. Spectacular sites of this pre-Anyang stage (Erligang) have been discovered at Zhengzhou. The lowest strata at Zhengzhou are typical Longshan Neolithic, but the next stages, Lower and Upper Erligang, show a dramatic change. Remains of a city wall 60 feet (18.3 m) across at the base and enclosing an area more than a mile square (1.6 km) have been uncovered, together with what were probably a palace and sacrificial halls (fig. 2.2), houses, bronze foundries, pottery kilns, and a bone workshop. Large graves were furnished with ritual bronze vessels (fig. 2.3), jade, and ivory, while the pottery included both glazed stoneware and the fine white ware first found at Anyang. It is possible, though by no means proved, that Zhengzhou was one of the early Shang capitals, although precisely which one has not been definitely established.

Recent discoveries have shown that the Shang kingdom was surrounded on all sides by a ring of cultures, or proto-states, each of which drew upon the bronze art of the metropolitan area while showing marked characteristics of its own that contributed to the bronze repertory of this era.[3] Representations of human figures, rare at Anyang, are found in the northeast (Liaoning); the earliest vessels in the shape of animals were found in Hunan; *nao* bells, rare at Anyang, were an important element in the ritual of the southern peoples; tigers and birds as motifs in Shang and Zhou art were especially popular in the south and southeast. During the period of Shang expansion under Wu Ding,

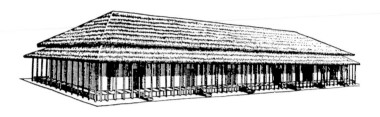

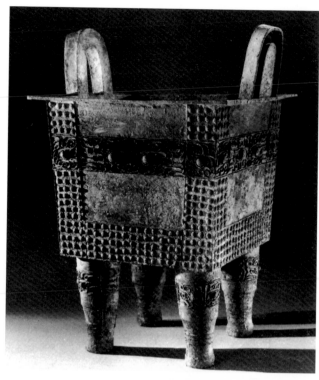

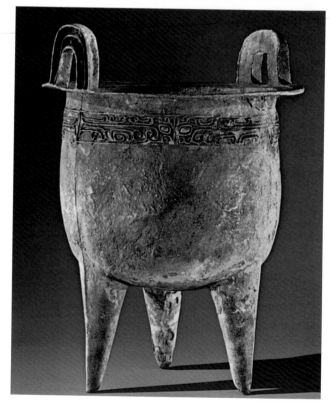

FIGURE 2.2 (ABOVE) Palace at Zhengzhou, reconstructed. Shang dynasty. After *Wenwu*, no. 4 (1984): 7.

FIGURE 2.3 (RIGHT TOP) *Ding* ritual vessel. Bronze. Ht. 100 cm. Excavated at Zhengzhou, Henan. Shang dynasty. Henan Provincial Museum, Zhengzhou. Photo: Seth Joel.

FIGURE 2.4 (RIGHT BELOW) *Ding* ritual vessel. Bronze. Ht. 48 cm. Excavated at Panlongcheng, Hubei. Shang dynasty. Hubei Provincial Museum, Wuhan.

these elements appeared in the Anyang bronzes, but did not survive for long.

The picture of bronze culture beyond the periphery of the Shang has been dramatically enlarged by these discoveries, of which we will discuss three of the most important. In 1974 archaeologists discovered at Panlongcheng, near Wuhan in the Yangzi Valley, the remains of what seems to be a palace—whether of a Shang governor or an independent ruler is not known—with sumptuously furnished tombs, from one of which comes the rather crude *ding* tripod illustrated in fig. 2.4.[4] From about the same time is a huge pit, thought to be a tomb, discovered, damaged though unlooted, in 1989 at Dayangzhou, southwest of Nanchang in Jiangxi.[5] This, the most richly furnished tomb (if indeed it is a tomb) yet found outside the Anyang area, contained fifty bronze vessels, a rich hoard of carved jades, and 356 pieces of pottery, one-fifth of which are glazed. Strange bronze masks with staring eyes and jagged teeth (fig. 2.5) point to local sacrificial worship.

Turning upriver to Sichuan, we come to one of the most sensational archaeological finds of recent years. In 1986–90 at Sanxingdui, north of Chengdu, the remains of a city wall seven and a half miles (12 km) in circumference were discovered, together with foundations of buildings and four "sacrificial pits." One pit contained layers of ritual jades and bronze vessels, with a few ceramics. The richest, pit no. 2, had three layers: on top, elephant tusks; in the middle, a rich assortment of bronze objects; at the bottom, chiefly jade and stone implements. Most remarkable of all are the more-than-life-size bronze standing figures from the middle layer (fig. 2.6) and forty-one bronze heads and masks, some covered with gold, others with huge protruding eyes—presumably deities or spirits of some sort. So far no writing has been discovered at the site, and the relationship of Sanxingdui to the Shang culture of Zhengzhou and Anyang, and to other more recently discovered Shang-period sites downriver, is not yet clear.[6] The technical quality and immense stylistic assurance of the bronze heads and masks, however, suggest that the culture of ancient Sichuan already had a long history.

At Sanxingdui quantities of cowrie shells identified as coming from the Indian Ocean have been found, probably used as currency, together with oracle bones, although unlike those from Anyang, they are not inscribed. This does not necessarily mean that these people had no writing; they

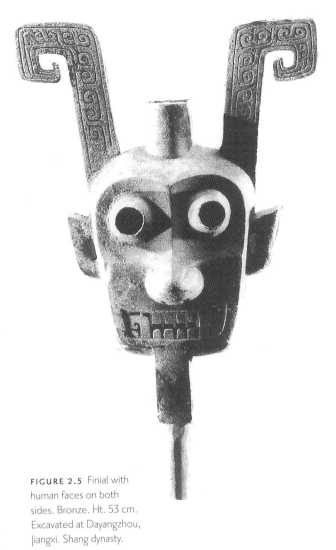

FIGURE 2.5 Finial with human faces on both sides. Bronze. Ht. 53 cm. Excavated at Dayangzhou, Jiangxi. Shang dynasty.

may have written on wooden slips, which would have perished in the damp earth of the Sichuan plain.

Chinese historians after 1949 followed orthodox Marxist doctrine, describing Shang and Zhou as prefeudal slave societies, and indeed the contents of the royal tombs at Anyang alone are enough to show that, under the Shang, slaves were many and brutally treated. But it seems that elements of feudalism were already present, for the inscriptions on the oracle bones indicate that successful generals,

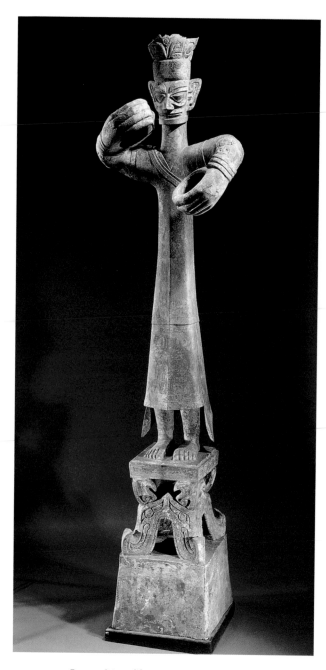

FIGURE 2.6 Figure of deity (?) on stand. Bronze. Overall ht. 262 cm. Excavated at Sanxingdui, Guanghan county, Sichuan. About 1200–1000 B.C. Institute of Archaeology and Cultural Relics Bureau, Sichuan.

sons, and even wives of the Shang rulers were enfeoffed, while small neighboring states paid regular tribute.

Prominent among the officials was the diviner, *zhenren*, who composed and probably wrote the inscriptions on the oracle bones and interpreted the cracks that appeared in them when a hot metal rod was applied to one of the holes bored into the back (fig. 2.7). These inscriptions were generally engraved, though it has recently been suggested that they were burnt in with a hot metal point, while a few were written with brush and ink. Over three thousand characters have been identified, about half of which have been deciphered; they were written in vertical columns, moving either to the left or to the right, apparently according to the dictates of symmetry. In early stages at Zhengzhou the oracle bones were mainly scapulae of pig, ox, or sheep; in the final phase at Anyang tortoise shells fastened with thongs were used almost exclusively. Wood and bamboo slips were also fastened that way, as shown in the pictograph for a book: 冊.

The inscriptions on the bones are either declarations of fact or of the ruler's intentions, or questions about the future that could be answered with a simple yes or no. They relate chiefly to agriculture, war, and hunting, the weather, journeys, the all-important sacrifices by which the ruler attuned himself to the will of Heaven, and concern about the succession. Here is an example: "Crack-making on *jiashen* [day 21], Que divined: [Charge:] 'Lady Hao [a consort of King Wu Ding] will give birth and it may not be good.' [Verification:] [After] thirty-one days, on *jiayin* [day 51], she gave birth. It really was not good. It was a girl."[7]

On the whole the inscriptions reveal that the Shang people had some knowledge of astronomy, knew precisely the length of the year, had invented the intercalary month, and divided the day into periods. Their religious belief centered in a supreme deity, Di, who controlled the rain, wind, and human affairs, and in lesser deities of the heavenly bodies, of the soil, of rivers, mountains, and special places (the *genii loci*). Special respect was paid to the ancestral spirits, who lived with Di and could affect the destinies of men for good or ill, but whose benevolent concern in the affairs of their descendants could be ensured by sacrificial rites.

The Anyang people built chiefly in wood and tamped earth. Remains have been found of several large buildings; one of them, over 90 feet (27 m) long, was raised on a plinth, its presumably thatched roof supported on rows of wooden

pillars, of which the stone socles remain. Another was laid out axially with steps in the center of the south side (fig. 2.8) and but for its roof would not have looked much different from any large traditional-style building in rural north China today. Some of the more important buildings were adorned with formalized animal heads carved in stone, and their beams were painted with designs similar to those on the ritual bronzes. The most popular method of construction—presumably because it was cheap and provided good protection against the piercing cold of the north China winter—was the *banzhu* ("plank building") technique, in which the earth was tamped between vertical boards with a pole: the smaller the diameter of the pole, the stronger the wall.

Anyang can still claim to be the most important site of the second millennium B.C., if only because eighty years of continuous excavation and study there have given us so detailed a picture of the area and its social and economic life. Yet a mystery still hangs about the place. One of the first things the excavators noticed was that it did not have the defensive wall that surrounded every major Chinese city until modern times; moreover, the buildings, unlike those at Zhengzhou and Panlongcheng, are aligned north-south and strung out in no apparent order. Perhaps Anyang was not a capital city at all, but merely the center of the royal tombs, sacrificial halls, bronze workshops, and the dwellings of the officials and priests, artisans, and humble folk who served them. If so, where was the administrative capital of the late Shang? Perhaps it was still at Zhengzhou, or at a site somewhere near Anyang that has still to be identified. Yet even if the capital was not at Anyang itself, this complex of halls, tombs, workshops, and dwellings was supremely important in the cultural history of early China.

The Chinese belief that the spirit of the departed must be provided with all that he possessed (or indeed, would have liked to possess) in his earthly life led to immolation and human sacrifice on a gigantic scale. But gradually these practices were almost entirely abandoned, and the human victims were replaced with straw or increasingly with pottery substitutes, not only models of furniture, farms, and houses, but also of servants, guards, and domestic animals. At the same time, the corpse was decked out with the richest clothing, jewelry, and jades that his family or the state could afford. In later times, some collectors were even to take their favorite paintings with them into the tomb.

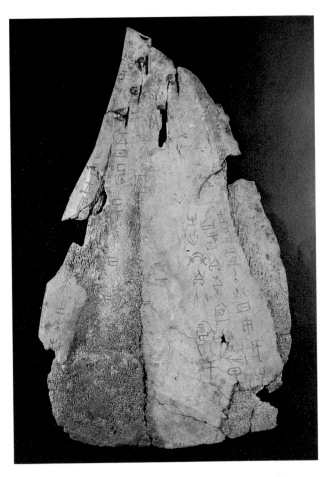

FIGURE 2.7 Oracle bone excavated at Yinxu, Anyang, Henan. Shang dynasty. National Palace Museum, Taipei. Photo courtesy of Liu Zhengcheng.

FIGURE 2.8 Reconstruction of a house at Xiaotun, Anyang, Henan. Late Shang period. From Shih Chang-ju and Kwang-chih Chang, *Annals of Academia Sinica* I (1954): 276.

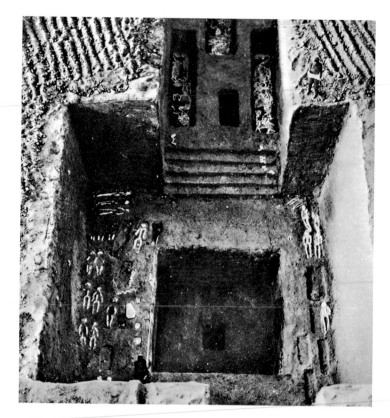

FIGURE 2.9 Replica of excavated tomb at Wuguancun, Anyang, Henan. Late Shang period.

FIGURE 2.10 Carriage burial, showing bronze fittings in place. Anyang, Henan. Late Shang period.

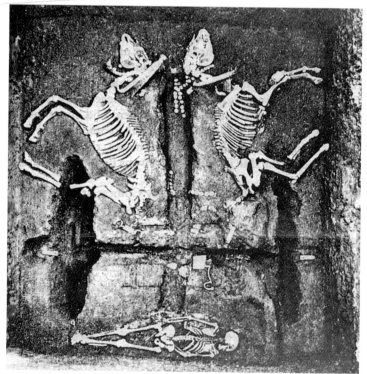

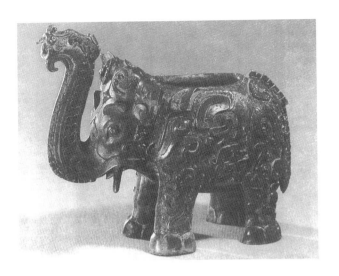

FIGURE 2.11 *Zun* ritual vessel in the shape of an elephant. Bronze. Ht. 22.8 cm. Isolated find near Changsha, Hunan. Shang dynasty. Hunan Provincial Museum, Changsha.

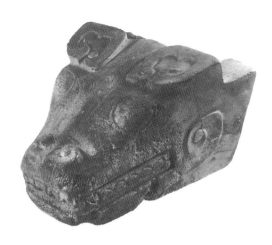

FIGURE 2.12 Ox head. Marble. L. 29.2 cm. Excavated at Houjiazhuang, Anyang, Henan. Late Shang period. Academia Sinica, Taipei.

However much one may deplore this custom, it has ensured the preservation of many beautiful things that would otherwise have been irretrievably lost.

The Shang royal tombs throw a lurid light upon early Chinese civilization. Some of them were of enormous size and furnished with bronze vessels, jade objects, and pottery. One royal personage, apparently an animal lover, had his pets, including an elephant, buried near him in separate graves. The tomb excavated at Wuguancun (Anyang) contained the remains of a canopy of painted leather, wood bark, and bamboo; in the approaching ramps and main chamber lay the complete skeletons of no fewer than twenty-two men (one beneath the tomb chamber) and twenty-four women, while the skulls of a further fifty men were buried in adjacent pits (fig. 2.9). In some cases the bodies show no signs of violence—the result, perhaps, of voluntary self-immolation by relations or retainers of the dead man—while in others, decapitation suggests that the victims may have been slaves, criminals, or prisoners of war. Elsewhere at Anyang, light carriages with their horses and driver were buried in specially prepared pits, with channels dug out for the wheels (fig. 2.10). The wood has of course perished, but impressions in the earth have made it possible to reconstruct the carriage itself and thus to determine the position and function of many of its beautiful bronze fit-

tings. Mass immolation was not practiced by the Zhou, though it appears to have been revived from time to time on a more modest scale by later rulers.

One often-noted aspect of early Chinese culture is the apparent rarity of monumental sculpture comparable to that of ancient Egypt and Mesopotamia. If there were large pieces in wood or clay, they have perished. Nothing like the life-size bronze votive figure from Sanxingdui (see fig. 2.6) has been found at Anyang. Shang-period sculpture seems to have been confined to smaller objects, such as bronze ritual vessels cast from clay models in the form of animals and birds (fig. 2.11), small figures of kneeling slaves or sacrificial victims, and pieces such as the ox head illustrated in fig. 2.12, carved four-square from the block, decorated in a style close to that of the bronzes, and slotted at the back, which may have been an architectural feature of some sort.

THE SHANG DYNASTY

POTTERY

Ceramics formed the backbone of early Chinese art—indispensable, ubiquitous, reflecting the needs and tastes of the highest and the lowest, lending their forms and decoration to the metalworker and, less often, borrowing from him. In the Shang, the crudest pottery is a gray earthen-

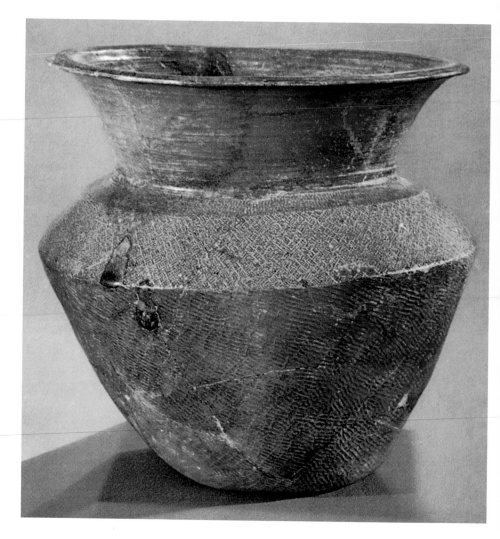

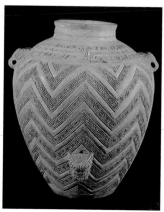

FIGURE 2.13 Urn. White pottery (restored). Ht. 33.2 cm. Excavated at Anyang, Henan. Late Shang period. Freer Gallery of Art, Smithsonian Institution, Washington, D.C.

FIGURE 2.14 *Zun* vase. Stoneware decorated with impressed pattern under yellowish-brown glaze. Ht. 28.2 cm. Excavated at Zhengzhou, Henan. Middle Shang period.

ware, cord-marked, incised, or decorated with repeated stamped motifs ranging from squares and coils—the ancestor of the thunder pattern (*leiwen*)—to simple versions of the zoomorphic masks that appear on the bronzes. Pottery decorated by stamping or carving geometric designs in the wet clay has been found in a number of Neolithic sites in the southeast. In south China, this technique persisted into the Han dynasty and was carried thence to southeast Asia—if, indeed, it had not originated there. It is seldom found in the Neolithic pottery of north China, and its appearance on vessels at Zhengzhou and Anyang suggests that by the Shang dynasty the culture of the southern peoples was already beginning to make its influence felt.

The beautiful white Shang pottery is unique in the his-

tory of Chinese ceramics. So fine is it that it has been taken for porcelain, but it is in fact a very brittle ware made from the fine loess blown across the North China Plain from the deserts to the north and west, finished on the wheel, and fired at about 1830° F (1000° C). Many writers have remarked how closely its decoration echoes that of the bronzes. As we have seen, southeastern China had already evolved a technique for stamping designs in the wet clay, which in turn influenced bronze design; the white stoneware urn in the Freer Gallery, illustrated in fig. 2.13, is indeed close in design and decoration to a bronze vessel in the Hellström collection.[8] This is no accident, for the bronze decoration was cast from clay molds bearing the designs in reverse. The Zhengzhou finds suggest that some of the motifs decorating both the white ware and the bronzes originated in the earlier stamped gray pottery; the techniques and designs used in woodcarving suggest another possible source. Some of the gray and buff ware found in Shang sites in Henan and Hubei is glazed. While in some cases the glaze was produced accidentally when wood ash fell on the heated pottery in the kiln, in others the ash glaze was deliberately applied (fig. 2.14). These Shang glazed wares, which are now being found over a wide area of northern, central, and eastern China, mark the beginning of a tradition that culminates two thousand years later in the Yue wares and celadons of Zhejiang and Jiangsu.

RITUAL BRONZES

According to tradition, when the emperor Yu of the Xia divided the empire, he ordered nine *ding* tripods to be cast in metal, brought as tribute from each of the nine provinces, and decorated with representations of the remarkable things characteristic of each region. These tripods were credited with magical powers: they could ward off noxious influences, for example, and cook food without fire. From dynasty to dynasty they were handed down as the palladia of empire, but at the end of the Zhou they were lost. The unsuccessful efforts of the first Qin emperor, Shihuangdi (r. 221–210 B.C.), to recover one of them from a riverbed are mocked in several humorous Han reliefs, though one of the Han emperors had no better success trying to accomplish the same thing by means of sacrifices. So strong was the tradition of the nine tripods that as late as the Tang dynasty the "empress" Wu caused a set to be cast to bolster up her dubious claim to the throne.

FIGURE 2.15 *Yaxing.* Seal (?) enclosing a pictograph for offering wine. Shang dynasty.

Long before any archaeological evidence of the Shang dynasty had been unearthed, the ritual bronzes bore witness to the power and vitality of this remote epoch in Chinese history. Bronze vessels have been treasured by Chinese connoisseurs for centuries; that great collector and savant, the Song emperor Huizong (r. 1101–25), is even said to have sent agents to the Anyang region to search out specimens for his collection. These vessels, which, as Howard Hansford aptly observed, formed a kind of "communion plate,"[9] were made for the offerings of food and wine to ancestral spirits that formed the core of the sacrificial rites performed by the ruler and aristocracy. Some of them bear short inscriptions generally consisting of two or three characters forming a clan name. Often the inscription is enclosed within a square device known as the *yaxing*, from its resemblance to the character *ya* (fig. 2.15). A number of theories about its meaning have been advanced. The recent discovery at Anyang of bronze seals leaving an impression of precisely this shape suggests that it was in some way connected with the clan name.

Chemical analysis shows that the bronze vessels were composed of 5–30 percent tin and 2–3 percent lead, the rest (apart from impurities) being copper. In the course of time many of them have acquired a beautiful patina, much valued by connoisseurs, that ranges from malachite green and kingfisher blue to yellow or even red, according to the composition of the metal and conditions under which the vessel was buried. Forgers have gone to enormous trouble to imitate these effects, and a case is recorded of one family in which each generation buried fakes in specially treated soil, to be dug up and sold by the next generation but one. It was long thought that the Shang and Zhou bronzes were made by the *cire-perdue* (lost wax) method, for how, it was argued, could such exquisite detail have been modeled except in wax? However, while the technique may have been

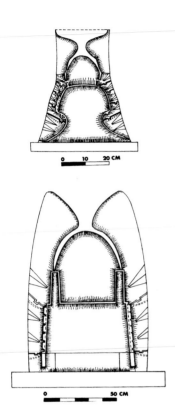

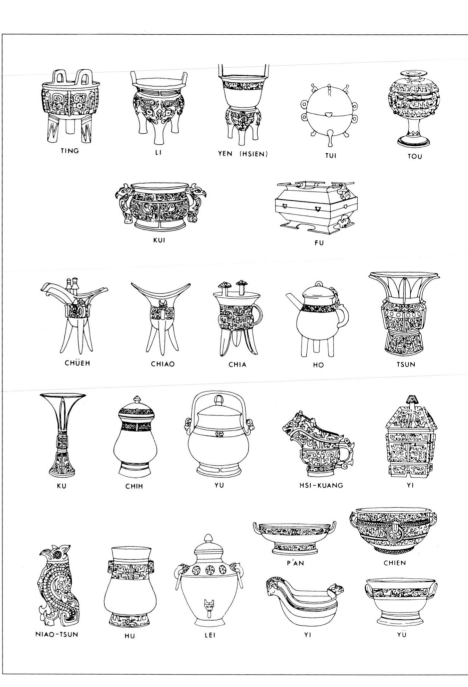

FIGURE 2.16 Sectional clay molds for casting bronze vessels. After Shih Chang-ju and Kwang-chih Chang, *Bulletin of the Institute of History and Philology* (Taipei, 1955): 113, 117.

FIGURE 2.17 Major types of Shang and Zhou bronze vessels. After Kwang-chih Chang, *Art, Myth, and Ritual* (Cambridge, Mass., 1983), fig. 38.

used in the Shang for casting small objects, numbers of outer and inner clay molds and crucibles have been found at Anyang and Zhengzhou, and there is now no question that the vessels were cast in sectional molds assembled around a solid central core (fig. 2.16) and that legs and handles were cast separately and soldered on. Many vessels still show ridges or rough places where two molded sections were imperfectly joined.

There are at least thirty main types of ritual vessels, of which twenty-four are illustrated in fig. 2.17. They range in size from objects a few inches tall to a gigantic *ding*—over 4 feet (1.2 m) high and weighing 1,760 pounds (800 kg)—cast by a Shang king in memory of his mother and unearthed at Anyang in 1939. They can most simply be grouped according to their use in the sacrifices. For cooking food (of which the essence only was extracted by the spirits, the participants later eating what the spirits left behind), the chief vessels were the hollow-legged *li* and *lihe* tripod (fig. 2.18) and the *xian* steamer. Both of these types, as we have seen, were common in Neolithic pottery and may then already have had a more than utilitarian function in some primitive rite. The *ding* (fig. 2.19), which has three or four straight legs, generally has fairly large handles or "ears" to enable it to be lifted off the fire. Vessels made for serving food included the two-handled *gui* and *yu* (basin). Among those for fluids (chiefly wine) were the *hu* (a vase or jar with a cover), the *you* (similar, but with a swing or chain handle, as in fig. 2.20, and sometimes fitted with a spout), the *zhi* (a cup with a bulbous body and spreading lip), the *he* (kettle), the tall and elegant trumpet-mouthed *gu* for pouring libations (fig. 2.21) and its fatter variant the *zun* (fig. 2.22; both derived from pottery prototypes), the *jia* for pouring and probably also for heating wine (see fig. 2.25), and, for mixing wine, the *guang* (see fig. 2.24), shaped like a gravy boat and generally provided with a cover and a ladle. Other vessels such as the *yi* and *pan* were presumably made for ritual ablutions.

During the fifteen hundred years that bronze casting was a major art form in China, the art went through a series of changes in style, reflecting ever greater sophistication in technique and decoration, that make it possible to date vessels within a century or less. Bronzes of the pre-Anyang phase, typified by those found at Zhengzhou and Panlongcheng, are often thinly cast and ungainly in shape. They are decorated with *taotie* masks (fig. 2.23) and dragonlike

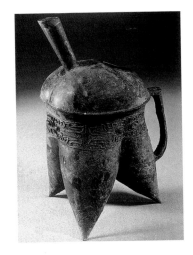

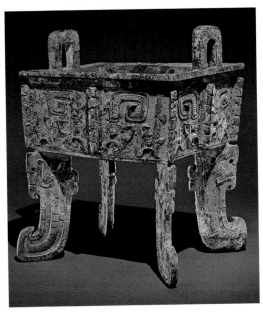

FIGURE 2.18 *Lihe* ritual vessel. Bronze. Ht. 25.4 cm. Middle Shang period. The Avery Brundage Collection. © Asian Art Museum of San Francisco.

FIGURE 2.19 *Fang* (square) *ding* ritual vessel. Bronze. Ht. 42.5 cm. From the tomb of Fu Hao at Anyang, Henan. Late Shang period. Institute of Archaeology, Beijing.

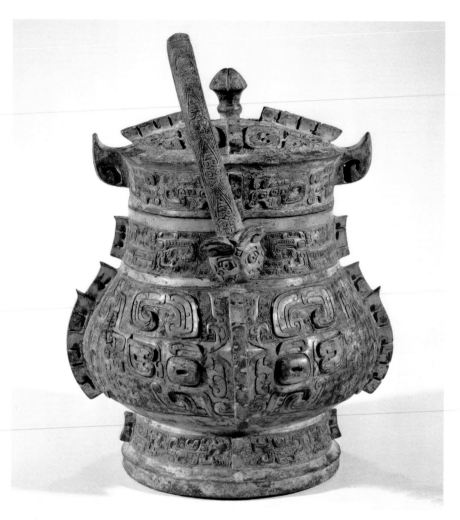

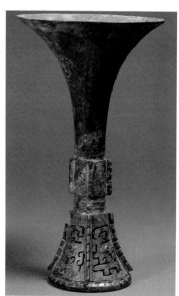

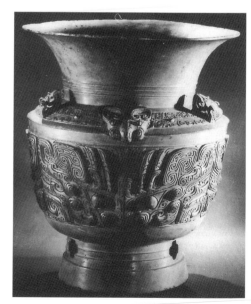

FIGURE 2.20 *You* ritual vessel. Bronze. Ht. 36.5 cm. Late Shang period. Freer Gallery of Art, Smithsonian Institution, Washington, D.C.

FIGURE 2.21 *Gu* wine vessel. Bronze. Ht. 25.6 cm. From the tomb of Fu Hao at Anyang, Henan. Late Shang period.

FIGURE 2.22 *Zun* ritual vessel. Bronze. Ht. 47 cm. Excavated at Funan, Anhui. Late Shang period. Photo: Musée du Petit Palais, Paris.

creatures with bosses resembling eyes, all rendered either in thin thread relief (style I) or in a band of ornament that looks as if it had been crudely carved in the clay model before casting (style II). The next stage (style III), found at both Zhengzhou and Anyang, is much more refined and accomplished, with dense, fluent curvilinear designs that often cover almost the whole surface of the vessel. In style IV the decoration (*taotie*, cicada, dragon, and so on) is separated from the background of fine curling scrolls by being modeled in clear flat planes. Finally, in style V, the main zoomorphic motifs rise in bold relief, and the background spirals may disappear altogether.

When Professor Max Loehr first identified these five styles in 1953,[10] he suggested that they followed each other in an orderly sequence, but in the light of more recent discoveries this clear sequence may have to be modified somewhat, for styles I and III have been found on the same vessel, while bronzes found in the tomb of Fu Hao, consort of Wu Ding, who was king during the later Anyang period, are decorated with elements from styles III, IV, and V. What happened to Shang bronze style after that was essentially an elaboration and refinement of these three later styles. The zoomorphic motifs that adorn the Shang bronzes and give them their intense vitality may seem innumerable but are for the most part variations and combinations of the same few elements—notably, the dragon, tiger, water buffalo, elephant, hare, deer, owl, bird, fish, cicada, and, possibly, the silkworm.

All these creatures were probably worshiped as tribal totems or, as K. C. Chang has suggested, as "helpers of shamans and shamanesses in the task of communication between heaven and earth, the spirits and the living."[11] Occasionally, in a frieze around an otherwise plain vessel, they may be represented naturalistically, but far more often they are so stylized as to be barely recognizable; their bodies dissolve and their limbs break down or take on a life of their own, sprouting other creatures. The *kui* dragon, for example, may appear with gaping jaws, with a beak, with a trunk, with wings, or with horns, or he may form the eyebrow of that most impressive and mysterious of all mythical creatures, the *taotie*.

This formidable mask, which often appears to be split open on either side of a flange and laid out flat on the belly of the vessel, is the dominating element in the decoration of Shang bronzes. Song antiquarians named it *taotie* in def-

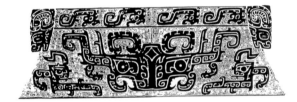

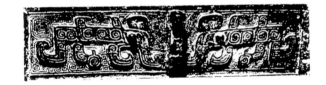

FIGURE 2.23 *Taotie* bands from ritual vessels, representing Max Loehr's five styles of Shang bronze decoration. From Li Chi, *Archaeologia Sinica*, n.s. I (1964): 71, and no. 5 (1972): 48, 100, and pl. 15.

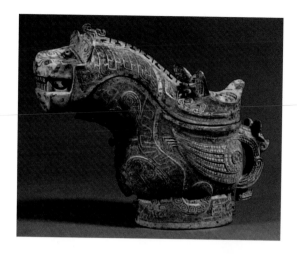

erence to a passage in a third-century B.C. text, the *Lüshi chunqiu,* which runs, "On the *ding* of the Zhou there is applied the *taotie:* having a head but no body he ate people, but before he swallowed them, harm came to his body." Thus by the end of the Zhou, the *taotie* was considered a monster; later it came to be called "the glutton" and was interpreted as a warning against overeating. Modern scholars have claimed that it represents a tiger or a bull; sometimes it has the characteristics of one, sometimes of the other. Mizuno Seiichi has drawn attention to a passage in the *Chunqiu zuozhuan* (a combination of the *Spring and Autumn Annals* with the *Zuozhuan,* the *Annals of Zuo*) describing the *taotie* as one of the four devils driven away by the emperor Shun and subsequently made defender of the land from evil spirits.[12] What the Shang people called this creature, and what it meant to them, may never be known.

Two examples will show how effectively the various elements can be combined and integrated with the shape of the vessel itself. The lid of the *guang* in fig. 2.24 terminates in a tiger's head at one end and an owl's at the other; the tiger's legs can clearly be seen on the front of the vessel, the owl's wing at the back. Between them a serpent coils up onto the lid, ending in a dragon's head at the crown of the dorsal flange. The main decoration of the magnificent *jia* in Kansas City (fig. 2.25) consists of *taotie* masks divided down the center by a low flange and standing out against a background of spirals, called *leiwen* by Chinese antiquarians, from their supposed resemblance to the archaic form of the character *lei* ("thunder"). However, the meaning—like that of the endless spirals painted on the Yangshao pottery—is lost. The *taotie* has large "eyebrows" or horns; a frieze of long-tailed birds fills the upper zone, while under the lip is a continuous band of "rising blades" containing the formalized bodies of the cicada, a common symbol of regeneration in Chinese art. The *jia* is crowned with a squatting heraldic beast and two large knobs for lifting the vessel off the fire with tongs, while the tapering legs are decorated with a complex system of antithetical *kui* dragons.

Occasionally, the effect is too bizarre and extravagant to be altogether pleasing, but in the finest vessels the main decorative elements play over the surface like a dominant theme in music against a subtle ground bass of *leiwen;* indeed, to pursue the analogy further, these motifs seem to interpenetrate like the parts in a fugue and at the same

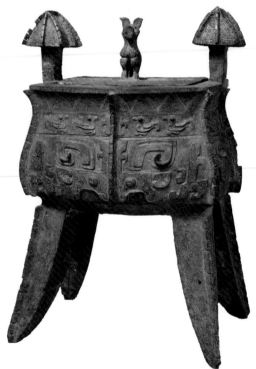

FIGURE 2.24 *Guang* ritual vessel. Bronze. Ht. 24.2 cm. Late Shang period. Harvard Art Museum, Arthur M. Sackler Museum, Bequest of Grenville L. Winthrop. Photo © President and Fellows of Harvard College.

FIGURE 2.25 *Jia* ritual vessel. Bronze. Ht. 34.2 cm. Late Shang period. The Nelson-Atkins Museum of Art, Kansas City, Missouri. Purchase: Nelson Trust.

time to pulsate with a powerful rhythm. Already in the sweeping decoration of the Yangshao painted pottery we saw a hint of that uniquely Chinese faculty of conveying formal energy through the medium of dynamic linear rhythms. Here in the bronzes that faculty is even more powerfully evident; many centuries later it will find its supreme expression in the language of the brush.

As we have seen, the craft of bronze-casting was widely spread over China by the end of the second millennium B.C., and each region had its own style. The bronze art of Sanxingdui represents a culture that seems to have had little contact with Anyang, while the *zun* (fig. 2.22) excavated in 1957 at Funan in Anhui, decorated in a style more fluid and "plastic" than that of late Shang at Anyang, relates to another vigorous tradition far to the southeast.

The bronze weapons used by the Shang people show several aspects of this many-faceted culture. Most purely Chinese was a form of dagger-ax known as the *ge* (fig. 2.26), with a pointed blade and a tang that was passed through a hole in the shaft and lashed to it, or, more rarely, shaped like a collar to fit around the shaft. The *ge* probably originated in a Neolithic weapon and seems to have had ritual significance, for some of the most beautiful Shang specimens have blades of jade, while the handle is often inlaid with a mosaic of turquoise. The *qi* ax, which also originated in a stone tool, has a broad, curving blade like that of a medieval executioner's ax, while its flanged tang is generally decorated with *taotie* and other motifs. A fine example of a *qi,* an executioner's ax, excavated in 1976 at Yidu in Shandong, is illustrated in fig. 2.27. On either side of the terrifying mask is a cartouche of *yaxing* shape containing the figure of a man offering wine on an altar from a vessel with a ladle. Less exclusively Chinese are the bronze daggers and knives, simple forms of which have been found at Zhengzhou. At Anyang they become more elaborate, the handle often terminating in a ring or in the head of a horse, ram, deer, or elk (fig. 2.28). These knives have their counterpart in the "animal style" of the Ordos Desert, Inner Mongolia, and of southern Siberia.

Whether China or central Asia was the source of the animal style has long been debated. Much turns upon the date of the southern Siberian sites such as Karasuk, where it also appears, and until that date is established the question of priority cannot be settled. It seems that an animal style ex-

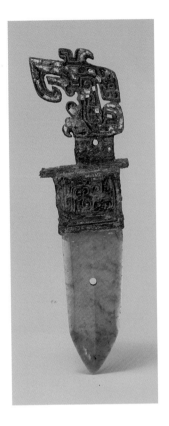

FIGURE 2.26 *Ge* dagger-ax. Bronze. L. 27.3 cm. From Anyang, Henan. Late Shang period. Seattle Art Museum, Thomas D. Stimson Memorial Collection. Photo: Paul Macapia.

FIGURE 2.27 *Qi* executioner's ax. Bronze. Ht. 28 cm. From Yidu, Shandong. Shang dynasty.

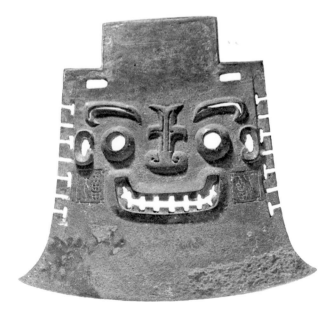

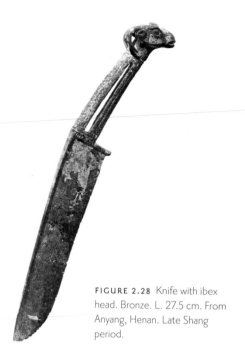

FIGURE 2.28 Knife with ibex head. Bronze. L. 27.5 cm. From Anyang, Henan. Late Shang period.

isted simultaneously in western Asia (Luristan), Siberia (Karasuk), and China roughly between 1500 and 1000 B.C. and that Chinese artisans drew upon this style from their western neighbors and at the same time contributed their own increasingly rich repertoire of animal forms. Elements of the animal style also appear in the bronze fittings made for furniture, weapons, and chariots. Excavations at Anyang have made it possible to reconstruct the Shang chariot and to assign to their correct place such objects as hubcaps, jingles, pole ends, awning fittings, and the V-shaped sheaths for horses' yokes.

The origin of the decoration on the bronzes presents a problem. The most striking element in it is the profusion of animal motifs, scarcely any of which appear in Chinese Neolithic art. The Shang people had cultural affinities with the steppe and forest folk of Siberia and, perhaps more remotely, with the peoples of Alaska, British Columbia, and Central America. The similarities between certain Shang designs and those, for example, in the art of the indigenous people of the North American west coast seem too close to be entirely accidental. Li Ji has suggested that the richly decorated, square-sectioned bronze vessels with straight sides are a translation into metal of a northern wood-carving art, and there is much evidence for the stylistic similarity between the décor of these bronzes and the art of the northern nomadic peoples. But the art of carving formalized animal masks on wood or gourd is native to southeast Asia and the Malay archipelago and is still practiced today. Also surviving in southeast Asia until modern times is the technique of stamping designs in wet clay, which may have contributed the repeated circles, spirals, and volutes to Chinese bronze ornament. But even if some elements are not native to China, taken together they add up to a decorative language that is powerfully and characteristically Chinese.

Whatever the origins of this language, we must not think of it is as confined solely to the sacrificial bronzes. Could we but transport ourselves to the home of some Anyang nobleman, we might see *taotie* and beaked dragons, cicadas and tigers, painted on the beams of his house, applied to hangings of leather and matting about his rooms, and probably even woven into his silk robes. The contents of excavated tombs reinforce the view that these motifs are not tied to the form or function of any individual bronze vessel but belong to the whole repertoire—part decorative, part symbolic, part magical—of early Bronze Age art.

JADE

Already in certain Neolithic sites we have encountered jade, selected, it appears, for objects of more than purely utilitarian purpose by virtue of its hardness, strength, and purity. In the Shang dynasty the craft of jade carving progressed a step further. It has been suggested that metal tools were already employed at Anyang, and there is evidence that the Shang lapidary may also have used a drill point harder than modern carborundum. Some small pieces carved in the round have been found in Shang period sites, but the vast majority consist of weapons and ritual and decorative objects carved from thin slabs seldom more than half an inch (1.3 cm) thick. The jades from Zhengzhou include long, beautifully shaped knives and ax blades (*ge*), circles, sections of disks, a figure of a tortoise, and flat plaques in the shape of birds and other creatures pierced at each end for use as clothing ornaments or pendants.

The finds at Anyang are incomparably richer in beauty, workmanship, and range of types than those at Zhengzhou. They include plaques in the shape of birds, fish, silkworms, and tigers; *bi* disks, *cong* tubes, *yuan* rings, and other ritual objects; beads, knives, and ceremonial axes (fig. 2.29). Among the rarest pieces are the small kneeling figures of servants or slaves from the tomb of Fu Hao (fig. 2.30), which are of particular value for the evidence they offer of dress and hair styles in the early Anyang period. The largest find at Anyang—although it is of marble rather than true jade—was a chime found lying on the floor of the grave pit at Wuguancun (fig. 2.31). Cut from a thin slab, pierced for suspension, and decorated with a tiger in raised thread relief, this impressive object bears witness to the importance of music in the rituals of the Shang court. We will have more to say about the symbolism and ritual use of jade later in this chapter (see p. 40).

Not all carving was done in such intractable materials as jade and marble. Some of the most beautiful of all Shang designs were carved in bone and ivory. Elephants roamed north China in prehistoric times and were probably still to be found south of the Yangzi in the Shang dynasty. We know that at least one Shang emperor kept one as a pet, perhaps sent as tribute from Yue, while a plentiful supply of ivory could be had from China's southern neighbors. On plaques of ivory and bone a few inches square, made presumably as ornaments for chariots, furniture, or boxes, were carved *taotie* and other designs of extraordinary intricacy and

FIGURE 2.29 Ax blade. Jade. From Anyang, Henan. Late Shang period.

FIGURE 2.30 Figurine of jade. Ht. 7 cm. From the tomb of Fu Hao at Anyang, Henan. Shang dynasty. Institute of Archaeology, Beijing.

FIGURE 2.31 Chime with tiger design. Stone. L. 84 cm. From tomb at Wuguancun, Anyang, Henan. Late Shang period.

beauty (fig. 2.32), sometimes inlaid with turquoise. Like the bronzes, these bone and ivory carvings show striking similarities to the art of the natives of the North American west coast. For years scholars have toyed with the fascinating possibilities that these similarities have opened up, but so far no archaeological links have been found to account for them.

THE WESTERN ZHOU

During the last years of the Shang dynasty, the vassal state of Zhou on the western frontier had grown so powerful that its ruler, Wen, controlled two-thirds of the Shang territories. Finally, possibly in 1045 B.C., Wen's son Wu, the Martial King, captured Anyang, and the last Shang ruler committed suicide. Under Wu's young successor, Cheng Wang, a powerful regent known to history as the Duke of Zhou (Zhou Gong) consolidated the empire, set up feudal states, and parceled out the Shang domains among other vassals, though he took care to permit the descendants of Shang to rule the little state of Song so that they could keep up the hereditary sacrifices to their ancestral spirits. Zhou Gong was chief architect of the dynasty that was to have the longest rule in China's history, and even though its later centuries were clouded by incessant civil wars in which the royal house was crushed and finally engulfed, the Zhou dynasty gave to China some of its most characteristic and enduring institutions.

There was no abrupt break with Shang traditions; indeed, many of those traditions were developed and perfected under the Zhou. Feudalism, court ritual, and ancestor worship became such effective instruments in welding the state together that during the time of confusion at the end of the dynasty many conservatives, Confucius among them, looked back upon the reigns of Wen, Wu, and the Duke of Zhou as a golden age. Religious life still centered on the worship of Shang Di, though the concept of Heaven (*Tian*) now began to appear and eventually replaced the cruder notions embodied in Shang Di. Bronze inscriptions and early texts indicate the beginnings of a moral code based on adherence to the will of Heaven and respect for *de* (virtue), both of which would become fundamental teachings of Confucius.

The Zhou court became the focus of an elaborate ritual in which music, art, poetry, and pageantry all combined under the direction of the master of ceremonies (*binxiang*) to give moral and aesthetic dignity to the concept of the state.

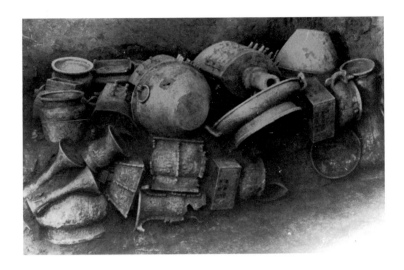

FIGURE 2.33 Hoard of buried bronze ritual vessels. Excavated at Zhuangbo, Fufeng, Shaanxi. Western Zhou period.

The king held audiences at dawn and dusk (a custom that survived until 1912) during which orders for the day, written on bamboo slips, were read out by the court historian and then handed to officials for execution. From the time of Mu Wang (947–928? B.C.) onward, it became the custom to preserve those orders by casting them on bronze ritual vessels. The inscriptions, ever longer as time went on, are one of the main sources for the study of early Zhou history, the other chief document being the *Book of Songs* (*Shijing*), an anthology of ancient court odes, ballads, and love songs said to have been compiled by Confucius, and the authentic chapters of the *Classic of History* (*Shujing*), which tell of the fall of the Shang and the early years of the Zhou. These documents bear witness to that sense of history that is one of the most striking features of Chinese civilization and, as a corollary, to the almost sacred place held in Chinese life by the written word.

ZHOU CITIES

At the moment, more is known about Shang architecture than about that of the early Zhou, for which we have to rely largely upon the evidence of the written word, although the picture is changing rapidly with the discovery of the remains of the cities and noble tombs of the petty states of late Shang and early Zhou, some of which are unrecorded in surviving historical texts. One of the chief sources for the study of Zhou institutions is the *Zhouli,* a manual of ritual and government compiled, it is believed, in the Former Han dynasty. Its authors, looking back through the mists of time

to the remote golden age, present a somewhat idealized picture of Zhou ritual and life. Nevertheless, the *Zhouli* remains significant, for its descriptions were taken as canonical by later dynasts, who strove always to follow the ancient institutions and forms as the *Zhouli* presented them. Writing of the ancient Zhou city, the *Zhouli* says: "The architects who laid out a capital made it a square nine *li* [about 3 miles (5 km)] on a side, each side having three gateways. Within the capital there were nine lengthwise and nine crosswise avenues, each nine chariot tracks wide. On the left was the ancestral temple, on the right the Altar of the Soil; in front lay the Court of State, at the rear the marketplace."[13]

For many years it was not known where the seat of early Zhou power lay. Then in the late 1970s the remains of an ancient Zhou city with palace buildings were found at Qishan, some 60 miles (100 km) west of Xi'an. The Zhou continued to rule from Qishan for some years after the conquest. Closer to Xi'an, on either side of the Feng River, archaeologists have for thirty years been unearthing rich remains from Zhou tombs as well as hoards of bronze vessels (fig. 2.33) probably buried when the capital was hurriedly moved to Luoyang in 771 B.C.[14]

Later in the Zhou, as the independent feudal states proliferated, the number of cities grew. Some were very large. The capital of the state of Qi in Shandong, for instance, was a mile (1.6 km) from east to west and two and a half miles (4 km) from north to south, surrounded by a wall of tamped earth over 30 feet (9 m) high. The capital of Yan in Hebei was even larger. These late Zhou cities with their

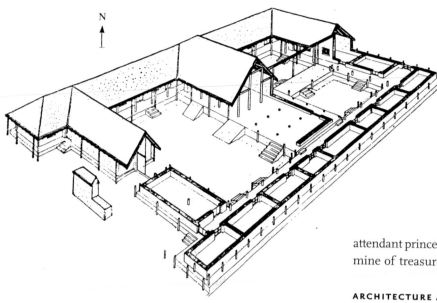

N

FIGURE 2.34 Palace at Fengchu, Shaanxi, reconstructed. 45 × 32.5 m. Western Zhou period.

attendant princely cemeteries form an almost inexhaustible mine of treasures for the archaeologist and art historian.

ARCHITECTURE AND SCULPTURE

The Book of Songs contains several vivid descriptions of ancestral halls and palaces. Here is part of one of them, translated by Arthur Waley:

> To give continuance to foremothers and forefathers
> We build a house, many hundred cubits of wall;
> To south and west its doors.
> Here shall we live, here rest,
> Here laugh, here talk.
> We bind the frames, creak, creak;
> We hammer the mud, tap, tap,
> That it may be a place where wind and rain cannot enter,
> Nor birds and rats get in,
> But where our lord may dwell.
> As a halberd, even so plumed,
> As an arrow, even so sharp,
> As a bird, even so soaring,
> As wings, even so flying
> Are the halls to which our lord ascends.
> Well leveled is the courtyard,
> Firm are the pillars,
> Cheerful are the rooms by day,
> Softly gloaming by night,
> A place where our lord can be at peace.
> Below, the rush-mats; over them the bamboo-mats.
> Comfortably he sleeps,
> He sleeps and wakes
> And interprets his dreams.[15]

漢長安南郊禮制建築復原

FIGURE 2.35 Mingtang ritual hall, reconstructed. Western Han period.

Such ballads give us a picture of large buildings with timber-framed rammed-earth walls standing on a high platform, of strong timber pillars supporting a roof whose eaves, though not yet curving, spread like wings, of floors covered with thick matting like the Japanese *tatami,* of warmth, light, and comfort. While the most monumental buildings were the ancestral halls, the palaces and private houses were often large, and some already had several successive courtyards, as they do today. The complex excavated at Fengchu in 1976, illustrated in fig. 2.34, has courtyards arranged on a central axis with a screen masking the entrance, little different from the palaces, mansions, and temples of later dynasties. This building was thatched, but some others of this period were roofed with pottery tiles.

Among the more conspicuous Zhou ceremonial buildings must have been the Mingtang (Bright Hall), a many-roomed square structure (symbolic of Earth) surrounded by a circular enclosure (symbolic of Heaven), of which detailed, though conflicting, accounts are given in early texts. The remains of the Zhou Mingtang have not been found, but an attempt to revive it was made in the Western Han period, and a reconstruction of the Han Mingtang is illustrated in fig. 2.35.[16] Also prominent in the cities were

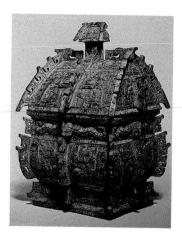

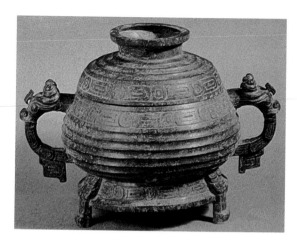

FIGURE 2.36 *Fang* (square) *yi* ritual vessel. Bronze. Long dedicatory inscription of the court annalist Ling. Ht. 35.6 cm. Western Zhou period. Freer Gallery of Art, Smithsonian Institution, Washington, D.C.

FIGURE 2.37 *Gui* ritual vessel. Bronze. Ht. 30.4 cm. Dated by inscription to 825 B.C. Western Zhou period. The Avery Brundage Collection. © Asian Art Museum of San Francisco.

the towers (*tai*) built of timber on a high platform of rammed earth, which passages in the *Zuozhuan* (Annals of Zuo) show were used by the princes as fortresses, for feasting, or simply as lookout towers.

RITUAL BRONZES

In the earliest Western Zhou bronzes, the Shang tradition is carried on with little change, one of the most significant differences being in the inscriptions. In the Shang, these were simple dedications to the spirits. Under the Zhou, as the religious function of inscriptions weakened, they became a means of communicating to the clan ancestors and recording for posterity some honor or achievement of the living aristocrat, thereby proclaiming his power and prestige. Sometimes running to several hundred characters in length, they are valuable historical documents in themselves. A typical short early Zhou inscription on a *gui* in the Pillsbury Collection in Minneapolis runs: "The king attacked Qiyu and went out and attacked Naohei. When he came back, he made *liao*-sacrifice [a burnt offering] in Congzhou and presented to me, Guo Bao X, ten double strings of cowries. I presume in response to extol the king's grace, and so I have made my dead father's *gui* vessel. May for a myriad years sons and grandsons forever treasure and use it."[17]

For perhaps a century after the Zhou conquest, Shang bronze styles survived (fig. 2.36), particularly in the region of northern Henan where the Zhou conquerors settled the remnants of the "stubborn" Shang. Gradually, popular

Shang shapes such as the *gu, jue, guang,* and *you* disappeared, and the *pan,* a shallow basin, became more common, perhaps reflecting less wine-swilling and more clean hands at the Zhou court, while the *ding* now becomes a wide, shallow bowl on three legs.

Bronzes of the Western Zhou tend to be more coarsely modeled than those of the late Shang, the Zhou shapes sagging and heavy, their flanges large and spiky, the vessels more treasured by Chinese connoisseurs for their inscriptions than for any beauty of form. The animal motifs featured so prominently in Shang décor, whose original purpose and meaning were forgotten, have dissolved into broad bands, meanders, and scale patterns (figs. 2.37 and 2.38). The disappearance of the *taotie, long* (dragon), and other mythical creatures, it has been suggested, was due to a change in the religious beliefs of the ruling class, for the Zhou saw animals and birds not as protective clan symbols, but as enemies to be fought against or conquered by earthly heroes such as the Archer Yi, who shot out of the sky nine of the ten sun-birds that were scorching the earth. Nevertheless, ritual vessels continued to be fashioned from time to time in animal shapes that, in the absence of Zhou dynasty sculpture, must suffice to give us an idea of the plastic feeling of the period. A fine early Zhou example is the pair of bronze tigers in the Freer Gallery, modeled powerfully in the round and covered all over with a decoration closely allied to that on the ritual vessels, which by its rhythmic movement greatly enhances the vitality of the form (fig. 2.39).

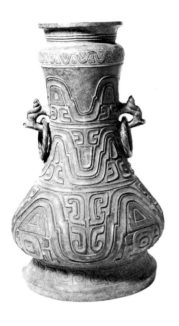

FIGURE 2.38 *Hu* ritual vessel. Bronze. Ht. 60.6 cm. Dated to 862 or 853 B.C. by inscription: "It was in the 26th year, 10th moon, first quarter, on the day *jimao*, when Fan Qu Shang had this bridal *hu* cast as a bridal gift for his first child Meng Fei Guai. May sons and grandsons forever treasure and use it." Western Zhou period. The Avery Brundage Collection. © Asian Art Museum of San Francisco.

FIGURE 2.39 Tiger. One of a pair. Bronze. L. 75.2 cm. Western Zhou period. Freer Gallery of Art, Smithsonian Institution, Washington, D.C.

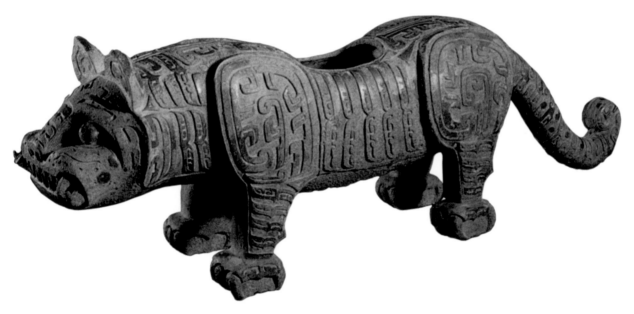

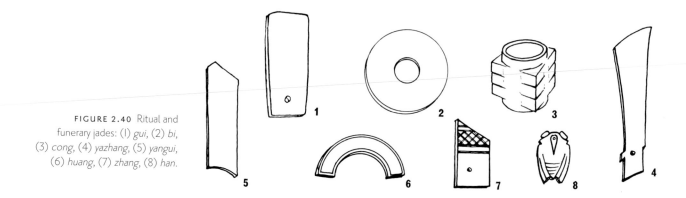

FIGURE 2.40 Ritual and funerary jades: (1) *gui*, (2) *bi*, (3) *cong*, (4) *yazhang*, (5) *yangui*, (6) *huang*, (7) *zhang*, (8) *han*.

JADE

Reliable archaeological evidence on the jade of the early and middle Zhou is scanty but constantly increasing with new finds. Before the Second World War, archaeologists working at Xincun in Xunxian, Henan, discovered a number of jade objects that were for the most part crude versions of Shang types, with the relief carving often confined to shallow incisions on a flat surface. Since 1950, excavations have confirmed the impression that the craft was in decline in the early Western Zhou. But the Zhou jades excavated under controlled conditions still represent a minute portion of the total number; these less than ideal circumstances, combined with the likelihood that the traditional forms must have persisted for long periods without change and that, when buried, jades may already have been treasured antiques, make the dating of individual pieces extremely difficult.

We have noted that ritual jades were discovered in the burial pits at Sanxingdui in Sichuan. It seems that early in the first millennium B.C. the capital (if indeed it was the capital) of Bashu was moved to Jinsha, in the western suburbs of Chengdu. Work in this site, still in progress, has yielded quantities of gold objects and jades, exquisitely worked, although the jade itself is of poor quality.

There is little doubt, fortunately, about the meaning and function of the ritual and funerary jades in Zhou times. According to the *Zhouli*, certain shapes were appropriate to particular ranks (fig. 2.40).[18] The king in audience, for example, held a *zhengui*, a broad, flat, perforated scepter; a duke held a *huan* (ridged scepter); while the lower ranks

of viscount and baron held *bi* disks decorated with the little bosses known as the "grain pattern." Proclamations were issued with jade objects to indicate royal authority—as, for instance, the *yazhang* (long knife) for mobilizing the imperial garrison, a *hu* (tiger) in two halves for transmitting military secrets, a *yangui* (scepter with concave butt) for protecting official envoys, and so on.[19] Equally specific were the jades used to protect the body at burial, numbers of which have been found in their original positions in the grave. Generally, the corpse lay on his or her back (a change from Shang practice). On the chest was placed a *bi* disk, symbol of Heaven; beneath the body a *cong*, symbol of Earth. To the east of the body was placed a *gui* scepter, to the west a tiger, to the north (at his feet) a *huang* (half-circle), to the south a *zhang* (a short stubby *gui*). The seven orifices of the body were sealed with jade plugs, while a flat plaque, or *han*, generally in the shape of a cicada, was placed in the mouth. Thus was the body protected from all harm without and sealed lest any evil influences should escape from within. Through the Zhou, the number of jade plaques and ornaments disposed about the body increased, until in the Western Han the logical limit was reached when the emperors and other members of the imperial family were buried in complete fitted jade suits, described in chapter 4.

In addition to mortuary jades, the early Zhou lapidaries carved many kinds of pendants and ornaments, as in the Shang dynasty, but since such carvings were far more beautiful and refined in the late Zhou period, we will defer discussion of them to chapter 3.

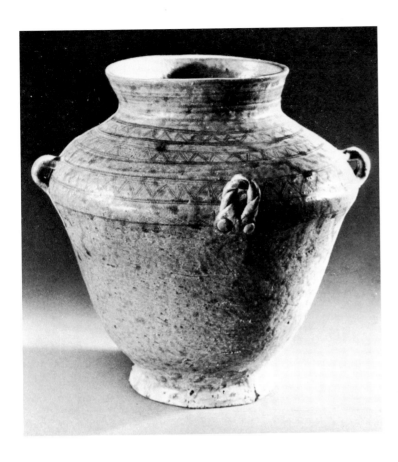

CERAMICS

By comparison with the bronzes, most of the pottery of the Western Zhou period so far discovered is sober stuff. Many of the finer pieces are rather crude imitations of bronze vessels, although generally only the shape is copied, such bronzelike decoration as there is being confined to bulls' heads or *taotie* masks attached to the sides. Although a few specimens of plain red ware have been found, most Western Zhou pottery consists of a coarse gray ware, the most popular purely ceramic shape being a round-bottomed, wide-mouthed storage jar that is often cord-marked.

But recent discoveries show that in addition to this mass of unglazed wares, a much more sophisticated ceramic art was beginning to develop. The Chinese language only distinguishes two types of ware: *tao* (pottery) and *ci* (which includes both stoneware and porcelain). Some of the Western Zhou wares are certainly *ci*, if not what we would call porcelain, a particularly fine example being a glazed jar (fig. 2.41) unearthed in 1972 from an early Western Zhou bur-

FIGURE 2.41 Jar. Stoneware covered with greenish-yellow glaze. Ht. 27.5 cm. From a tomb at Beiyaocun, Luoyang, Henan. Western Zhou period.

FIGURE 2.42 Big seal script *(dazhuanshu)*. (Top) Stone drum. Late Western Zhou period (?). Palace Museum, Beijing. (Bottom) Rubbing. Japanese collection.

ial site at Beiyaocun in Henan. The important tomb of the reign of Mu Wang at Puducun near Xi'an contained similar vessels decorated with horizontal grooves and covered with a thin bluish-green felspath glaze quite different from the blackish or yellowish Shang glazes. Other glazed wares, datable by bronze inscriptions to the eleventh and tenth centuries B.C., have been found in graves in Henan, Jiangsu, and Anhui. They may all be considered ancestors of the great family of celadons of later dynasties.

EARLY CHINESE WRITING

Early writing in China can hardly be called "calligraphy," which means "beautiful writing," for what survives from the late Neolithic period consists of functional marks, as yet undeciphered, presumably denoting numerals, clan names, or the maker or owner of some utilitarian object. These marks do not appear to be linked to form sentences. The first evidence of sentence structure comes in the early Bronze Age, in the form of the statements and questions engraved on the oracle bones in a style that later antiquarians called *jiaguwen* (small ancient script) and in the somewhat more formal style *guwen* (ancient script) cast on the ritual bronze vessels.

As we noted, in the Zhou period bronze inscriptions became longer, and their style came to be known as *dazhuanshu* (big seal script). The most famous examples of the big seal style are the inscriptions carved on the set of cylindrical "stone drums" unearthed in the Tang dynasty and carved possibly in the sixth century B.C.; fig. 2.42 illustrates a part of one of them. The *dazhuan* style, perfectly adapted to the carving of seals, has survived down the centuries, promoted by the scholars as a formal style redolent of antiquity. During the first millennium B.C. the big seal script became refined into the small seal script, *xiaozhuanshu* (fig. 2.43), which became the official form when the First Emperor, Shihuangdi (r. 225–210 B.C.), united the scattered Warring States and imposed a blanket standardization on virtually everything produced and used throughout the empire.

Because of the long preservation of the seal script—chiefly on bronze vessels, on seals, and, most famously, on the stone drums—one might assume it was the most widely used style of this period. But it is now clear that most writing was done with brush and ink on wood or bamboo slips in a much freer style. The oldest of these slips with writing on them yet discovered date to the sixth century B.C.,

but there is little doubt that brush writing was used for utilitarian purposes—messages and orders, numerals, accounts, inventories, and so on—at a much earlier date. This style of writing came in the Han dynasty to be called *lishu,* clerical or official script (fig. 2.44). The *lishu,* preserved on many Han stone tablets and on rubbings taken from them, is strong and somewhat angular, with the horizontal strokes emphasized and often exaggerated.

Can the writing of the pre-Han period be called "calligraphy"? Writing, *shu,* is listed—together with ritual and etiquette, charioteering, calculation, music, and archery—as one of the "six skills" that, according to Confucian tradition, every gentleman aimed to acquire, and there is little doubt that skillful writing was admired. But there are no surviving texts earlier than the Han that mention calligraphy as an art form or that discuss its aesthetics. For this reason we defer discussion of calligraphy as an art—indeed, as the supreme art—in China to a later chapter.

FIGURE 2.43 Small seal script *(xiaozhuanshu).* Rubbing from a tablet on Mount Tai. Qin dynasty (third century B.C.). Palace Museum, Beijing.

FIGURE 2.44 Clerical script *(lishu).* Rubbing from a stone from Mount Tai. Former Han dynasty. Palace Museum, Beijing.

EASTERN ZHOU AND THE PERIOD OF THE WARRING STATES

The first phase of Zhou history ended in 771 B.C. with the death of You Wang and the shift of the capital eastward from Shaanxi to Luoyang in Henan in the following year. By this time the feudal states were growing more and more powerful, and Ping Wang, the first ruler of the Eastern Zhou, was helped to power by two of them—Jin and Zheng. Before long the Zhou state was declining still further, until eventually it became a mere shadow of its former self, kept artificially alive by the powerful states that surrounded it solely to maintain the ancestral rites of the royal house, from which the "mandate of Heaven" had not yet been withdrawn. The period from 770 to 476 is often known as the Chunqiu ("Spring and Autumn"), because the events of the greater part of it are recorded in the *Lüshi chunqiu*— the *Spring and Autumn Annals* compiled by Lü Buwei (290?– 235 B.C.)—while for the rest we have the stories in another compendium, the *Zuozhuan* (Annals of Zuo). The rulers of these states, some of whom called themselves kings, spent their time, it appears, in making aggressive and defensive alliances with other states, in keeping the northern barbarians at bay, and in paying lip service to the shrunken Zhou, which survived until its destruction in 256 B.C. at the hands of the Qin.

By the fifth century B.C. the aptly named Warring States (475–221 B.C.) were continually fighting each other for territory. In the north, Jin kept the desert hordes at bay until it was destroyed in 403 and parceled out among the three states of Zhao, Han, and Wei (map 3.1). At one time these three formed an alliance with Yan and Qi in the northeast against the power of the semibarbarian Qin, now looming dangerously on the western horizon. The smaller states of Song and Lu, which occupied the lower Yellow River Valley, were not militarily powerful, though they are famous in Chinese history as the home of the great philosophers. In the region of modern Jiangsu and Zhejiang, Wu and Yue were emerging into the full light of Chinese culture, while a huge area of central China was under the domination of the southward-looking and only partly Sinicized state of Chu. Gradually Chu and Qin grew stronger. In 473 Wu fell to Yue, then Yue to Chu. Qin was even more successful. In 256 it obliterated the pathetic remnant of the great state of Zhou; thirty-three years later it defeated its rival Chu, simultaneously turning on the remaining states of Wei, Zhao, and Yan. In 221 B.C. Qin defeated Qi, and all China lay prostrate at its feet.

As of 2007 the royal Zhou tombs had still not been

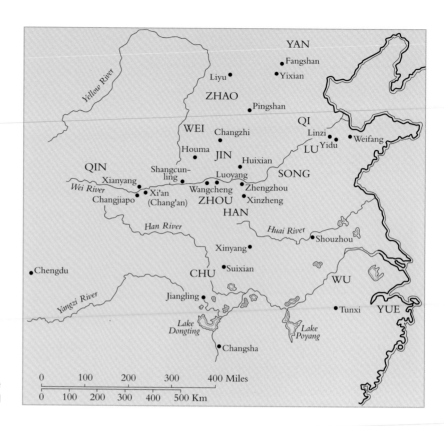

MAP 3.1 China in the Warring States period

found. Yet to give but one example of the wealth of finds from the capitals of the rival states, ten years of excavation of Yongcheng, the site of the capital of the aggressive state of Qin almost 90 miles (140 km) to the west of Xi'an, have revealed not only a palace and ancestral halls, but also a complex of thirty-three large tombs, of which the largest is that of Duke Jing (577–537 B.C.).[1] This gigantic pit, ten times the size of the largest of the Shang tombs at Anyang, has been repeatedly robbed, but enough survives to show that it was eight stories deep and lined with thousands of trimmed cypress logs stacked one upon another (fig. 3.1)—a prerogative of the royal Zhou house that the Qin rulers were powerful enough to ignore. The bones of 182 male and female slaves immolated with the duke show that, in Qin at least, Shang death ritual practices still persisted.

As often happens in history, these centuries of increasing political chaos were accompanied by social and economic reform, intellectual ferment, and great achievement in the arts. Iron tools and weapons were coming into use. Now for the first time private individuals could own land, and trade was developing, much aided by the invention of currency—bronze "spade" money in central China, knife-shaped coins in the north and east. This was the age of the Hundred Schools, when roving philosophers known as *shui ke* ("persuading guests") offered their counsel to any ruler who would listen to them. The most enlightened patronage was that offered by King Xuan of Qi, who welcomed scholars and philosophers of every school to his court.

But the openness of King Xuan was exceptional. Confucius, the greatest of the scholar-philosophers, was ill-used in the state of Lu. His teachings are enshrined in the idea of a gentleman: one who concerns himself about the Way (of Virtue) and does not worry about his salary, who is courteous, filial, and modest, loves learning, is generous with wisdom and benevolence, and pays due attention to the

FIGURE 3.1 Tomb of Duke Jing (d. 537 B.C.) of pre-dynastic Qin, during excavation. Fengxiang county, Shaanxi. Warring States period.

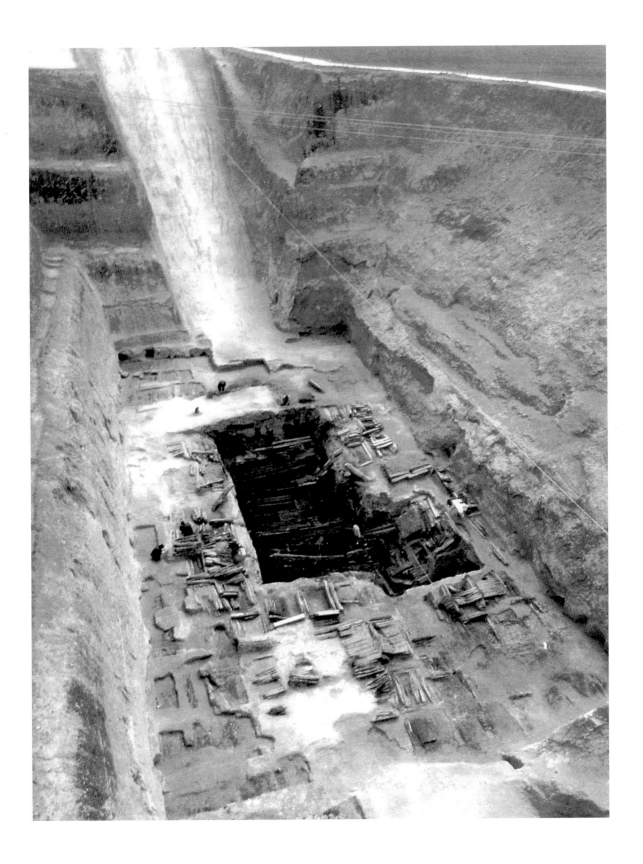

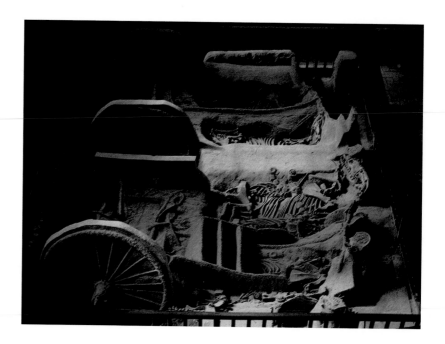

FIGURE 3.2 Chariot burial. Liulige, Huixian, Henan. Warring States period.

rituals that give visible order and harmony to the state. But in these chaotic times, few rulers saw the advantage to themselves of such doctrines, wanting power at home and victory over their enemies abroad, and they were often more attracted by the Machiavellian doctrines of Lord Shang and the Legalists, which were to find their ultimate expression in the rise of the totalitarian state of Qin.

Against the social commitment of Confucius and his follower Mencius, on the one hand, and the amoral doctrines of the Legalists, on the other, the Daoists offered a third solution—a submission not to society or the state but to the universal principle, Dao. Laozi taught that discipline and control only distort or repress one's natural instinct to flow with the stream of existence. In part, this philosophy was a reaction against the rigidity of the other schools, but it was also a way to escape the hazards and uncertainties of the times into the world of the imagination. It was, in fact, through Daoism, with its intuitive awareness of things that cannot be measured or learned from books, that the Chinese poets and painters were to rise to the highest imaginative flights. The state of Chu was the heart of this new liberating movement. The great mystical philosopher-poet Zhuangzi (c. 350–275 B.C.) belonged in fact to the neighboring state of Song, but, as the modern philosopher Feng

Youlan has observed, his thought is closer to that of Chu, while Qu Yuan and Song Yu, who in their rhapsodic poems known as *sao* poured out a flood of passionate feeling, were both natives of Chu. Not only the finest poetry of this period but also the earliest surviving paintings on silk were produced within its boundaries.[2]

During the early Warring States period, however, the North China Plain of southern Shaanxi and northern Henan was still the heart of Chinese civilization, protected by the defensive walls under construction at intervals along China's northern frontiers. The most ancient section of wall was built about 353 B.C. across modern Shaanxi, not only to keep the marauding nomads out, but, equally, to keep the Chinese in.

Until recently, archaeologists had devoted much less attention to the remains of the Zhou dynasty than to those of the Shang. Before the Second World War, only one important late Zhou site had been scientifically excavated: at Xinzheng in Henan archaeologists found tombs containing bronzes that span the years from the baroque extravagances of the middle Zhou to the simpler forms and more intricate decoration of the early Warring States. At the same time, the local farmers living between Luoyang and Zhengzhou had for some years been robbing tombs at Jincun, the

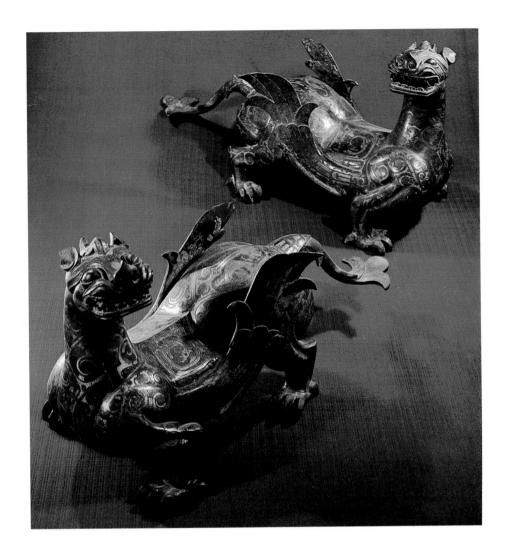

FIGURE 3.3 Mythical animals. Bronze inlaid with silver. L. 40.5 cm. From a royal tomb of the state of Zhongshan, near Hejiazhuang, Hebei. Warring States period, late third century B.C.

area of the Eastern Zhou capital. Bronzes believed to have come from these tombs range in style from late, and rather subdued, versions of the Xinzheng manner to magnificent examples of the mature style of the fourth and third centuries B.C. By the 1980s, many excavations had revealed the extravagance of the feudal courts. The burying of no fewer than nineteen carriages with their horses in a Wei state royal grave at Liulige, Huixian (fig. 3.2), shows that the old Shang custom still survived, soon to be superseded by the interring of models in pottery, bronze, or wood.[3]

The Jincun and Huixian finds lay in the territory of a powerful state, but not all the finest bronzes have been unearthed from such sites. A royal tomb of the hitherto al-

most unknown northeastern state of Zhongshan (c. 310 B.C.),[4] opened south of Beijing in 1978, yielded huge bronze standards of a kind never seen before as well as intricately inlaid bronze creatures (fig. 3.3). Likewise, some of the most remarkable finds of recent years have come from tombs of the tiny state of Zeng, which led a precarious existence in central China until it was swallowed up, probably by Chu—but not before one of its rulers had been buried with the largest and finest set of bronze bells ever discovered in China. Such finds show that feudal rulers, however weak, used bronzes not merely as symbols of power, but also as evidence of wealth and high culture to display to neighbors and rivals. Perhaps the lack of similar

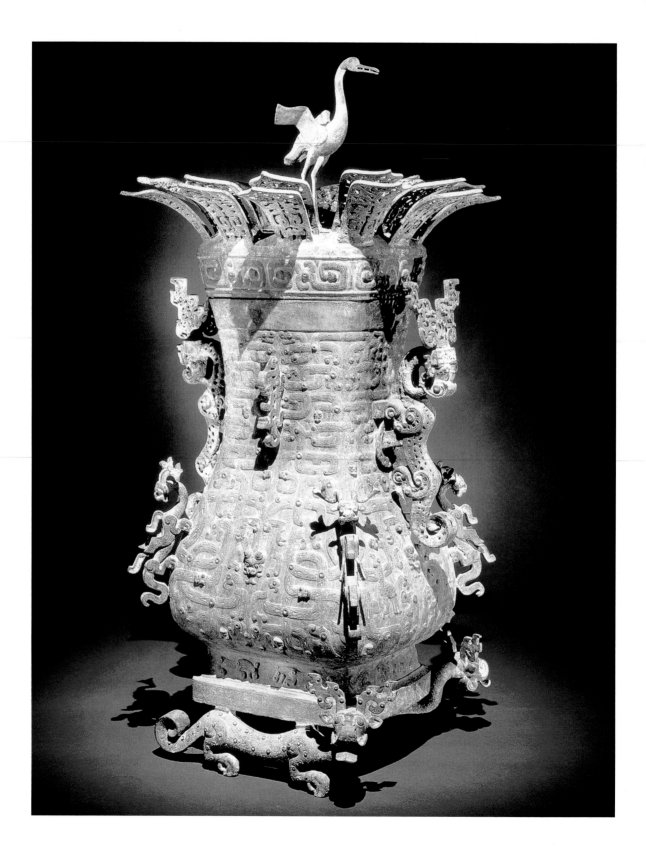

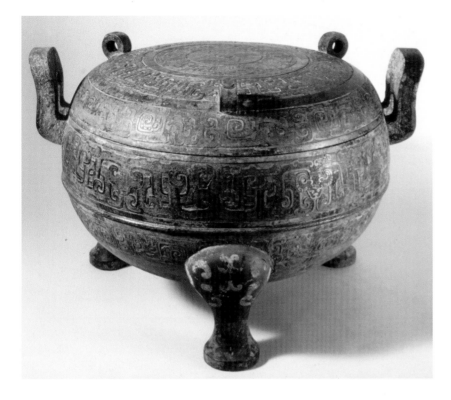

FIGURE 3.4 (OPPOSITE) *Hu* ritual vessel. Bronze. Ht. 118 cm. From Xinzheng, Henan. Eastern Zhou period. Palace Museum, Beijing.

FIGURE 3.5 (LEFT) *Ding* ritual vessel with reversible cover, Liyu style. Bronze. Ht. 23.5 cm. Early Eastern Zhou period, sixth to fifth century B.C. The Avery Brundage Collection. © Asian Art Museum of San Francisco.

interstate competition when China was united under the Qin and Han dynasties may help to account for the greater plainness and uniformity of Han bronzes.

CHANGES IN BRONZE STYLE

After the fall of Shang the craft of bronze casting in northern Henan continued for a while with little change, probably because the Zhou rulers made use of the Shang workshops and craftsmen. But soon all that changed, as Zhou court taste manifested itself. The stylistic change was given further impetus in the eighth and seventh centuries B.C. by foreign ideas and techniques brought back by the Zhou kings from their northern campaigns and by the rise of the feudal states, which were beginning to develop artistic styles of their own. The most striking new feature the northern contact introduced is the art of interlacing animal forms into intricate patterns. This technique first appears in Chinese art in the bronzes excavated from seventh-century graves at Xinzheng and Shangcunling in Henan. A *hu* unearthed at Xinzheng (fig. 3.4), datable to around 600 B.C., stands on two tigers; two more tigers with huge horns and

twisting bodies curl up the sides to form handles, while smaller tigers play at their feet. The body is covered with an overall pattern of flat, ropelike interlaced dragons, the lid surrounded with flaring leaf-shaped flanges.

Other changes are also apparent in bronze style.[5] Ungainly excrescences are shorn off, and the surface is smoothed away to produce an unbroken, almost severe silhouette. The decoration becomes ever more strictly confined and is often sunk below the surface (fig. 3.5) or inlaid in gold or silver. Hints of archaism appear in the emphasis upon the *ding* tripod and in the discreet application of *taotie* masks, which now reappear as the clasps for ring handles.

This decrescendo from the coarse vigor of the middle Zhou style continues in the later bronzes from Xinzheng and in the new style associated with Jincun and Houma, the capital of the state of Jin from 584 to 450 B.C. The typical broad, three-legged *ding* from these northern sites, of which the best known is Liyu, for example, is decorated with bands of interlocked dragons separated by plaitlike fillets (fig. 3.6). There is a tendency to imitate other materials such as a leather water flask, the strapwork and texture of the animal's pelt being clearly suggested by what Bernhard

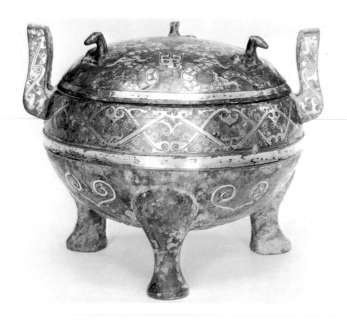

FIGURE 3.6 (ABOVE TOP) *Ding* ritual vessel. Bronze inlaid with silver. Ht. 15.2 cm. Probably from Jincun, Luoyang. Later Warring States period, fourth to third century B.C. Minneapolis Institute of Arts, Bequest of Alfred F. Pillsbury.

FIGURE 3.7 (ABOVE) Detail of decoration on top of *bo*-type bell. Bronze. Warring States period. (For side view, see fig. 3.9.) Freer Gallery of Art, Smithsonian Institution, Washington, D.C.

FIGURE 3.8 (OPPOSITE) *Bianhu* flask. Bronze inlaid with silver. Ht. 31.2 cm. Warring States period, late fourth to third century B.C. Freer Gallery of Art, Smithsonian Institution, Washington, D.C., Gift of Charles Lang Freer.

Karlgren called "teeming hooks," which may be seen filling the background on the top of the bell in fig. 3.7. But on the most beautiful of these flasks, such as the *bianhu* ("flat vessel") shown in fig. 3.8, the symmetrical decoration consists of bars, angles, and volutes, inlaid in silver and probably derived from lacquer painting, that give the vessel an extraordinary liveliness and elegance. This *bianhu* is typical of the finest inlaid bronzes unearthed from the later phases at Jincun. The simple shapes often recall pottery: except for the masks and ring handles, the surface is flat, giving full play to the inlaid decoration, which is sometimes geometric, sometimes sweeping in great curves over the contour of the vessel. Although gold had been used at Anyang, now the goldsmith's art comes into its own, and in form, decoration, and craftsmanship the finest of the inlaid Warring States bronzes from the Luoyang region are unsurpassed.

With the decline of the old ruling caste and the emergence of a wealthy upper-middle class less schooled in the traditional rites, the metalworker's art was diverted from "community plate," so to speak, to "family plate." A rich man would give his daughter inlaid vessels as part of her dowry, while for himself he could adorn his furniture and carriages with bronze fittings inlaid with gold, silver, and malachite and, when he died, take them with him into the next world. If anyone criticized him for his extravagance, he might well quote in self-defense this advice from the philosophical and economic treatise of *Guanzi:* "Lengthen the mourning period so as to occupy people's time, and elaborate the funeral so as to spend their money. To have large pits for burial is to provide work for poor people; to have magnificent tombs is to provide work for artisans. To have inner and outer coffins is to encourage carpenters, and to have many pieces for the enshrouding is to encourage seamstresses."[6]

Confucius, like his contemporary Pythagoras, recognized the value of music as a moral force in society. Solemn dances accompanied the sacrifices at the feudal courts as an aid to right thinking and harmonious action, so it is not surprising that some of the finest bronzes of the Eastern Zhou and Warring States should be the bells made in sets of up to sixteen. The long-handled *nao* bells already in use in the Shang were set mouth-upward in a wooden frame; turned mouth-downward and hung diagonally on the frame they became the *zhong,* fully developed under the

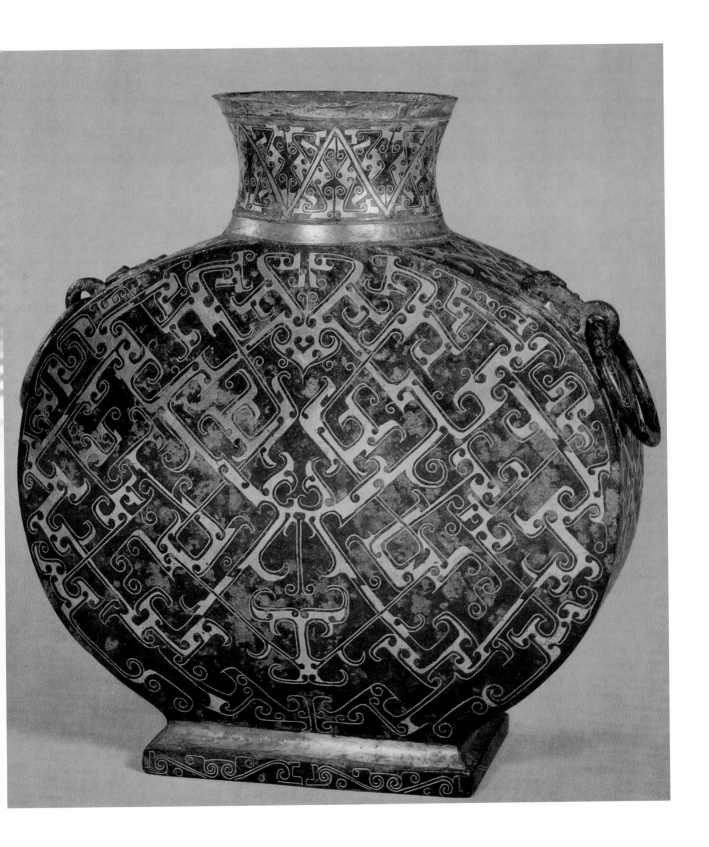

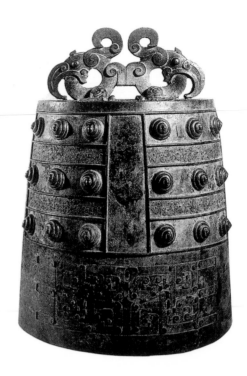

FIGURE 3.9 (RIGHT) *Bo*-type bell. Bronze. Ht. 66.4 cm. Warring States period. Freer Gallery of Art, Smithsonian Institution, Washington, D.C.

FIGURE 3.10 (MIDDLE) Racks of bells. Bronze and lacquered wood. Ht. 237 cm. From the tomb of the Marquis Yi of Zeng (d. c. 433 B.C.). Suxian, Hubei. Warring States period. Hubei Provincial Museum, Wuhan.

FIGURE 3.11 (BOTTOM) Striking the bells. Rubbing from a third-century A.D. stone relief in the tomb at Yinan, Shandong (see fig. 4.8).

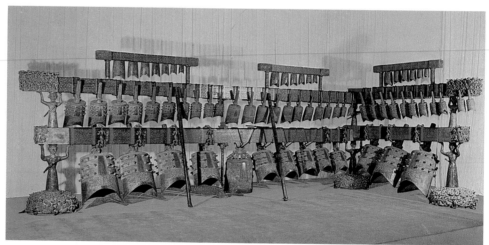

Zhou. A similar type of bell called a *bo* (fig. 3.9) also appeared in the Shang, reaching its greatest refinement in the Zhou, when its projecting bosses, now reduced to serpent coils, alternate with bands of delicate interlacing on either side of a central panel for a dedicatory inscription that might be inlaid in gold.

Elliptical in section, the ancient Chinese bells are unique in the world in producing two different notes, depending upon which part of the rim is struck. The most complete set of musical instruments yet discovered (fig. 3.10) occupied two sides of the "music room" in the tomb of the Marquis Yi of the petty state of Zeng, referred to above.[7] It contained sixty-five bells (one dated to 433 B.C.), thirty-two stone chimes, zithers, pipes, a drum, and, in a separate room, the remains of twenty-one girls. Clearly by this time music was no longer purely ritual (if indeed it ever had been), but had become a prominent feature of the entertainment of the feudal courts (fig. 3.11).

While the aristocracy of metropolitan China were indulging in music, dancing, and other delights in the comfort and security of their great houses, those in less fortunate areas were fighting a desperate battle against the savage tribes who harried the northern frontiers. Mounted on horseback and using the compound bow, the nomads were more than a match for the Chinese troops, who were finally forced to abandon the chariot and copy the northerners' methods and weapons of war.

The nomads' influence on the Chinese did not end with warfare. Their arts were few but vigorous. For centuries they and their western neighbors of the central Asiatic steppe had been decorating their knives, daggers, and harnesses with animal carvings—first in wood and later in bronze cast for them, it is believed, by slaves and prisoners of war. This "animal style," as it is called, was totally unlike the abstract yet fanciful style of the Chinese bronzes.[8] Sometimes the modeling is realistic, but more often it is formalized crudely and without the typical Chinese elegance of line. With barbaric vigor the nomads of the Ordos Desert and the wild regions to the north and west of it fashioned elk and reindeer, oxen and horses (fig. 3.12); they also liked to depict a tiger or eagle leaping on the back of some terrified game beast—a scene they often witnessed, and the representation of which probably was intended to bring success to their own hunting expeditions. Hints of this animal style appeared, as we have seen, on some of the knives at Anyang.

FIGURE 3.12 Ordos-style harness fittings. Bronze. Warring States period. *Upper:* L. 11.4 cm. Freer Gallery of Art, Smithsonian Institution, Washington, D.C., Purchase. *Lower:* L. 11.5 cm. © The Trustees of the British Museum, London.

During the late Zhou and Han, when the impact on China of the Xianyun, the Xiongnu, and other northern tribes was at its height, its influence can be seen in the design of some of the inlaid bronzes, on which hunting scenes showing fights with fierce beasts are modeled with a curiously unChinese angularity and harshness of form (fig. 3.13), although the shape of the vessel itself and its geometric decoration are purely Chinese.

The widest variety of animal designs is found on the bronze garment or belt hook. Many of these hooks are indeed purely Chinese in style, being carried out in the exquisite inlaid technique of Jincun and Shouzhou. Court dancers wore them, as we know from the *Zhaohun* (The summons to the soul):

> Two rows of eight, in perfect time, perform a dance of Zheng;
> Their *xibi* buckles of Jin workmanship glitter like bright suns.[9]

The beautiful specimen illustrated in fig. 3.14 is fashioned in gilt bronze, inlaid with a dragon in jade and multicol-

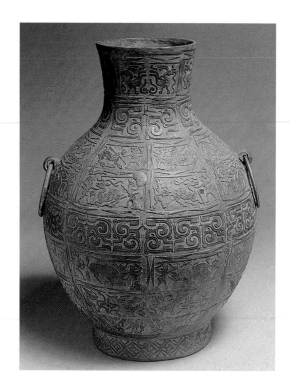

ored balls of glass. Some, representing the creatures of the steppes singly or in mortal combat, are almost purely "Ordos." Yet others are in a mixed style: a garment hook recently excavated at Huixian, for example, is decorated with three penannular jade rings in a setting formed of two intertwined dragons in silver overlaid with gold. The dragons are Chinese, but the sweeping angular planes in which they are modeled come from the northern steppes.

CERAMICS

No such barbarian influences appear in the pottery of north China at this time: the nomads, indeed, had little use for pottery and no facilities for making it. The gray tradition continued, but the coarse cord-marked wares of the early Zhou were left behind. In the meantime the technique of glazing had vastly improved. By the middle of the Warring States era half the wares produced were glazed. Shapes became more elegant, often imitating bronze—the most popular forms being the *zun,* the three-legged *ding* (fig. 3.15), the tall covered *dou* ("stem-cup"), and an egg-shaped covered *dui* on three feet. Generally they are heavy and plain, but some of those found at Jincun bear animals and hunting scenes stamped or incised with great verve in the wet clay before firing. In southeast China the development of the high-fired glazed wares continued, leading to the fine Yue ware of the Han dynasty. As we have seen, bronze vessels had long been buried with the dead. But bronze was expensive, and in the late Zhou ceramic substitutes became popular, not only for burial but also for display. Potters made ceramic vessels imitating bronze and painted lacquer; they would even on occasion imitate metal by clothing the pottery in tinfoil. The coarsely potted earthenware jar in fig. 3.16 is decorated with slip and glass paste (now much degraded), which must have been intended to give the effect of a richly ornate piece in metal and jade.

FIGURE 3.13 *Hu* ritual vessel. Bronze inlaid with hunting scenes (inlay missing). Ht. 39.3 cm. Late Warring States period. The Avery Brundage Collection. © Asian Art Museum of San Francisco.

FIGURE 3.14 Garment hook. Gilt bronze inlaid with jade and glass. L. 15.5 cm. Late Warring States period. Harvard Art Museum, Arthur M. Sackler Museum, Bequest of Grenville L. Winthrop. Photo © President and Fellows of Harvard College.

THE ARTS OF CHU

While what might be called the classical tradition was developing in the Henan-Shaanxi region, a different style of art was maturing in the large area of central China dominated by the state of Chu. It is not known precisely how widely the boundaries of Chu extended (particularly in a

FIGURE 3.15 (LEFT) *Ding* ceremonial vessel. Pottery imitating bronze. Ht. 35 cm. Warring States period. The Avery Brundage Collection. © Asian Art Museum of San Francisco.

FIGURE 3.16 (LEFT BELOW) Bowl. Earthenware decorated with slip and inlaid with glass paste. Ht. 9.5 cm. Said to have come from Xunxian, Henan. Late Warring States period. © The Trustees of the British Museum, London.

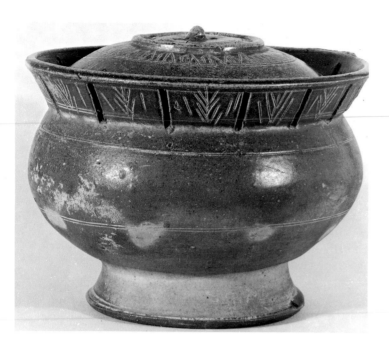

southward direction), but they included the city of Shouzhou on the Huai River in modern Anhui, while the influence of the art of Chu can be traced in the bronzes of Huixian, Henan, in the Bashu culture of Sichuan, and even in northern Hebei. Until Qin rose menacing in the west, Chu, secure in the lush valleys of the Yangzi and its tributaries, had developed a rich culture in which poetry and the visual arts flourished exceedingly. So vigorous, indeed, was Chu culture that even after Qin sacked the last Chu capital, Shouzhou, in 223 B.C., it survived with no significant change into the Western Han, which is why discussion of Chu art is shared between this chapter and the next.

In the late sixth century B.C., Shouzhou was still under the state of Cai. A grave of this period excavated in the district contained bronzes, most of which were restrained versions of the Xinzheng style, and the art of Shouzhou, even after the city's absorption into the expanding state of Chu, always retained some of its northern flavor. It must also have been an important ceramic center at that time, if we are to judge by the beauty and vigor of the pottery excavated there. The covered bowl illustrated in fig. 3.17 is typical of Chu ceramics: the body is of gray stoneware with incised decoration under a thin olive-green glaze, the immediate predecessor of the Yue-type wares of the Han dynasty and the ancestor of the celadons of the Song.

Only in recent years has archaeological excavation of Chu sites, notably at the capital near Jiangling and at Changsha and Xinyang, revealed both the wealth and the essentially southern character of Chu art. Indeed, it is interesting to speculate on the course that Chinese culture might have taken if the victory in 223 B.C. had gone not to the Qin savages from the western marches, but to this relatively sophisticated and enlightened people.

By the late Zhou period the burying of figurines (*yong*) as a substitute for human victims had become widespread. Confucius, however, condemned the use of wooden figures, which he thought would tempt people on, or back, to burying the living with the dead; he thought straw figures were safer. In the north, these *yong* were made of pottery (or if of wood, have not survived), but the waterlogged tombs of the Yangzi Valley were ideal for the preservation of wooden figures (fig. 3.18), carved and often painted and clothed like dolls, giving important information about late Zhou costume.

Evidence of the art of weaving was found in the Neolithic village of Banpo in Shaanxi; the Shang people at Anyang

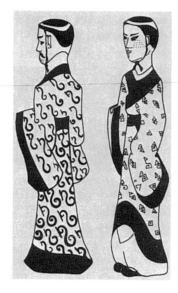

FIGURE 3.17 Covered bowl. Gray stoneware with olive-green glaze. Ht. 16.5 cm. Probably from Shouzhou, Anhui. Warring States period. Honolulu Academy of Arts.

FIGURE 3.18 Painted wooden funerary figures from tombs at Changsha, Hunan. Ht. about 30 cm. Late Warring States period or early Han period. After Kwang-chih Chang, *The Archaeology of Ancient China*, 2nd ed. (New Haven, 1968), fig. 156.

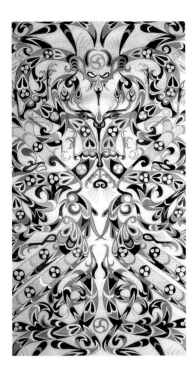
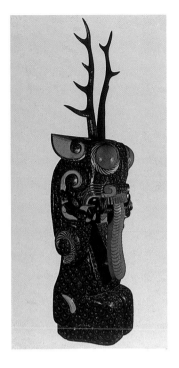

wore tailored clothing of silk and hemp; while a number of passages in the early Zhou *Book of Songs* refer to colored woven silk. Burial conditions in the south were also favorable to the preservation of textiles in the tomb, for the finest have been found in the territory of Chu.

For four hundred years, until its destruction by Qin in 278 B.C., the city of Yingdu, near present-day Jiangling, was the capital of Chu. No fewer than 340 aristocratic tombs have been found in the hills nearby, of which most are from the Warring States period.[10] The coffin in a small tomb discovered in 1982 yielded a treasure trove of textiles datable to between 350 and 250 B.C. They include plain woven silk, gauze, painted warp or weft pattern brocade, fine embroidery, embroidered and painted trousers, painted brocade skirts, and brocade hats. Fig. 3.19 illustrates the dragon and phoenix pattern on an embroidered quilt, a beautiful design that shows a genius for rhythmic linear movement—shared with the inlaid bronzes and lacquer work of the period—that is purely Chinese. Textiles will be discussed further in the next chapter, on the Han dynasty, a time when foreign expansion and contacts brought a new richness and variety to textile design.

FIGURE 3.19 Pattern on an embroidered quilt (restored). Silk. From a tomb near Jiangling, Hubei. Chu culture. Late Warring States period.

FIGURE 3.20 Cult object or guardian in the form of a long-tongued creature eating a snake. Carved and lacquered wood. Ht. 195 cm. Excavated at Xinyang, Henan. Chu culture. Late Warring States period.

FIGURE 3.21 Drawing of a drum or gong stand. Lacquered wood. Ht. 163 cm. From Xinyang, Henan. Late Warring States period.

Most spectacular among the grave finds from the Chu kingdom are the cult objects consisting of grotesque monster heads, sometimes sprouting antlers and a long tongue (fig. 3.20), and the drum or gong stands formed of birds standing back to back on tigers or entwined serpents, decorated in yellow, red, and black lacquer. A gong stand (fig. 3.21) found in 1957 in a tomb in the Chu city of Xinyang, Henan, reflects Chu's contacts with the south: bronze drums found in the Dong Son region of northern Vietnam also bear snake or bird designs, believed to be connected with rain magic. Stands similar to the one in fig. 3.21 are engraved on a number of bronze vessels from Chu sites.

FIGURE 3.22 Painted silk panel from tomb at Changsha, Hunan. Ht. 37 cm. Third century B.C.

FIGURE 3.23 Bowl. Painted lacquer. Diam. 35.4 cm. Late Warring States period. Seattle Art Museum, Eugene Fuller Memorial Collection. Photo: Paul Macapia.

PICTORIAL ARTS

Miraculously preserved in the Chu graves were the two oldest paintings on silk yet discovered in China, one of which is illustrated in fig. 3.22. Sketched swiftly with deft strokes of the brush, it shows a woman in full-skirted dress, tied with a sash at the waist, standing in profile attended by a phoenix and by dragon creatures that bear the soul up to Heaven. Other and far larger silk paintings have been found in Han tombs at Changsha, together with writing and painting materials.

Some of the most beautiful painting, however, appears on the lacquerware of Chu and Shu (present-day Sichuan). The craft had first developed in north China during the Shang dynasty, but now it reached a new level of refinement. Lacquer is the pure sap of the lac tree (*Rhus vernicifera*), with color added. It was applied in thin layers over a core of wood or woven bamboo; more rarely a fabric base was used, producing vessels of incredible lightness and delicacy. In late Zhou and Han tombs in central China, large quantities of lacquer bowls, dishes, toilet boxes, trays, and tables have been found (fig. 3.23). They are beautifully decorated in black on a red ground, or red on glossy black, with swirling volutes that may transform themselves into tigers, phoenixes, or dragons sporting amid clouds.

Also to be classed with the pictorial arts are the lively scenes cast in the body of bronze vessels and inlaid, gen-

erally with silver. On the *hu* in fig. 3.24 we can see an attack on a city wall, a fight between longboats, men shooting wild geese with arrows on the end of long cords, feasting, mulberry picking, and other domestic activities, all carried out in silhouette with great vitality, elegance, and humor. It is instructive to compare these essentially southern scenes with the fiercely northern hunting and animal combat scenes illustrated on the *hu* in fig. 3.13.

BRONZE MIRRORS

Large numbers of bronze mirrors have been found both in the north and within the confines of the ancient Chu state. At first, and always to some degree, their purpose was to reflect not only one's face but one's heart and soul as well. An entry in the *Zuozhuan* under the year 658 B.C. says of a certain individual: "Heaven has robbed him of his mirror"—that is, made him blind to his own faults. The mirror too is that in which all knowledge is reflected. "The heart of the sage is quiet," wrote Zhuangzi; "it is a mirror of Heaven and Earth." The mirror also holds and reflects the sun's rays, warding off evil and lighting the eternal darkness of the tomb.

Decorated bronze disks thought to be mirrors have been found in sites of the Qijiaping culture of northwest China, Gansu and Qinghai, datable to between 2000 and 1750 B.C. Bronze mirrors were also made at Anyang and in the Zhou feudal states (fig. 3.25), although they were rare. The craft improved remarkably, like all else, during the Spring and Autumn and Warring States periods. Of the many new types, I can mention only a few. Mirrors from the Luoyang region are decorated on the back with stylized dragonlike creatures that whirl around the central boss (to which a tassel was attached) against a background of geometric designs picked out in minute granulations (fig. 3.26). The swirling coils of the dragons relate to lacquer painting, while the backgrounds seem to be copied from textile designs. By contrast, many of the mirrors from the state of Chu have concentric rings of interlaced snakes or large staggered -shaped motifs resembling the later form of the character for "mountain," *shan,* set against an intricate "comma" pattern (fig. 3.27). This rich inventory of Warring States mirror designs was inherited and only gradually modified by the craftsmen of the Western Han.

FIGURE 3.24 Designs on an inlaid bronze *hu.* Late Warring States period.

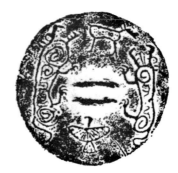

FIGURE 3.25 (ABOVE) Rubbing of the back of a bronze mirror. Diam. 6.7 cm. Excavated from Guo State Cemetery at Shangcunling, Henan. Spring and Autumn period, early Eastern Zhou.

FIGURE 3.26 (ABOVE RIGHT) Luoyang-type mirror. Bronze. Diam. 16 cm. Late Warring States period, third century B.C. Museum of Fine Arts, Boston; Jacob Hirsh Hecht Fund. Photo © 2008 Museum of Fine Arts, Boston.

FIGURE 3.27 (RIGHT) Shouzhou-type mirror. Bronze. Diam. 15.3 cm. Late Warring States period, third century B.C. Ashmolean Museum, Oxford.

JADE

This power to unite in one object the most intricate refinement of detail with a dynamic rhythm and boldness of silhouette is present also in the carved jades of the late Zhou period, which must surely be among the great achievements of Chinese craftsmanship. Now that jade was no longer reserved for the worship of Heaven and Earth or for the use of the dead, it became at last a source of delight for the living. Indeed, as the ritual objects such as the *bi* and *cong* lost their original symbolic power, they too became ornaments, while jade was now used for sword fittings, hairpins, pendants, garment hooks—in fact, wherever its qualities could show to best advantage. Sometimes glass was used as a cheaper substitute for jade.[11] But glass is fragile. Among the few surviving pieces is the beaker shown in fig. 3.28, once thought to be Islamic of the eighth or ninth century. Put together from fragments, it is decorated with glass roundels set with "eyes" similar to those that can just be seen on the inlaid gilt-bronze belt hook illustrated in fig. 3.14.

The dating of jade on purely stylistic grounds is often,

FIGURE 3.28 Beaker with applied roundels (restored). Glass. Ht. 11.7 cm. Late Warring States period, fourth to third century B.C. Courtesy of Giuseppe Eskenazi, London.

FIGURE 3.29 Four linked disks for a belt or pendant. Jade. L. 21 cm. Eastern Zhou period, fifth century B.C. © The Trustees of the British Museum, London.

in view of the Chinese love of copying the antique, extremely unreliable. But the jade objects found in scores of Warring States tombs since 1950 confirm the impression that at that time the quality of carving rose to new heights; the stones were chosen for their rich, unctuous texture; the cutting was flawless and the finish beautiful. A chain of four disks in the British Museum (fig. 3.29), connected by links and carved from a single pebble less than 9 inches (23 cm) long, is a technical tour de force, suggesting that the iron drill and cutting disk were already in use. Few of the *bi* disks of the period are left plain; their surface is generally decorated with a row of spirals, either engraved or raised to form the popular "grain pattern," and sometimes confined within an outer geometric border. Flat plaques in the form of dragons, tigers, birds, and fish combine an arresting silhouette with a surface treatment of extraordinary delicacy. One of the finest is the celebrated double disk in Kansas City

(fig. 3.30), ornamented with heraldic dragons—two on the outer rim, a third crawling around a small inner disk in the center. On occasion, the relief technique and motifs on a jade piece would be borrowed from the goldsmith's art, which came into its own during the Warring States period. A beautiful instance of this borrowing is the small sword hilt illustrated in fig. 3.31, from the Sir Joseph Hotung Collection in Hong Kong.

As we survey the inlaid bronzes of Jincun, the mirrors of Shouzhou, the marvelous lacquerware of Changsha, the jades, and other crafts, we become aware that the period between 500 and 200 B.C. was one of the great epochs in the history of Chinese art, for it was at this time that the ancient symbolic creatures such as the *taotie* were domesticated, as it were, and refined into a vocabulary of decorative art that was to provide an inexhaustible reservoir of designs for the craftsmen of later dynasties.

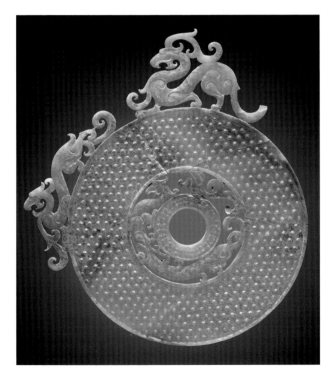

FIGURE 3.30 Two concentric *huan* disks decorated with dragons. Jade. Diam. of outer disk 16.5 cm. Warring States period. The Nelson-Atkins Museum of Art, Kansas City, Missouri. Purchase: Nelson Trust. Photo: E. G. Schempf.

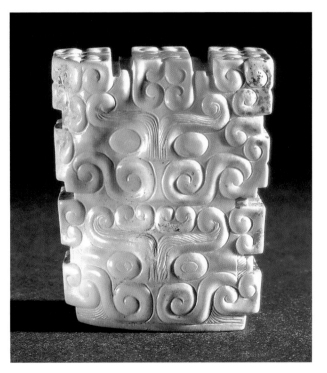

FIGURE 3.31 Sword hilt. Jade. L. 4.2 cm. Warring States period. Sir Joseph Hotung Collection, Hong Kong.

THE QIN AND HAN DYNASTIES

By 221 B.C. the inexorable Qin armies had crushed the remnants of the ancient feudal order. Now all China was united under the iron rule of King Zheng, who set up his capital in Xianyang and proclaimed himself Qin Shihuangdi—first emperor of the Qin dynasty. Aided by his Legalist minister Li Si, he proceeded to consolidate the new state, strengthening the northern frontiers against the Xiongnu and, at the cost of a million lives, linking the sections of wall built by the previous kings of Zhao and Yan into a continuous rampart about 1,500 miles (2,400 km) long. The boundaries of the empire were greatly extended, bringing south China and Tonkin for the first time under Chinese rule. The feudal aristocracy was dispossessed and forcibly moved in their tens of thousands to Shaanxi; rigid standardization of the written language, of weights and measures, and of wagon axles (important in the soft loess roads of north China) was enforced; and over it all Shihuangdi set a centralized bureaucracy controlled by the censors. All that recalled the ancient glory of Zhou was to be obliterated from men's minds. Copies of the classical texts were burned, and the death penalty was imposed on anyone found reading or even discussing the *Book of Songs* or the *Classic of History*.

Many scholars were martyred for protesting. But while these brutal measures imposed an intolerable burden on the educated minority, they unified the scattered tribes and principalities, so that now for the first time we can speak of China as a political and cultural entity. This unity survived and was consolidated on more humane lines in the Han dynasty, so that the Chinese of today still look back on this epoch with pride and call themselves "men of Han."

The megalomania of the first emperor drove him to build at Xianyang vast palaces the likes of which had never been seen before. One series, ranged along the riverside, copied those of each of the kings whom he had defeated. The climax was the Efang Palace, now in the course of excavation; he never lived to complete it, and it was obliterated in the wholesale destruction that, as so often in Chinese history, marked the fall of the dynasty. Some years ago Chinese archaeologists unearthed the remains of an earlier palace, the Jique, built around 350–340 B.C. for a predecessor of Qin Shihuangdi by his minister Shang Yang. A sketch of what it may have looked like is shown in fig. 4.1. Because Qin Shihuangdi lived in constant fear of assassination, the roads connecting his many palaces were protected by high walls.

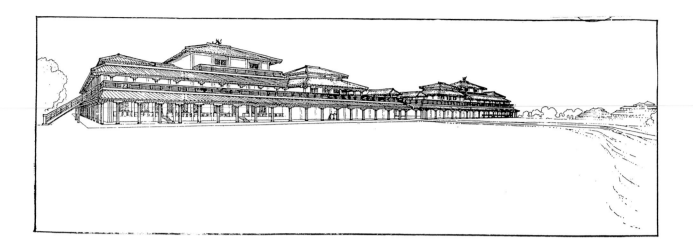

FIGURE 4.1 Reconstruction of the Jique Palace at Xianyang, Shaanxi, built for a predecessor of Qin Shihuangdi by his minister Shang Yang (356–338 B.C.). Late Warring States period.

So great was his dread of even a natural death that he was forever seeking through Daoist practitioners the secret of immortality. In his search for the elixir, so tradition has it, he sent a company of aristocratic boys and girls across the Eastern Sea to where the fabulous Mount Penglai rises amid the waves, ever receding as one approaches it. The children never returned, and it was later thought that they might have reached the shores of Japan.

Shihuangdi died in 210 B.C. The reign of his son Hu Hai was short and bitter. His assassination in 207 was the climax of a rebellion led by Xiang Yu, a general of Chu, and Liu Bang, who had started his career as a bandit. In 206 the Qin capital was sacked; Xiang Yu proclaimed himself King of Chu, while Liu Bang took the crown of Han. For four years the two rival kings fought for supremacy, until finally in 202, when defeat seemed inevitable, Xiang Yu committed suicide and Liu Bang, after the customary refusals, accepted the title of Emperor of the Han with the reign name Gaozu. He established his capital at Chang'an and there inaugurated one of the longest dynasties in Chinese history. Under the Han, Chang'an embraced a conglomeration of palaces, chief of which were the Weiyanggong, seat of the emperor's power, and the Changlegong, residence of the empress. This area was later to be the capital of the Tang dynasty (see map 6.2) and of the much smaller Ming and Qing city, no longer a capital—today's Xi'an (map 4.1).

So sharp was the popular reaction against the despotism of the Qin that the Western, or Former, Han rulers were content to adopt a policy of laissez-faire in domestic matters and even restored the old feudal order in a limited way. At first there was chaos and disunion, but Wendi (179–157 B.C.) brought the scattered empire together and began to revive classical learning and to restore to court life some of the dignity and order that had attended it under the Zhou. The early Han emperors were constantly either fighting or bribing the Xiongnu, who had taken advantage of the fall of Qin to drive their archenemy, the Yuezhi, westward across the deserts of central Asia and to invade north China. Finally, in 138 B.C. the emperor Wu (140–87 B.C.) sent out a mission under Zhang Qian to make contact with the Yuezhi and form an alliance with them against the Xiongnu. The Yuezhi were no longer interested in their old and now distant enemy, and the mission failed, but Zhang Qian spent twelve years in the western regions, where he found Chinese silk and bamboo, brought there, he was told, by way of India. He returned to Chang'an with a report that must have stirred the public imagination as much as the reputed travels of Marco Polo or of Vasco da Gama did in a later age. Henceforth, China's eyes were turned westward. Further expeditions, sent into distant Ferghana (to the north of present-day Afghanistan) to obtain the famous "blood-sweating" horses for the imperial stables, opened up a trade route that later carried Chinese silk and lacquer to Rome, Egypt, and Bactria. Travelers told of snowcapped ranges

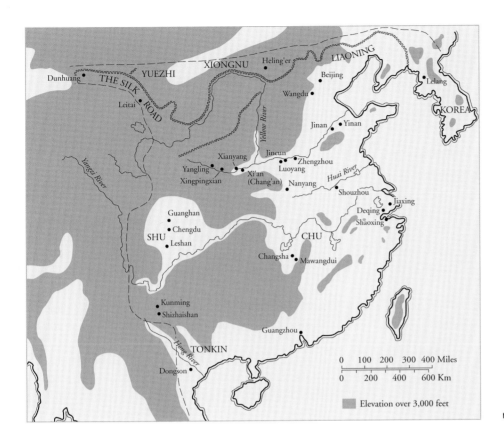

MAP 4.1 China in the Han dynasty

reaching to the clouds, fierce nomadic tribes, and the excitement of hunting wild game among the mountains. Somewhere beyond the horizon lay Mount Kunlun, the axis of the world. As the home of Xiwangmu—the Queen Mother of the West—Kunlun was the counterpart of the foam-washed Penglai, on which dwelt Dongwanggong, the immortal King of the East.

Not only was the far west the source of myths and legends, but there is also increasing evidence to suggest that even before the Han some knowledge of the culture of the Eastern Mediterranean and the "Near East" had filtered through by way of the Parthians, an association of tribes that, in the west, were in contact with the world of Alexander the Great (356–323 B.C.) and, in the east, were the trading partners, and often the enemy, of the state of Qin. The sudden appearance in China of the monumental use of stone, of realistic life-size sculptured figures such as those in the pits associated with the tomb of Qin Shihuangdi, and even the pyramid that was the tomb-mound of the first em-

peror, all suggest that, however remote, the culture and art of the ancient Western world, including those of Egypt, are reflected in these things, which had no antecedents in the native civilization of China.

During the first two centuries of the Han, the popular mind, from the emperor down, was filled with fantastic lore, much of which is preserved in pseudoclassical texts such as the *Huainanzi* (Prince Nan of Huainan) and *Shanhaijing* (Classic of hills and seas), useful sources for interpreting the more fabulous themes in Han art. Anticipating rewards, people looked constantly for good omens (*xiangrui*) to report to the throne, and every ruler after Wendi, especially Wudi, claimed he too had seen them.[1] Such omens included white unicorns, phoenixes, flying horses, red wild geese, stones from the sky, mysterious rays of light, and other strange things (fig. 4.2). In Xuandi's reign, phoenixes appeared fifty times, and during just five years of the reign of Wang Meng more than five hundred *xiangrui* appeared— obviously recorded to bolster the legitimacy of his usurpation.

With the unification of the empire, many local cults had found their way to the capital, home to shamans, magicians, and oracles from all over China. Meanwhile, the Daoists were roaming the hillsides in search of the magical *lingzhi* ("spirit fungus"), which, if properly gathered and prepared, would guarantee immortality, or at least a life span of a few hundred years. Yet at the same time Confucian ceremonies had been reintroduced at court, scholars and encyclopedists had reinstated the classical texts, and Wudi, in spite of his private leanings toward Daoism, deliberately gave Confucian scholars precedence in his entourage.

These diverse, often opposing, elements in Han culture—native and foreign, Confucian and Daoist, courtly and popular—give to Han art both its vigor and the immense variety of its styles and subject matter. Many of its themes are still unidentified, among them the winged, kneeling figure holding two supports (presumably for some wooden object), fashioned in bronze inlaid with gold, that was excavated in 1987 from a Han tomb in the eastern suburbs of Luoyang (fig. 4.3). The grotesque stylization, in marked contrast to the naturalism of so much Han art, suggests the continuation of a tradition in the rendering of the features of supernatural beings that went back to the Shang and would survive into the Six Dynasties.

When Wudi died, China was at one of the heights of its power. The empire was secure, its arms feared across the northern steppes; Chinese colonies were flourishing in Tonkin, Liaoning, Korea, and central Asia. But Wudi's successors were weak and the administration crippled by palace intrigues and the power of the eunuchs, a new force in Chinese politics. In A.D. 9, a usurper named Wang Mang seized the throne and under the cloak of Confucian orthodoxy embarked upon a series of radical reforms that, had he been served by an honest and loyal administration, might have achieved a revolution in Chinese social and economic life. But by antagonizing the privileged class Wang Mang ensured his own downfall. He was murdered by a merchant, and his brief Xin (New) dynasty came to an end in A.D. 25. By this time the city of Chang'an had been reduced to a vast ruin, its palaces and mausoleums plundered, its inhabitants dead or dying of hunger. The Han house was restored and at once began the task of reconstruction. From its capital at Luoyang, the Eastern, or Later, Han reached out once more into central Asia, consolidated its hold on Annam and Tonkin, and for the first time made

contact with Japan. By the end of the century, so great was Han prestige that for a time even the distant Yuezhi, now established as the Kushan dynasty in Afghanistan and northwest India, sent embassies to Luoyang.

The Kushan brought Indian culture and religion into central Asia. This region now became a melting pot of Indian, Iranian, and provincial Roman art and culture, which in turn traveled eastward to China by way of the oases to the north and south of the Tarim Basin. Buddhism may have been known by repute at least in the Western Han—the mythical Mount Kunlun was probably a Chinese version of the Buddhist Meru or the Hindu Kailas, the axis of the universe—but now it began to take root in Chinese soil. The well-known story of the emperor Ming, who in A.D. 67 dreamed of a "golden man" (a Buddhist image) in the far west and sent emissaries to fetch it, is a late fabrication. Yet two years earlier the Prince of Chu had held a feast for monks (śrāmana) and lay brethren, an indication that at least one monastic community existed in central China by that date. Not long after, there are references to Buddhism in the *Xijingfu* (Rhapsody on the western capital [Chang'an]), by Zhang Heng (78–139). Early evidence for Buddhism, which some scholars date to the late Eastern Han, appears also in motifs on bronze mirrors as well as in crude rock-cut reliefs over the entrance to a tomb shaft at Jiading in Sichuan (fig. 4.4) and, in a more recent find, on the other side of China in northern Jiangsu.[2]

Until the time of troubles that accompanied the downfall of the Han, however, Buddhism was merely one among many popular cults. Officially, Confucianism still reigned supreme, and the Eastern Han saw the enormous expansion of a scholarly and official class nurtured in the Confucian doctrines. Many of these men had been trained in the Imperial Academy, founded by Wudi in 136 B.C. From its graduates, selected by competitive examination in the classics, were drawn recruits for that remarkable civil service that was to rule China for the next two thousand years. Unswerving loyalty to the emperor, respect for scholarship, and a rigid conservatism that sought for every measure the sanction of antiquity—these became the guiding principles of Chinese social and political life. Such ideals, however, offer no stimulus to the imagination; only when Confucianism was enriched by Buddhist metaphysics in the Song dynasty did it become a source of highest inspiration to painters and poets.

FIGURE 4.3 Kneeling figure of winged immortal (?). Bronze with gilding. Ht. 15.5 cm. From a tomb at Luoyang, Henan. Eastern Han dynasty, second century A.D.

FIGURE 4.4 Seated Buddha. Rubbing from relief above entrance to a shaft tomb at Jiading, Sichuan. Late Han dynasty (?).

Already in the Western Han those who possessed skills useful to the emperor were organized under a bureau known as the Yellow Gate (Huangmen), which was based on the somewhat idealized picture of Zhou institutions set out in the *Zhouli*. The highest ranks in this professional hierarchy were known as *daizhao*, officials in attendance on the emperor. They included not only painters, Confucian scholars, and astrologers, but also jugglers, wrestlers, and fire-swallowers, all of whom might be called upon at any time to display their various skills in the imperial presence. The lower ranks of artists and artisans—those who made and decorated furniture and utensils for court use, for example—were known as *huagong*. This organization was not confined to the court, however; each commandery, in theory, had its own agency (*gongguan*) for the production and decoration of such things as ritual vessels, robes, weapons, and lacquerware, for the last of which Chu (Hunan) and Shu (Sichuan) were especially famous. Gradually, however, this system was relaxed. Under the Eastern Han, the emergence of the scholar-official class, the decline of the rigid Confucian order at court, and the corresponding rise of Daoist individualism all combined to reduce the importance of these largely anonymous professionals. By the end of the dynasty a gulf had developed between the intellectual aristocracy and the unlettered craftsmen that was to have a profound influence on the character of later Chinese art.

The wonders of Chang'an and Luoyang are vividly described in the *fu* rhapsodies on the Han capitals by Zhang Heng and Sima Xiangru. Though the poets may have exaggerated the beauties of these cities, we do have some idea of the scale of the palaces and government buildings. The audience hall of the Weiyang Palace at Chang'an, for example, was over 400 feet (120 m) long—considerably longer than the Taihedian, its counterpart in latter-day Beijing. To the west of the capital, Han Wudi built a pleasure palace, linked to the Weiyang Palace within the city by a covered two-story gallery 10 miles (16 km) long. At Luoyang the palace lay in the center of the city with a park behind it, built up with artificial lakes and hills into a fairy landscape in which the emperor could indulge his Daoist fancies. Other parks farther from the capital and likewise landscaped on a colossal scale were stocked with all manner of game birds and beasts, some brought as tribute from remote corners of the empire. From time to time a vast imperial hunt—or rather, slaughter—was organized, followed by lavish feasting and entertainment. The *fu* poems describe these extraordinary spectacles, in which, by some Leonardesque device, Penglai and Kunlun, with wild animals fighting on their slopes, might be made to appear out of a cloud of smoke while attendants in galleries overhead crashed boulders together to simulate thunder. These hunts among mountains, and the orgies that followed them, were to become favorite subjects of Han art.

ARCHITECTURE

Practically nothing survives above ground to show what Han buildings looked like, because the Chinese almost always used timber— unlike the Egyptians, Greeks, and Romans, who built in stone— and wood is so easily destroyed by fire, pillage, or neglect. Nevertheless, we get some idea of the scale of military construction from a granary, built in the reign of Han Wudi, that has recently been discovered in a remote area of Gansu where the Han wall peters out into the Gobi Desert (fig. 4.5). Called the Chengkanghe, after the river that flows nearby, and built of mud bricks bonded, like the wall at this point, with courses of reed matting, it is the largest ancient structure to have survived above ground in China. For the rest, we must rely on written descriptions and on the representations of buildings in Han wall paintings and reliefs.

The palace gateways were marked by pairs of tall watchtowers (*que;* fig. 4.6), while within the palace precincts stood multistoried pavilions (*lou*) or towers (*tai*) used for entertainment, for admiring the view, or simply for storage. When Luoyang burned in A.D. 185, the Cloud Tower (Yuntai) went up in flames and with it a huge collection of paintings, books, records, and objets d'art—to say nothing of the portraits of thirty-two distinguished generals that Wudi had had painted on the walls of the tower itself. This is the first recorded occasion when the art treasures accumulated through a whole dynasty were destroyed in a few hours, a disaster repeated again and again in Chinese history. Palaces, mansions, and ancestral halls were built of timber, their straight-tiled roofs supported by a simple system of brackets resting on wooden pillars. Their timberwork was picked out in rich colors, and their inner walls, like those of the Yuntai, were often decorated with wall paintings. These great mansions and their pleasures come vividly

FIGURE 4.5 Granary, built of mud brick to supply troops and labor on the Great Wall at Chengkanghe, Yumen, Gansu. Former Han dynasty. Photo by the author, 2005.

FIGURE 4.6 *Que* gateway to a palace or mansion. Rubbing from a brick relief from a tomb in Sichuan. Ht. 41 cm. Han dynasty. Chengdu Museum, Sichuan.

FIGURE 4.7 Feasting and entertainment. Relief tile from a tomb in Chengdu, Sichuan. Ht. 39.5 cm. Eastern Han dynasty. Sichuan Provincial Museum, Chengdu.

before our eyes as we read such poems as the *Zhaohun,* a passionate appeal addressed by an unknown Han author to the soul of a king that, in the king's illness, has left his body and gone wandering to the edge of the world.[3]

Much of our knowledge of Han architecture derives from the reliefs and engravings on the stone slabs lining tombs and tomb shrines. In crude perspective, they show two-storied gateways flanked with towers and often surmounted by a strutting phoenix, symbol of peace and of the south (see fig. 4.6). Many tomb reliefs show ritual and social activities. Among the liveliest are the molded reliefs of entertainments from Sichuan, showing the host, hostess, and guests sitting on mats on the floor (fig. 4.7), as people still do in Japan today. The humbler dwellings—farmhouses, granaries, even pigsties and watchmen's huts—survive in the rough and lively pottery models made to be placed in the tombs.

Never in Chinese history was so much lavished on the tombs of commoners as in the Eastern Han dynasty. In emulation of the emperor Ming, who set the fashion, the wealthy who could afford it squandered their assets in displays of filial piety. Huge numbers of tombs dating from the Eastern Han have been unearthed. Although nearly all were robbed at the end of the Han, their shells survive

to show a great variety of regional styles. In the Chinese colonies in the northeast and Korea, for example, tombs were square or rectangular, roofed with stone slabs, or shaped like beehives, with corbeled brick vaults. Tombs in Shandong were often also of stone, sunk in the ground, while before them stood stone shrines (*ce*) for offerings to the departed. A Shandong tomb discovered at Yinan (fig. 4.8) was laid out as for a living occupant, with reception halls, bedrooms, and kitchen. In Sichuan most of the tombs were barrel-vaulted and built of bricks, on the inner face of which a lively scene was stamped in relief.

In Hunan the tombs of the Chu state, whose culture underwent a great revival under the Han, were either rectangular chambers, sometimes vaulted in brick, or deep pits containing a heavy timber construction (*guo*), with chambers or compartments for offerings, surrounding a many-layered lacquered wood coffin such as the one illustrated in fig. 4.9, from the undisturbed tomb of the Marquise of Dai at Mawangdui, in Changsha.[4] The compartments around the central coffins were packed with food and clothing, figurines, ritual and domestic utensils of every useful sort, and the funerary banner discussed later in this chapter (see figs. 4.30 and 4.31), all listed in an inventory written on 312 bamboo slips. The contents of this tomb, filled

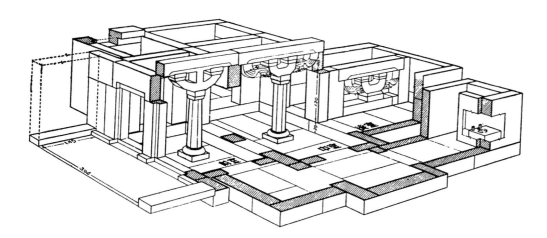

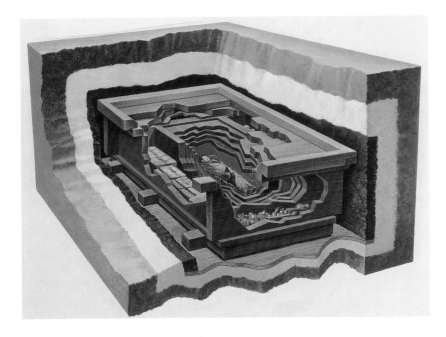

FIGURE 4.8 Isometric sketch of a stone tomb at Yinan, Shandong. Eastern Han dynasty.

FIGURE 4.9 Sketch of tomb at Mawangdui, Changsha, Hunan, showing lining of pit, tomb chamber, and triple coffin. Western Han dynasty. Drawn by David Meltzer. Copyright 1974, National Geographic Society.

FIGURE 4.10 Horse trampling a barbarian archer. Stone. From the supposed tomb of He Qubing (d. 117 B.C.). Ht. 188 cm. Western Han dynasty.

FIGURE 4.11 Horse and cavalryman. Life-size pottery figures from Pit No. 1, east of the tomb of Qin Shihuangdi (d. 210 B.C.) at Lintong, Shaanxi. Qin dynasty.

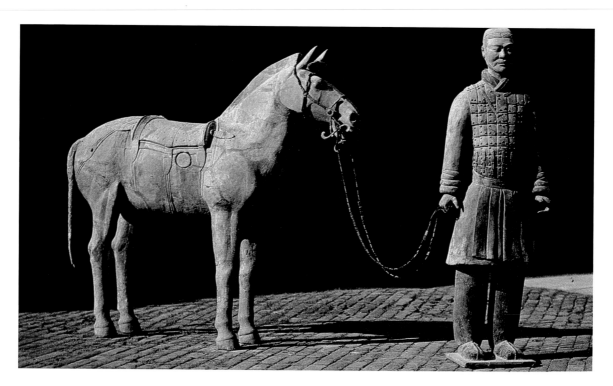

with water for two thousand years, were marvelously preserved not only because they were never robbed, but also because the thick double wall of white clay and charcoal that lined the pit filtered out all impurities.

SCULPTURE AND THE DECORATIVE ARTS

The earliest monumental stone sculpture yet discovered in China dates from the Western Han dynasty—surprisingly late in the history of one of the major civilizations and suggestive of cultural influences from western Asia. Near Xianyang in Shaanxi is an artificial hill believed to be the Shouling (literally, "longevity peak") of General He Qubing, who died in 117 B.C. after a brief and brilliant career campaigning against the Xiongnu. On and around the mound were placed life-size crudely carved figures of animals and monsters, now exhibited in a nearby museum. Most famous of these is the figure of a horse, standing with majestic indifference over a fallen barbarian who is attempting to kill it with his bow and arrow and with his pike (fig. 4.10). The modeling is massive but shallow, giving the impression of two reliefs back to back. Indeed, in its heavy, flat treatment, this piece is more reminiscent of the Sasanian rock-cut reliefs at Taq-i-Bustan than of anything in early Chinese art. Many writers have pointed out how appropriate such a monument would be to a Chinese general whose victories over the western barbarians owed much to the very horses that China had acquired from the enemy and used so effectively against them.

In early times, Chinese tombs were not marked by monumental sculpture, but in the first century A.D. the emperor Ming (58–76) introduced a change in ritual, transferring rites formerly held outside the grave area to the tomb itself, which became the focal point of both secular power and ancestral worship. A sacrificial hall was built before the tomb, approached by a "spirit road" (*shen dao*) of stone guardians and auspicious creatures—a custom that persisted almost continuously up to the nineteenth century. These spirit roads, or what is left of them, comprise much of the surviving monumental sculpture of premodern China.[5]

Western Han stone sculpture is crude, as if the craftsman had not yet mastered the art of carving in the round. He was much happier modeling in clay. The custom of putting clay figures (*yong*) in or near the grave as substitutes for the living—the number strictly regulated according to

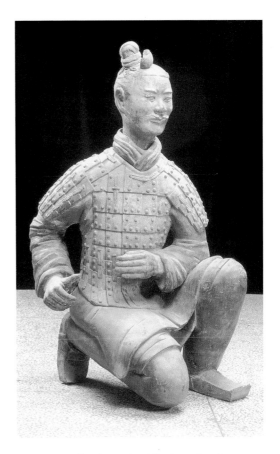

FIGURE 4.12 Kneeling archer. Life-size pottery figure from Pit No. 1, east of the tomb of Qin Shihuangdi at Lintong, Shaanxi. Qin dynasty.

the rank of the deceased—was already common in the Warring States period and became even more widespread in the Han. The Han *yong* have their spectacular forebears in the extraordinary clay figures found in 1975 in a pit to the east of the tomb of Qin Shihuangdi near Xi'an, Shaanxi province. This one pit alone—originally a huge subterranean shed—contained six thousand life-size figures of men and horses (fig. 4.11), some with chariots. Each figure is fashioned individually. The legs are solid, supporting a hollow body that, along with the separate arms and head, was formed of coiled strips of clay over which a finer "skin" was smeared, with the features stuck on or worked with a tool (fig. 4.12). The civilian officials and armor-clad soldiers bearing shining bronze swords were painted, and some bear

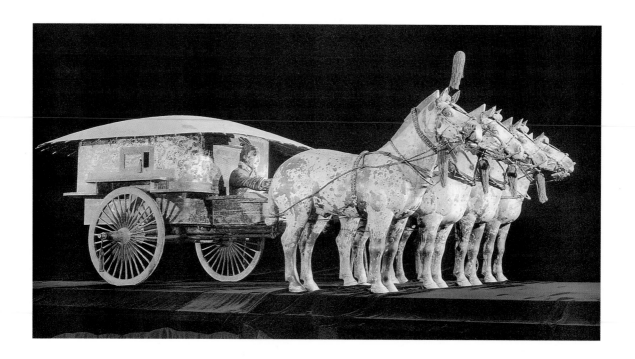

FIGURE 4.13 (ABOVE) Carriage and horses. Bronze. One-third life size. From pit to the west of the tomb of Qin Shihuangdi at Lintong, Shaanxi. Qin dynasty.

FIGURE 4.14 (RIGHT) Figurines from the tomb of the emperor Jingdi (r. 156–140 B.C.) at Yangling near Xianyang, Shaanxi. Ht. approx. 62 cm. Western Han dynasty. Institute of Archaeology, Xi'an, Shaanxi.

FIGURE 4.15 (OPPOSITE) Rhinoceros. Bronze inlaid with gold. L. 57.8 cm. Ht. 34 cm. Found in Xingping, Shaanxi. About third century B.C. Historical Museum, Beijing.

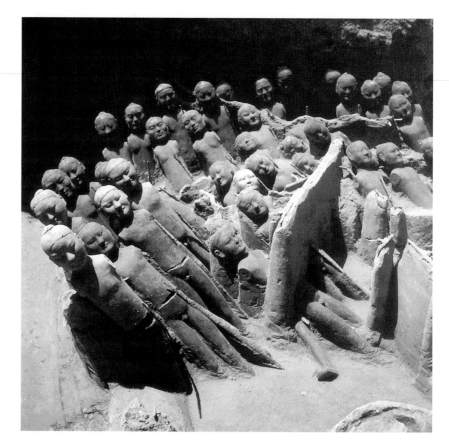

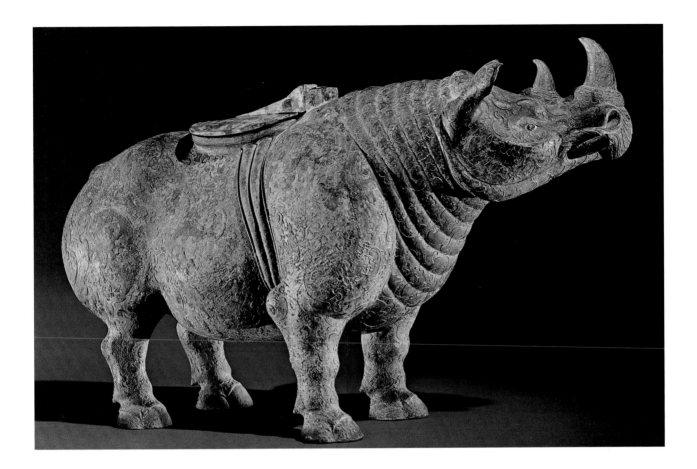

the seals of the craftsman and foreman in charge. To the west of the tomb another, smaller, pit was discovered in 1980 in which lay carriages, horses, and grooms one-third life size and exquisitely fashioned in bronze picked out in gold and silver (fig. 4.13).[6] Since then, as the archaeologists work closer and closer around the base of Qin Shihuangdi's great tomb-mound, many more pits have been discovered, one containing the remains of suits of body armor made of stone. Far too heavy to be worn by a soldier, these suits may have had symbolic meaning.

During the Western Han, the placing of clay figures in the tomb did not spread far beyond the imperial family. Different in style from the terra-cotta army of Qin Shihuangdi, and far fewer in number, are the young men and boys, naked and armless, found with the remains of chariots in pits connected with the tomb of the Western Han emperor Jingdi (156–140 B.C.; fig. 4.14). The blend of live-liness and delicacy in their features suggests a level of refinement in Han art that is seldom seen in the *yong,* but survives in the figures and animals cast in bronze from clay molds, such as the vessel in the form of a rhinoceros illustrated in fig. 4.15. Once it was inlaid all over the body in silver with an intricate pattern of cloud scrolls; now only the glassy eye remains. But even with the inlay gone, this marvelous piece, found buried in a field to the west of Xi'an in 1963, shows how successfully the craftsman of Qin or early Han was able to combine surface decoration with lively realism.

By the Eastern Han, the rich furnishing of the tomb had spread to all who could afford it—and many who could not. Thus we find in Eastern Han tombs a wide variety of models (*mingqi,* literally, "bright, or spirit, utensils") including servants and guards, farmhands, musicians, and jugglers such as the occupant probably never enjoyed in his lifetime.

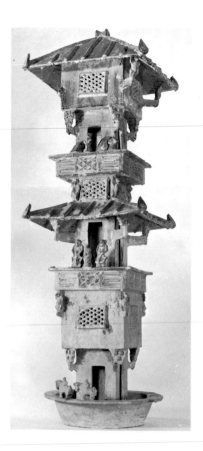

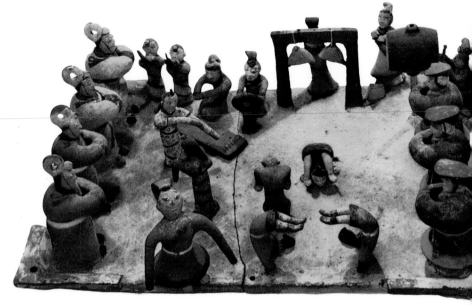

FIGURE 4.16 (LEFT) Watchtower. Pottery with greenish glaze. Ht. 120 cm. Eastern Han dynasty. With permission of the Royal Ontario Museum, Toronto. © ROM.

FIGURE 4.17 (ABOVE) Tray with figures of musicians, dancers, acrobats, and spectators. Painted pottery. L. 67.5 cm. From a tomb at Jinan, Shandong. Western Han dynasty.

There were barns with fowl modeled in relief on the top. There were watchtowers in several stories (fig. 4.16), their wooden beams and transoms either indicated by incisions in the clay or painted red. The houses and barns of the south China tombs are raised on stilts, like those in southeast Asia today. Farm animals are modeled with uncanny realism. Watchdogs from Sichuan graves are squat and menacing, those from Changsha, with heads erect and muzzles quivering, so alert one can almost hear them sniffing. These figurines are a useful source of information on the daily life, beliefs, and economy of Han China. The delightful tableau excavated in 1969 from a Western Han tomb at Jinan, Shandong, depicts the kind of entertainment with music, tumblers, and dancers that was often represented on the walls of tombs and tomb shrines (fig. 4.17). They illustrate, too, the extent of China's foreign contacts at that time. The pottery stand for a bronze "coin-tree" found in a grave in Sichuan (fig. 4.18), for example, is decorated with a frieze of

elephants in relief, modeled with a lively naturalism that has no counterpart in other Han reliefs but at once calls to mind the animals of the four quarters carved on the capital of the Aśokan column at Sārnāth, in north India.

A few of the Han figurines were individually modeled, but the majority of the smaller pieces were mass-produced in molds; though the forms are reduced to essentials, none of their vitality or character is lost. At Changsha, where the clay was often poor and glazes were apt to flake off, the *mingqi* were generally made of painted wood, which, like the silk and lacquer found in the Changsha tombs, has miraculously survived the ravages of time.

Some of the most striking relics of Han art are the bronze figures found in tombs. A particularly beautiful example, in gilt bronze, is the kneeling servant girl, from the tomb of Prince Liu Sheng's wife, Dou Wan, holding a lamp of which the chimney is her sleeve (fig. 4.19). Arresting in a more dynamic way is the bronze horse from an Eastern Han

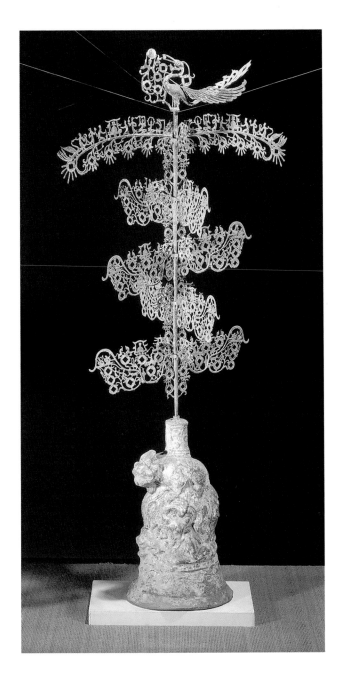

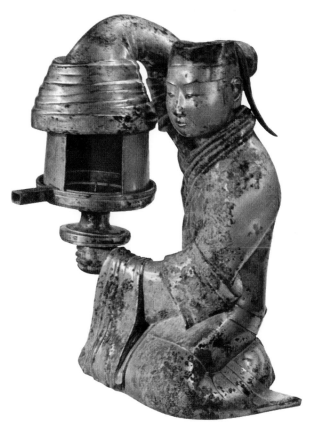

FIGURE 4.18 (LEFT) Money tree. Bronze on molded pottery stand. Ht. 105 cm. Excavated in Pengshan county, Sichuan. Eastern Han dynasty. Sichuan Provincial Museum, Chengdu.

FIGURE 4.19 (ABOVE) Lamp held by kneeling servant girl. Gilt bronze. Ht. 48 cm. Probably made in 173 B.C. From the tomb of Dou Wan (d. c. 113 B.C.) at Mancheng, Hebei. Western Han dynasty. Cultural Relics Bureau, Beijing.

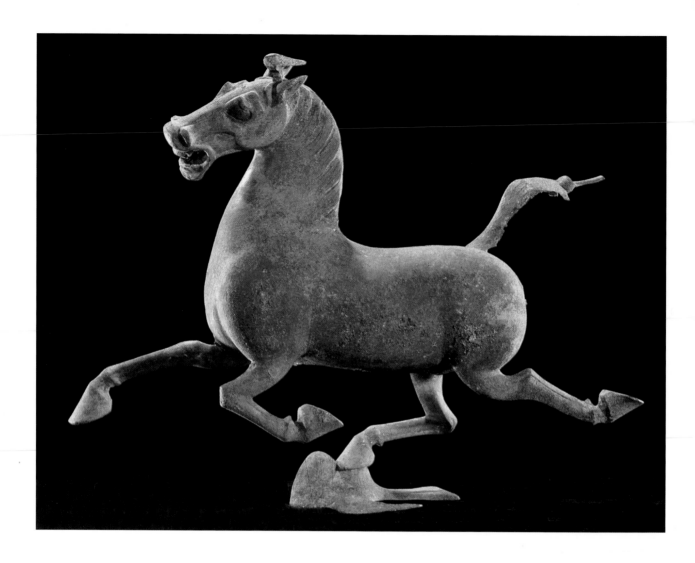

tomb discovered in Leitai, Gansu, in 1969 (fig. 4.20). He is poised as if flying, one of his hooves resting on a swallow with wings outstretched. As we have noted, the flying horse was one of the auspicious signs beloved of the Han emperors and their subjects. It is worth noting also that the wife of the emperor Chengdi (32–6 B.C.), a famous dancer, was known as Fei Yan, Flying Swallow.

Although the idea of executing stone sculpture in relief may have been derived from western Asia, it had been thoroughly assimilated by the Eastern Han. Stone reliefs have been found in almost every part of China. Best known are the animals and figures carved on a pair of funerary pillars (*que*) standing before the tomb of an official named Shen who

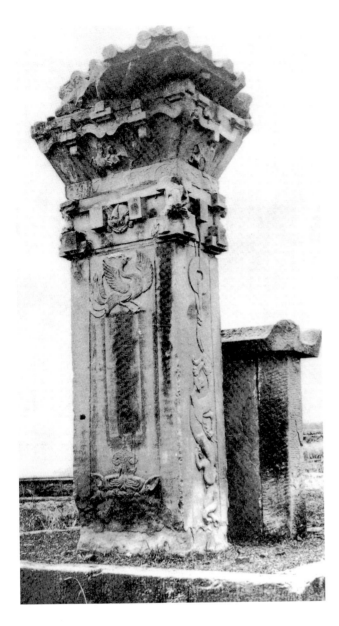

FIGURE 4.21 (LEFT) *Que* pillar. Stone. From tomb for a member of the Shen family at Quxian, Sichuan. Han dynasty. Photo: Victor Segalen, 1914; courtesy of Flammarion, Paris.

FIGURE 4.22 (ABOVE) Naked archer. Drawing by Victor Segalen of relief on one of the Shen family stone pillars. Han dynasty. Courtesy of Flammarion, Paris.

was buried in Quxian, Sichuan, during the second century A.D. (fig. 4.21). The pillars themselves are timber towers translated into stone. In high relief between the beam ends is a monster like a gargoyle; at the corners, crouching Atlantean figures—perhaps representing barbarian prisoners—support the beams, while above on each main face stand a beautifully modeled deer and rider. Most truly sculptural of the Shen *que* reliefs is the tiny figure of a naked archer, of which no good photograph exists, but which comes wonderfully to life in the drawing made on the spot in 1914 by the French explorer and poet Victor Segalen (fig. 4.22).[7]

Nearly all of what passes for relief sculpture in the Han period, however, is not really sculpture at all so much as engraving in the flat surface of a stone slab or flat relief with the background cut back and striated to give a contrasting texture. These slabs preserve the subject matter—and something even of the composition—of the lost mural paintings of the Eastern Han dynasty. They not only give

FIGURE 4.23 The archer Yi, the Fusang tree, and reception in a mansion. Detail of rubbing from a stone relief panel in the tomb shrine of Wu Liang (d. A.D. 151) at Jiaxiang, Shandong.

a vivid picture of daily life in this far-off time, but also show clear regional differences in style, so that we can without much difficulty identify the elegant dignity of some of the Shandong reliefs, the luxuriance of the stones from Nanyang in Henan, the cruder vigor of the reliefs from distant Sichuan. In later centuries, China will become ever more a single cultural entity, and these regional styles will largely disappear.

The stone shrines standing before the tombs were often decorated with engraved designs, the best-known series being those at the Xiaotangshan (Hill of the Hall of Filial Piety) near Feicheng in Shandong and the slabs from three (or possibly four) now-demolished shrines of the Wu family near Jiaxiang in southwestern Shandong, dated by their inscriptions to between A.D. 145 and 168. They give a vivid impression of the syncretic nature of Han art, in which Confucian ideals, historical events (real and legendary), Daoist mythology, auspicious omens, and folklore all contribute. On the shallow end gables of two of the Wu shrines we find Dongwanggong to the east and Xiwangmu to the west; below are depicted the legendary meetings of Confucius and Laozi and scenes of ancient kings, filial sons, and virtuous women. The attempted assassination of Qin Shihuangdi and his effort to raise one of the tripods of the emperor Yu are favorite themes in these shrines.

The lower register in the center of three of the shrines—

thought to be that of Wu Liang, who died in A.D. 151—is occupied by a scene of homage, very likely to the Han emperor himself.[8] A detail from the Left Shrine (fig. 4.23) shows heavily robed officials paying their respects to a figure, not visible off to the right, while to the left stands the auspicious Fusang tree from which the legendary folk hero Yi shoots nine of the ten suns (here symbolized by crows) that are scorching the earth. Women of the court are busy in the upper story, while monkeys, birds, and other creatures of good omen scamper about. In such a setting, the soul of the dead could pass easily from the world of the living to the world of the spirits.

PAINTING

There can be little doubt that both the style and the subject matter of the tomb reliefs owe much to the great cycles of wall paintings in halls and palaces, almost all trace of which has disappeared. Only a few miles away from the Wu family tombs stood the Lingguang Palace, built by a brother of Han Wudi. The fame of its wall paintings is celebrated in a poem by Wang Yanshou, written a few years before the Wu shrines were erected, that exactly describes the subject matter of their reliefs:

> Upon the great walls
> Flickering in a dim semblance glint and hover
> The Spirits of the Dead.
> And here all Heaven and Earth is painted, all living
> things
> After their tribes, and all wild marryings
> Of sort with sort; strange spirits of the sea,
> Gods of the hills. To all their thousand guises
> Had the painter formed
> His reds and blues, and all the wonders of life
> Had he shaped truthfully and colored after their kinds.[9]

These paintings live only in the imagination, for the buildings that housed them have long since crumbled to dust. But an increasing number of painted tombs now coming to light give an impression of Han wall painting at a humbler level. Many depict with lively naturalism the daily life of a country estate reminiscent of the self-contained villa estates of late Roman Britain; but the paintings are difficult to reproduce satisfactorily, and published copies are deceptive. We find the same naturalism in molded brick

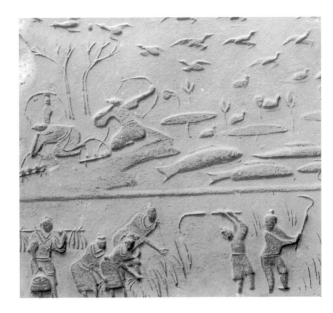

FIGURE 4.24 Shooting birds on a lakeshore and harvesting. Molded pottery tile. Ht. 42 cm. From a tomb at Guanghan, Sichuan. Han dynasty. Chengdu Museum, Sichuan.

reliefs from tombs at Guanghan in Sichuan. One depicts the salt mines, with pipelines of bamboo carrying the brine over the hills to the evaporating pans, methods still in use in Sichuan in the twentieth century. Another (fig. 4.24), divided horizontally, shows in the lower half men harvesting and threshing in the rice fields while another man brings their lunch; above, two hunters kneeling at a lakeshore shoot up at rising ducks, the arrows trailing long cords. The border of the lake winds back, seeming almost to lose itself in the mist, while behind the hunters stand two bare trees. On the surface of the water are fish and lotus flowers and ducks swimming away as fast as they can go. This delightful scene shows that in the Eastern Han, craftsmen in Sichuan were beginning to solve the problem of continuous recession in depth.

Another way to solve the problem was to omit the landscape altogether. In the lively scene on the wall of a tomb in Liaoyang showing guests coming to the funeral feast (fig. 4.25), there is no ground, no hint of any setting, and yet we seem to be looking down on an open plain across which the horsemen and carriages dash with tremendous

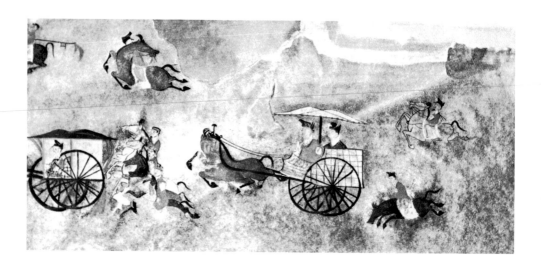

FIGURE 4.25 Guests arriving for the funeral feast. Detail of a wall painting in a tomb in Liaoyang, northeastern China. Eastern Han dynasty.

speed. This painting shows that before the end of the Han dynasty, painters had mastered the lateral movement from right to left and the sense of a space that seems to extend far beyond the picture area, both characteristic of later scroll painting.

Landscape, however, must have played a subordinate part in the fresco cycles that decorated the palaces and ancestral halls. The themes were most often Confucian. A passage from the *Hanshu* (History of the Han dynasty), for example, speaks highly of the mother of Ri Di (the regent He Guang, d. 68 B.C.), who "in teaching her sons had very high standards: the Emperor [Wudi] heard of it and was pleased. When she fell ill and died, he ordered her portrait to be painted on [the walls of] the Ganquan Palace. . . . Every time Ri Di saw the portrait he did obeisance to it and wept before he passed on." Other passages in the *Hanshu* bear witness to the Daoist predilections of the Han emperors. Wudi, for example, had a tower in the Ganquan Palace on which were depicted "the demons and deities of Heaven, Earth, and the Supreme Unity. Sacrificial utensils were set out, by which the divine beings were to be addressed."[10]

Didactic too, if in a more human and amusing way, are the figures painted on a celebrated series of tiles—now in the Museum of Fine Arts, Boston—from the gable of a tomb shrine. One scene depicts an animal combat, another a group of gentlemen in animated conversation (fig. 4.26), while a third may represent, as Laurence Sickman has suggested, an incident in the life of the virtuous Princess Jiang

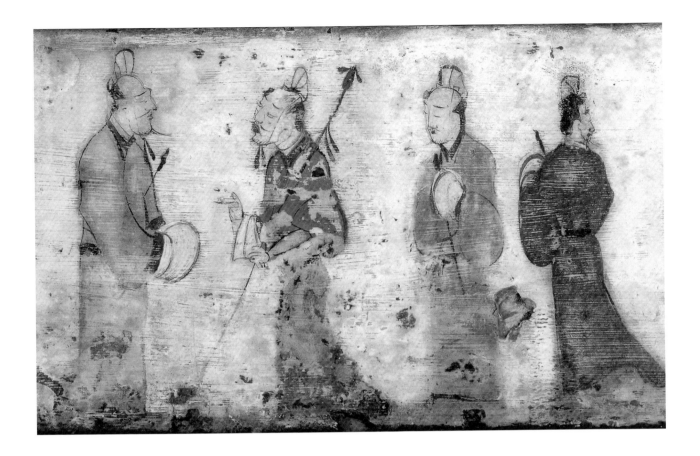

FIGURE 4.26 Gentlemen in conversation. Detail of a painted pottery tile. Ht. 19 cm. From a tomb near Luoyang, Henan. Eastern Han dynasty. Museum of Fine Arts, Boston; Denman Waldo Ross Collection; Gift of C. T. Loo. Photo © 2008 Museum of Fine Arts, Boston.

of the ninth century B.C., who took off her jewels and demanded to be incarcerated in the jail for court ladies as a protest against the emperor's dissipation—a threat that soon brought him to his senses. The figures, drawn in long sweeping lines with a sensitive, pliant brush, stand and move with wonderful ease and grace; the men discuss the affair in dignified agitation while the women, elegant and playful, seem to find the whole incident amusing. Happy the man whose tomb was adorned with such charming figures!

CALLIGRAPHY

We saw in chapter 2 how the art of writing evolved in China from undeciphered marks on Neolithic pottery to the range of style practiced in the Han dynasty. The development of calligraphy owed much to the invention of paper, of which an improved version suitable for writing on with a brush was presented to the throne by the chief eunuch, Cai Yong, in A.D. 105. Cai Yong, himself a master of poetry, prose, and music, associated fine writing with good government. By the end of the dynasty the idea of writing style as the expression of the writer's character was beginning to gain ground, and in the following two centuries calligraphy as an art form reflected the discovery of the self that shows also in poetry and in portrait painting, which now aimed to portray, not the official role of the subject, but his personality and temperament.

By the end of the Han dynasty, the calligrapher's range

of styles had been greatly extended to include not only the monumental *lishu* (clerical script; see fig. 2.44), but also the more cursive version of it, *xingshu* (running script), and the *caoshu* (literally, "grass script"), so swiftly written that the characters are often run together. Not all calligraphers approved of this uninhibited way of writing, as is shown by the earliest surviving text on the art, *Fei caoshu*—which Richard Barnhart happily translates as "A pox on the cursive script!"—written by Cao Yi in the late Han period. Sadly, no examples of Han dynasty *caoshu*—not even reliable copies of them—survive.

Perhaps this tendency to too much freedom inspired someone to write the brief *Bizhentu* (Battle array of the brush), setting out the correct way of holding the brush and analyzing the form of the eight essential strokes. This manual has been attributed both to a mysterious Lady Wei and to the great third-century calligrapher Wang Xizhi, but some scholars think the *Bizhentu* is spurious and that such "how-to" texts belong to a much later date.

Until the end of the Han dynasty the squared *lishu,* with its heavily stressed horizontal strokes, was the standard form of brush writing, illustrated by the 312 bamboo slips listing the items buried with the Marquise of Dai at Mawang-dui and by many inscriptions carved on stone tablets (*bei;* fig. 4.27). By the third century, however, the *lishu* was going out of fashion, as we shall see in chapter 5.

LACQUER AND RELATED ARTS

The power of the Chinese craftsman to impart life and movement to his subjects comes through vividly in the decoration of the lacquer objects for which Sichuan province is especially famous. That the output of its factories—especially those of Shu and Guanghan—must have been considerable we know from the first-century A.D. *Discourse on Salt and Iron,* whose author protests that the wealthy classes were spending five million copper cash annually on lacquer alone. Despite this demand, much of the lacquerware was made for export. A number of Sichuan lacquer bowls, cups, and boxes, bearing dates between 85 B.C. and A.D. 71, have been found in tombs in far-off Lelang, near Pyongyang, North Korea.

Most famous, though undated, of the Korean finds is the "painted basket" (actually a box) found in a tomb at Lelang. Around the top, under the fitted lid, are ninety-four

FIGURE 4.27 Clerical script *(lishu)* on bamboo slips excavated at Fangmatang, Gansu. Qin dynasty. Provincial Museum of Gansu Province, Lanzhou. Photo courtesy of Liu Zhengcheng.

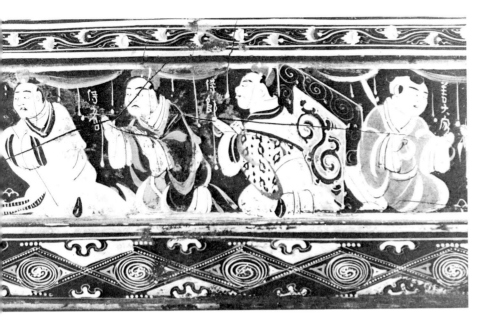

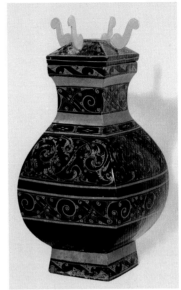

figures of filial sons, virtuous and wicked rulers, and ancient worthies (fig. 4.28). All are sitting on the floor, but monotony is avoided by the skill and inventiveness with which they turn to one side or the other, gesticulate, or engage in lively conversation. Even in this crowded space we find the same sense of individuality, of interval and psychological relationship between the figures, as we encountered on the tiles in fig. 4.26. Other lacquer objects such as bowls and trays, of which many beautiful examples have been preserved in the waterlogged soil of Changsha, are adorned with sweeping scrolls and volutes evolved out of the décor of the lacquers and inlaid bronzes of the Warring States. Now, however, these whirls erupt into flame-like tongues (fig. 4.29). The presence of a flying phoenix turns these tongues into clouds; when set about with tigers, deer, and hunters they are magically transformed into hills. Sometimes the transformation is aided by vertical striations suggesting grass or by little trees growing from the volutes. There is no attempt to depict a real landscape; rather, the craftsman has taken the sweeping volute as the essential form common to all things in nature and by means of a few accessories transformed it into clouds, waves, or mountains without robbing it of any of its rhythmic force. Because its forms follow the natural sweep and movement of the artist's hand, they express the rhythms of nature itself.

FIGURE 4.28 Paragons of filial piety. Painted in lacquer on a basketwork box. Ht. of figures about 5 cm. From a tomb at Lelang, North Korea. Eastern Han dynasty. National Museum, Seoul.

FIGURE 4.29 Covered *fanghu* jar. Wood decorated with lacquer. Ht. 50.5 cm. From a tomb at Mawangdui, Changsha, Hunan. Western Han dynasty. Hunan Provincial Museum, Changsha.

From the kind of pictorial art that I have been describing we may imagine what the finest Han paintings must have been like. They were probably painted on silk or hemp cloth, since paper, a Chinese invention, was still in the early stages of development. Fragments of hemp-fiber paper wrapping a mirror were found in an early Western Han tomb near Xi'an, and we know that in A.D. 105, during the Eastern Han, the eunuch Cai, in charge of the Imperial Workshop (Shangfang), presented to the throne what must have been a much improved paper made from vegetable fibers. Still, paper was probably not used by artists for some time, and paintings continued to be executed on rolls of silk. Figure subjects included illustrations to the classics and histories and more fanciful works such as the *Huainanzi* and *Shanhaijing*, while for landscape there were illustrations to the *fu* rhapsodies describing the capitals, palaces, and royal hunting parks.

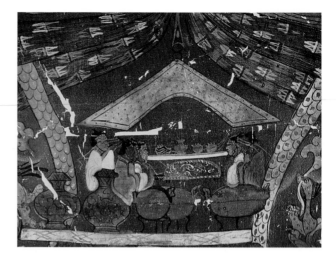

FIGURE 4.30 (LEFT) Line drawing of funerary banner showing design painted on silk. Ht. 205 cm. From Tomb No. 1 at Mawangdui, Changsha, Hunan. Western Han dynasty. Hunan Provincial Museum, Changsha.

FIGURE 4.31 (ABOVE) Detail from the banner in fig. 4.30, showing sacrifice to the deceased. Ht. of detail approx. 26 cm. Western Han dynasty. Hunan Provincial Museum, Changsha.

It has long been thought that the hanging scroll was introduced with Buddhism from India, because the earliest known pictures in this form were the Buddhist banners of the Tang dynasty discovered at Dunhuang. However, in the tombs of the wife of the Marquis of Dai and of her son at Mawangdui, outside Changsha, were found two T-shaped silk banners, draped over the swathed corpses in their coffins, that are a thousand years older than all known Chinese hanging scrolls and leave no doubt that the format is native to China. Called "flying garments" in the inventory placed in the tomb, possibly because they were believed to bear the soul of the dead aloft into the sky, they depict beings of the nether world, the world of men, and the heavens, and each includes a portrait of the deceased and a sacrificial scene.[11] In the funerary banner illustrated in figs. 4.30 and 4.31, for example, we see relatives kneeling at either side of the altar, before which the corpse of the Marquise lies on a litter, already swathed in the garments in which she will be buried. These tombs were also hung with large silk paintings of courtly and domestic pursuits, feasting and dancing, and a map of the presumed domain of the Marquis, embracing much of modern Hunan and Guangdong.

BRONZE

With the fall of the Zhou, the traditional rituals were forgotten, and consequently Han bronzes, while many were no doubt used in ancestral rites, are generally more utilitarian or decorative than those of the Shang and the Zhou. Shapes are simple and functional, the commonest being the deep dish and the wine jar (*hu*), which were often decorated with inlaid designs in gold or silver. One object with definite ritual associations is the *Boshan xianglu*, a censer in the shape of a fairy mountain often covered with animals, hunters, and trees modeled in relief. Waves of the Eastern Sea lap its base, while a hole behind each little peak emits the incense smoke symbolizing the auspicious cloud vapor (*yunqi*) exhaled by the fairy mountain—and, indeed, by all mountains, for according to traditional Chinese belief, all nature is alive and "breathing." The beautiful hill-censer inlaid with gold illustrated in fig. 4.32 was found in the Western Han tomb of Liu Sheng, the brother of the emperor Wu, along with the prince's jade-clad corpse (described later in this chapter; see fig. 4.41).

The culture of China's neighbors to the southwest was utterly different from that of the nomads on the northern frontiers. Over the years, at and around Jiangchuan, 50 miles (80 km) south of Kunming in Yunnan, scores of tombs have been opened, revealing bronze weapons and ritual objects and gold and jade ornaments. Most extraordinary are the drum-shaped containers filled with cowrie shells, the top of one of which is illustrated in fig. 4.33. The figures who crowd it are evidently taking part in a sacrificial rite. Prominent are the ceremonial drums, some of which seem to be enormous, while a set of smaller drums stands on a platform under a wagon roof of a type still seen in continental southeast Asia and Sumatra today.

From Chinese sources we know that these are tombs of the rulers of a non-Chinese tribe, or group of tribes, that the Chinese called Dian and that flourished in remote independence well into the Han dynasty. The realistic modeling on the tops of the Shizhaishan "drums" has a counterpart in the Chinese tomb figurines of the Han dynasty, but in its technique and decoration Shizhaishan bronze art seems more closely related to the simple bronze crafts of China's southwestern minorities and to the more sophisticated culture of northern Vietnam known as Dong Son.

Han tombs have yielded great quantities of bronze objects, including harnesses and carriage fittings, swords and

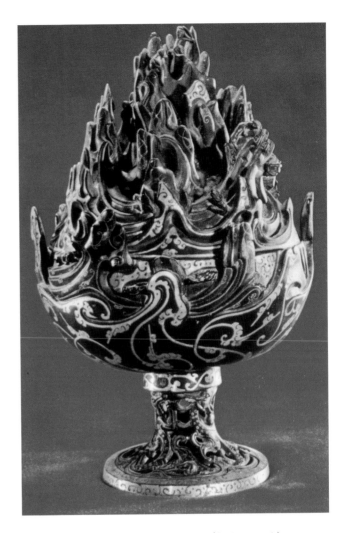

FIGURE 4.32 Fairy mountain incense burner (*Boshan xianglu*). Bronze inlaid with gold. Ht. 26 cm. From the tomb of Liu Sheng (d. 113 B.C.) at Mancheng, Hebei. Hebei Provincial Museum, Shijiazhuang.

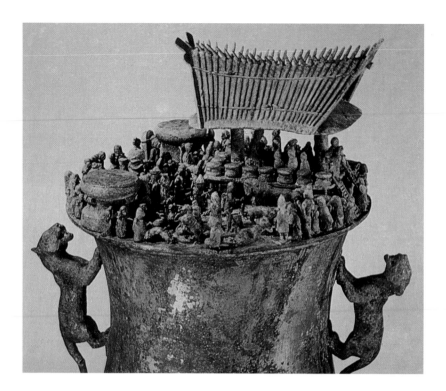

FIGURE 4.33 Drum-shaped container for cowrie shells, with a detail of the sacrificial scene modeled on the top. Bronze. Diam. 34 cm. From Shizhai-shan, Yunnan. Dian culture. Third to second century B.C.

knives, utensils and belt buckles, many of which are inlaid with gold or silver, turquoise or jade. Even the trigger mechanism of a crossbow was often so cunningly inlaid as to make it an object of beauty. Some of these designs show the powerful impact of the animal style of the Ordos region, which in turn was influenced by that curious mixture of stylization and realism characteristic of the art of the northern steppes.

BRONZE MIRRORS

The bronze mirrors of the Han dynasty continue the traditions developed at Luoyang and Shouzhou during the Warring States. The Shouzhou coiled-dragon design becomes more complex and crowded, the dragon's body being drawn in double or triple lines, while the background is generally crosshatched. Another group, also chiefly from Shouzhou, has an overall design of spirals on which a scalloped, many-pointed device is sometimes superimposed; its significance may be astronomical. Most interesting and most preg-

nant with symbolic meaning are the "TLV" mirrors (so called because of their T-, L-, and V-shaped markings), of which the finest were produced in the Luoyang region from the Wang Mang interregnum (A.D. 9–25) to about A.D. 100, although the design was already being used on mirror backs in the second century B.C.

A typical TLV mirror back (fig. 4.34) has a large central boss surrounded by a square panel with twelve smaller bosses separating the characters of the twelve earthly branches. The Ts, Ls, and Vs protrude into a circular zone adorned with animals, which, taken together with the fifth (central) zone, symbolize the five elements, a system of cosmology first set down by Zou Yan (c. 350–270 B.C.) and very popular in Han times. According to this system, the great ultimate (*taiji*) produces the positive-negative dualism of *yang* and *yin,* the interaction of which in turn gives birth to the five elements (*wuxing*), from which all events and objects derive. The five elements—water, fire, metal, wood, and earth—relate to one another and are symbolized as follows:

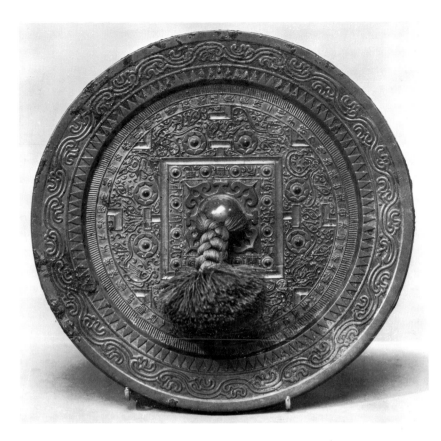

FIGURE 4.34 TLV-type cosmological mirror. Bronze. Diam. 20.3 cm. Han dynasty. Formerly Raymond A. Bidwell Collection, Springfield, Mass.

ELEMENT	FUNCTION	COLOR	DIRECTION	SEASON	SYMBOL
water	puts out fire	black	north	winter	"black warrior" (snake and tortoise)
fire	melts metal	red	south	summer	bird (phoenix)
metal	destroys wood	white	west	autumn	tiger
wood	overcomes earth	green	east	spring	dragon
earth	absorbs water	yellow	center		*cong* (earth)

On the TLV mirror, the central circle within a square represents the earth symbol, *cong*, while the four directions, seasons, and colors are symbolized by their animals in the appropriate quarters. Many bear inscriptions that clearly set out the meaning and purpose of the design, such as this one on a mirror in the Museum of Far Eastern Antiquities, Stockholm:

> The Imperial mirror of the *Shangfang* [Imperial Workshop] is truly without blemish; a skilled artisan has engraved it and achieved a decoration; to the left the Dragon and to the right the Tiger eliminate what is baleful; the Red Bird and Black Warrior conform to the *yin* and *yang* forces; may your sons and grandsons be complete in number and be in the center; on it are Immortals such as are customary [on mirrors]; may you long preserve your two parents; may your joy and wealth be splendid; may your longevity outstrip that of metal and stone; may you be like a prince or a king.[12]

The TLV design was primarily an auspicious cosmological diagram combining celestial and terrestrial symbols. Its terrestrial elements made up the board for playing *liubo*

FIGURE 4.35 *Liubo* gaming board. Stone. 44.4 × 40.1 cm. From Zhongshan royal tomb in Pingshan county, Hebei. Warring States period. Institute of Cultural Relics, Shijiazhuang, Hebei.

FIGURE 4.36 Immortals playing *liubo*. Rubbing from a stone relief at Xinjin, Sichuan. Han dynasty. Chengdu Museum, Sichuan.

FIGURE 4.37 Mirror with Daoist motifs. Bronze. Diam. 13.7 cm. Late Eastern Han period. The Avery Brundage Collection. © Asian Art Museum of San Francisco.

(fig. 4.35), a popular game in Han times that is represented on a number of Han reliefs and in clay models. The object of this game, which Professor Yang Lien-sheng has reconstructed from ancient texts, is to capture your opponent's men or drive them into the "benders" (presumably the Ls, on the outer edge) in order to attain the center, or, as Schuyler Cammann has put it, "to establish an axis for symbolic control of the Universe."[13] In Han mythology *liubo* was a favorite game of Dongwanggong and of ambitious human heroes who sought to pit their skill against that of the gods and, by defeating them, to acquire magical powers (fig. 4.36). To judge by the mirror designs, the game seems to have gone out of fashion toward the end of the Han dynasty. The mirror backs of the late Han and the Three Kingdoms produced in the Shaoxing district of present-day Zhejiang often preserve the directional symbolism but now become crowded with figures fully modeled in relief; for the most part these are Daoist fairies and immortals (fig. 4.37), but after about A.D. 300, Buddhist themes begin to appear as well.

JADE

The advances in jade-carving techniques during the Warring States continued under the Han. Now the lapidary could hollow out large pebbles in the form of toiletry boxes and bowls for eating and drinking such as the *yushang* ("winged cup"), an oval bowl with flanges on the long sides (fig. 4.38). Winged cups have been found in sets standing on a tray and were made not only in jade, but also in silver, bronze, pottery, and lacquer. This new technical freedom made the lapidary more adventurous, inspiring him to carve, in three dimensions, figurines and animals—of which one of the most beautiful specimens is the famous horse in the Victoria and Albert Museum (fig. 4.39). He no longer rejects the flawed stone but, rather, begins to exploit the discolorations: the brown stain, for instance, becomes a dragon on a white cloud. Jade has by this time begun to lose its ritual significance; it is now the delight of the scholar and the gentleman, for whom its ancient associations and beauty of color and texture are a source of intellectual and sensual pleasure. Henceforward he will be able to enjoy his pendants and garment hooks, his seals and the other playthings on his desk, in the confident knowledge that in them aesthetic and moral beauty are united. A striking example

FIGURE 4.38 *Yushang* ("winged cup"). Jade. L. 13.2 cm. Han dynasty. Freer Gallery of Art, Smithsonian Institution, Washington, D.C.: Purchase.

FIGURE 4.39 Head and shoulders of a horse. Jade. Ht. 18.9 cm. Han dynasty. Victoria and Albert Museum, London. V&A Images.

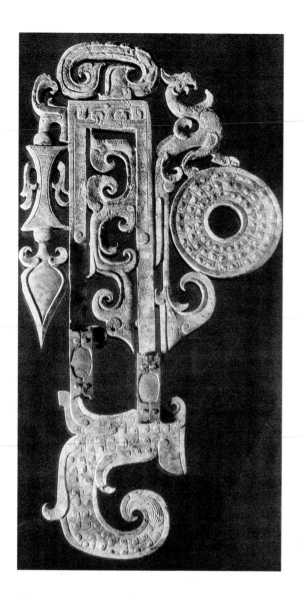

of the jadesmith's art is the ornamental openwork plaque illustrated in fig. 4.40, an object so precious to its royal owner that when broken it was mended with gold clasps. Found with other treasures in Guangzhou in 1983, in the tomb of the semi-independent ruler of the kingdom of Nanyue (second century B.C.), it shows how high-style Chinese crafts—in this case rather old-fashioned—had penetrated by this time into the extreme south of China, and how the *bi* disk, once so potent a symbol, had by the Han become a mere element in an ornamental assembly.

The Chinese belief in the preserving power of jade inspired the crafting of jade burial suits, made at enormous cost in human travail, for members of the Han imperial family (fig. 4.41). Han Wudi's brother, Liu Sheng (d. 113 B.C.), was completely dressed—head, body, legs, and arms—in a fitted suit made from two thousand thin jade plaques sewn together at the corners with gold thread. It was reckoned that Liu Sheng's burial suit and that of his wife, Dou Wan, would each have taken about ten years to make.[14]

The fall of the Han precipitated a reaction against this sort of extravagance; jade shrouds, for instance, were banned in A.D. 222, as were tomb shrines (*ci*) like those of the Wu family discussed earlier in this chapter. Most Six Dynasties graves are much more simply furnished.

FIGURE 4.40 Openwork tablet (with ancient repair). Jade inlaid with gold. L. 14 cm. From the tomb of Chao Mei, king of the Southern Yue (d. 122 B.C.), in Guangzhou. Western Han dynasty. Guangdong Provincial Museum, Guangzhou.

FIGURE 4.41 Burial suit of Prince Liu Sheng (d. 113 B.C.). Made from about 2,500 thin jade plaques sewn together with gold wire. L. 188 cm. From tomb at Mancheng, Hebei. Western Han dynasty.

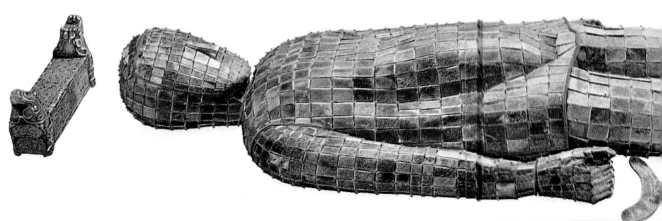

TEXTILES

Under the Han dynasty, the customs and amenities that in Shang and Zhou had been confined to a minute privileged aristocracy now spread over a much wider area and a much larger segment of society. At the same time, Chinese handicrafts traveled far beyond China's frontiers—to Indochina and Siberia, Korea and Afghanistan. The ruins of a Chinese-style palace discovered in southern Siberia contained Chinese bronze fittings, coins, and tiles as well as pottery house models presumably made locally by Chinese potters. Chinese archaeologists have suggested that this might have been the palace of the daughter of Madame Wenji, who had married a chieftain of the Xiongnu in A.D. 195 but was eventually forced to return to China, leaving her devoted husband and children behind.

Chinese textiles, too, reached the limits of the civilized world. The Greek word *Seres* ("the Silk People") was probably first used not of the Chinese themselves—of whom the Greeks had no direct knowledge—but of the western Asiatic tribes who traded in this precious commodity. Direct intercourse with China came only after Zhang Qian's expedition and the establishment of the Silk Road across central Asia. This great caravan route, leaving China at the Jade Gate, Yumen, in modern Gansu, crossed central Asia to the north and south of the Taklamakan Desert, reuniting in the region of Kashgar, whence one branch led westward across Iran to the Mediterranean world while the other struck south into Gandhāra and India. Chinese stuffs have been found in the Crimea, Afghanistan, Palmyra, and Egypt, while in Rome in the time of Augustus there was a special market for imported Chinese silk in Vicus Tuscus. According to legend, the consort of the Yellow Emperor first taught the Chinese people how to cultivate the mulberry on which the silkworm feeds and to spin, dye, and weave the threads. So important has the industry been to China that, until the Revolution of 1911, the empress sacrificed to the spirit of the consort of the Yellow Emperor every year in her own temple in Beijing.

Evidence of the art of weaving was found in the Neolithic village of Banpo in Shaanxi. The Shang people at Anyang had tailored clothing of silk and hemp, and a number of passages in the *Book of Songs* refer to colored woven silk. Silk panels with painted designs have been found in late Zhou graves in Changsha, while equally important finds of early Chinese textiles were made in central Asia (fig. 4.42), notably in the waterlogged tumulus graves at Noin-Ula in southern Siberia, excavated by the Koslov expedition in 1924–25, and in the sand-buried sites of Turfan and Khotan, explored first by Sir Aurel Stein in the early years of the twentieth century and, more recently, by Chinese ar-

FIGURE 4.42 Figured silk textile. Excavated at Noin-Ula, Mongolia. Han dynasty. Hermitage Museum, St. Petersburg.

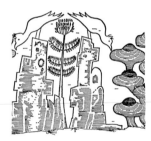

FIGURE 4.43 Woven silk textile. From Tomb No. I at Mawangdui, Changsha, Hunan. Western Han dynasty.

FIGURE 4.44 Drawing of detail of silk panel. From Noin-Ula, Mongolia. Han dynasty. Hermitage Museum, St. Petersburg.

chaeologists. The grave in Changsha that yielded the silk banner shown in fig. 4.30 was also crammed with rolls of silk. The techniques included moiré, damask, gauze, quilting, and embroidery, and the designs were chiefly of three kinds: pictorial, generally representing animal combats such as appear also on the Ordos bronzes; diapered, with geometrical motifs repeated over the whole surface (fig. 4.43); and designs composed of those endless rhythmic cloud volutes that we have already encountered on the inlaid bronzes, set about with horsemen, deer, tigers, and more fabulous creatures. The silk panel from Noin-Ula illustrated in fig. 4.44 is a Daoist landscape composed of giant spirit fungi (*lingzhi*) alternating with rocky crags topped by phoenixes and adorned with formalized trees, the mixed Chinese-Western style suggesting that Chinese weavers were already designing for the export market.

CERAMICS FOR USE AND FOR BURIAL

Han ceramics vary enormously in quality, from unglazed and roughly modeled earthenware to a high-fired glazed stoneware verging on porcelain. Most of the grave goods were made of coarse pottery generally covered with a lead glaze that easily oxidizes in damp soil, producing that silvery-green iridescence so attractive in this class of Han wares. The technique of lead glazing was known in the Mediterranean world before the Han and, if not discovered independently, may have been introduced by way of central Asia during the first century B.C. into north China, whence it spread southward, eastward, and westward. The finest of these lead-glazed wares are the jars (*hu*) for grain or wine (fig. 4.45). Their shapes are simple and robust, the imitation of bronze being aided by a lustrous finish and the application of *taotie* masks in relief, while incised lines or geometric motifs around the shoulder enhance the beauty of their form. Sometimes they are decorated with a frieze depicting, in relief under the glaze, a hunt among mountains (fig. 4.46), in which all manner of creatures real and imaginary chase each other around and around—as on those extraordinary full-scale models of Mount Penglai that were made to appear at the hunting feasts of the Han emperors. These reliefs, in which we often find towering ranges of hills, may well preserve the designs of Han scroll paintings on silk.

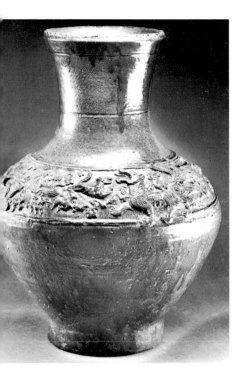

FIGURE 4.45 *Hu* storage jar. Stoneware decorated with relief designs under a dark green glaze. Ht. 40.5 cm. Han dynasty. The Nelson-Atkins Museum of Art, Kansas City, Missouri. Purchase: Nelson Trust.

FIGURE 4.46 The hunt among mountains. Relief decoration on the shoulder of a pottery *hu*. Han dynasty. Line drawing after Nils Palmgren, *Selected Chinese Antiquities from the Collection of Gustav Adolf, Crown Prince of Sweden* (Stockholm, 1948), fig. 239a.

FIGURE 4.47 *Yue* jar. Third century A.D. Leon Lee Collection, Hong Kong.

Of quite a different kind was the fine-quality felspathic stoneware made in a number of centers in Zhejiang. This ancestor of the Song celadons has a hard body and thin glaze ranging in color from gray to olive green to brown (fig. 4.47). It is often called Yue ware, because the type site is at Jiuyan near Shaoxing, the old name of which is Yuezhou.[15] Recent Chinese writers confine the term *Yue ware* to the porcelaneous celadon made for the court of Wu-Yue in the tenth century A.D., calling all earlier celadons "old Yue" or simply *qingci*, "green porcelain." However, this translation is misleading, since some of the Yue stoneware can hardly be called green, and none of it is true porcelain. In this book, therefore, the term *Yue ware* is retained to cover the whole huge family of pre-Song Zhejiang celadons.

The Jiuyan kilns were in operation at least from the second century A.D.; those at Deqing, north of Hangzhou, perhaps a little later. Many of their products, found in dated tombs in the Nanjing region, are imitations of bronze vessels, even to the loop handles and *taotie* masks that adorn them. Some are stamped with geometric or diaper designs under the glaze, preserving an ancient tradition of central and southern China that spread not only northward but also into the Nanhai, the peninsula and islands of southeast Asia.

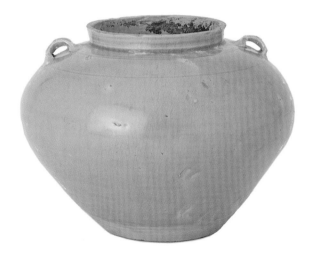

Gradually, however, true ceramic forms began to emerge, aided by a rich, luminous, and even luscious glaze. The Jiuyan kilns seem to have closed down in the sixth century, after which the Yue tradition was carried on in many parts of Zhejiang, the chief factories being around the shores of Shanglinhu in Yuyaoxian, where the remains of more than twenty celadon kilns have been discovered so far.

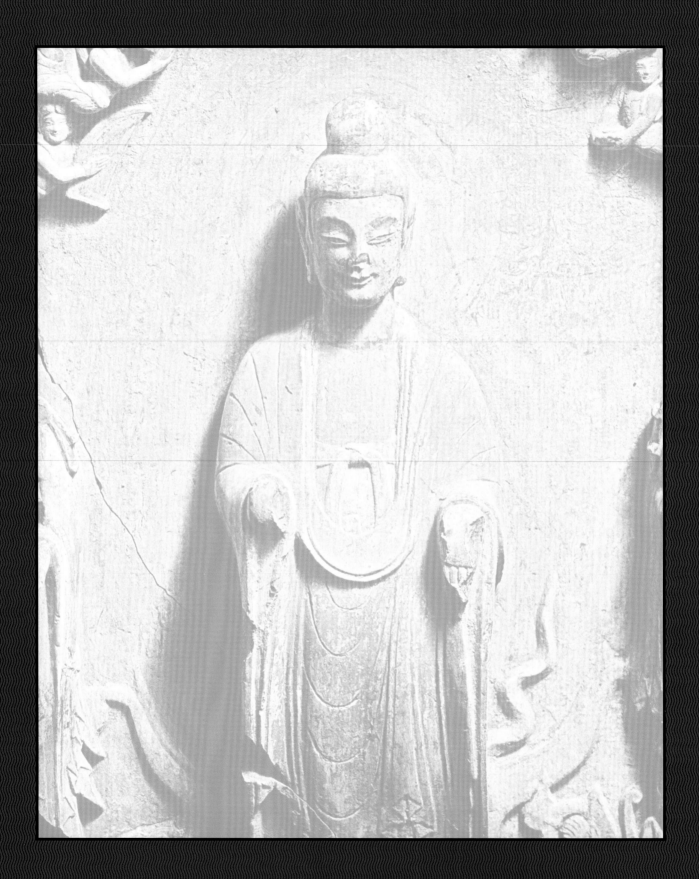

THE THREE KINGDOMS
AND THE SIX DYNASTIES

During the four hundred years between the fall of the Han dynasty and the rise of the Tang, China went through a period of political, social, and intellectual ferment comparable to that of modern Europe. No fewer than thirty dynasties and lesser kingdoms passed across the scene before the Sui reunited the empire in A.D. 581. At the fall of the Han dynasty in 220, China was divided into the Three Kingdoms of Wu, Wei, and Shu (map 5.1); in 280 a general who had usurped the throne of Wei in 265 reunited the Three Kingdoms and renamed his dynasty Jin. The crude figurine of a man on horseback in fig. 5.1 is typical of this benighted era. Beyond the northern frontiers, the Xiongnu and the Xianbi were watching with interest the incessant civil wars to which the now fragmented empire was victim. When, soon after A.D. 300, two rival princes rashly appealed to them for aid, they promptly advanced into China. In 311 the Xiongnu captured Luoyang, massacred twenty thousand of its inhabitants, and took the emperor prisoner; they then moved on to Chang'an, which they sacked, while the Jin court fled in panic to Nanjing. It is said that two million penniless refugees found work on the estates built up in the south by landed families who, as the

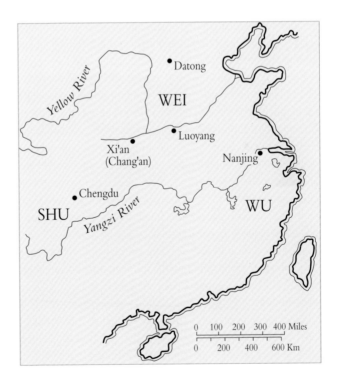

MAP 5.1 China during the Three Kingdoms

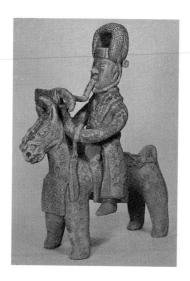

FIGURE 5.1 Man on horseback. Pottery figure. Ht. 23.5 cm. Excavated from a tomb of A.D. 302 at Changsha, Hunan. Western Jin dynasty. Hunan Provincial Museum, Changsha.

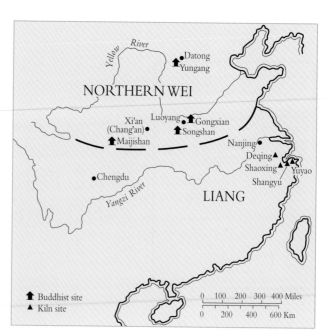

MAP 5.2 China during the Six Dynasties

dynasties came and went, held the power and were the chief patrons of scholarship and the arts.

The Xiongnu and Xianbi were not the only tribes to take advantage of China's weakness by invading the north; sixteen petty barbarian kingdoms were to rise and fall before the Toba Wei, a Turkish tribe, brought the whole of north China under their rule in 439. They established the capital of the Northern Wei dynasty near Datong in northern Shanxi, abandoned their nomadic way of life, and adopted Chinese dress, eventually becoming so Sinicized that the use of the Toba language was forbidden altogether. At the same time, they energetically defended their northern borders against other, more barbarous, tribes and pushed their cavalry as far as Kucha in the Tarim Basin, thus reopening the trade route into central Asia.

The invasions had split China into two countries and two cultures. While the north sank into barbarism, huge numbers of Chinese refugees migrated to the south. Nanjing now became the cultural and political center of "free China," to which merchants and Buddhist missionaries came from southeast Asia and India. Yet this region too was in a perpetual state of unrest, and huge quantities of art treasures were destroyed in the turmoil.

Four more dynasties—the Liu Song, Southern Qi, Liang (map 5.2), and Chen—ruled from Nanjing before the split between north and south was healed. The Confucian order was undermined, and the southern Buddhist temples and monasteries now grew to such vast proportions—particularly under the Liang emperor Wu (r. 502–550)—that they constituted a serious threat to the political and economic stability of the realm. With the eclipse of the Confucian bureaucracy, the great landed families often exerted the greatest influence on politics and the arts, outliving the dynasties themselves.

DAOISM

Many intellectuals in the south sought escape from the chaos of the times in Daoism, poetry, music, calligraphy, and the delights of *qing tan*—literally "pure talk"—that is, philosophical discussions free from Confucian orthodoxy. Daoism came into its own in the third and fourth centuries, when it seemed to answer the yearnings of men of feeling and imagination for a vision of the eternal in which they could forget the chaos of the present. This conglomeration of folklore, nature worship, and metaphysics was rooted in the native soil of China. It had first become a cult in the Eastern Han when Zhang Daoling, a mystic and magician from Sichuan who called himself Tianshi (Heavenly Master), gathered round him a group of followers with whom

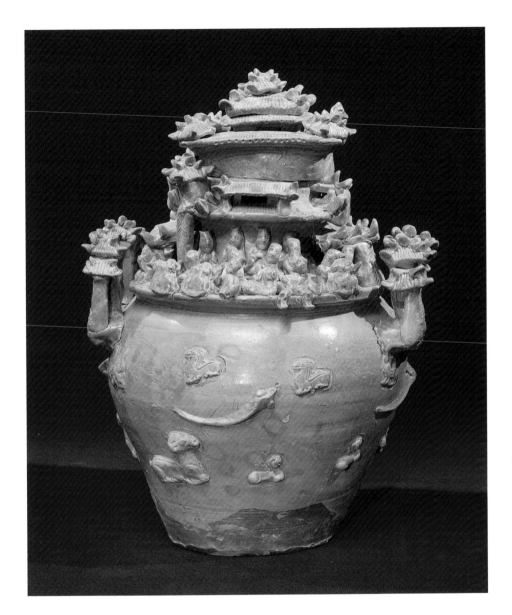

FIGURE 5.2 Burial urn with multistory pavilions, modeled figures of musicians, dancers, acrobats, dragons, monkeys, etc., and appliqué decoration on the body. Stoneware covered with olive-green glaze. Ht. 37.5 cm. Probably from Shaoxing, Zhejiang. Third century A.D. Photo courtesy of Michael Weisbrod, New York.

he roamed the countryside in search of the elixir of life. Sometimes he would take them to the top of Cloud Terrace Mountain (Yuntaishan) and there invent ordeals to test their magic powers. By the Jin dynasty the Daoist movement, which had originated as a private revolt against the established order, had grown into a full-fledged church, with a canon of scriptures, a hierarchy, temples, and all the trappings of a formal religion copied from the Buddhists.

"Popular Daoism" was rooted in local beliefs and su-perstitions then pervasive in China and little understood today. An illustration is the extraordinary funerary jar shown in fig. 5.2, from a third-century tomb. Crowded with dancers, musicians, acrobats, monkeys, rams, and other creatures under a many-tiered roof suggesting a shrine of some sort, this jar must be associated with an ancient burial cult in the Shaoxing area of Zhejiang. On a higher level, however, the Daoists were the intellectual avant-garde. The reaction against Confucianism had undermined the moral-

istic and didactic functions claimed for poetry and painting by the Confucians, and now the imagination again took flight in poetry more inspired than any since the *Elegies of Chu.* Typical of the age is the poet Tao Yuanming (365–427), who, though forced several times to take office to support his family, retired whenever he could to his country cottage, where he grew his own vegetables, drank excessively, and read books—though he said he did not mind if he failed to understand them completely. This was not merely escape from political and social chaos; it was escape also into the world of the imagination.

THE BIRTH OF AESTHETICS

It was in these turbulent years that the Chinese painter and poet first discovered himself. Lu Ji's *Wenfu* (Rhyme-prose on literature),[1] written in A.D. 300, is a penetrating, even passionate, rhapsody on the ordeal that T. S. Eliot called the "intolerable wrestle with words and meanings" and on the mysterious sources of poetic inspiration. New critical standards were evolving, culminating in Xiao Tong's preface of A.D. 530 to his *Wenxuan* (Literary anthology), in which he wrote that his selection of prose and poetry had been guided not by moral considerations but by aesthetic merit alone. This sophisticated position was not reached at once, however. Literary criticism in the third and fourth centuries had taken the form of *pinzao*—a mere classification (often in nine grades), according to merits and faults, first applied to statesmen and other public figures, then to poets. The great painter Gu Kaizhi used it in discussing artists of Wei and Jin (if indeed the surviving text is from his hand). Xie He employed it more methodically in his famous *Guhua pinlu* (Ancient painters' classified record), written in the second quarter of the sixth century, in which the author grades forty-three painters of former times into six classes, a useful but undistinguished contribution to art history. What has made Xie He's brief work so significant for the whole history of Chinese painting is its preface, which sets out the six principles (*liu fa*) by which paintings, and painters, are to be judged. They are:

Much—perhaps too much—has been written about the six principles. But they cannot be passed over, for they have, with some variation or rearrangement, remained the pivot around which all subsequent art criticism in China has revolved. They are:

1. *Qiyun shengdong*: "Spirit Harmony—Life's Motion" (Arthur Waley); "animation through spirit consonance" (Alexander Soper)
2. *Gufa yongbi*: "bone-means use brush" (Waley); "structural method in the use of the brush" (Soper)
3. *Yingwu xiangxing*: "fidelity to the object in portraying forms" (Soper)
4. *Suilei fucai*: "conformity to kind in applying colors" (Soper)
5. *Jinying weizhi*: "proper planning in placing [of elements]" (Soper)
6. *Chuanyi muxie*: "that by copying, the ancient models should be perpetuated" (Shio Sakanishi)[2]

The third, fourth, and fifth laws are self-explanatory; they reflect the kind of technical problems that painting encountered in its early development. The sixth acknowledges the need to train one's hand and acquire an extensive formal repertoire, and it also indicates a reverence for the tradition itself, of which every painter felt himself to be a custodian. Making exact copies of ancient, worn masterpieces was a way of preserving them, just as, at a later date, working "in the manner of" great painters of the past, while adding something of oneself, was a way of putting new life into the tradition.

The experience of the painter—what Cézanne called, in a celebrated phrase, "une sensation forte devant la nature"—is enshrined in the phrase *qiyun,* Soper's "spirit consonance." *Qi* is that cosmic spirit (literally, breath or vapor) that vitalizes all things, that gives life and growth to the trees, movement to the water, energy to human beings, and that is exhaled by the mountains as clouds and mist. The artist must attune himself to this cosmic spirit and let it infuse him with energy so that in a moment of inspiration—and no word could be more appropriate—he may become the vehicle for its expression. William Acker once asked a famous calligrapher why he dug his ink-stained fingers so deep into the hairs of his huge brush when he was writing; the calligrapher replied that only thus could he feel the *qi* flow down his arm, through the brush, and onto the paper. The *qi* is a cosmic energy that, as Acker puts it, "flows about in ever-changing streams and eddies, here deep, there shallow, here concentrated, there dispersed."[3] It infuses all things, for there is no distinction between the animate and the inanimate. Seen in this light, the third, fourth, and fifth

principles involve more than mere visual accuracy; as the living forms of nature are the visible manifestations of the workings of the *qi*, only by representing them faithfully can the artist express his awareness of this cosmic principle in action.

CALLIGRAPHY

The second of Xie He's principles, *gu* (the "bone"), refers to the structural strength of the brushstroke itself—the quality through which awareness of the inner vital spirit is expressed, whether in painting or calligraphy. We saw in the previous chapter how calligraphy came to be regarded as a fine art before the end of the Han. Now, in the south, where Chinese culture was barely touched by the barbarians in occupation of the north, it came to its full flowering, and the writing of Wang Xizhi (303?–361?; fig. 5.3) and of his son Wang Xianzhi (344–388) was to become a model ever after. They were both members of a circle based in the southern capital (today's Nanjing) that also included the painter Gu Kaizhi, who was steeped in Daoist lore, metaphysics, and the quest for immortality.

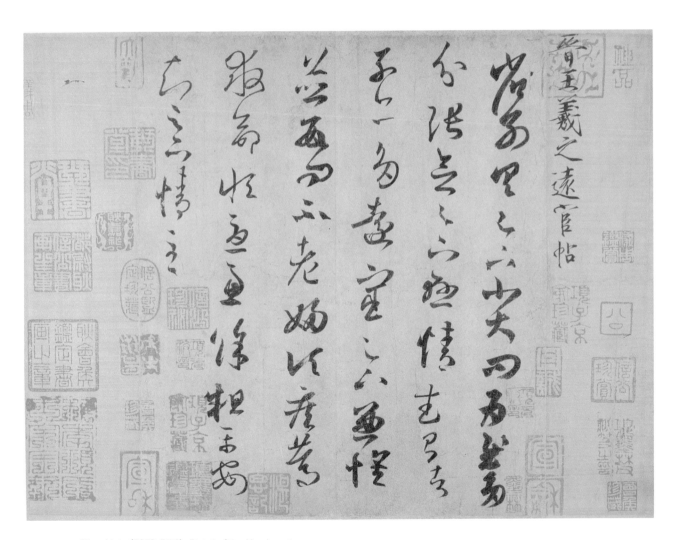

FIGURE 5.3 Wang Xizhi (303?–361?). Detail of the *Yuanhuantie*. *Xingshu* (running script). Western Jin dynasty. National Palace Museum, Taipei. Photo courtesy of Liu Zhengcheng.

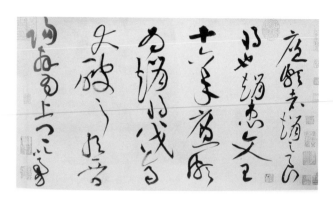

FIGURE 5.4 (ABOVE) Huang Tingjian (1045–1105). Part of a biography in Sima Qian's *Shiji* (Classic of history). Song dynasty. The Metropolitan Museum of Art, New York. Photo courtesy of Liu Zhengcheng.

余每觀才士之所作竊有以得其用心夫其放言遣辭良
多變矣妍蚩好惡可得而言每自屬文尤見其情恒患意
不稱物文不逮意蓋非知之難能之難也故作文賦以述
先士之盛藻因論作文之利害所由他日殆可謂曲盡其
妙至於操斧伐柯雖取則不遠若夫隨手之變良難以辭
逮蓋所能言者具於此云爾

None of their works survive today in the original, but from countless later copies and rubbings taken from inscriptions carved in stone, it seems they were masters of three styles then current. *Caoshu* (literally, "grass," or cursive, script) was a swiftly written, abbreviated, and sometimes hard-to-read style in which characters are often run together (fig. 5.4); it derived from (and may have been contemporary with) the *lishu* (clerical script) of the Han dynasty. *Kaishu* or *zhenshu* (regular script) evolved into a less angular and "masculine," more supple and graceful, form of *lishu*. Fig. 5.5 shows the modern calligrapher Chang Ch'ungho's transcription of the opening lines of the *Wenfu* of Lu Ji, in the *lishu* style of the period. By the Tang dynasty *kaishu* had become the standard form, still learned by every Chinese child today. A slightly more cursive form of *kaishu*, in which individual styles may be simplified or abbreviated but the characters still remain separate and distinct, became known as *xingshu* (running script). Perhaps the most famous example of early Chinese calligraphy is the preface to the *Orchid Pavilion Essay* (*Lanting xu*), by Wang Xizhi, which survives today in what is generally agreed to be a Tang tracing copy (fig. 5.6).

By the fourth century, Chinese calligraphy—equipped with a range of styles and a sophisticated aesthetic vocabulary—had become the senior visual art in China, judged not, as it once had been, by the moral content of what was written, but by the beauty of the writing itself.

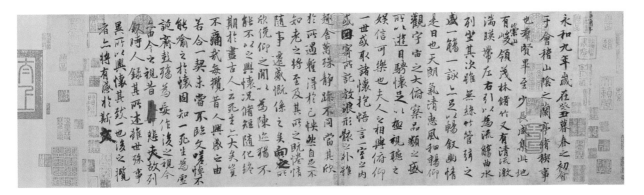

FIGURE 5.5 (LEFT) Clerical script *(lishu)*. Transcription (in the style of the third to fourth century by the modern calligrapher Chang Ch'ung-ho) of the opening lines of the *Wenfu* (Rhapsodic prose-poem on literature) by Lu Ji (c. A.D. 300).

FIGURE 5.6 (ABOVE) Wang Xizhi. *The Lanting Preface*. Tang dynasty copy. Palace Museum, Beijing. Photo courtesy of Liu Zhengcheng.

THE BIRTH OF LANDSCAPE PAINTING

It was perfectly possible to be both a Buddhist and a Daoist. Zong Bing, a distinguished Buddhist scholar and painter of the early fifth century, spent his life wandering amid the beautiful hills of the south with his equally romantic wife and, when he was too old to wander any more, re-created the landscapes that he loved on the walls of his studio. The short *Hua shanshui xu* (Preface on landscape painting), one of the earliest surviving writings on this new art form, is attributed to him. In it he maintains that landscape painting is a high art because landscapes "both have material existence and reach out into the realm of the spirit." He declares that he would like to be a Daoist mystic, meditating upon the void. He has tried it and is ashamed to confess that he failed; but, he asks, is not the art of the landscape painter, who can reproduce the very forms and colors that inspire the Daoist adept, even more wonderful? He is innocently amazed at the power of the artist to bring down a vast panorama of mountains within the compass of a few inches of silk. Visual accuracy he holds to be essential, for if the landscape is well and convincingly executed, if the forms and colors in the picture correspond to those in nature, then "that correspondence will stir the spirit, and when the spirit soars, truth will be attained. What more," he asks, "could be added to this?"

Another brief essay, this one attributed to Wang Wei, a musician and man of letters who died in 443 at the age of twenty-eight, starts by pointing out that paintings must correspond to the *ba gua* (eight trigrams): just as the *ba gua* are a symbolic diagram of the workings of the universe, so must landscape painting be a symbolic language through which the painter may express not a relative, particularized aspect of nature seen at a given moment from a given viewpoint, but a general truth, beyond time and place. Though he too is full of wonder at the artist's mysterious power of pictorial compression, he insists that painting is more than the exercise of skill: "The spirit must also exercise control over it; for this is the essence of painting." The landscapes of Wang Wei, Zong Bing, and their contemporaries were all lost centuries ago, but the ideals enshrined in these and other writings of this critical formative period have inspired Chinese painters up to the present day.

The life and work of Gu Kaizhi (c. 344–406), more perhaps than that of any other creative personality of his time, seem to embody the forces that inspired men in these turbulent years. Wildly unconventional, yet a friend of the great at court, a calligrapher and painter of Daoist landscapes who was seldom far from the hurly-burly of intrigue in the capital, he moved unharmed among the rival politicians and warlords, protecting himself by the aura of idiocy that the Daoists held to be the only true wisdom. His biography tells us that he was famous for his portraits, in which he captured not merely the appearance but the very spirit of his subject.[4] This was an important change from the formal portrait of the Han dynasty, which was not so much of individuals as of examples of virtue to be emulated and of

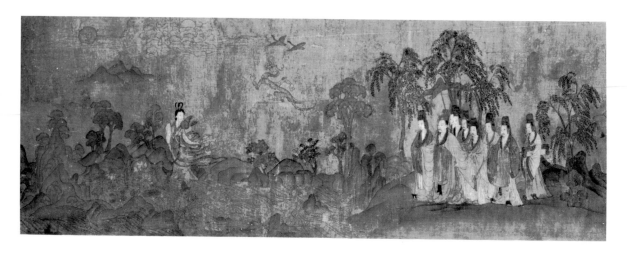

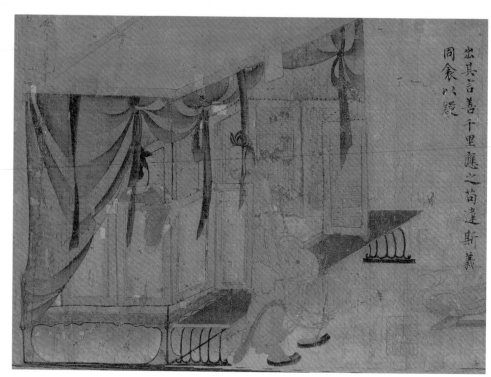

FIGURE 5.7 (ABOVE)
After Gu Kaizhi (344–406?).
The Fairy of the Luo River, part of
a handscroll illustrating a *fu*
poem by Cao Zhi. Ink and color
on silk. Ht. 24 cm. About twelfth
century. Freer Gallery of Art,
Smithsonian Institution, Washing-
ton, D.C., Gift of Charles Lang
Freer.

FIGURE 5.8 (RIGHT)
After Gu Kaizhi. The emperor
with one of his concubines. De-
tail of the handscroll illustrating
*The Admonitions of the Instruc-
tress to the Court Ladies,* by
Zhang Hua. Ink and slight color
on silk. Ht. 25 cm. Tang dynasty
(?). © The Trustees of the British
Museum, London.

FIGURE 5.9 (OPPOSITE) Filial sons and
virtuous women of antiquity. Part of a four-panel
folding screen. Wood painted in lacquer. Ht. 81.5
cm. From the tomb of Sima Jinlong (d. 484) at
Datong, Shanxi. Northern Wei dynasty.

wickedness to be shunned. But Gu Kaizhi was a landscape painter too. A fascinating essay attributed to him describes how he would go about painting Cloud Terrace Mountain and the ordeal to which Zhang Daoling subjected one of his disciples on the top of a precipice. The text shows that Gu conceived of the mountain in strictly Daoist terms, bracketed east and west by the green dragon and the white tiger, its central peak ringed with clouds and surmounted by the strutting phoenix, symbol of the south. We do not know whether he ever painted this picture or not, though he probably did. Only three paintings associated with his name have survived. One, of which there are Song versions in the Freer Gallery and the Palace Museum, Beijing, illustrates the closing moments in the *fu* "The Fairy of the Luo River" (*Luoshen fu*), by Cao Zhi (fig. 5.7). Both these copies preserve the archaic style of the time, particularly in the primitive treatment of the landscape, which provides the setting for the scene where the fairy bids farewell to the young scholar who had fallen in love with her and sails away in her magic boat.

The Luoshen scroll uses continuous narration, in which the same characters appear several times, whenever the story requires. This device seems to have come from India with the introduction of Buddhism, for there is no evidence of it in Han art. Probably the Han scrolls most often used the convention employed in *The Admonitions of the Instructress to the Court Ladies,* in which the text alternates with the illustrations. The *Admonitions* scroll, illustrating a poem by Zhang Hua, is not included among recorded works of Gu Kaizhi in Tang texts and was first attributed to him in the collection of the Song emperor Huizong; there are, indeed, details of the landscape that suggest it may be a copy from the Tang period. Yet it clearly derives from a painting by a very early master. The scene in fig. 5.8 shows the emperor gazing doubtfully at a concubine seated in her bed-couch. The couplet to the right runs: "If the words that you utter are good, all men for a thousand leagues around will make response to you. But if you depart from this principle, even your bedfellow will distrust you." The fourth scene, now much faded and damaged, illustrates the virtuous Lady Ban refusing to distract the Han emperor Cheng from affairs of state by going out with him in his litter. The same scene and almost the same composition appear on a painted wooden screen (fig. 5.9) discovered in 1965 in the tomb of Sima Jinlong, a Chinese official who,

FIGURE 5.10 Riders. Detail of a wall painting in the tomb of Lou Rui (d. 570) at Taiyuan, Shanxi. Northern Qi dynasty.

FIGURE 5.11 Hunting scene. Wall painting in the Tomb of the Wrestlers at Tonggou, Jilin. About fifth century.

after loyally serving the Northern Wei court, died at Datong in 484 and was buried in the Wei imperial mausoleum. Other scenes on this precious panel illustrate virtuous women of antiquity and, at the top, the emperor Shun meeting his future wives. While it is tempting to think that the treatment of the Lady Ban scene was inspired by a version of the Gu Kaizhi scroll that had found its way to north China, both may be based on an older traditional rendering of the theme.

When Yuandi abdicated in 555, he deliberately consigned to the flames over two hundred thousand books and pictures in his private collection, so it is not surprising that nothing has survived of the works of the other leading masters of the Southern Dynasties who were active in Nanjing. A Tang history of painting, however, records the titles of a number of paintings of this period, from which we know what subjects were popular. There were the stock Confucian and Buddhist themes; great panoramas illustrating the descriptive *fu;* landscapes depicting famous mountains and gardens; scenes of city, village, and tribal life; fantastic Daoist landscapes and pictures of the figures symbolizing the constellations; illustrations of historical events; legends such as the story of Xiwangmu. The great majority were presumably either standing screens or long handscrolls. At least three paintings of bamboo are recorded.

By the sixth century there was considerable intercourse between the northern and southern kingdoms, the rich cul-

ture of Nanjing influencing and refining the art of the northern courts. By mid century the style of figure painting that the successors of Gu Kaizhi had developed in Nanjing was well established in north China, although the works of the early northern masters, among whom the most famous was Yang Zihua, are all lost. Nevertheless, the style of this forgotten master may well survive in the wall paintings that line the tomb of Lou Rui (531–570), a distinguished official and nephew of the first queen of Northern Qi, who was buried with great pomp near Taiyuan (fig. 5.10). The figures are painted in a fine, springy line, with long oval faces; the processional scenes—with riders on horseback trotting, jostling, pausing to look back—are full of animation. The dynastic history said of Yang Zihua's horses that "sounds of stamping and whinnying, like begging for water and food, could often be heard from Yang's paintings of horses."[5] It is unlikely that the tomb paintings are by him, but they could well have been executed by court artists in his style and under his supervision.

Through the sixth century, figure painting was still the senior art, but as the technical problems of depicting the natural world were mastered, the landscape setting became more prominent. We can get some idea of its richness and vitality from the few wall paintings that survive in tombs of the period, such as the hunt-in-a-landscape on the wall of a tomb at Tonggou in Jilin province (fig. 5.11). By comparison with these lively but provincial decorations, the en-

FIGURE 5.12 *The Story of the Filial Shun.* Detail engraved on a stone coffin slab. Ht. 62 cm. Late Northern Wei period, c. 520–530. The Nelson-Atkins Museum of Art, Kansas City, Missouri. Purchase: Nelson Trust.

gravings on a celebrated stone coffin in the Nelson-Atkins Museum of Art, Kansas City, are, in subject matter and technique, a good deal more sophisticated (fig. 5.12). They depict incidents in the lives of six famous filial sons of antiquity. The figures seem hardly more than the excuse for magnificent landscape panoramas, so richly conceived and so beautifully drawn that they must surely have been copied from a handscroll—or, as Sickman suggests, a wall painting—by an accomplished artist. Each incident is set off from its neighbors by hills with overlapping tops called *que*, which have powerful Daoist associations; half a dozen kinds of tree are distinguishable, tossed by a wind that sweeps through their branches, while above the distant hills the clouds streak across the sky. The scene in which the filial Shun escapes from the well into which his jealous stepfather Yao cast him is astonishing in its animation, and only in his failure to lead the eye back through a convincing middle distance to

the horizon does the artist reveal the limitations of his time. Though its subject is respectably Confucian, its treatment exudes a joy in the face of living nature that is purely Daoist. It serves also to remind us that in spite of the ever-growing demands of Buddhism for art of an entirely different kind, there was already coming into being at this time a purely native landscape tradition allied to calligraphy and based on the language of the brush.

BUDDHISM

Buddhist communities were already established in north China before the end of the Han dynasty. Now, however, political and social chaos, loss of faith in the traditional Confucian order, and the desire to escape from the troubles of the times all contributed to a wave of religious enthusiasm, and the new doctrine spread to every corner of the empire.

It was accepted, beyond the lower strata of society, not out of blind and innocent faith—for that is not a sentiment to which the educated Chinese are prone—but perhaps because it was new, it filled a big gap in Chinese spiritual life, and its speculative philosophy and moral justification of the renunciation of worldly ties appealed to intellectuals, who were now often reluctant to take on the perilous responsibilities of office. As we shall see, it was also politically useful to China's rulers between the Han and the Tang. The new faith must have proved an effective consolation, if we are to judge by the vast sums spent on the building of monasteries and temples and their adornment during these troubled years.[6]

We must pause in our narrative for a moment to consider the life and teachings of the Buddha, which form the subject matter of Buddhist art. Gautama Siddhārtha, called the Buddha, or the Enlightened One, was born about 567 B.C., the son of a prince of the Śākya clan ruling on the border of Nepal. He grew up surrounded by the luxuries of the palace, married, and had a son, Rāhula. His father deliberately shielded him from all contact with the miseries of life beyond the palace gates, but in spite of the care with which his excursions were planned for him, Śākyamuni was finally confronted with the reality of old age, sickness, and death, and he saw a vision of an ascetic pointing to his future path. Deeply disturbed by his "Four Encounters," as they came to be called, he resolved to renounce the world and search for the cause of so much suffering. One night he stole out from the palace, cut off his hair, bade farewell to his horse and groom, and embarked upon his quest. For many years he wandered, seeking, first with one teacher and then with another, the answer to the mystery of existence and a way of release from the intolerable cycle of endless rebirths to which all living things are subject according to karma, the inexorable law of cause and effect. Then one day at Bodhgayā, seated under a pippala tree, he entered into a trance. For three days and nights he remained motionless. The demon Māra sent a host of demons to assault him and his three lovely daughters to dance seductively before him, but without moving from where he sat, the Lord rendered the former powerless while the latter he transformed into withered hags. Finally, in the moment of enlightenment, the answer came to him. In his first great sermon in the Deer Park at Benares (Varanasi),

he gave his message to the world in the form of the "Four Noble Truths":

> All existence is suffering (dukkha).
> The cause of suffering is craving, lust, desire—even desire for existence itself.
> There is an end to suffering, for this craving can be suppressed.
> There is a way of suppression, through the Noble Eightfold Path.

The Buddha also taught that there is no such thing as a soul, but that all life is transitory, all in a perpetual state of becoming. By following the Eightfold Path, which involves right conduct, right belief, and right meditation, the devotee can break the cycle of rebirths that binds us eternally to the wheel of existence and so secure his release and his final merging in eternity, like a cup of water poured into the sea. Śākyamuni achieved enlightenment in his lifetime, although he continued to walk the earth, gathering disciples, performing miracles, and spreading his teaching, until his final departure, the Mahāparinirvāṇa, at the age of eighty. His teaching was austere and, moreover, only for the chosen few who were prepared to renounce the world and face the rigors of life as a mendicant or, later, the regimen of the monastery. Its appeal lay partly in its simplicity—a welcome relief from the complexities of Hindu theology and metaphysics—and partly in the hope it offered of release from a destiny from which Hindu doctrine saw no escape.

The new faith grew slowly and did not become a truly national religion until it was embraced by King Aśoka (272?–232 B.C.), who devoted himself with tremendous energy to its propagation (map 5.3). Legend has it that he erected eighty-four thousand stūpas (relic mounds) in a single day, and his monastic and temple foundations were on a scale that many a pious Buddhist ruler has since tried to emulate. His missionary activities brought the faith to Śri Lanka and to Gandhāra in northwest India, where it came in contact with the religious ideas and artistic forms of the provincial Greco-Roman world.

It was probably in Gandhāra that, under these influences and encouraged by the great conference organized by King Kanishka (second century A.D.) of the Kushans, the first great development in Buddhist doctrine took place. The core of the dogma remained unaltered but the new schools—

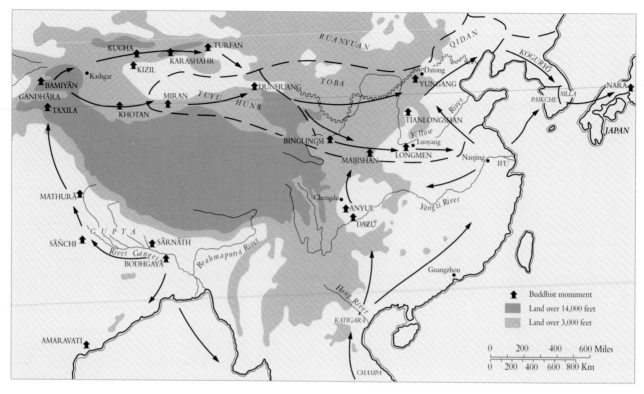

MAP 5.3 The spread of Buddhism into central and eastern Asia

which called themselves Mahāyāna ("greater vehicle"), referring derogatively to the more conservative sects as the Hīnayāna ("lesser vehicle")—taught that salvation was open to all through faith and works. Now the Buddha ceased to be an earthly teacher, but was conceived of as pure abstraction, as the universal principle, the godhead, from whom truth, in the form of the Buddhist *dhārma* ("law"), radiates with a blinding light across the universe. By this elevation to a status parallel to that of the Hindu Brahmā, the Buddha receded far beyond the reach of mortals.

Bhakti, the adoration of a personal god, expressed in Hinduism in the love of Krishna, demanded a more approachable deity; so there came into existence the bodhisattvas ("ones destined for enlightenment"), who have postponed their own end that they might bring help and comfort to suffering humankind. Of the bodhisattvas, the most popular was Avalokiteśvara ("the Lord who looks down [in mercy]"), who on his translation to China as Guanyin became identified both with his female reflex, Tārā, and with the ancient Chinese mother-goddess, and thus impercep-

tibly acquired female sex—a process that was complete by the end of the tenth century. Almost as important were Manjuśrī (Wenshu in Chinese), the god of wisdom, and Maitreya, the deity who, though now still a bodhisattva, will in the next cycle descend to earth as the Buddha; to the Chinese he has become Milefo, the pot-bellied "god of wealth" who sits grinning at the entrance of every temple. In time the pantheon grew to extraordinary proportions, the vast array of Buddhas and bodhisattvas being attempts to express the infinite aspects and powers of God. These developments were, however, for the theologians and metaphysicians. The common people needed only the comfort of Avalokiteśvara and the secure knowledge that, merely by speaking once the name of the Buddha Amitābha, they would on quitting this world be reborn in his Western Paradise beyond the sunset.

It was probably also in Gandhāra, and under Western influence, that the Buddha was first represented in sculpture. The style of Gandhāra is a curious mixture of the classical realism of Greco-Roman provincial art with the

Indian genius, fostered at the southern Kushan capital of Mathurā, for giving concrete, plastic expression to an abstract, metaphysical concept. From Gandhāra, Buddhism, and with it this new synthetic art, spread northward across the Hindu Kush to central Asia, thence to run like a powder trail eastward along the string of oases to the north and south of the Tarim Basin.

BUDDHIST ART REACHES CHINA

Buddhist sculpture preceded Buddhist architecture into China, for it was the images—brought in the luggage of missionaries, travelers, and pilgrims, who were no doubt prepared to swear that what they carried was an exact replica of some famous icon in India or central Asia—that were most deeply venerated. The earliest known exactly dated Chinese Buddhist image (fig. 5.13), cast in 338, is clearly an imitation of a Gandhāran prototype. Such icons were set up in shrines built in the traditional Chinese style, which grew until the monastery or temple became a kind of palace, with courtyards, pavilions, galleries, and gardens. No attempt was made in these timber buildings to imitate the Indian temple. But the stūpa presented a different challenge. The monk Song Yun, returning from Gandhāra early in the sixth century, had described (as doubtless had many before him) the gigantic stūpa erected by King Kanishka, one of the wonders of the Buddhist world. Built in timber, it was reputedly at least 700 feet (213 m) high in thirteen stories, capped by a mast with thirteen golden disks. The Chinese already possessed, in the towers called *lou* and *que* (see figs. 4.6 and 4.16), multistoried timber buildings that could be adapted to this new purpose (fig. 5.14, nos. 1–3).

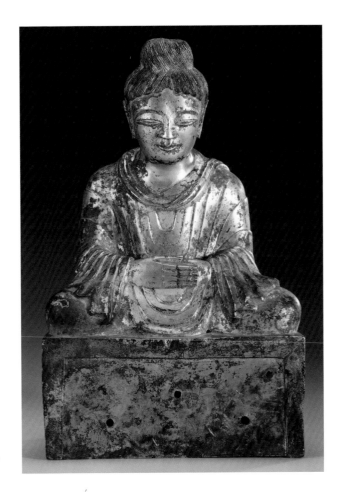

FIGURE 5.13 Śākyamuni Buddha. Gilt bronze. Ht. 39.4 cm. Dated equivalent to 338. The Avery Brundage Collection. © Asian Art Museum of San Francisco.

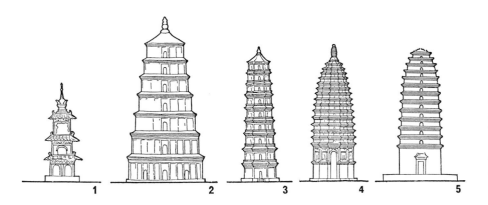

FIGURE 5.14 Types of pagoda. Nos. 1–3 derived from the Han timber *lou:* (1) Yungang, Northern Wei; (2) Xi'an, Tang; (3) Guangzhou, Ming. Nos. 4–5 derived from the Indian *śikhara* tower: (4) Songshan, c. 520; (5) Xi'an, Tang.

FIGURE 5.15 (ABOVE)
Twelve-sided stone and brick
pagoda of Songyuesi on
Mount Song, Henan. Ht.
approx. 38 m. Northern Wei
dynasty, c. 520.

FIGURE 5.16 (OPPOSITE)
General view of Maijishan,
Gansu, from the southeast.
Photo: Dominique Darbois.

The Chinese examples of this period have all perished, but the pagodas at Hōryūji and Yakushiji near Nara in Japan still stand as monuments to this simple, graceful style. The earliest surviving datable pagoda on Chinese soil, however, is the twelve-sided stone tower on Mount Song in Henan (fig. 5.15), erected in about 520. It has no surviving Chinese antecedents. Its profile echoes the curve of the Indian *śikhara* tower; the arched recesses on the main faces recall the niches on the great stūpa at Bodhgayā, and, as Soper has observed, many of the details are Indian or are based on southeast Asian modifications of the Indian style found in the kingdom of Champa (Vietnam), with which China was now in contact. But gradually the Indian elements were absorbed, and the later stone and brick pagodas imitate, in their surface treatment, the posts, brackets, and projecting roofs of the Chinese timber prototypes.

At Bāmiyān in Afghanistan a high cliff more than a mile (1.6 km) in length was hollowed out into hundreds of cave shrines, some of which were decorated with frescoes, and bracketed at either end by colossal standing Buddha figures carved out of the rock, plastered, and painted. (In 2001 they were completely destroyed by Taliban fanatics.) This fashion for decorated cave shrines, which had originated in India, spread to Khotan, Kucha, and other central Asian city-states, where the already syncretic Greco-Indian tradition of painting and sculpture became mixed with the flat, heraldic, decorative style of Parthia and Sasanian Iran. The routes that skirted the Taklamakan Desert joined at Dunhuang, the gateway to China. There, possibly in A.D. 366, pilgrims hewed from the soft rock the first of what were to develop during the next thousand years into a range of nearly five hundred chambers and niches set about with plaster sculpture and adorned with frescoes. Further stages on the pilgrim route into China were marked by cave shrines at Binglingsi, about 50 miles (80 km) southwest of Lanzhou, and Maijishan (fig. 5.16), 28 miles (45 km) southeast of Tianshui. The former was only rediscovered in 1951, while restoration of the latter, which had always been known to the people of the Tianshui district, did not begin until 1953. In their spectacular sites and the quality and richness of their sculpture, these shrines surpass Dunhuang, whose glory lies chiefly in its paintings. No one knows who hollowed out these caves or decorated them. What is certain is that by commissioning the work the donor or donors could acquire merit. As Wu Hung put it, "Devo-

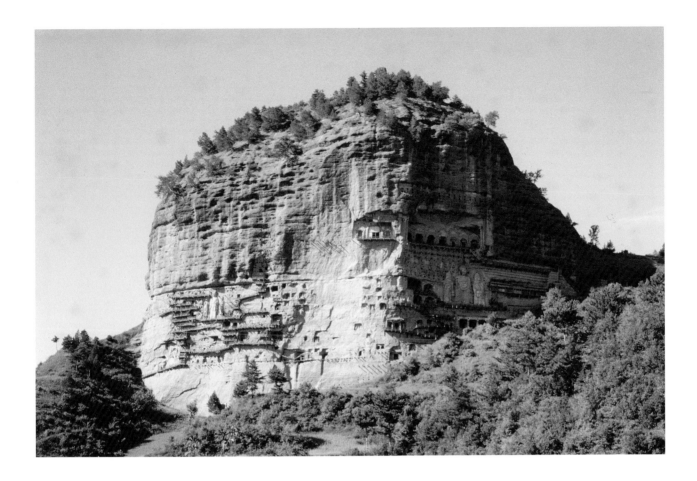

tional art is essentially an art of image-making rather than image viewing"[7]—and indeed some of the votive paintings at Dunhuang are hidden in dark corners, where worshipers might never see them.

BUDDHIST SCULPTURE UNDER THE NORTHERN WEI

THE FIRST PHASE

In 386 the Toba Turks established their ascendancy over north China as the Wei dynasty, with their capital at Datong. Their rulers had embraced Buddhism with enthusiasm, for, like the Kushans in India, they were excluded from the traditional social and religious system of those they had conquered.[8] At the urging of the overseer of monks, Tanyao, they began, soon after 460, to hew out of the cliffs at Yungang a series of shrines and colossal figures that were

to be a monument not only to Buddhism but also to the splendor of the royal house itself. By the time the capital was moved south to Luoyang in 494, twenty large caves and some minor ones had been excavated; work resumed under the Sui (581–618) and again between 916 and 1125, when Datong became the western capital of the Liao dynasty. The earliest caves—those numbered 16 to 20—were dedicated by the emperor to himself and four earlier Wei rulers, possibly as a penance for the harsh repression of the faith by his Daoist grandfather in 444. These five caves contain huge seated or standing Buddhas cut in the living rock, while the seated Buddha of Cave 20 (fig. 5.17) was originally protected by a timber façade of several stories. This colossus, nearly 45 feet (13.7 m) high, sits in an attitude of meditation; his shoulders and chest are massive and yet finely proportioned, his face is clear-cut with something of the masklike quality often found in Gandhāra, while the drapery is suggested

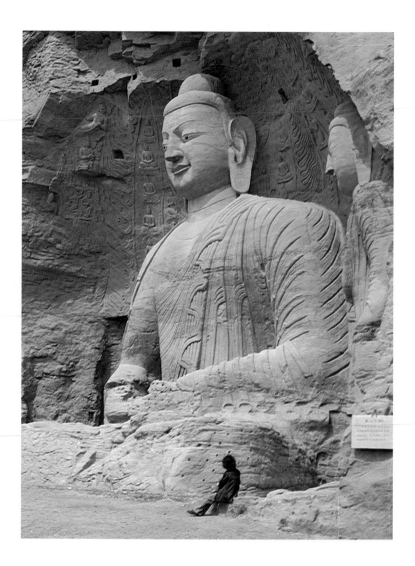

FIGURE 5.17 Śākyamuni Buddha with attendant Buddha, perhaps Maitreya. Sandstone. Ht. 13.7 m. Cave 20, Yungang, Shanxi. Northern Wei dynasty, c. 470–480. Photo by the author, 1975.

by flat, straplike bands that disappear into points as they pass around the contour of arm or shoulder. Perhaps, as Laurence Sickman has suggested, this curious convention is the result of the sculptor's following, and not properly understanding, a line drawing of some western or central Asian prototype, for great pains were taken to copy the style of the more venerated images as closely as possible.[9]

By about 480 a change was beginning to appear in the sculpture at Yungang, when this solid and somewhat heavy style was modified and refined by the native Chinese predilection for abstract expression through the flowing, rhythmic line. The carvings in Cave 7 (fig. 5.18), one of the most richly decorated of all, bear witness to this transfor-

mation. This is one of the "paired" caves dedicated by members of the imperial family about 480 or 490. Every inch of the walls is decorated with reliefs once painted in bright colors and testifying to the gratitude, to the generosity, and perhaps also to the anxiety about their future destiny of the imperial donors. Long panels tell the life of the Buddha in a series of vivid reliefs, while above is the heavenly host— Buddhas, seated or standing, bodhisattvas, flying *apsaras*, musicians, and other celestial beings. The decoration of this cave reminds us, in its wealth of detail and in its contrast between the realism of the earthly figures and the serenity of the heavenly ones, of the beatific visions of the Italian Primitives.

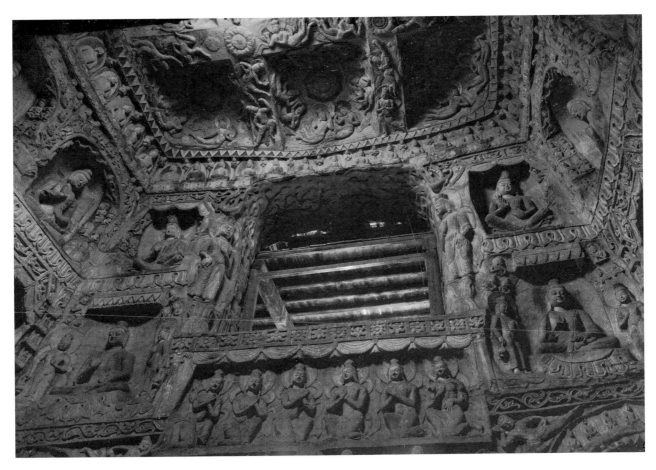

FIGURE 5.18 Interior of Cave 7, Yungang, Shanxi. Northern Wei dynasty, late fifth century. Photo courtesy of Mizuno Seiichi.

THE SECOND PHASE

The Luoyang region was closer to the center of the purely Chinese tradition of pictorial expression in linear, as opposed to plastic, terms; and so it was inevitable that this tendency, already apparent in the later caves at Yungang, should have found its fulfillment after the move to the south in 494. At Longmen, only 10 miles (16 km) from the new capital, sculptors found a fine gray limestone that permitted greater refinement of expression and finish than the coarse sandstone of Yungang. The new style culminated in the cave known as the Central Binyang Cave, commissioned by the emperor Xuanwu and probably completed in 523. Against each of the interior walls is a large figure of

the Buddha (fig. 5.19), attended by standing bodhisattvas or the favorite disciples Ānanda and Kāsyapa. On either side of the entrance, the walls were decorated with godlings in relief, *Jātaka* tales, scenes of the celebrated debate between Vimalakīrti and Manjuśrī, and two magnificent panels showing the emperor and empress attended by their retinue, coming in procession to the shrine. The empress panel (fig. 5.20), badly damaged in removal many years ago, has been carefully restored and now forms part of the important Chinese collection in Kansas City. Executed in flat relief, its sweeping linear rhythms and wonderful sense of forward movement suggest the translation into stone of the style of wall painting that must have been current at the

FIGURE 5.19 (RIGHT) Buddha group on south wall of Binyang-dong, Longmen, Henan. Stone. Late Northern Wei period, probably completed in 523. Photo courtesy of Mizuno Seiichi.

FIGURE 5.20 (BELOW) The Wei empress in procession with court ladies. Restored relief panel from Binyangdong, Longmen, Henan. Ht. 198 cm. Late Northern Wei period. The Nelson-Atkins Museum of Art, Kansas City, Missouri. Purchase: Nelson Trust.

FIGURE 5.21 (OPPOSITE) Stele illustrating the life of the Buddha and the teachings of the *Lotus Sūtra*. Stone. In Cave 133, Maiji-shan, Gansu. First half of sixth century. Photo: Dominique Darbois.

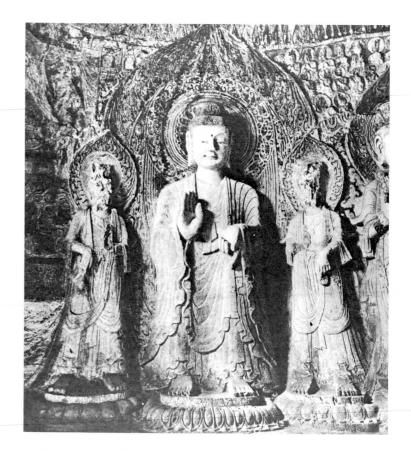

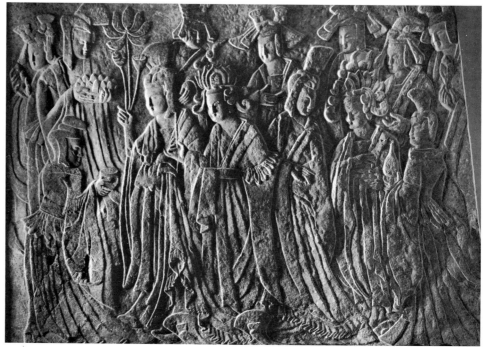

Wei court—further proof that, besides the imported, hieratic forms reserved for the deities themselves, there was another, more purely Chinese, style to which painters and sculptors instinctively turned in representing secular themes.

Because of the great scarcity of Buddhist sculpture from the southern kingdoms, we are apt to think that the stylistic revolution that reached its culmination at Longmen must have originated in the north and gradually spread southward. But it now seems that the opposite was the case: that the art of the southern courts centered in Nanjing was the dominant factor in the development of Buddhist sculpture in the Six Dynasties. One of the earliest innovators was Dai Kui, a contemporary of Gu Kaizhi at the Jin court in Nanjing. His work, in which he is said to have raised the art of sculpture to a new level, probably reflected the style of contemporary painting—the flat, slender body, sweeping robes, and trailing scarves that we see in copies of the Gu Kaizhi scrolls. This treatment of figure and drapery does not appear in the sculpture of the north until a century later, when we first encounter it in the later stages at Yungang and the earliest caves at Longmen, and there is much evidence to show that it was introduced by artists and sculptors from the south.

The arrangement of the Central Binyang Cave at Longmen was probably intended to suggest the interior of a temple, whose equipment would also have included freestanding images in stone, stone votive steles, and gilded bronze images. The steles were carved and set up in the temple as an act of piety or gratitude by one or more subscribers, whose names they often bore. They consisted either of a flat slab shaped like a pippala leaf against which one figure or, more often, a group of three stands out almost in the round, or of a rectangular slab decorated, often on all four sides, with Buddhas, bodhisattvas, and lesser deities, illustrations to favorite texts such as the *Lotus Sūtra* (*Saddharmapundarīka sūtra*), and scenes from the life of the Buddha carved in relief. They are of peculiar interest and value because they concentrate in little space the essentials of the style and iconography of the period, and they are frequently dated.

In Cave 133 at Maijishan, eighteen of these steles still stand in their original positions against the walls, where they were set up by pious devotees.[10] Three of these are splendid examples of the mid-sixth-century style, one a veritable "poor man's bible" (fig. 5.21). The upper central panel is devoted to the incident in the *Lotus Sūtra* in which Śākyamuni by the power of his preaching causes Prabhūtaratna, a Buddha of the distant past, to appear beside him. In the center and below are Buddhas flanked by bodhisattvas— a simple presentation of the paradise theme. The left panel shows (going downward) Śākyamuni descending from the Tuṣita heaven, where he had preached to his deceased mother; Śākyamuni as a young prince; the renunciation; and the first preaching in the Deer Park. On the right panel we see a bodhisattva meditating under a tree; the Mahāparinirvāna; Sāmantabhadra on his elephant; the temptations

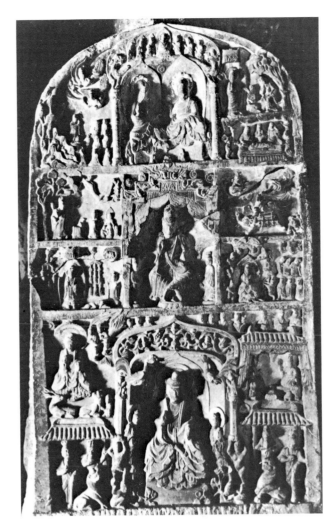

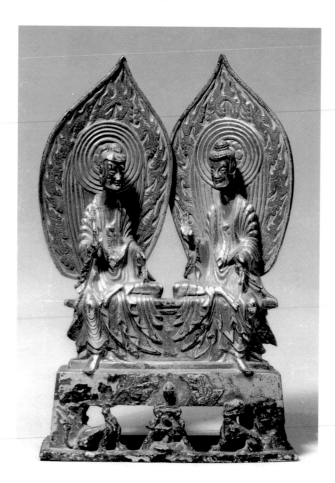

material, these bronzes—ranging from simple seated Buddhas to elaborate altar groups complete with stand, flame *mandorla,* and attendant deities—are among the supreme examples of Chinese Buddhist art. One of the most perfect examples of the mature Wei style is the exquisite group of Śākyamuni preaching his doctrine to Prabhūtaratna, dated equivalent to 518, in the Musée Guimet (fig. 5.22). The form is expressively attenuated; the eyes slant, the mouth wears a sweet, withdrawn smile, while the body seems about to disappear altogether under a cascade of drapery that no longer defines the figure beneath but, like the drapery of the Romanesque sculpture of Moissac or Vézelay, in its expression of a state of spiritual ecstasy seems to deny the body's very existence. Here the influence on sculpture of the sweeping rhythms of the painter's brush is apparent, while the air of spirituality is certainly enhanced by the extraordinary linear elegance and almost exaggerated refinement of the style of this period as a whole.

Fine examples of the late second phase of Chinese Buddhist sculpture were found in 1996 when workers were clearing ground for a school sports field at Qingzhou, east of Ji'nan in Shandong.[11] The pit contained up to four hundred complete and broken steles and free-standing figures, some retaining much of their original color. At some time, possibly in the twelfth century—no one knows precisely when or why—they had been broken, some repaired, and later buried. In the Tang dynasty the Wangxingsi at Qingzhou had been an important temple, visited by the Japanese monk Ennin in 840. The refined, elegant style of the steles of the mid sixth century are illustrated in fig. 5.23 by a finely detailed standing Buddha with attendant bodhisattvas and *apsaras* bearing a stūpa up into the sky.

THE THIRD PHASE

Unlike the Wei, the nomadic tribes who established the Northern Qi dynasty (550–77) were hostile to Chinese culture and made little attempt to follow the Chinese artistic tradition. They preferred the Indian style, which is clearly shown in the sculpture of the period at Qingzhou and in many fine examples in museums in Asia and the West. In the sculpture of this third phase the body begins to expand once more, filling the robes, which, instead of fluttering free with a life of their own, begin to mold themselves to the cylindrical form, subtly accentuating its mass (fig. 5.24).

of Māra; and the theological disputation between Manjuśrī and Vimalakīrti (holding the fan).

Few of the great bronze images of this period have survived. They were nearly all destroyed or melted down in the persecutions that intermittently scarred the history of Buddhism in China. To see the largest, if not the finest, example of an altarpiece in the Wei linear style, we must journey to Japan; there, in the Kondō (Golden Hall) of the monastery of Hōryūji at Nara, is a magnificent Buddha trinity that, though probably executed by an immigrant from Korea in 623, is a late survival of the style of mid-sixth-century China. Some of the smaller gilded bronze images, made for domestic chapels and shrines, escaped destruction. Because of the precision of their modeling and the beauty of their

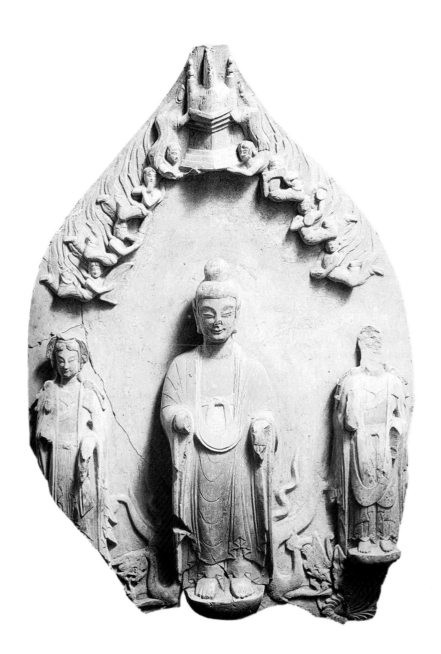

FIGURE 5.22 (OPPOSITE) Śākyamuni
and Prabhūtaratna. Gilt bronze. Ht. 26 cm.
Northern Wei dynasty, dated equivalent to
518. Musée Guimet, Paris.

FIGURE 5.23 (LEFT) Buddha triad within
mandorla. Limestone with traces of original
paint. Ht. 76 cm. Late Northern Wei or Eastern
Wei, c. 530–550. Qingzhou Municipal
Museum, Shandong.

FIGURE 5.24 (BELOW) The development
of the Buddha image: (1) Yungang, c. 460–
480; (2) Longmen, c. 495–530; (3) Qizhou,
c. 550–580; (4) Sui, c. 580–620; (5) Tang,
c. 620–750. After Mizuno Seiichi, *Chinese
Stone Sculpture* (Tokyo, 1950), fig. 1.

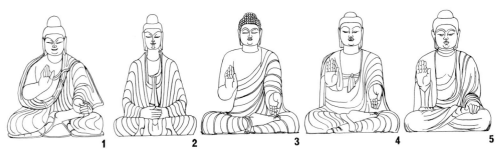

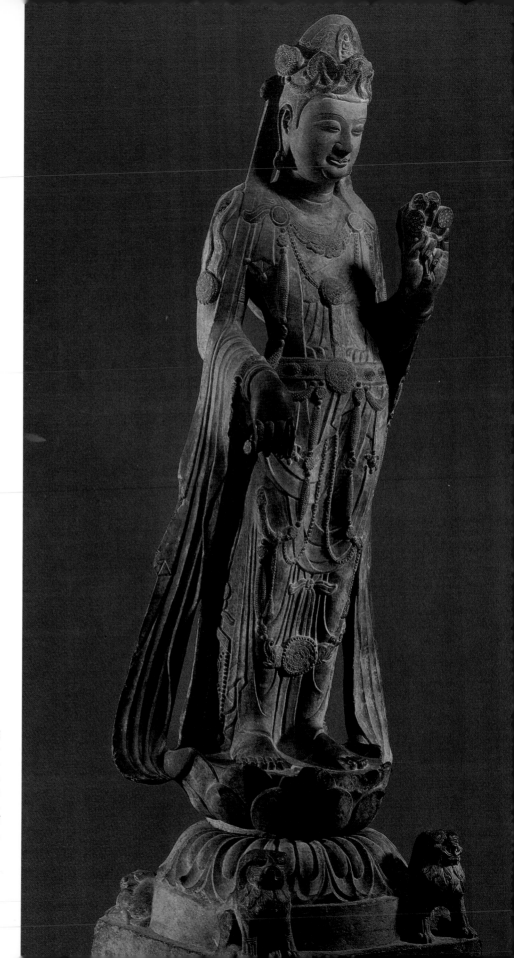

FIGURE 5.25 Standing
bodhisattva. Stone. Ht. 249 cm.
From Qinglongsi, Xi'an, Shaanxi.
Northern Zhou dynasty, c. 580.
Museum of Fine Arts, Boston;
Francis Bartlett Donation of 1912.
Photo © 2008 Museum of
Fine Arts, Boston.

FIGURE 5.26 Minor deities and worshipers. Fragment of a stone relief from Wanfosi, Qionglai, Sichuan. Sixth to early seventh century.

Against these now smooth surfaces, the jewelry of the bodhisattvas provides a contrasting ornament; the head becomes rounded and massive, the expression austere rather than spiritual. In the stone sculpture of the third phase, Chinese craftsmen produced a style in which precision of carving and richness of detail are subordinated to a total effect of grave and majestic dignity (fig. 5.25). Although the change was stimulated by a renewal of Indian influence on Chinese Buddhist art, this time it came not across central Asia, where contact with the West was now broken by fresh barbarian incursions into the Tarim Basin, but up from the Indianized kingdoms of southeast Asia, with which the court of Nanjing had close diplomatic and cultural relations. There are abundant records of Buddhist images being sent to Nanjing from Indochina in the sixth century, though none of these has yet been identified. However, in 1953 there was found in the ruins of the Myriad Buddha Temple (Wanfosi) at Qionglai near Chengdu, Sichuan, a buried hoard of about two hundred pieces of Buddhist sculpture. Some of the pieces clearly show the indirect influence of Gupta art (fig. 5.26), while others have stylistic affinities with the sculpture of the Dvāravātī kingdom of Thailand and with figures and reliefs excavated at Dong Duong and other sites in the ancient kingdom of Champa. Nothing comparable to the Qionglai find has yet been unearthed at Nanjing itself, where the destruction of early Buddhist monuments was almost complete; but there is no doubt that the Buddhist art of Sichuan at this time was strongly influenced by artistic developments at the southern capital.

BUDDHIST PAINTING

Along with profound changes in sculptural style, the introduction of Buddhism inspired a new school of painting of which both the content and the forms were largely foreign. A Song writer tells of a certain Kang Senghui, a Sogdian, who in A.D. 247 came to the Wu kingdom (Nanjing) by way of Indochina "to install icons and practice ritual circumambulation. It so happened that Cao Buxing saw his iconographic cartoons for Buddhas [in the style of] the Western Regions, and copied them; whence it came about that the Cao [style] has been popular through the generations all over the world." By the end of the sixth century, however, nothing survived of Cao's work, according to Xie He, "except one dragon in the Privy Pavilion"—where books, pictures, and secret records were kept. The new style culminated in the work of Zhang Sengyou, the greatest of the painters working for the Liang emperors at Nanjing. His work was remarkable—according to contemporary accounts—for its realism: he painted dragons on the wall of Anlesi, and when, in spite of his warning, he was persuaded to paint in their eyes, they flew away amid thunder and lightning. He decorated many Buddhist and Daoist temples in Nanjing with frescoes; he was a portraitist and also executed long scrolls illustrating such homely themes as the "Drunken Monk" and "Children Dancing at a Farmhouse." But all were lost centuries ago, and none of the later pictures claiming to be copies of his work gives more than a hint of his style. Nevertheless, we may be sure that one feature of this imported manner was the Indian technique of arbitrary shading, found in the wall paintings at Ajantā, which was used to give an effect of roundness and solidity unlike anything that China had seen before.

WALL PAINTINGS AT DUNHUANG

Fortunately, the wall paintings at Dunhuang survive, though for the most part they must be but a faint echo of the grand manner of metropolitan China. The earliest dated chapel at Dunhuang was dedicated in 366. Today paintings of the Northern and Western Wei can be seen in thirty-two of the

caves, and there were probably many more before dilapidation and later repainting took their toll. Of these, the finest are in Caves 257 (P 110) and 249 (P 101).[12] The vigorous rendering of the preaching Buddha in Cave 249 (fig. 5.27) is a good example of the mixture of styles that we find everywhere at Dunhuang. The stiff heraldic pose of the Buddha shows how the "linear" Chinese manner—which we have already seen influencing the sculpture of the period—has been frozen into a flat decorative pattern, indicating perhaps the hand of some itinerant painter from central Asia who has also attempted, unsuccessfully, to suggest an In-

dian fullness in the modeling of his attendant bodhisattvas and *apsaras*. The subjects of these early frescoes are generally Buddhist trinities, scenes from the life of the Buddha, and endless *Jātaka* tales that, under the guise of recounting incidents in the Buddha's previous incarnations, draw upon a rich storehouse of Indian legend and folklore. Unlike the hieratic Buddhas and bodhisattvas crudely copying some Western model, these delightful scenes reveal the Chinese journeyman artist at his most spontaneous; indeed, while artists from central Asia and beyond may have executed some of the main figures, donors were probably content to leave the accessory scenes to local talent.

A famous panel in Cave 257 tells the story of the Buddha's incarnation as a golden gazelle (fig. 5.28). The simple humped hills slant back diagonally in rows like the seated figures in the Han banqueting scenes. Between them, the participants are painted almost in silhouette on a flower-strewn ground. The sense of open space is Chinese, as is the emphasis on linear movement; but the decorative flatness of the figures, the dappled deer, and flower-sprinkled ground have a Near Eastern origin. Most striking are the decorations on the sloping tentlike ceiling of Cave 249 (fig. 5.29), painted early in the sixth century. While the Buddhas dominate the main walls, the ceiling is a riot of celestial beings—Buddhist, Hindu, and Daoist, the latter including Xiwangmu and Dongwanggong, with lesser deities. Beneath them runs a frieze of gaily colored mountains over which mounted huntsmen pursue their quarry, after the fashion of Han decorative art. These paintings are a vivid illustration of the way in which Chinese Buddhism, at least at the popular level, came to terms with Daoism and native folklore.

FIGURE 5.27 (ABOVE) Buddha preaching the law. Wall painting in Cave 249 (P 101), Dunhuang, Gansu. Northern Wei dynasty.

FIGURE 5.28 (RIGHT) The Buddha incarnate as a golden gazelle (the *Rūrū Jātaka*). Wall painting in Cave 257 (P 110), Dunhuang, Gansu. Northern Wei dynasty. Photo: Dominique Darbois.

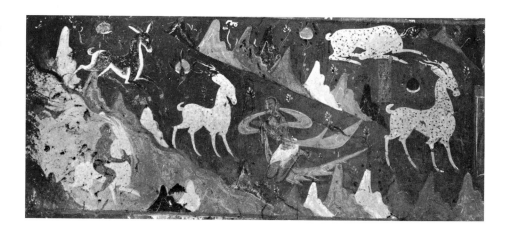

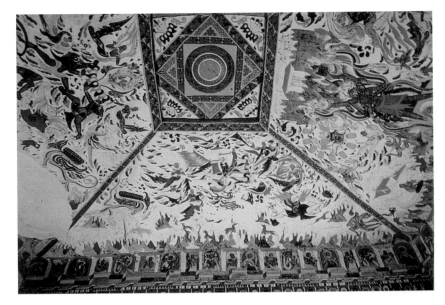

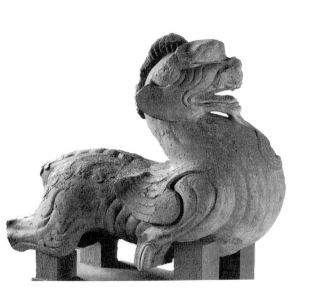

FIGURE 5.29 (LEFT)
Landscape with fabulous beings, on lower part of ceiling of Cave 249 (P 101), Dunhuang, Gansu. Northern Wei dynasty.

FIGURE 5.30 (BELOW LEFT)
Chimera. Stone. L. 214 cm. From an imperial tomb in Jiangsu. Mid sixth century. University of Pennsylvania Museum, Philadelphia.

FIGURE 5.31 (BELOW)
Detail of engraved design on side of coffin of General Prince Zheng Jing. Carved in Luoyang, 524. Minneapolis Institute of Arts, The William Hood Dunwoody Fund.

FUNERARY SCULPTURE

This was the heyday of Buddhist faith in China. Many people were cremated, denying themselves the elaborate burials that had been characteristic of the Han. But the Confucian rites were not altogether neglected, and some of the imperial burials were as spectacular as ever. The actual tombs of the Liang emperors have never been found among the green hills and rice fields outside Nanjing, but much of the monumental sculpture that lined the "spirit way" still survives.[13] The winged beasts of the sixth century are more graceful than those of the Han (fig. 5.30), being animated by a more plastic feeling for volume and dynamic linear movement that also found expression in miniature in the beautiful gilt bronze lions, tigers, and dragons, of which there are examples in Western museums (fig. 5.31). Some of the larger tombs in the Nanjing region were lined with bricks molded with lines of thread relief, which, when correctly laid, formed a picture that covered a large area of the wall. These relief pictures—depicting themes popular with the southern gentry, such as the Seven Sages of the

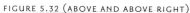

FIGURE 5.32 (ABOVE AND ABOVE RIGHT)
The Seven Sages of the Bamboo Grove, with
a detail showing Xi Kang (223–262). Drawing
and rubbing (detail) of brick relief from the
wall of a tomb near Nanjing, Jiangsu. Ht.
approx. 80 cm. About fifth century.

FIGURE 5.33 (RIGHT) Saddled horse.
Painted pottery. Ht. 24.1 cm. Said to have
come from a tomb near Luoyang, Henan.
Northern Wei dynasty. With permission of the
Royal Ontario Museum, Toronto. © ROM.

FIGURE 5.34 (OPPOSITE) Vase. Stoneware
with molded appliqué decoration under
greenish glaze (foot restored). Ht. 38.3 cm.
Probably from Jingxian, Hebei. Sixth century.
Ashmolean Museum, Oxford.

Bamboo Grove (fig. 5.32)—may well preserve not only the composition but also the style of early southern masters such as Gu Kaizhi.

CERAMICS

The years when the northern half of China was ruled by non-Chinese invaders and the southern half by native emperors from Nanjing highlight a contrast between the northern and southern artistic traditions that became a permanent feature of the ceramics industry. Although northern and southern wares sometimes imitated each other, there was a great difference in the materials and techniques of the northern and southern potters. The body of northern wares, for instance, was made from true clays—usually secondary, sedimentary kaolins—often mined in association with coal deposits; southern pseudo-clays were made by crushing and refining volcanic rocks high in quartz, silica, and potassium mica. Some southern bodies are little more than pulverized quartz mica, giving them a "sugary" look.[14]

Northern wares were fired, often with coal, in oval *mantou* kilns (shaped like steamed buns), southern wares in long wood-fired, tunnel-shaped "dragon kilns" that climbed up a hillside. Northern glazes were fluxed with calcium or magnesium oxide and fired at temperatures between 2336° and 2498° F (1280° and 1370° C); southern wares used a limestone flux (before the tenth century they had used wood ash) and were fired at a slightly lower temperature. True porcelain was developed in the north in the Sui dynasty (late sixth to early seventh century), but did not appear in the south for another three hundred years.

The ceramics industry of north China only gradually recovered from the disastrous invasions and social chaos of the fourth century. The quality and variety of the *mingqi* (objects placed in the tomb) deteriorated. Rarer now are the farms and pigsties that give so delightful a picture of Han rural economy. But to compensate, the best of the grave figurines have an almost fairylike elegance that reminds us of the ladies in the Gu Kaizhi scrolls. Moreover, the horses are no longer the tough, stocky, deep-chested creatures of Han art; they seem, rather, in their heraldic grace of form and the richness of their trappings, to evoke a bygone age of chivalry (fig. 5.33). The Northern Wei figurines are usu-

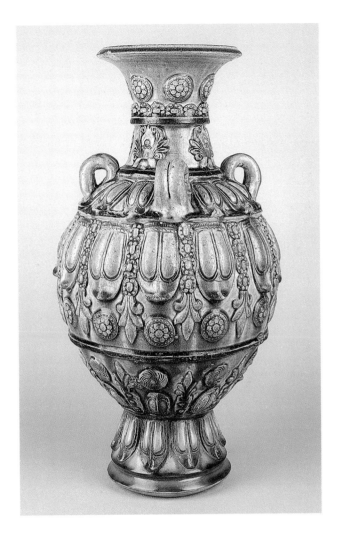

ally dark-bodied and unglazed, but some are painted with colors that have mellowed to soft reds and blues through long burial.

Not until the second half of the sixth century did really fine high-fired wares appear in the north. Some vessels—the so-called jeweled type—show the same variety and robustness of decoration that we find in the Buddhist sculpture of the period, borrowing motifs such as the lotus from the repertory of Buddhist art and pearl roundels and lion masks in appliqué from Sasanian metalwork. Some of the finest—hard bodied and covered with a bluish-green, yellow, or olive glaze—were found in tombs in Hebei (fig. 5.34).

This was a restless and uncertain age in Chinese ceramic

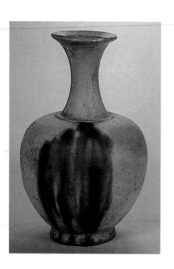

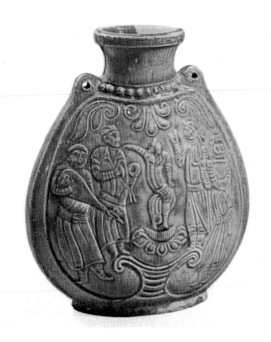

FIGURE 5.35 (ABOVE) Vase. Stoneware slipped and splashed with green under an ivory-white glaze. Ht. 23 cm. From a tomb of 575 at Anyang, Henan. Northern Qi dynasty. Henan Provincial Museum, Zhengzhou.

FIGURE 5.36 (ABOVE RIGHT) Flask. Stoneware decorated with dancers and musicians in relief under a golden brown glaze. Ht. 19.5 cm. From a tomb of 575 at Anyang, Henan. Northern Qi dynasty. Henan Provincial Museum, Zhengzhou.

art, although here and there an untroubled mastery was achieved, as in the beautiful porcelaneous vase in fig. 5.35, from the tomb of a Northern Qi official buried at Anyang in 575. It is covered with an ivory-white crackled glaze splashed with green—a technique that, until the discovery of this vase, was considered unknown in China before the Tang dynasty. This tomb also contained pottery flasks with Sasanian-style figures in relief under a brown glaze (fig. 5.36). A similar mixture of Chinese and western Asiatic motifs and techniques can be seen in other crafts in China at this time, notably in metalwork and relief sculpture, showing that the cosmopolitanism that we think of as typical of the first half of the Tang dynasty was already well established in the sixth century.

So far relatively few Six Dynasties kiln sites have been discovered in the north. In the lower Yangzi Valley, by contrast, kilns have been located in ten counties in Zhejiang alone, while many of their products have been unearthed from dated tombs of the third and fourth centuries in the Nanjing region. The strange stoneware jar illustrated in fig. 5.2 was probably excavated from a Western Jin tomb of about A.D. 300.

Of the southern pottery centers that produced the

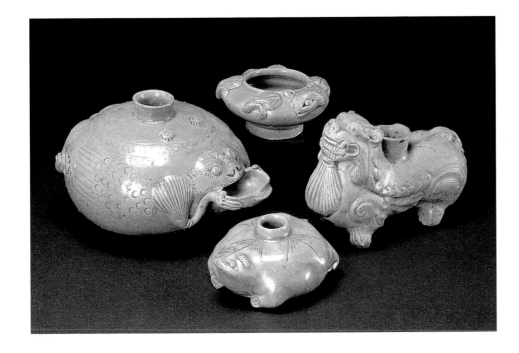

celadons, the most important were those in Shangyuxian and around the shores of Shanglinhu in Yuyaoxian, the latter of which were active into the Tang and Five Dynasties (fig. 5.37). In addition to celadon, the kilns at Deqing, north of Hangzhou, also produced a ware with a rich black glaze. But in general the early Zhejiang celadons show, in the growing strength and purity of their shapes (fig. 5.38), the final emancipation of the Chinese potter from his earlier bondage to the aesthetic of the metalworker.

Indeed, freedom in the arts seems to be the keynote of this period, not only in technique and design but also in the attitude of the privileged classes toward the arts. For this was the age of the first critics and aestheticians, the first gentleman-painters and calligraphers, the first great private art collections, and the birth of such cultivated pursuits as garden designing and conversation as a fine art. Just as the sixth-century anthologist Xiao Tong selected the poems for his *Wenxuan* anthology on grounds of literary merit alone, so, it seems, did patrons in the Six Dynasties come for the first time to value their possessions—whether paintings or calligraphy, bronzes, jade, or pottery—simply because they were beautiful.

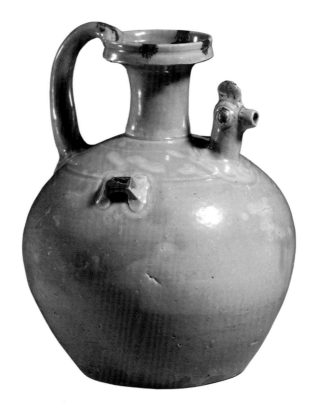

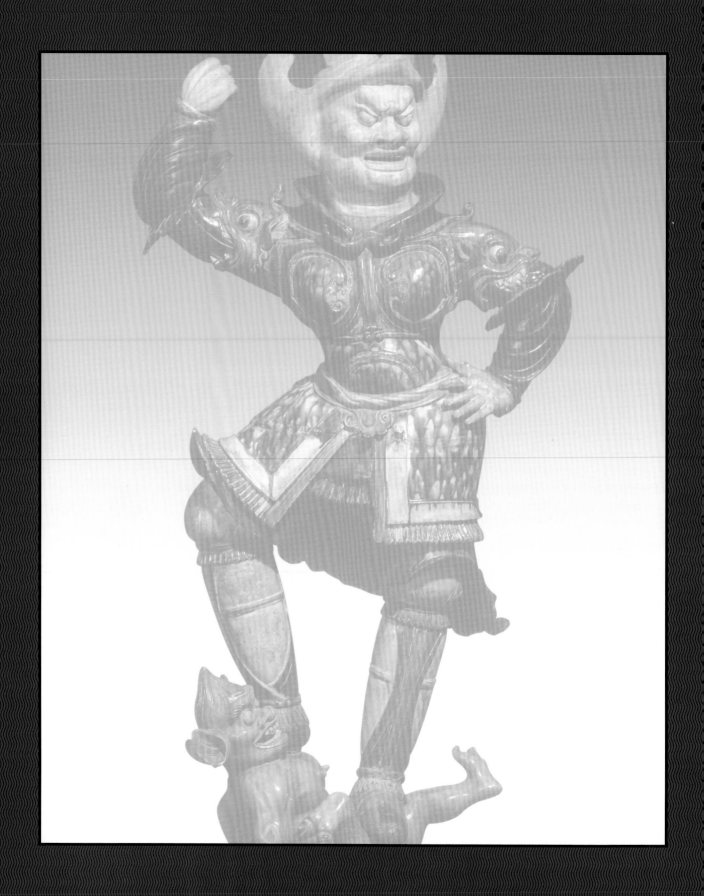

THE SUI AND TANG DYNASTIES

The new ideas and forms first, and often tentatively, tried out during the Six Dynasties period did not find their fullest expression in those restless centuries; they needed an era of stability and prosperity to come to fruition. Wendi, who founded the Sui dynasty in 581, was an able general and administrator who united China after four hundred years of fragmentation, carried the prestige of Chinese arms into central Asia, and conquered the south, forcing the nobles and officials of Nanjing to move to his new capital city, Chang'an, bringing with them the rich poetic and artistic culture of the southern courts. But his son Yangdi squandered the resources of the empire on palaces and gardens built on the scale of Versailles and on vast public works, including a long section of the Grand Canal constructed to link his northern and southern capitals, for the building of which over five million men, women, and children were recruited into forced labor. These huge projects, as a Ming historian put it, "shortened the life of his dynasty by a number of years, but benefited posterity unto ten thousand generations." Combined with four disastrous wars against Korea, they were too much for his long-suffering subjects, who rose in revolt. Soon the ducal Li family joined the insurrection, and the Sui dynasty collapsed. In 617 Li Yuan cap-

tured Chang'an and in the following year mounted the throne as the first emperor of the Tang dynasty. In 626 he abdicated in favor of his second son, Li Shimin, who then, at the age of twenty-six, became the emperor Taizong, thereby inaugurating an era of peace and prosperity that lasted well over a century.

The Tang was to the Six Dynasties as the Han was to the Warring States, or, to stretch the parallel a little, as Rome was to ancient Greece: a time of consolidation, of practical achievement, of immense assurance. We do not find in Tang art the wild and fanciful taste of the fifth century, which saw fairies and immortals on every peak. Nor does it carry us, as does Song art, into those silent realms where man and nature are one. There is metaphysical speculation, certainly, but it is to be found in the difficult schools of Mahāyāna idealism, which interested only a small minority, and it is expressed, moreover, in forms and symbols that touch neither the imagination nor the heart. For the rest, Tang art has incomparable vigor, realism, and dignity; it is the art of a people thoroughly at home in a world they knew to be secure. There is an optimism, an energy, a frank acceptance of tangible reality that gives the same character to all Tang art—at least to the art of the first two centuries of the

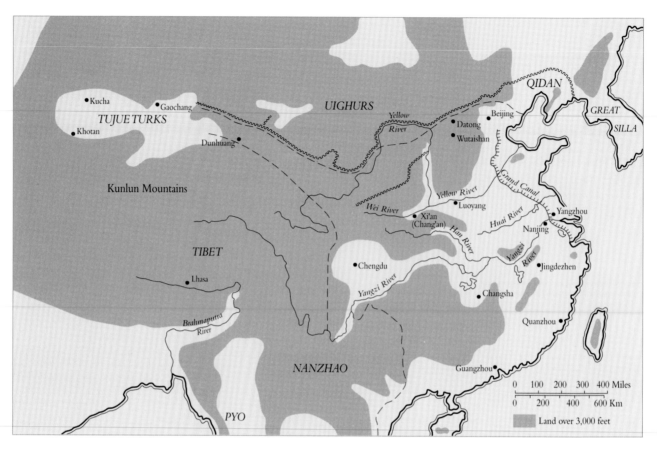

MAP 6.1 (ABOVE)

China in the Tang dynasty

MAP 6.2 (RIGHT)

Chang'an in the Tang dynasty

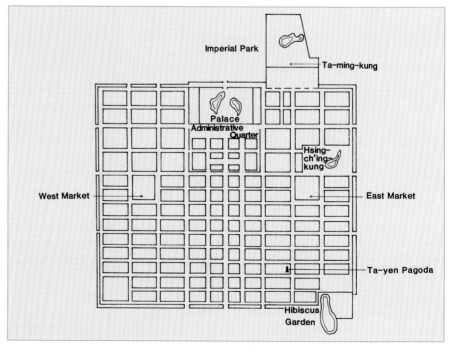

dynasty—whether it be the most splendid fresco from the hand of a master or the humblest tomb figurine made by the village potter.

By the time of Taizong's death in 649, China had established control over the flourishing central Asian kingdoms of Kucha and Khotan (map 6.1), begun the conquest of Korea (then known as Great Silla), linked Tibet to the royal house by marriage, and established relations with Japan and the southeast Asian kingdoms of Funan and Champa (parts of modern Cambodia and Vietnam). Chang'an, laid out by the Sui, now became a city of a size and splendor rivaling, if not surpassing, Byzantium. It was planned on a grid 7 by 6 miles (11.2 × 9.6 km; map 6.2). In the northern sector lay the government buildings and the imperial palace, which was later moved to a cooler, less crowded site outside the northeast corner of the city. In its streets one might have encountered priests from India and southeast Asia, merchants from central Asia and Arabia, Turks, Mongols, and Japanese, many of whom are humorously caricatured in the pottery figurines from Tang graves (fig. 6.1). Moreover, these foreigners brought with them their own faiths, which flourished in an atmosphere of rare religious tolerance and curiosity. Taizong himself, though personally inclined toward Daoism, for reasons of state supported the Confucians and strengthened the administrative system. This astonishing man also treated the Buddhists with respect—notably that great traveler and theologian Xuanzang, who had left China in defiance of an imperial order in 629 and, after incredible hardships and delays, had reached India, where he acquired a reputation as a scholar and metaphysician. In 645 he returned to Chang'an, bringing with him the texts of the idealistic Vijñānavādin School of the Mahāyāna. The emperor came out to meet him, and his entry into the capital was a public triumph.

Never before had Buddhism stood so high in Chinese history; but it was not the only foreign religion on Chinese soil. There were also Zoroastrian and Manichaean temples and Nestorian Christian churches in the capital and, from the mid eighth century onward, Muslim mosques. The art of this period is as full of imported motifs as were the streets of Chang'an with foreigners. Far to the south, Yangzhou, situated at the point where the Grand Canal meets the Yangzi River, was another thriving cosmopolitan city. About one hundred pieces of Persian pottery have been excavated there.

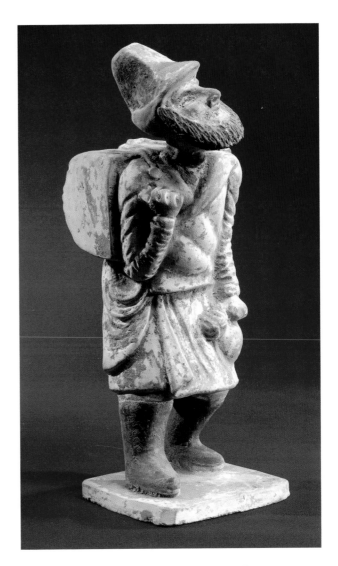

FIGURE 6.1 Foreign merchant. Painted pottery. Ht. 32.1 cm. Tang dynasty. Courtesy of Michael Weisbrod, New York.

China enjoyed a hundred years of peace and prosperity at home and enormous prestige abroad thanks not only to Li Shimin but also to two outstanding personalities who succeeded him. Gaozong, who ascended the throne in 649, was a weak and benevolent man dominated by his concubine, Wu Zetian, who after his death in 683 had the shocking effrontery to declare herself "emperor." But such was the ability of this cruel and pious woman (her Buddhist patronage is immortalized in some of the finest sculpture

FIGURE 6.2 Tumulus and processional way of the tomb of the emperor Gaozong (d. 683) and his consort Wu Zetian (d. 705) at Qianxian, Shaanxi. Photo by the author.

at Tianlongshan) that Confucian ministers loyally served her until her forced abdication in 705 at the age of eighty-two brought to an end two decades of stability and peace (fig. 6.2).

Seven years later the throne passed to the man who, as Xuanzong (known as Minghuang, 713–756), was to preside over the most brilliant court in Chinese history, a period comparable to the Gupta in the reign of King Harsha or to Florence under Lorenzo de' Medici. Like Taizong, Minghuang (the "brilliant emperor") cherished and upheld the Confucian order, and in 754 he founded the Imperial Academy of Letters (Hanlinyuan), which is older by nearly a thousand years than any existing European academy. All the talent and wealth of the country that was not given to the construction and adornment of Buddhist temples seemed to be concentrated on his court, his palaces, his favorite scholars, poets, and painters, his schools of drama and music, his orchestras (two of which came from central Asia), and, finally, his mistress, the lovely Yang Guifei. Through her influence An Lushan, a general of Mongol or Tungus origin, had become a favorite with Minghuang. Suddenly, in 755, An Lushan revolted, and the emperor and his court fled in panic from Chang'an. To appease his mutinous es-

cort, Minghuang, now over seventy, was forced to hand Yang Guifei over to the soldiers, who promptly strangled her and left her body in a ditch by the roadside. A few years later Minghuang's son Suzong crushed the rebellion, the dynasty staggered to its feet, and there was even something of a revival in the early years of the ninth century. But the power of the Tang was broken, its glory past, and the long, slow death of the dynasty had already begun.

Yet so rich was Tang culture that, in poetry at least, creativity continued undimmed through the length of it, although the mood as reflected in the almost fifty thousand Tang poems that survive changed from the simple springlike optimism of the seventh century through the mature summer and autumn of the eighth and early ninth centuries—the time of the great Li Bai, Du Fu, and Bai Zhuyi—to the wintry intensity and emotional extravagance of late Tang poets such as Du Mu and Li Shangyin. Too little Tang painting survives to show whether it too had its seasons.

In 751 Muslim forces advancing from the west heavily defeated Chinese armies in central Asia, bringing Chinese Turkestan permanently under Muslim influence. The Arab conquest of central Asia began the destruction of that chain

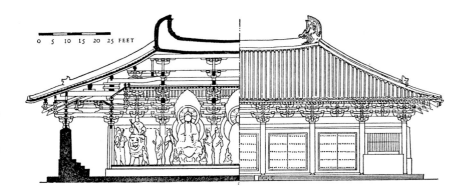

FIGURE 6.3 The main Buddha hall of Foguangsi at Wutaishan, Shanxi. Ninth century. Redrawn by P. J. Darvall in *Yingzao xueshi huikan* (Beijing).

of prosperous, partly Sinicized kingdoms that had provided the overland link between China and the West in the seventh century, a process of destruction that was in due course to be completed by the ferocity of the Mongols. Contact with the Western world was now maintained through the southern ports. The quays of Guangzhou and other southern ports were thronged with Chinese and foreigners who lived in peaceful prosperity with each other until the peasant rebel Huang Chao massacred foreigners in 879. And at Quanzhou in Fujian (Marco Polo's Zayton), excavations have revealed that as late as the thirteenth century Hindus, Arabs, Manichaeans, and Jews were settled in that great trading port, whose cosmopolitanism is symbolized by the twin pagodas of the Kaiyuan temple, built in the twelfth century by Chinese and Indians working side by side.

ARCHITECTURE

As so often happens in history, China became less tolerant as its power declined, and foreign religions suffered accordingly. The Daoists were jealous of the political power of the Buddhists and poisoned the mind of the emperor against them, while the Confucians had come to look upon certain Buddhist practices (particularly celibacy) as un-Chinese. The government also viewed with increasing alarm the vast sums spent on the monasteries and their unproductive inmates, who now numbered several hundred thousand. In 845 all foreign religions were proscribed and all Buddhist temples confiscated by imperial edict. The ban on Buddhism was later relaxed, but in the meantime so thorough had been the destruction and looting that today little survives of the great Buddhist architecture, sculpture,

and painting of the seventh and eighth centuries. Again we must look to Japan, where the monasteries at Nara, itself a replica of Chang'an, preserve some of the finest of Tang art. Tōdaiji was not an exact copy of a Tang temple, but in its grandeur of scale and conception it was designed to rival the great Chinese foundations. It was built on a northeast axis with pagodas flanking the main approach. A huge gateway leads into a courtyard dominated by the Great Buddha Hall (Daibutsuden), 326 feet long by 170 feet deep by $14\frac{3}{4}$ feet high (99.4 × 51.8 × 4.5 m), housing a gigantic seated Buddha in bronze, consecrated in 752. Much restored and altered, the Buddha Hall is today the largest wooden building in the world, though in its time the Jianyuandian at Luoyang, long since destroyed, was even larger.

The earliest known Tang wooden temple building is the small main hall of Nanchansi in Wutaixian, Shanxi, built in 782; the largest is the main hall of Foguangsi on Wutaishan (fig. 6.3), built in the mid ninth century.[1] Both of these buildings show a slight curve in the silhouette of the roof—a feature that was to become more pronounced with time and to be a dominant feature of east Asian architecture. Many theories have been advanced to account for it, the most far-fetched being that it imitated the sagging lines of the tents used by the Chinese in some long-forgotten nomadic stage. In fact, the reasons are both aesthetic and practical. By about the sixth century the Chinese had discovered not only that this roofline was beautiful, but also that the flattening out of the roof toward the eaves helped to prevent the heavy tiles from sliding off, while the lift at the corners (just perceptible in the drawing of Foguangsi) helped to accommodate the extra bracketing required to sup-

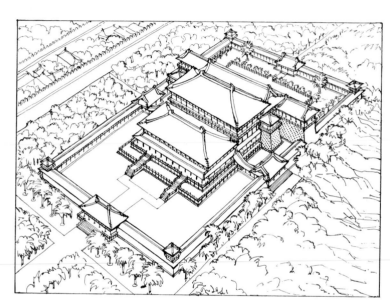

FIGURE 6.4 (ABOVE LEFT) The Western rigid roof truss and the Chinese beam-frame truss compared.

FIGURE 6.5 (ABOVE) The development and decline of the bracket system: (I) Tang, 857; (2) Song, 1100; (3) Yuan, 1357; (4) Ming; (5) Qing, 1734.

FIGURE 6.6 (LEFT) Conjectural reconstruction of the Lindedian of the Daming Palace at Chang'an, built 634. Tang dynasty. Drawn by T. A. Greeves.

port the enormous overhang of the eaves at this point. The curve is made possible by the Chinese "beam-frame" construction, which, unlike the Western rigid triangular truss, can be made to take any shape simply by varying the height and position of the little queenposts on which the purlins sit (fig. 6.4). The curve, used with great delicacy in the Sui, gradually became more pronounced, particularly in south China, and more picturesque.

By the Tang dynasty, the heavy bracketing system (which, with the column it is poised upon, constitutes the nearest Chinese architecture comes to an "order" in the Western sense) is a little more complex: the brackets extend outward and upward to support two slanting cantilever arms called *ang*, the inner ends of which are anchored to a crossbeam. In Song and Yuan construction, the *ang* ride freely balanced on the bracketing system (nos. 2 and 3 in fig. 6.5), creating a dynamic and meaningful play of forces comparable to

Gothic vaulting. During the Ming and Qing, however, as the details become increasingly fussy and elaborate, the true function of *ang* and bracket is lost, and the whole degenerates into an intricate but structurally meaningless assemblage of carpentry, a mere decorative frieze running along under the eaves (as in nos. 4 and 5).

The sketch in fig. 6.6 shows a conjectural restoration of one of the palaces of the Daminggong at Chang'an. It is instructive to compare this building with the three great halls of the Forbidden City in Beijing (see fig. 8.3). While the latter are far larger in scale, the grouping of the buildings is much less interesting. The interlocking of masses on ascending levels buttressed at the sides by wings and towers, which gives such strength to the Tang complex, was not attempted in Beijing. Tang (and indeed Song) palaces seem to have been not only more enterprising architecturally, but also more natural in scale than the vast, isolated,

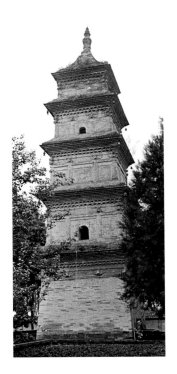

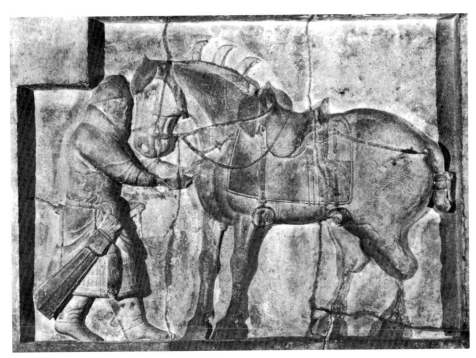

FIGURE 6.7 (ABOVE) Pagoda of Xinjiaosi, Chang'an (Xi'an), Shaanxi. Brick. Built about 699 to receive the ashes of Xuanzang. Rebuilt 828. Tang dynasty.

FIGURE 6.8 (ABOVE RIGHT) A charger and his groom. Stone relief from the tomb of the emperor Taizong (d. 649). L. 152 cm. Tang dynasty. University of Pennsylvania Museum, Philadelphia.

and coldly ceremonial structures of the Qing dynasty, suggesting a more human concept of the role of the emperor in the earlier period.

A few Tang stone and brick pagodas have survived. Some—the pagoda built for Xuanzang's ashes at Chang'an (fig. 6.7), for example—are straightforward translations of a form of construction derived from the Han timber tower (*lou*). The Jianfosi at Chang'an (cf. fig. 5.14, no. 5), by contrast, derives ultimately from the Indian *śikhara* tower of stone, which we have already encountered in its purest form in the pagoda on Mount Song (see fig. 5.15). The imitation of Indian forms was carried still further in the Treasure Pagoda of Foguangsi on Wutaishan, which originally had a dome, copied perhaps from a sketch or souvenir brought back by a returning pilgrim. Under the influence of the mystical Mahāyāna sects, an attempt was even made to incor-

porate the dome of the stūpa into a timber pagoda; none survives in China, but the twelfth-century Tahōtō of Ishiyamadera is a Japanese example of this odd misalliance.

BUDDHIST SCULPTURE: THE FOURTH PHASE

Until the dissolution of the monasteries in 845, their insatiable demand for icons, banners, and wall paintings absorbed the energies of the great majority of painters and sculptors. Some of the sculptors' names are recorded: we read in Zhang Yanyuan's history, for example, of Yang Huizhi, a painter in the time of Wu Daozi, who, "finding that he made no progress, took to sculpture, which he thought was an easier craft." Zhang also mentions other pupils and colleagues of Wu who became noted for their work in clay and stone; indeed, as we shall see, Tang sculpture in its extraordinary linear fluidity seems often to have been formed by the brush rather than the chisel. Little secular sculpture was carried out, apart from the guardian figures and winged horses and tigers that lined the "spirit way" leading to the tombs. The earliest and most famous example of Tang funerary sculpture is the set of panels depicting in relief the six favorite chargers of Taizong (fig. 6.8), executed, according to tradition, after designs by the senior court painter

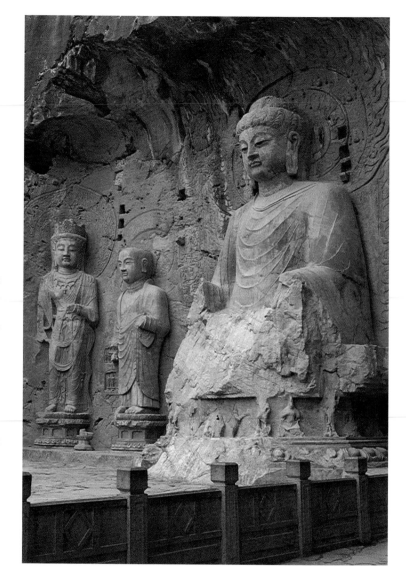

FIGURE 6.9 (RIGHT) Vairōcana
Buddha, flanked by Ānanda, Kāśyapa,
and attendant bodhisattvas. Stone.
Ht. 13.37 m. Fengxiansi, Longmen,
Henan. Tang dynasty, 672–675.
Photo: John Service.

FIGURE 6.10 (OPPOSITE LEFT)
Standing Buddha. Udayāna type.
White marble. Ht. 145 cm. From
Xiude pagoda, near Quyang, Hebei.
Tang dynasty. Victoria and Albert
Museum, London. V&A Images.

FIGURE 6.11 (OPPOSITE RIGHT)
Torso of standing bodhisattva. Stone.
Ht. 98 cm. From Tianlongshan,
Shanxi. Tang dynasty, mid eighth cen-
tury. Museum Rietberg, Zürich.
Photo: Wettstein & Kauf.

Yan Liben. The style is plain and vigorous, the modeling so flat that the origin of these monumental silhouettes in line paintings seems not at all improbable.

The great Chinese Buddhist bronzes of the seventh and eighth centuries have all disappeared, melted down in the persecution of 845 or lost through subsequent neglect, and the style can best be seen in the temples at Nara in Japan. Only in the cave shrines has stone and clay sculpture survived in any quantity. At Longmen, Wu Zetian ordered the carving of a colossal figure of the Buddha Vairōcana flanked by the disciples Ānanda and Kāśyapa, with attendant bod-

hisattvas (fig. 6.9). Obviously intended to rival in size and magnificence the great Buddha of Yungang, this figure of the Buddha of Boundless Light far surpasses it in power of modeling, refinement of proportion, and subtlety of feeling. Even though badly damaged, the Vairōcana well expresses the ideal of the Mahāyāna, which saw the Buddha not as a great teacher but as a universal principle radiating out in all directions for all time. It was also a political statement of Wu Zetian's manifest authority as self-styled "emperor" of China.[2]

More directly modeled on an Indian prototype—perhaps

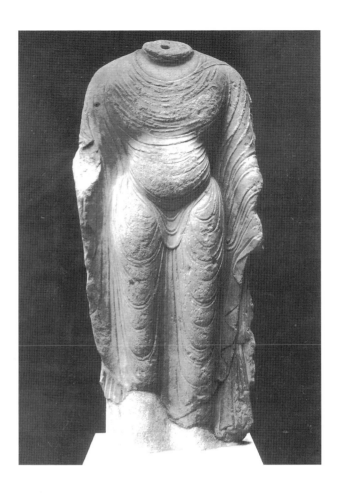

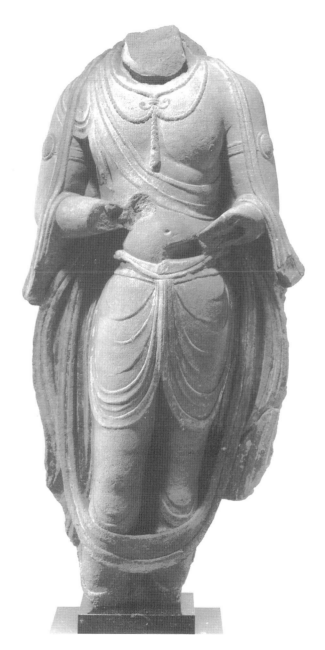

on a version of the celebrated sandalwood image reputedly made by King Udayāna in the Buddha's lifetime, a copy of which Xuanzang brought to China in 645—is the thoroughly Gupta torso in marble from Quyangxian, Hebei, now housed in the Victoria and Albert Museum, London (fig. 6.10). This tendency to treat stone as though it were clay reached its climax in the cave shrines carved out at Tianlongshan during the reigns of Wu Zetian and Minghuang. Here the figures are carved fully in the round (fig. 6.11), with the exquisite grace and richly sensuous appeal that we find in Greek sculpture of the fourth century B.C. The modeling has an all-too-Indian suavity and voluptuousness; the drapery seems as though poured over the fleshy body. But to compensate, there is a new mobility of movement. In these figures, the Indian feeling for solid swelling form and the Chinese genius for expression in linear rhythm are at last successfully reconciled in a great synthesis, producing

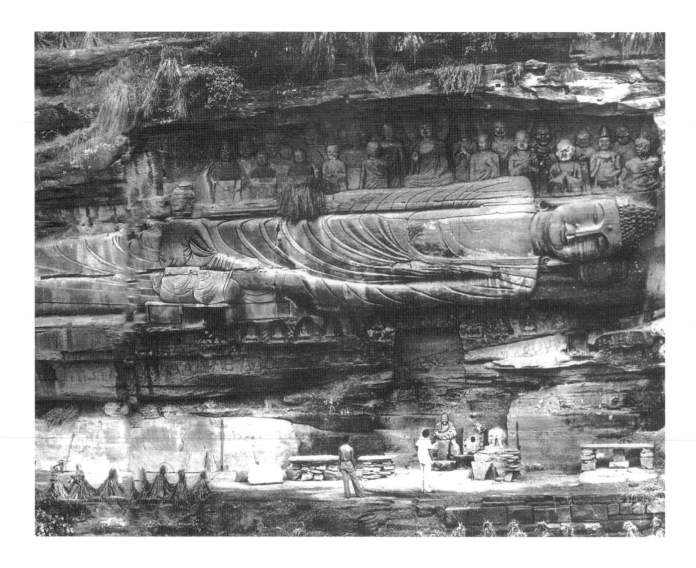

a style that was to become the basis of all later Buddhist sculpture in China.

Buddhist temples, pagodas, sculpture, and painting were created all over China, wherever pious donors were prepared to pay for them. I could list scores of sites, often showing strong local stylistic character, but have room for only one sensational example of relief sculpture, first visited by Chinese investigators as recently as 1982, northeast of Anyue in central Sichuan. Illustrated in fig. 6.12 is the gigantic figure of Śākyamuni, 88½ feet (27 m) long, at the moment he entered Nirvāna, attended by his disciples and protected at his head and feet by guardians, while another disciple, seated at his knees, is feeling his pulse. The for-

mality and crispness of the modeling suggest the work of a master, though whether he was a local man is impossible to say. An inscription in a nearby cave tells us that this is the site of the Anfusi (Reclining Buddha Temple), built in 734.[3]

Although Buddhist beliefs and art were dominant, Daoism had its place too, with followers building temples and fashioning icons in direct competition with the imported faith. But although some Tang emperors favored the Daoists for practical reasons, incorporating their practices into court ritual, Daoist votive images, being forged from an awkward marriage of folk religion and the most abstruse metaphysical concepts, could never match the finest Buddhist art.

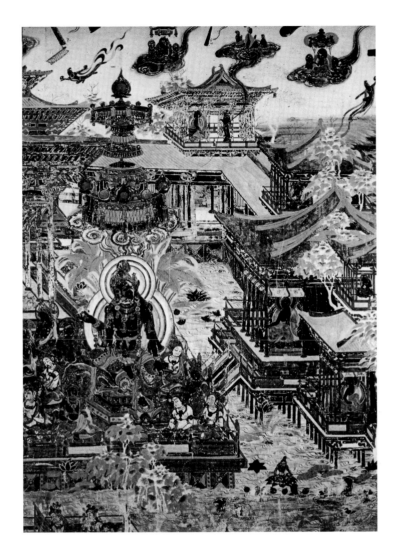

BUDDHIST PAINTING: FOREIGN INFLUENCES

The Buddhist painting of this period must have contained as rich a mixture of native and foreign elements as did sculpture. During the seventh century the most popular subjects were those that illustrated the teachings of the Tiantai sect based on the *Lotus Sūtra* (*Saddharmapundarīka sūtra*), an encyclopedic text that, in its combination of theology and metaphysics, ethics, magic, and simple human appeal, seemed to satisfy all human needs; we already encountered some of its themes on the sculptured steles of the Northern Wei. Even more popular were the teachings of the Jingtu (Pure Land) School, which had cut its way through the growing forest of metaphysical abstractions of the later Mahāyāna with the doctrine that through simple faith one might be reborn and so find release and eternal bliss in the Western Paradise of Amitābha (fig. 6.13). By the mid seventh century, however, new concepts were coming into Buddhism that were eventually to bring about its decline. The later Mahāyāna in India had become deeply colored by a highly abstract and idealistic metaphysics, on the one hand, and by the practices of the Tantric sects of revived Hinduism, on the other. Tantrism held that by sheer concentration of willpower, aided by magic spells (mantras) and diagrams (mandalas), a deity could be invoked to bring about desirable changes in the order of things. This school also believed in the Hindu concept of the Śakti, a female ema-

nation, or reflex, of a deity who would be doubly efficacious if presented clasping her in ecstatic union. At its finest, this new art has a power that is overwhelming, but it too easily degenerates into the soulless repetition of magical formulas.[4] It found its true home in the bleak wastes of Tibet, whence it reached out to paralyze the art of Dunhuang during the Tibetan occupation, from about 750 to 848. In the course of time, the revolt of the Chinese spirit against the sentimental, the overly intellectual, and the diabolical aspects of these sects found expression in the Chan (Zen) School of contemplative mysticism, but as this doctrine did not greatly affect painting until the Song dynasty, we will defer discussion of it to chapter 7.

In 847 the scholar and connoisseur Zhang Yanyuan completed his *Lidai minghuaji* (Record of famous painters of successive dynasties), the earliest known history of painting in the world. This important book, which has happily survived, includes a catalogue of the frescoes in the temples of Chang'an and Luoyang and is as full of the names of great painters and their works as Baedeker's guide to Florence. But the persecution of 845, coupled with wars and rebellions, fire, and sheer neglect, destroyed all this art. According to contemporary accounts, the work of the foreign painters aroused much interest and had considerable influence on local artists. During the Northern Qi, Cao Zhongda painted figures that, according to Zhang Yanyuan, "were clad in garments that clung to the body; they looked as if they had been drenched in water"—an apt description also of the sculpture at Tianlongshan. The Khotanese painter Yuchi (or Weichi) Bozhina had come to Chang'an in the Sui dynasty; he specialized not only in Buddhist subjects, but also in strange objects from foreign lands and in flowers, which he painted with great realism. The emperor Taizong honored Yuchi Yiseng (thought to be Bozhina's son) with a ducal title. "His paintings," says another ninth-century work, the *Tangchao minghualu* (Record of famous painters of the Tang dynasty) of Zhu Jingxuan, "whether votive images, human figures, or flowers and birds, were always foreign-looking and not like Chinese things"; while Zhang Yanyuan said of his brushwork that it was "tight and strong like bending iron or coiling wire." A Yuan critic wrote of him that "he used deep colors, which he piled up in raised layers on the silk." His work is long since lost, but it seems that his "relief style" of flower painting was not a subtle use of shading to give an effect of solid volume, as is often supposed on the basis of descriptions in early texts, but a much cruder technique wherein the pigment was laid on in a heavy impasto until the flowers actually did stand out from the wall. Traces of this technique survive in the much-damaged wall paintings in the caves at Maijishan.

WU DAOZI

Although some Tang painters were no doubt seduced by such devices into thoroughly un-Chinese experiments, Wu Daozi, the greatest artist of them all, seems from contemporary accounts to have worked in a purely Chinese style, which in its grandeur of conception and fiery energy of execution makes him one with Michelangelo. Born about 700, he is said to have painted three hundred frescoes (using the term loosely; they were painted on dry plaster, not wet) in the temples of Luoyang and Chang'an. None of his pictures has survived; indeed, by the eleventh century the poet Su Dongpo said he had seen but two genuine ones, his friend Mi Fu three or four. But we can obtain a vivid idea of the vigor, solidity, and realism of his work from descriptions written by those who had seen it—more vivid, certainly, than is provided by the third-hand copies, odd rubbings, and sketches on which our estimates are generally based. The twelfth-century writer Dong Yu said of him: "Wu Daozi's figures remind me of sculpture. One can see them sideways and all around. His line work consists of minute curves like rolled copper wire." (Another writer says this effect was more characteristic of his early work; it suggests the influence of Yuchi Yiseng.) "However thickly his red or white paint is laid on," Dong Yu continues, "the structure of the forms and modeling of the flesh are never obscured." Earlier, Dong Yu had remarked that "when [Wu Daozi] paints a face, the cheekbones project, the nose is fleshy, the eyes hollow, the cheeks dimpled. But these effects are not got by heavy ink shading. The shape of the features seems to have come spontaneously, yet inevitably." All spoke of the whirlwind energy of his brush, so remarkable that crowds would gather to watch him as he worked. Perhaps his technique is reflected in the head of the Indian sage Vimalakīrti (fig. 6.14), painted by an unknown eighth-century artist on the wall of Cave 103 at Dunhuang. His influence on later figure painting was enormous.

THE HŌRYŪJI KONDŌ CYCLE

No major works survive in China to demonstrate that fusion of Indian formal ideals with traditional Chinese language of the brush that took place in the Tang dynasty and that we have already referred to in sculpture as the "fourth phase." But this great synthesis did take place, and was in turn passed on to Korea and Japan, where examples survived well into the twentieth century. About the beginning of the eighth century, the walls of the Kondō (Golden Hall) of Hōryūji Temple, Nara, were decorated with four large rectangular panels depicting the paradises of the Buddhas of the four directions and eight vertical panels with bodhisattvas. These paintings, after miraculously surviving for twelve hundred years, were almost totally destroyed by fire in 1949, a disaster to the art world as great as if the frescoes in the Sistine Chapel or those in the cave temples of Ajantā had perished. A part of the most popular paradise—that of Amitābha—is illustrated in fig. 6.15. The composition is a simple and serene arrangement of deities, the bodhisattvas Mahāsthāmprāpta and Avalokiteśvara standing on either side of Amitābha, who sits turning the wheel of the

FIGURE 6.14 (ABOVE) Vimalakīrti in debate with the bodhisattva Manjuśrī. Detail of a wall painting in Cave 103 (P 137) at Dunhuang, Gansu. Tang dynasty, eighth century.

FIGURE 6.15 (LEFT) The Paradise of Amitābha. Detail of a wall painting in the Kondō (Golden Hall) of Hōryūji, Nara, Japan. Early eighth century.

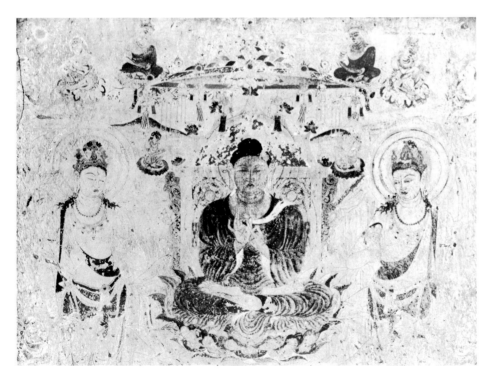

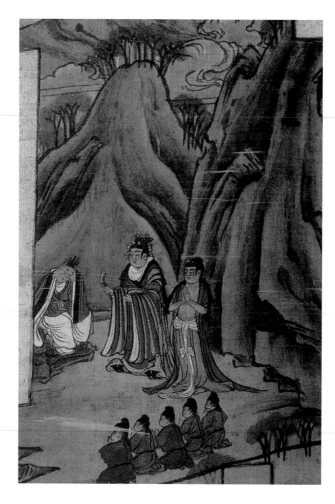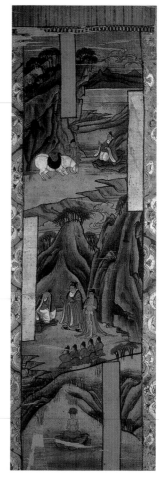

law on his lotus throne beneath a bejeweled canopy. The figures are drawn with a sweeping brush line of extraordinary delicacy and precision that evokes a feeling of the solid form, from which the Indian tactile sensuality has been abstracted. Indeed, except for the iconography and the contours themselves, little here is Indian. Arbitrary shading is used with great restraint to amplify the roundness of an arm or chin, but much more is accomplished by the almost imperceptible modulations of the brush line itself, while the folds of the drapery are emphasized by a kind of shading that—if the *Admonitions* scroll is a faithful copy of the style of Gu Kaizhi—goes back to the fifth century. Only in the jewelry is there a hint of that rich impasto with which the Yuchis had astonished Chang'an. Apart from these details, the forms, as Dong Yu said of Wu Daozi, seem "to have come spontaneously, yet inevitably."

DUNHUANG

Long after the cult of Amitābha had declined in metropolitan China, it lived on in the hearts of the pilgrims and country folk at Dunhuang, who must have gazed with awe at the huge heavenly visions that filled the walls of the seventh- and eighth-century caves. In 1907 in a walled-up storeroom at Dunhuang, Sir Aurel Stein found a great hoard of manuscripts and silk banners. Many were craftsmen's work, but taken as a whole they represent the only considerable group of undoubtedly genuine Chinese silk paintings from the Tang dynasty that have survived. The banners include a number of paradises and single deities (especially the increasingly popular Guanyin) painted in warm colors with a wealth of detail and floral ornament. The most appealing and lively parts of these banners are the little panels at the sides, which tell in miniature the story

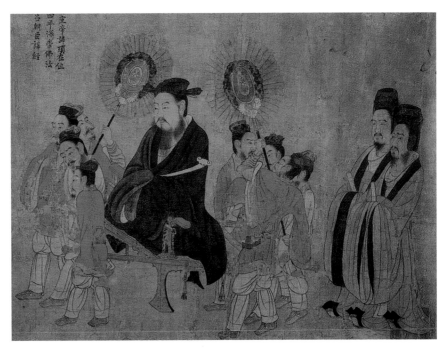

of the Buddha's life on earth, generally in a landscape setting (fig. 6.16), much as the predella of a Quattrocento altarpiece tells the story of Jesus. It seems that until Tibetan esoteric Buddhism laid its cold hand on Dunhuang, the Chinese painters there used a landscape setting wherever they could. Sometimes, indeed, it dominates the theme in a thoroughly un-Indian fashion. In Caves 103 (P 54) and 217 (P 70), for example, the old subdivision into superimposed horizontal scrolls has been replaced by a panoramic landscape of towering peaks that fills the whole wall (fig. 6.17). There is still a tendency to break up the composition into smaller connected "space cells," and the transition through the middle distance to the horizon is hardly better managed than on the stone sarcophagus now in Kansas City (see fig. 5.12). But other paintings at Dunhuang, notably the landscape vignettes in Cave 323 (P 137M), show that this problem was successfully solved in the eighth century.[5]

COURT PAINTING

We must return from distant Dunhuang naturalism to the splendors of the Tang court. A famous scroll in the Museum of Fine Arts, Boston, bearing portraits of thirteen emperors from Han to Sui (fig. 6.18) has traditionally been attributed to Yan Liben, the son and brother of two famous artists, who was himself a court painter in attendance (*daizhao*) to Taizong and rose to the high office of Minister of the Right under Taizong's successor. This handscroll—or part of it, for more than half is a copy from the Song dynasty—is the epitome of the Confucian ideal, now restored to its proper place as the pivot of Chinese society. While each group makes a monumental composition by itself, together they form a royal pageant of incomparable dignity. The figures are full, the robes ample, the brush line fluent and of even thickness. Arbitrary shading is used with restraint to give volume to the faces and, more generously, to the folds of the robes, as on the Amitābha in the Kondō at Hōryūji.

Fifty years ago our knowledge of Tang painting was enlarged by the opening of a group of richly decorated princely tombs in Qianxian, to the northwest of Xi'an. Is it perhaps the hand of a pupil of Yan Liben that we see in the lovely paintings that line the tomb of Princess Yongtai? The unfortunate girl was murdered, or forced to commit suicide, at the age of seventeen by the "emperor" Wu Zetian. When that monstrous woman died, the restored emperor built, in 706, a subterranean tomb for his daughter, its walls adorned with the figures of serving girls (fig. 6.19).

The drawing is free and vivacious, sketchy yet perfectly controlled. These paintings, done solely for the pleasure of the dead princess, bring us closer to an understanding of Tang courtly wall painting as it approached its climax in the eighth century. Meanwhile, the vast tomb of Gaozong and Wu Zetian sleeps, unviolated, in the depths of a hill of rock not far away, and until at some future date it is opened, we can only imagine the treasures of art and craft it must contain.

The quality of Tang court life is further revealed in the paintings attributed to Zhou Fang and to Zhang Xuan, a court painter under Minghuang who was chiefly celebrated for his paintings of young nobles, saddle horses, and women of rank. So far as is known, none of their works survives in the original, but there may be a careful copy of a painting by one or the other of these masters, *Court Ladies Preparing Silk* (fig. 6.20), which is attributed to the Song emperor Huizong, but is more likely a product of his palace studio: it is hard to imagine the emperor having the time to make replicas of this sort, although he often put his name to them. We see a lady, about to pound the silk strands, rolling up her sleeves. Another draws out the thread; a third is sewing. The color is rich and glowing, the detail of jewel-like precision. There is neither ground nor background, but the picture has depth, and there is a subtle and uniquely Chinese sense of almost tangible space between the figures.

Court painters such as Zhou Fang and Zhang Xuan worked for the emperor, as did the poets, to celebrate the more memorable social and cultural events of court life. The emperor also engaged these artists to paint portraits not only of his favorite concubines and virtuous ministers, but also of strangers from the West whose exaggerated features have ever been a source of delight to the Chinese. In a more serious vein were portraits of Buddhist priests, such as the series of the patriarchs of the Zhenyan (Shingon) sect, painted by Li Zhen, a contemporary of Zhou Fang. Long forgotten in China, the work of this artist has been cherished in Japan for its austere and noble evocation of the spirit of mystical Buddhism.

The emperor Minghuang was passionately fond of horses, particularly the tough, stocky ponies from the western regions, and is said to have had over forty thousand in his stables. The striking painting of one of his favorites, Night White, has long been attributed to the noted horse

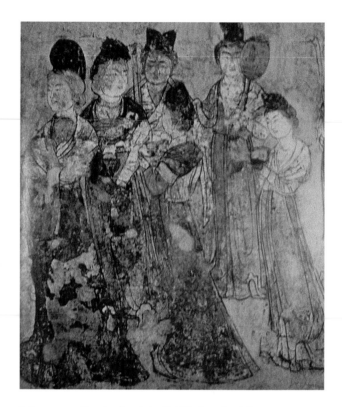

FIGURE 6.19 Female attendants. Detail of a wall painting in the tomb of Princess Yongtai at Qianxian, Shaanxi. Tang dynasty, about 706.

specialist Han Gan (fig. 6.21). Tethered to a post, the horse rears up with eye dilated as though the painter has startled him. Although the painting has been restored, enough of the original remains to suggest the dynamic energy of movement and solidity of modeling that we also find in the best of the Tang pottery figurines.

Court artists were not always treated with the respect they deserved. Zhang Yanyuan tells of the indignity to which the great Yan Liben was once subjected when he was rudely summoned—the courtiers used the term *hua shi*, roughly equivalent to "master craftsman painter" (a term that would never be applied to a scholar, a high official, or a gentleman)—to sketch some ducks that were swimming about on the palace lake in front of Taizong. After this humiliation, Yan advised his sons and pupils never to take up the art.

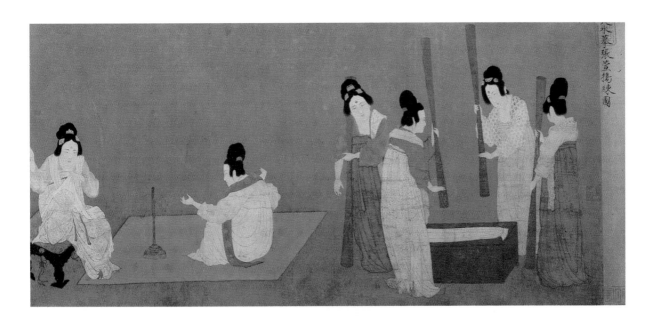

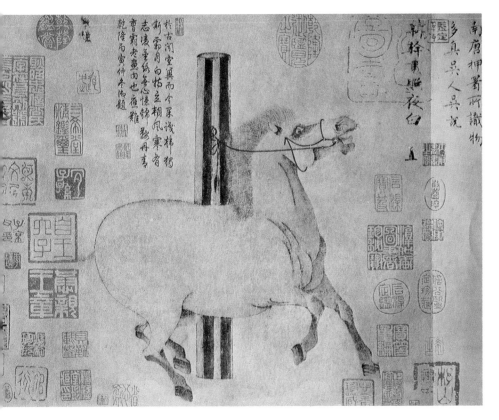

FIGURE 6.20 (ABOVE) Attributed to Song Huizong (r. 1101–25). *Court Ladies Preparing Silk*. Detail of a handscroll after a Tang dynasty original. Ink and color on silk. Ht. 37 cm. Song dynasty. Museum of Fine Arts, Boston; Special Chinese and Japanese Fund. Photo © 2008 Museum of Fine Arts, Boston.

FIGURE 6.21 (LEFT) Attributed to Han Gan (active 740–760). *Night White* (a favorite horse of Tang Minghuang). Handscroll. Ink on paper. Ht. 29.5 cm. Tang dynasty (?). The Metropolitan Museum of Art, New York; Purchase, The Dillon Fund Gift, 1977. Photo: Malcolm Varon; © 1990 The Metropolitan Museum of Art.

FIGURE 6.22 (ABOVE) Style of Wang Wei (?) (699–
c. 760). *Snowy River*. Part of a handscroll (?). Ink and color
on silk. Formerly Manchu Household Collection, Beijing.

FIGURE 6.23 (OPPOSITE) Landscape in the linear style.
Copy of detail of a wall painting in the tomb of Yide at
Qianxian, Shaanxi. Tang dynasty, 706.

LANDSCAPE PAINTING

During these prosperous years, when painters were occu-
pied with Buddhist frescoes, portrait painting, and other
socially useful activities, their hearts, if not their feet, were
roaming the hills and valleys far from the glitter of the cap-
ital. By the beginning of the Tang, the tradition of landscape
painting—which had been born in the Six Dynasties and
was later to rise to such supreme heights—had advanced
little, partly because of the ever-increasing demand for Bud-
dhist icons and partly because artists were still struggling
with the most elementary problems of space and depth. But
during the Tang dynasty these difficulties were mastered.

According to later Chinese critics and historians, two
schools of landscape painting came into being during the
Tang. One, practiced by the court painter Li Sixun and his
son Li Zhaodao, painted in the precise line technique de-
rived from earlier artists such as Gu Kaizhi and Zhan Zi-
qian, adding decorative mineral colors; the other, founded
by the poet-painter Wang Wei, developed monochrome land-
scape painting in the *pomo* ("broken ink") manner. The first
school, later called the Northern School, became the spe-
cial province of court painters and professionals, while the
second, the so-called Southern School, was the natural mode
of expression for scholars and amateurs. As we shall see
when we come to a discussion of Ming painting, this doc-
trine of the Northern and Southern Schools, and of the
founding role of Wang Wei, was invented by a group of late
Ming scholar-critics to bolster their belief in the superior-
ity of their own kind of painting over that of the professionals
and court painters of the day. But I mention it here because
it has dominated Chinese thinking about landscape paint-
ing for nearly four hundred years. In fact, the line between
the two kinds of painting was not so sharply drawn in the
Tang dynasty. Wang Wei's elevation to this pinnacle in the
history of Chinese painting was an expression of the belief,
shared by all scholar-painters from the Song dynasty onward,
that a man's painting, like his handwriting, should be wit-
ness not to his skill with the brush, but to his quality as a
man. Because Wang Wei was the ideal type of man, it was
argued, he must also have been the ideal type of painter.

A gifted musician, scholar, and poet, Wang Wei (699–
c. 760) joined the brilliant group of painters and intellec-
tuals around Minghuang's brother, Prince Qi. He got into
political difficulties at the time of the An Lushan rebellion,
but was extricated by his brother and restored to imperial
favor. When his wife died in 730 he became a devout Bud-
dhist, though whether this conversion influenced his paint-
ing is not known. He was famous in his lifetime for his
snow landscapes, but the work for which he is best remem-
bered by later painters is a long panoramic handscroll de-
picting his country estate, Wangchuan, outside Chang'an.
This picture disappeared long ago, and although the gen-
eral composition has been preserved in many later copies,
one of which was engraved on stone in the Ming dynasty,
these reproductions give little idea of the style, still less
the technique, of the original. Perhaps the nearest we shall
ever get to his intensely poetic relationship with nature is
the beautiful little *Snowy River* (fig. 6.22), formerly in the
Manchu Household Collection and now lost. To judge from
old photographs, the technique is simple and archaic, the

mood, so suggestive of deep winter, profoundly poetic. When he first saw this painting, the great Ming critic Dong Qichang (see chapter 9) was convinced that at last he had found a genuine Wang Wei, although when he saw the picture again four years later, his enthusiasm for it had cooled considerably.[6]

It is difficult to write with any certainty about the style of Tang landscape painting when almost all we have to go on are the frescoes and banners from Dunhuang and the recently discovered paintings in the Tang tombs. But enough has been revealed to suggest that by the eighth century three styles had come into being, which we might call the linear, the boneless, and the painterly. In the linear style, which traces its origins back to Gu Kaizhi and beyond, the forms are drawn in fine, clear lines of more or less even thickness and filled with washes of color, as in the landscape from the tomb of Yide of which a detail is illustrated

in fig. 6.23. In the boneless style, exemplified in the detail from Cave 217 (P 70) at Dunhuang (see fig. 6.17), color is broadly applied in opaque washes with little or no outline, a technique that seems to have been reserved for wall painting.

In the third style, the painterly, an articulated, calligraphic line is combined with broken interior ink washes to produce a richly integrated texture. This style—in the development of which Wang Wei's contemporary Zhang Zao rather than Wang Wei himself was a key figure[7]—seems to have become fully expressive in the eighth century and can be illustrated, in crude form, by the details from a Dunhuang banner shown in fig. 6.16. Major painters of later dynasties would develop the painterly style into the mainstream of ink landscape painting, whereas the linear style would sink for the most part to the level of the professional craftsman-painters, and the boneless style would reappear

FIGURE 6.24 (OPPOSITE) Covered jar with swing handle, decorated with parrots and peonies. Beaten silver with traced decoration in gilt. Ht. 24 cm. Excavated at Hejiacun, Xi'an, Shaanxi. Tang dynasty, eighth century.

FIGURE 6.25 (RIGHT) Octagonal wine cup. Beaten silver with traced and relief decoration in gilt. Ht. 6.5 cm. Excavated at Hejiacun, Xi'an, Shaanxi. Tang dynasty, eighth century.

from time to time in, for example, the idiosyncratic landscapes of Mi Fu and his son Mi Youren (see fig. 7.24) and in the painting of flowers.

In the last century of the Tang, the focus of cultural activity shifted from Chang'an and Luoyang to the southeast, which was rapidly becoming more populous and more prosperous. In the region of Nanjing and Hangzhou, landscape painters now made their most daring experiments in "breaking the ink," while the weakening of traditional restraints on artistic, as on social, behavior encouraged the eccentrics to indulge in techniques of ink flinging and splashing as wild as those of the New York School of the 1950s. The work of these expressionists, alas, is lost, but their styles were taken up by some of the Chan painters of the tenth century and again in the late Southern Song.

DECORATIVE ARTS

The objects, apart from painting and sculpture, with which our Western collections illustrate the achievement of Tang culture are, for the most part, grave goods. Although they have appealing vigor and simplicity, they bear little relation to the finest of Tang crafts. But masterpieces of Tang decorative arts were buried for a variety of reasons. Two pot-

tery jars unearthed in 1970 at Hejiacun, Xi'an, were crammed with gold and silver vessels and other treasures believed to have been buried when their owner fled from the rebel An Lushan in 756. Among the finest pieces was the covered jar illustrated in fig. 6.24, decorated with parrots and peonies in gilt repoussé, which was probably made by immigrant Sogdian craftsmen in Chang'an. Many of the other shapes—such as the stem cup, foliated bowl, flat platter, and octagonal wine cup (fig. 6.25)—are of western Asiatic origin; the decoration, applied with a typically Tang lavishness and delicacy, includes animals and figures, hunting scenes, flowers and birds, generally chased or engraved and set off against a background of rows of tiny punched circles, a technique borrowed from Sasanian metalwork.

When a pagoda was consecrated, it was the custom to place a relic and other treasures in a chamber beneath it. In 873 the emperor presented (or sent back from the palace) a rich treasure in gold and silver to Famensi, a temple under imperial patronage 70 miles (112 km) west of Chang'an. The temple pagoda partially collapsed in 1981. Before it was reconstructed, archaeologists opened a series of underground chambers, resembling a royal tomb, to reveal a hoard of treasures of palace quality.[8] They included, in addition to a reputed finger bone of the Buddha, relic

FIGURE 6.26 (ABOVE) Casket for Buddha relic. Gilded silver with pearls. Ht. 50 cm. From the deposit under Famensi in Fufeng, Shaanxi. Late Tang period.

FIGURE 6.27 (ABOVE RIGHT) "Lion and grape" mirror. Bronze. Diam. 24.1 cm. Tang dynasty. Formerly in the collection of Mr. and Mrs. Myron S. Falk, New York.

caskets of gold and silver (fig. 6.26), gold and silver incense burners, a gold monk's staff, a variety of silk textiles, fine glassware, a tea service, and Yue ware porcelain of a quality not seen before in modern times.

Yet, as discoveries in China multiply, they are unlikely to match what is still the richest collection of Tang-style decorative arts in the world—the contents of the Shōsōin Repository, which were presented to Tōdaiji Temple in Nara in 756 by the widow of the emperor Shōmu. This remarkable collection contains furniture, musical instruments, and gaming boards painted, lacquered, or inlaid with floral designs in mother-of-pearl, tortoiseshell, gold, and silver; in addition, there are glass vessels, mirrors, silk brocades, maps, paintings, and calligraphy. Many of these masterpieces of craftsmanship must have been imported from China.

Extravagant Tang taste also demanded that mirror backs be gilded or silvered. The old abstract and magical designs gave way to a profusion of ornament auspicious in a more general way: symbols of conjugal felicity, entwined dragons, phoenixes, birds, and flowers in relief or inlaid in silver or mother-of-pearl. The influence of Manichaean symbolism may be seen in the "lion and grape" design (fig. 6.27), which was popular for a short time; its sudden disappearance may have coincided with the suppression of foreign religions in 843–45.

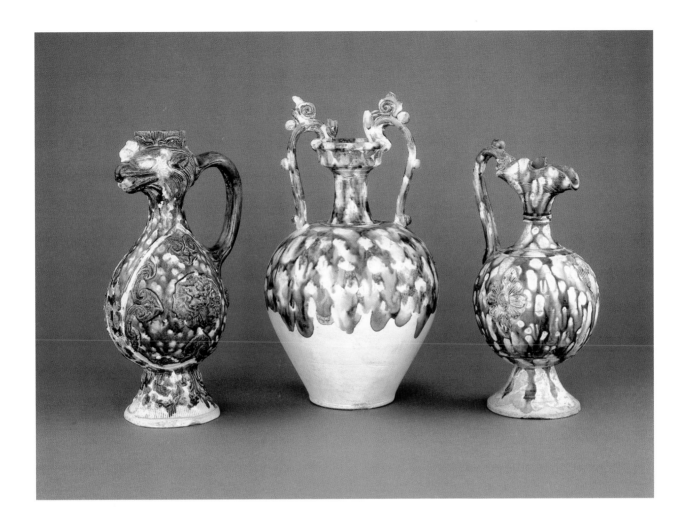

CERAMICS

Tang ceramics, too, made much use of foreign shapes and motifs (fig. 6.28). The metal ewer was copied in stoneware, often with appliqué designs in relief under a mottled green and brown glaze; the rhyton was reproduced from an old Persian shape; the circular pilgrim bottle, which appears in the blue-glazed pottery of Parthian Persia and Syria, reappears in China decorated roughly in relief with vintaging boys, dancers, musicians, and hunting scenes. The Hellenistic amphora in Chinese stoneware loses its static symmetry: the playful dragon handles, the lift and buoyancy of its silhouette, the almost casual way in which the glaze is splashed on—all bespeak the touch of the Chinese craftsman, who brings the clay to life under his hands. Not all

FIGURE 6.28 Two ewers and an amphora. Pottery slipped and decorated with three-color glaze. Ht. (left to right) 28 cm, 31.2 cm, 27 cm. Tang dynasty. © The Trustees of the British Museum, London.

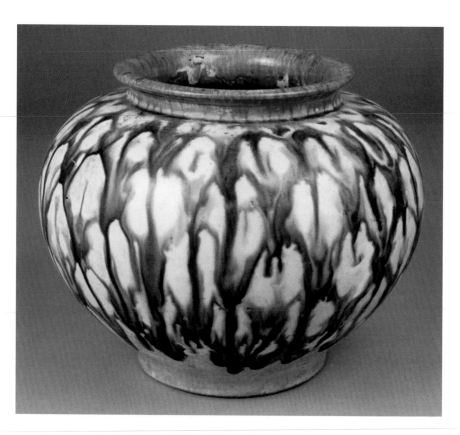

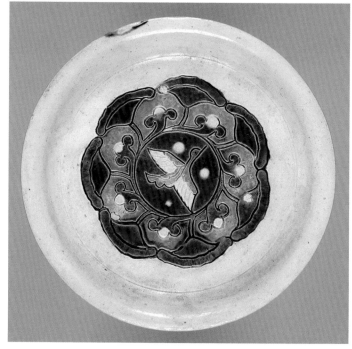

FIGURE 6.29 Jar. Pottery slipped and decorated with splashed polychrome glaze. Ht. 17.9 cm. Tang dynasty. The Avery Brundage Collection. © Asian Art Museum of San Francisco.

FIGURE 6.30 Dish. Pottery stamped and decorated with polychrome glaze. Diam. 19 cm. Tang dynasty. Gift of Sir Herbert Ingram, Ashmolean Museum, Oxford.

the customers for these wares were Chinese. Many Sogdians had settled in Chang'an, chiefly merchants, who controlled the caravan routes to the West. They were rich, often took Chinese names, spoke Chinese, and followed Chinese burial customs.

The Tang dynasty is notable in the history of Chinese ceramics for the dynamic beauty of its shapes, for the development of colored glazes, and for the perfecting of porcelain. No longer are potters limited to the simple green- and brown-tinted glazes of the Han. A white ware with blue-green splashes was already being made in north China under the Northern Qi dynasty (550–577). The fine white earthenware of the Tang dynasty is often clothed in a polychrome glaze (fig. 6.29) made by mixing copper, iron, or, more rarely, cobalt (imported from Afghanistan) with a colorless lead silicate to produce a rich range of colors, from blue and green to yellow and brown; and the glaze is applied more thinly than before (often over a white slip), is generally finely crackled, and stops short of the base in an uneven line. Dishes are stamped with foliate or lotus patterns and decorated with colored glazes confined by the incised lines of the central design, whereas elsewhere the colors tend to run together (fig. 6.30).

These typical Tang wares, now called *sancai* (three-colored), were made in kilns chiefly located in Hebei, Shaanxi, Henan, and Sichuan. Production declined after the An Lushan rebellion of 755, although it continued in Sichuan and later in the north under the Liao dynasty. The Tang love of rich effects is also seen in the marbled wares, made by mixing a white and a brown clay together and covering the vessel with a transparent glaze. The more robust Tang wares were exported in large quantities by the caravan routes to the Near East, where they were imitated in the poor-quality clay of Iran and Mesopotamia, while the Changsha wares were shipped from the southern ports to the Philippines and Indonesia, India and East Africa, a trade that grew steadily with the centuries, while that across central Asia eventually dried up altogether.

As we saw in chapter 5, two different ceramic traditions had developed north and south of the Yellow River–Yangzi River watershed. Probably during the Sui dynasty the north China potters perfected true porcelain—a hard, translucent ware fused at a high temperature with the aid of a flux, which causes it to ring when struck. In 851 *The Story of China*

and India, a work in Arabic by an unknown author, appeared in Basra. It contained information about the Cantonese supplied by a merchant named Sulaiman, who writes: "They have a pottery of excellent quality, of which bowls are made as fine as glass drinking cups; the sparkle of water can be seen through it, although it is pottery."[9] Indeed, this white ware was in demand far beyond China's shores, for fragments of it were found in the ruins of the Abbasid city of Samarra, in Iran, which was the summer residence of the caliphs from 836 to 883. Although the site was inhabited after that date, most of the huge quantity of shards found there belong to the years of its heyday and bear witness to a flourishing export trade in Chinese ceramics.

What was this white ware?[10] An almost pure white stoneware was being produced in Gongxian, Henan, early in the seventh century. But the Gongxian kilns, from recent studies, have another claim to our attention. The blue and white porcelain that was to become famous throughout the world in later centuries was long thought to have originated in the Jingdezhen kilns in the fourteenth century or a little earlier (see chapter 8). But three high-fired dishes decorated with floral patterns in underglaze blue (fig. 6.31) were part of the cargo of a ship that went down in the ninth century off the island of Belitung in the Java Sea, while in 1975, in excavating the old prosperous Tang city of Yangzhou on the Grand Canal, Chinese archaeologists unearthed shards of a white ware with underglaze cobalt blue decoration that included both Chinese brush motifs and geometrical designs that originated in western Asia.[11] They have shown that this Tang dynasty blue and white ware was made in the Gongxian kilns in Henan. It seems that, gauged from finds so far, production of Gongxian blue and white was never great and that the technique was forgotten after the brief Five Dynasties period.

There was another Tang ware that was whiter and finer still. An *Essay on Tea* (the *Chajing*) written, it is believed, by the poet Lu Yu in or before 760, says that for drinking tea one should use Yue bowls, which give it the coloring of ice or jade, or the ware of Xingzhou, which is as white as snow or silver. For many years no one knew what this Xing ware was, and efforts to find the kilns in the Xingzhou district of Henan failed. But in 1980 and 1981 kilns were discovered in Linchengxian, a little to the north, that produced a ware that exactly fits Lu Yu's description. The exquisite

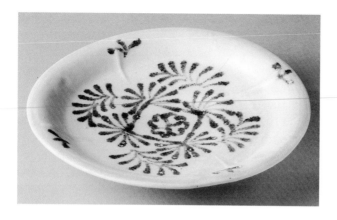

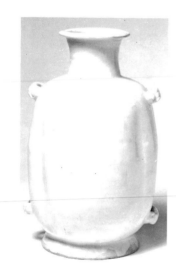

vase in fig. 6.32, excavated in Xi'an in 1955, may well be an example of Xing ware. As the white wares became more popular, kilns that made them began to multiply. In the latter half of the dynasty, the south was imitating the north. In Jiangxi, for example, a pale bluish-white ware, the predecessor of the lovely Song *qingbai* (or *yingqing*), was already being made in the Shihuwan kilns near Jingdezhen, which by the Southern Song was to become the ceramic capital of China.

In the meantime, Hunanese potters working in the kilns of Youzhou and Tongguan, north of Changsha, were experimenting with what may have been the first underglaze painting in Chinese ceramic history.[12] Some of their jars, dishes, and ceramic pillows (fig. 6.33) are vigorously, if crudely, decorated with birds and flowers painted under the transparent glaze in a brown made from iron oxide or a green or blue derived not from cobalt, as in north China, but from copper oxide. Another illustration of the vigor and adventurousness of Tang ceramics is the hard gray stoneware, ancestor of the famous Jun wares of the Song dynasty, that was made in kilns at Huangdao, not far from Junzhou. The full, massive shapes covered with a rich brown or black glaze are often made even more striking by bluish-white phosphatic splashes (fig. 6.34).

In north China the high-fired stoneware with a bluish or greenish glaze continued through the Tang, to find its most perfect expression in the "northern celadon" of the Northern Song period. But in the north, celadon—or what Chinese experts now call simply "green ware"—was only one of several traditions, whereas in southeast China it was the principal one. Before the end of the Tang, Yue ware had reached a high level of perfection at the Shanglinhu kilns near Hangzhou. The body is porcelaneous, and bowls and vases are sometimes decorated with molded or incised flowers and plants under an olive-brown glaze.

Most highly prized of the products of the Yue kilns was the *mise* ("secret color") ware described in a ninth-century poem as having a "kingfisher blue" glaze. Until the 1980s, no Yue ware matching this description had been discovered. But among the treasures in the Famensi deposit mentioned above were sixteen pieces of a greenish-blue porcelain that may well be the mysterious *mise* ware (fig. 6.35). It seems to have been the finest and rarest of the "tribute wares" sent up to the Tang court from the Yue kilns. Yue ware of everyday quality (fig. 6.36) was an important item in the export

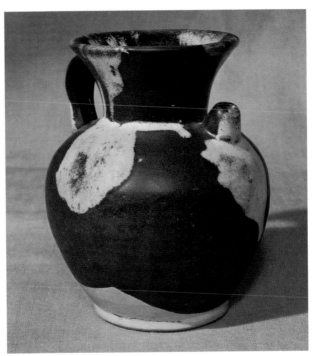

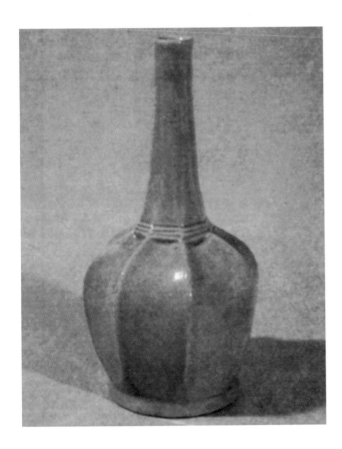

FIGURE 6.34 (ABOVE) Jar. Huangdao ware. Stoneware carved with a brownish-black splashed glaze. Ht. 14.7 cm. Tang dynasty. The Barlow Collection, University of Sussex.

FIGURE 6.35 (LEFT) Vase. *Mise* ("secret color") porcelain with bluish-green glaze. From the deposit under Famensi in Fufeng, Shaanxi. Late Tang period.

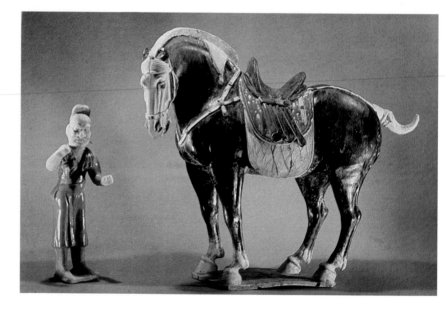

FIGURE 6.36 (ABOVE)
Lobed bowl. Yue stoneware covered with grayish-olive glaze. Diam. 19 cm. Tang dynasty. Victoria and Albert Museum, London. V&A Images.

FIGURE 6.37 (RIGHT)
Horse and groom. Pottery with polychrome glaze over white slip. Horse ht. 66.5 cm. Excavated in Luoyang, Henan. Tang dynasty.

trade of the increasingly prosperous southeast. Huge quantities of it have been found at Samarra, in Iran; at Fostat, south of Cairo; and in sites in southeast Asia, Indonesia, Borneo, and the Philippines.

That most of the Tang wares we enjoy today were made neither for the collector's pleasure nor even for domestic use but simply as cheap grave goods probably accounts for their unsophisticated charm and vigor. These qualities are most apparent in the great numbers of figurines placed in the tombs (fig. 6.37), which give a vivid picture of daily life in Tang times. They vary in size from animals and toys a few inches high to gigantic horses, Bactrian camels, armed men, and fantastic squatting guardian creatures popularly called *qitou* or *bixie*. They include a fascinating array of officials, servants, dancing girls, and musicians (figs. 6.38 and 6.39); indeed, among them women predominate.

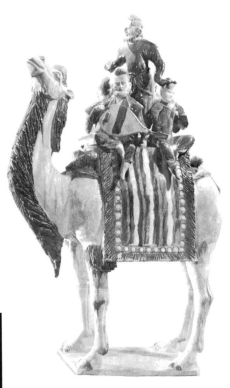

FIGURE 6.38 (RIGHT) Camel with central Asian musicians on its back. Pottery with polychrome glaze over white slip. Ht. approx. 70 cm. From a tomb at Xi'an, Shaanxi. Tang dynasty.

FIGURE 6.39 (BELOW) Entertainers. Pottery, painted over a grayish-white slip. Ht. of tallest figure 25 cm. Tang dynasty. Courtesy of Giuseppe Eskenazi, London.

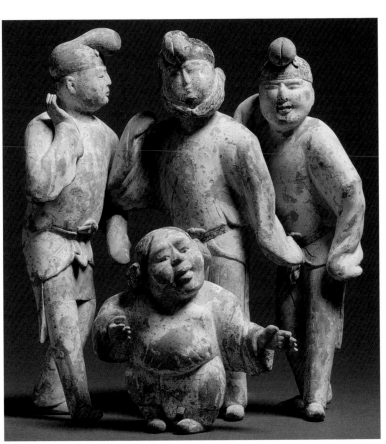

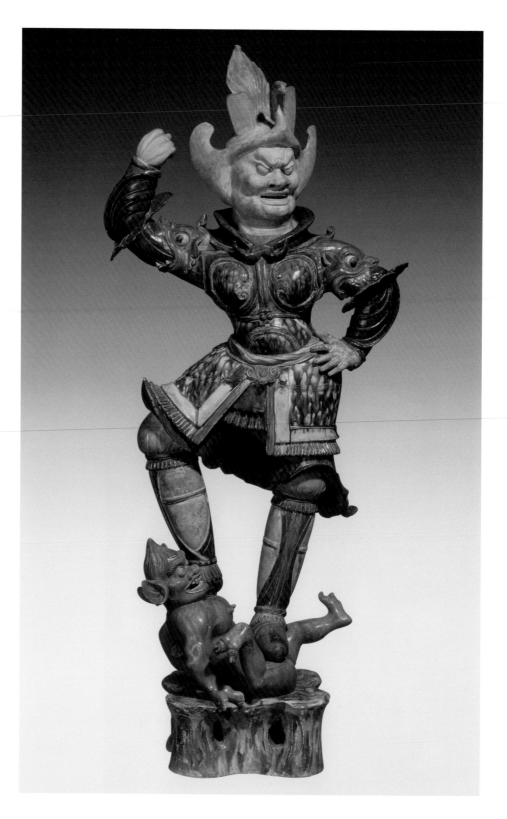

Women rode horseback with the men and even played polo. A passage in the "Treatise on Carriages and Dress" in the *Jiu Tangshu* (Old Tang history) records that "at the beginning of the Kaiyuan period [713–742] the palace ladies who rode behind the carriages all wore central Asian hats, exposing the face, without a veil. Suddenly, their hair also was exposed when they broke into a gallop. Some were wearing men's dress and boots."[13]

Something of the gaiety of Tang courtly life is captured in these pottery figurines. The fairylike slenderness of the Six Dynasties women gives way in the fashion of the eighth century to an almost Victorian rotundity; Yang Guifei herself was said to have been plump. But these women make up in character what they lack in elegance. And Chinese potters clearly derived much amusement from caricaturing the extraordinary clothes, the beards, and the great jutting noses of the foreigners from central and western Asia. The human figurines were almost always made in molds, with the front and back cast separately, while the larger figures and animals were made in several pieces, generally with the base, or underside of the belly, left open. The *sancai* figurines, which in time acquired a minute crackle diffi-

cult for the forger to imitate, were reserved for the imperial family and high officials—the tomb of Princess Yongtai contained 172 *sancai* figurines—while lesser persons had to be content with figurines painted on the clay after firing. The earliest datable *sancai* figurines were found in a tomb near Xi'an of 663; production declined sharply in the chaos following the An Lushan rebellion of 755, but tomb finds show that they were still being used as late as 850.[14]

The most spectacular of the Tang figurines are the fierce armed men who are often modeled standing on demons (fig. 6.40). They may represent actual historical figures. Once, when the emperor Taizong was ill, ghosts started screeching outside his room and throwing bricks and tiles about. A general, Qin Shubao, who claimed that he had "killed men like chopping up melons, piling up corpses like ant-hills," offered, with a fellow officer, to stand guard outside the imperial sickroom, whereupon the screeching and brick throwing abruptly ceased. The emperor was so pleased that he had the generals' portraits painted to hang on either side of his palace gate. "This tradition," the Tang source tells us, "was carried forward into later years, and so these men became door-gods."[15]

THE FIVE DYNASTIES
AND THE SONG DYNASTY

Tang China never fully recovered from the An Lushan re-bellion, and gradually what had been a great empire shrank in both body and spirit. The loss of central Asia to Islam, the Tibetan invasion, rebellions by warlords and peasants, and the consequent breakdown in the irrigation system on which prosperity and good order depended—all made the downfall of the dynasty inevitable. In 907 China finally disintegrated into the state of political chaos dignified by the name of the Five Dynasties. The title is an arbitrary one, chosen to cover those royal houses that had their capitals in the north; set up mostly by military adventurers, they had such grandiose names as Later Tang, Later Han, and Later Zhou. Between 907 and 922, the Later Liang had four rulers belonging to three different families. Although the south and west were divided among the Ten (Lesser) Kingdoms, in fact those regions were far more peaceful and prosperous.

As before when the country was divided, Sichuan had a flourishing culture. Chengdu, the capital of the Former Shu, was distinguished by its scholars, poets, and painters, who, when the country was reunited under the Song, were to make their way up to the new capital, Bianjing (modern Kaifeng), taking with them the great traditions of figure and flower painting that they had inherited from the late

Tang. The style of late Tang decorative art is reflected in the jades, silver work, and sculpture found in 1942 in the tomb of the Former Shu ruler Wang Jian, who died in 918 (fig. 7.1).

Meanwhile, as before, the northern barbarians watched with patient interest the disintegration of their old enemy. In 936 the first ruler of the Later Jin made the fatal gesture of ceding sixteen prefectures encompassing northern Hebei and Shanxi provinces to the Qidan, with the result that once again the nomads had a footing in north China. Ten years later they established the kingdom of Great Liao over a wide area of north China (map 7.1), which was not to be finally restored to Chinese hands for over four hundred years. With the addition of Chinese territories, the Liao also gained Chinese artisans skilled in ceramics and in wood and metal working. Early Liao art such as ceramic production, gold and silver wares, and tomb mural paintings share close ties with late Tang and Five Dynasties practices.

In 959 the last emperor of the Later Zhou died, and in the following year the regent, General Zhao Kuangyin, ascended the throne as the first emperor of a new dynasty. At first it seemed that the Song would be just one more in a succession of short-lived houses. But Zhao was an able

FIGURE 7.1 Warrior supporting funerary platform, with musician in the background. Stone. Ht. 60 cm. From the tomb of Wang Jian (d. 918) at Chengdu, Sichuan. Five Dynasties period.

MAP 7.1 China in the Song dynasty

FIGURE 7.2 (OPPOSITE) Detail of a wood-cut illustration to the *Bizangquan* commentary on the Buddhist *Tripitaka*. Printed in 1108. Ht. 22.6 cm. Northern Song dynasty. Harvard Art Museum, Arthur M. Sackler Museum, Louise H. Daly, Anonymous and Alpheus Hyatt Funds. Photo © President and Fellows of Harvard College.

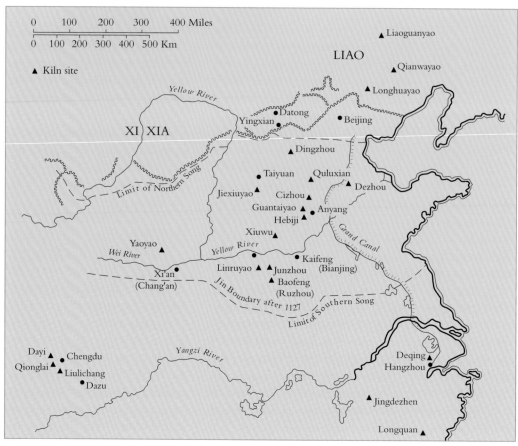

man; in sixteen years of vigorous campaigning he had practically united China, though, as L. C. Goodrich observed, the Song armies never succeeded in breaking the iron ring around the imperial boundaries: the Qidan, the Jurchen Tungus (until 1234), and the Mongols held firm in the north, as did the Tangut, a Tibetan people (c. 990–1227), and the Mongols in the northwest and Annam and Nanchao in the southwest. In 1125 the dynasty suffered a disaster from which it barely recovered when the Jurchen raided the capital at Bianjing and captured the whole court, including the emperor Huizong, famous throughout history as a painter, collector, and connoisseur. By 1134 the Jurchen had destroyed the remnants of the Liao empire as well. In 1127 a young prince and the remaining Song officials had fled south beyond the barrier of the Yangzi, where the court wandered from place to place for several years before setting up what they hoped was to be their temporary capital at Hangzhou. The Jurchen, who named their dynasty Jin, were now in control of all China north of the Yangzi River–Yellow River watershed. Like the Liao before them, they were prevented from making further incursions into Song territory only by the enormous tribute China paid every year, chiefly in coin and rolls of silk, until Genghis Khan with his savage hordes descended from the north, obliterating friend and foe alike.

Hemmed about by hostile powers, the Song turned inward. Han China had lived in a fabulous world whose boundaries were mythical Kunlun and Penglai far beyond the horizon. Tang China had embraced central Asia and welcomed all that the West had to offer. Now Song China, at peace with itself and buying peace with its neighbors, examined the world with a new curiosity, a deeper reverence. During the Song, China rediscovered the world of feeling and imagination revealed in the Six Dynasties and then lost under the strong light of Tang positivism. The depth of Song philosophical insight, combined with a perfect balance of creative energy and technical refinement, made the tenth and eleventh centuries one of the great epochs in the history of Chinese art.

During this time China was ruled by a succession of emperors as cultivated as any in history. Under them, the intellectuals who ran the government formed an elite who were permitted to remain seated in the imperial presence and to debate rival policies with complete freedom. Their prestige was perhaps partly due to the rapid spread of print

ing, for which Chengdu, the capital of Shu, was already the chief center in the tenth century. There the first paper money had been printed; between 932 and 953 the first edition of the *Classics* was issued in 130 volumes, and before the end of the tenth century the Buddhist *Tripitaka* (fig. 7.2) appeared in over five thousand volumes, along with the Daoist canon. With the aid of this new craft it became possible to synthesize knowledge as never before, and there began the unending compilation of dictionaries, encyclopedias, and anthologies that was to become ever more characteristic of Chinese intellectual activity until the Revolution of 1911.

This desire for intellectual synthesis led Zhou Dunyi and Zhu Xi to establish the doctrine of Neo-Confucianism, in which the Confucian moral principle (*li*) was identified with the Daoist first cause (*taiji*)—seen as both a metaphysical and a moral force—and was at the same time enriched by a theory of knowledge and a way of self-cultivation derived partly from Buddhism. To the Neo-Confucians, *li* became the governing principle that gives to each form its inherent nature. By "investigating things"—that is, by a process

of study, part scientific and part intuitive, that leads outward from the near and familiar—the cultivated man could deepen his knowledge of the world and of the workings of *li*. The realism of Northern Song painting—whether revealed in the texture of rocks, the form of flowers and birds, or the construction of a riverboat—bears witness to a profound and subtle examination of the visible world that found philosophical expression in early Neo-Confucianism.

An important by-product of the Confucian revival, or a parallel manifestation of the same backward-looking impulses perhaps, was a new interest in ancient arts and crafts. The consequent demand for reproductions of archaic ritual vessels and implements in bronze and jade was to grow with the centuries (fig. 7.3). Although there is little secure evidence for dating these reproductions, the general opinion is that those of the Song dynasty are on the whole more accurate and archaic in feeling than those of the Ming and Qing. Illustrated catalogues of the bronzes and jades in the collection of the emperor Huizong were published in the twelfth century (fig. 7.4); their subsequent reprinting in less reliable editions served as the source for many of the fanciful reproductions of later centuries.

FIGURE 7.3 (ABOVE) Winged lion in the style of the Warring States period. Bronze inlaid with gold and silver. Ht. 21.5 cm. Attributed to the Song dynasty. © The Trustees of the British Museum, London.

FIGURE 7.4 (RIGHT) A page from the *Xi Qing gujian yipian*, supplement to the illustrated catalogue of bronzes in the collection of the Qianlong emperor, showing a *you* vessel similar to that in fig. 2.20 and its inscription. Qing dynasty. Modern reprint.

FIGURE 7.5 (OPPOSITE TOP) Seven-tiered bracket for a palace hall. Woodcut illustration from the Song dynasty builders' manual *Yingzao fashi* (1925 ed.).

FIGURE 7.6 (OPPOSITE BOTTOM) The eight-sided pagoda of Fogongsi at Yingxian, Shanxi. Ht. approx. 60 m. Built 1058. After a drawing by Liang Ssu-ch'eng.

ARCHITECTURE

It is in character with the synthesizing trend of the period that the first great manual of rigidly standardized architectural practice—the *Yingzao fashi,* presented to the emperor in 1100—should have been written in the Song dynasty.[1] In it the author, Li Jie, a practicing architect in the Board of Works, combines historical scholarship with straightforward technical information on materials and construction, which in his time was becoming increasingly complex and refined, if not so grand in scale as in the Tang dynasty. The *ang,* for example, is no longer a simple cantilevered arm jutting out to hold up the eaves; it is cut loose from supports at either end and poised on top of an intricate bracketing system held in balance by a complex play of stresses and strains (fig. 7.5). In time this intricacy for its own sake would lead to degeneration, but in Song timber construction it combines structural boldness with refinement of detail. Song taste also preferred the delicate to the robust, the tall and slender to the gigantic and solid. The capital, Bianjing, was a city of towers. Temples had roofs of yellow tiles and floors of yellow and green. Timber and stone pagodas now acquired little projecting roofs at each story, curving up at the point where two faces met.

Like the Toba Wei, the Liao and Jin fostered Buddhism because they too were aliens on Chinese soil, and their patronage inspired a revival of the faith in north China as well as in the Song domain itself. The eight-sided pagoda of Fogongsi (fig. 7.6) in Yingxian in Shanxi, built in 1058 under Liao patronage, is one of the few surviving examples of a major Song-style pagoda—rich in detail, dynamic in bracketing, noble in proportion. In the city of Datong in northern Shanxi, a secondary capital under both the Liao and the Jin, two important temples stand side by side: Lower Huayansi, completed in 1038 under the Liao and still virtually intact, and Upper Huayansi, rebuilt after a fire in 1140, although its five great Buddhas were remade in the Ming dynasty and its frescoes repainted late in the nineteenth century. At Lower Huayansi not only is the sculpture original but the walls also retain the original sutra cases fashioned like scaled-down pavilions, their intricate carpentry providing a rare example of the style of the period. In this sumptuous shrine, architect and sculptor have combined their arts in the service of theology to create a fabulous Buddha world by which the worshiper, on entering the hall, is surrounded and enveloped (fig. 7.7). Buddhas, bodhisattvas, guardians,

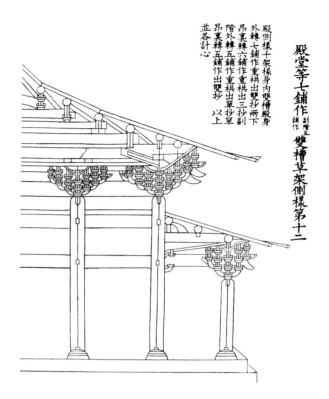

殿堂等七鋪作_{副階五}雙槽草架側樣第十二

殿側樣十架椽身內雙槽殿身
外轉七鋪作重栱出雙抄兩下
昂裏轉六鋪作重栱出三抄副
階外轉五鋪作重栱出單抄單
昂裏轉五鋪作出雙抄
並各計心 以上

FIGURE 7.7 (ABOVE) Interior of Lower Huayansi, Datong, Shanxi. Liao dynasty, 1038. Photo by the author, 1975.

FIGURE 7.8 (OPPOSITE) *Luohan (arhat)*. Pottery with polychrome glaze. Ht. 105 cm. From Yizhou, Hebei. Liao dynasty, tenth to eleventh century. The Metropolitan Museum of Art, New York; Frederick C. Hewitt Fund. Photo: Lynton Gardiner; © 1989 The Metropolitan Museum of Art.

and *arhats* take their apportioned place in a gigantic three-dimensional mandala, the total effect of which is to saturate the eye, and the mind of the believer, with the manifold and all-embracing powers of God.

SCULPTURE

One of the most impressive examples of Liao sculpture is the set of pottery figures of *luohan (arhats)* found in the 1920s in a cave at Yizhou near Beijing. One is in the British

Museum, and five more are in other Western collections. When they were discovered, the vigorous modeling, the dignity and realism, and above all the three-color glaze all suggested a Tang date because at the time the possibility that the Liao and Jin had produced art of any quality was not seriously considered. But it is now known that north China in the tenth to twelfth centuries was the center of a flourishing culture that preserved the traditions of Tang art, with subtle differences, not only in sculpture but also in ceramics. These figures, and others executed in dry lacquer, are not so much portraits of individual monks as expressions of a variety of spiritual states. In the face of the young *arhat* in the Nelson-Atkins Museum is portrayed all the inward struggle, the intensity of concentration, of the meditative sects of which Chan was the chief. When we turn to the figure in the Metropolitan Museum (fig. 7.8), we see in the bony skull, lined features, and deep-set eyes of an old man the outcome of that struggle; it has taken its toll of the flesh, but the spirit has emerged serene and triumphant.

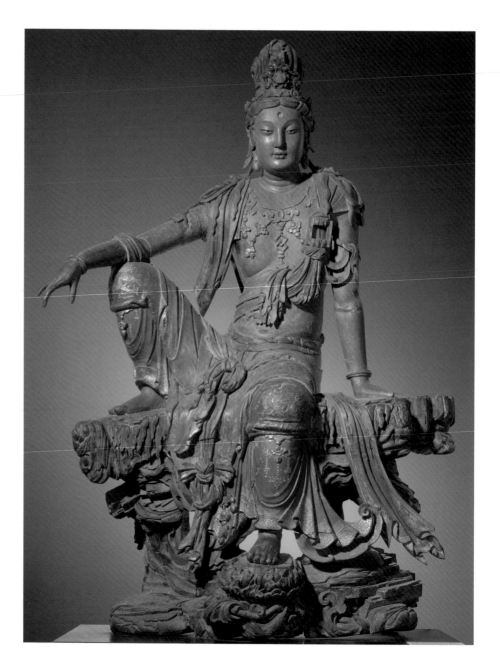

But not all sculpture of this period was an archaistic revival or a prolongation of the Tang tradition. The figures in wood and plaster represent an evolution beyond the Tang style. The Buddhas and bodhisattvas are still fully modeled—even to the extent of a fleshiness that can be displeasing—but what they have lost in dynamic energy they have gained in a new splendor of effect. They stand against walls cov-ered with huge frescoes painted in the same ample and spectacular manner. In fact, so closely does the style of the one echo that of the other that Laurence Sickman's vivid description of the sculpture could apply equally to the painting:

An almost uncanny impression of movement, as though the gods were stepping forward with an easy, stately pace,

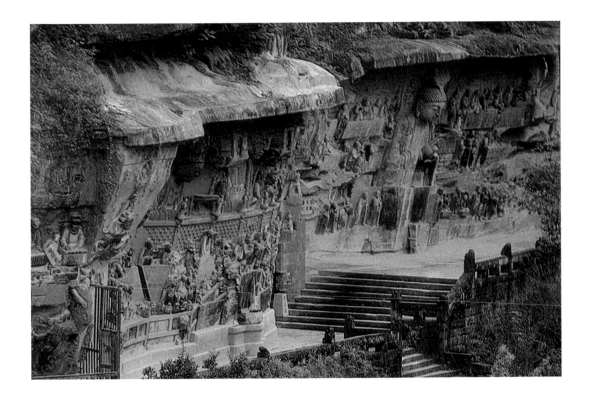

or had just taken their seats on the lotus throne, is produced by the great agitation and restless movement of the garments and encircling scarves. These latter accessories are especially important in creating an almost spiral movement in three dimensions as the long, broad ribbons trail over the arms, loop across the body and curve around the back. In the actual carving the folds are deep, with sharp edges, so that the maximum contrast is obtained between highlight and shadow. Frequently the ends of garments and scarves are caught up in whorls and spirals obviously derived from the calligraphic flourishes of painting.[2]

This suave and restless splendor was clearly designed, like that of the High Baroque art with which it has so much in common, to capture the attention of the worshiper through its emotional appeal. It is no accident that it finds its most splendid expression in the figures of Guanyin, the comforter, the giver of children, the preserver from peril of all those who call her name. She looks down upon suffering humanity with calm detachment; yet she is not indifferent, and her regard is full of sweetness without being sentimental, although the bodhisattva on the right in the photograph from Huayansi (see fig. 7.7) appears to be weeping for the sufferings of humanity. In the beautiful figure from the Nelson-Atkins Museum (fig. 7.9), a potential extravagance of effect is held delicately in check by the refinement of Song taste.

At another level, Song sculpture could be anything but refined. Although institutional Buddhism appealed less and less to the intelligentsia after the mid Tang, its doctrines of rewards and punishments continued to exert their hold on the common people. Some very down-to-earth Song religious art was produced for the edification of the masses, and some of the most interesting sites are in rather remote places. In chapter 6 we discussed the giant recumbent Buddha at Anyue in central Sichuan (see fig. 6.12). At Dazu, not far from Anyue, a local benefactor of the Southern Song period, around 1200, collected over many years the money to pay for the creation of an array of sculpture that covers a horseshoe-shaped cliffside 1,640 feet (500 m) long (fig. 7.10). On it are presented not only Buddhas and bodhisattvas but an astonishing display of reliefs illustrating Buddhist and Confucian moral tales, virtues and vices, judgments, rewards, and punishments (fig. 7.11). These vivid carvings belong to a tradition of popular didactic sculpture

that survived till recent times in Buddhist and Daoist temples and has been vigorously revived in the People's Republic for propaganda purposes, a striking example being *The Rent Collection Courtyard* of 1965, illustrated in fig. 11.26.

CHAN PAINTING IN THE FIVE DYNASTIES

Buddhism as a popular religion, however, never fully recovered from the suppression of 845. During the later Tang the speculative and Tantric sects decayed, partly because they had no roots in Chinese soil. But for the Chan sect (known in Japan as Zen) the position was different. Like Daoism, it emphasized quietism, self-cultivation, the freeing of the mind from all intellectual and material dross so as to leave it open and receptive to those flashes of blinding illumination when suddenly, for a moment, the truth is revealed. To create the right atmosphere for meditation, the Chan monks built their temples in beautiful secluded places where the only sound might be the wind in the trees and the rain falling on the stones of the temple courtyard. Their aims, and the very techniques by which those aims were to be realized, had much in common with the Daoists', although the Chan monks' practices were a good deal more strenuous. So it was chiefly in Chan that Buddhism, after nearly a thousand years in China, finally came to terms with Chinese ideals.

The Chan painter, in seeking a technique to express the

FIGURE 7.11 (ABOVE) Soul suffering the torments of hell. Detail of rock-cut sculpture at Dazu, Sichuan. Southern Song dynasty.

FIGURE 7.12 (RIGHT) In the manner of Shi Ke (active mid tenth century). *Two Minds in Harmony*. Part of a handscroll. Ink on paper. Ht. 44 cm. Song dynasty. Tokyo National Museum.

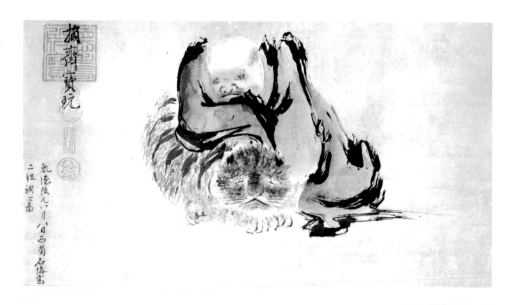

intensity and immediacy of his intuition, turned to the brush and monochrome ink and, with the concentration of the calligrapher, proceeded to record his own moments of truth in the outward forms of Buddhas and *arhats* or, indeed, of any subject that he chose to paint. Already in the last century of the Tang dynasty some artists were practicing techniques as wildly eccentric as those of any modern Western action painter. None of their work survives, but contemporary descriptions of it suggest that these individualists either were Chan adepts or were fired by the same impulse toward irrationality and spontaneity as that which inspired the Chan painters. Only slightly later Guanxiu, after a lifetime of painting Buddhist subjects in the lower Yangzi region, came, full of years and honor, to the court of Wang Jian at Chengdu, where he died in 912. His *arhats* were drawn with that exaggeration bordering on perversity that is typically Chan. With their bony skulls, huge eyebrows, and pronounced Indian features, they have the ugliness of caricature, as if only by deliberate distortion can the sudden, electrifying experience of the Chan mystic be suggested. Since the experience itself is incommunicable, all the artist can do is try to shock the viewer into awareness. But even to suggest that these paintings have a purpose may be suggesting too much, and we should see them simply as pictorial metaphors for an event, or "happening," in the mind that cannot be described. "Illumination," they seem to say, "is like this."

The few surviving copies of Guanxiu's work are treasured in Japan, where Zen long outlasted its popularity in China. When Guanxiu died, his mantle fell upon Shi Ke (fig. 7.12), a wild and eccentric individual who, according to an eleventh-century historian, "liked to shock and insult people and compose satirical rhymes about them." By this time, writers were fond of classifying painters into three grades: *neng* (capable), *miao* (wonderful), and *shen* (divine, superhuman); but for Shi Ke and his like even *shen* was not enough, for it still implied obedience to the rules. For these untamed masters they coined the term *yi*, meaning "completely unrestrained by rules." "Painting in the *yi* style," wrote another author, "is difficult; those who follow it . . . despise refinement and rich coloring and draw the forms quite sketchily, but grasp the natural [*ziran*] spontaneously."[3] The notion of *yi* was to crop up again and again in the history of Chinese painting to describe painters who, so far as the orthodox canons were concerned, were *hors concours*.

COURT PAINTING IN THE LATE FIVE DYNASTIES AND THE NORTHERN SONG

In the meantime quite another tradition was flourishing at Nanjing, whose painters might have raised their hands in horror at the antics of the fauves out in Chengdu. In the southern capital Li Houzhu, the "emperor" of the Southern Tang, had re-created in miniature the luxury and refinement of the Tang court under Minghuang. One recent writer describes the art produced under his patronage as the twilight of the Tang, another as premature Song; all we can say for certain is that it provides an important link between the two great epochs. Under Li Houzhu's patronage, the spirit of Zhou Fang and Zhang Xuan was reborn in Zhou Wenzhu and Gu Hongzhong. Fig. 7.13 shows a detail of a painting that is probably a close copy, dating from about the twelfth century, of a scroll by Gu Hongzhong depicting the nocturnal entertainments of the high official Han Xizai, rumors of whose thoroughly un-Confucian behavior with singing and dancing girls had reached the ears of the emperor. It is said that Li Houzhu sent a painter in attendance (*daizhao*) to observe and record what was going on and then confronted Han Xizai with the evidence of his dissipation. The scene looks respectable enough, but the casual attitudes of Han, his friends, and his singing girls, the meaningful glances, the figures half-hidden behind bed curtains, are all highly suggestive; indeed, not the least intriguing thing about this picture is the way in which licentiousness is suggested in a formal language of such exquisite refinement and dignity. The painting, which the fourteenth-century writer Tang Hou considered "not a pure and fitting object for a high-class collection,"[4] is also extremely revealing as a document on tenth-century costume, furniture, and porcelain and shows how lavishly paintings, including monochrome landscapes, were used in interior decoration, forming panels on the beds as well as tall free-standing screens. It would seem that the hanging scroll had not yet become fashionable.

In the Northern Song palace, the Jade Hall, the meeting place of the Hanlin Academicians, was decorated around three walls with huge panoramas of waves, clouds, and mountains by Dong Yu, and dominated in the center of the back wall by a landscape by Juran, of whom more below.[5] Behind the seat reserved for the emperor stood a screen painted by Guo Xi. Commissions like these inspired the masters to create huge compositions. Sadly, all that sur-

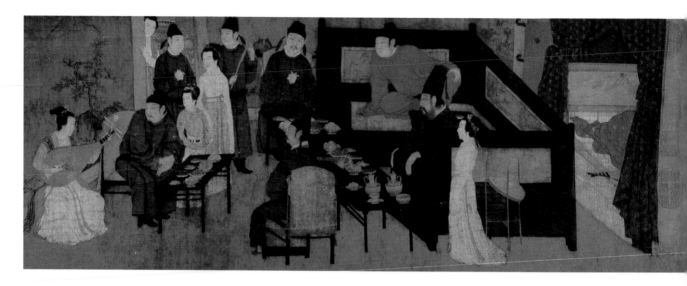

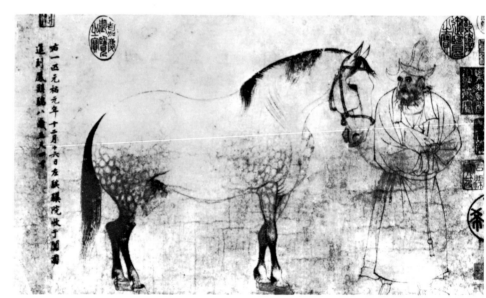

FIGURE 7.13 (ABOVE) Attributed to Gu Hongzhong (tenth century). *The Night Entertainments of Han Xizai.* Detail of a handscroll. Ink and color on silk. Ht. 29 cm. Probably a Northern Song copy (twelfth century). Palace Museum, Beijing.

FIGURE 7.14 (RIGHT) Attributed to Li Longmian (1046–1106). *Horse and Groom.* One of five tribute horses. Detail of a handscroll. Ink on paper. Ht. 30.1 cm. Northern Song dynasty. Formerly Manchu Household Collection, Beijing.

vive of them today are a few panels from screens, mounted as hanging scrolls.

The last great exponent of the Tang figure-painting tradition was Li Gonglin (1046–1106), better known as Li Longmian, from the name of his country estate, of which he, in emulation of Wang Wei, painted a long panoramic handscroll. Several versions of the scroll exist. Li Longmian moved in an intellectual circle at court that included the poet Su Dongpo and the historian Ouyang Xiu, and it is recorded that even the great statesman Wang Anshi,

who was "careful in choosing his friends," condescended to visit him. In early life Li was a famous painter of horses (fig. 7.14) until, so the story goes, a Daoist told him that if he continued much longer in this vein he would become like a horse himself, whereupon he switched to other themes. He was thoroughly eclectic, spending years copying the old masters, and though his own technique was restricted largely to ink line (*baimiao*), his subject matter included everything from horses and genre scenes to Daoist fairy landscapes, Buddhist figures, and paintings

of Guanyin amid rocks, of which he created an ideal conventional type. His sweeping brush line, characterized by a typically Song refining of the manner of Wu Daozi, also provided a model for figure painters that endured down to Ming times.

CONNOISSEURSHIP

The reverence for the past revealed in Li Longmian's sedulous copying of the old masters is from this point on to loom large in Chinese connoisseurship and to present the most formidable problems to the expert. In the case of a master we may assume that his motives were the honorable ones of training his hand and of transmitting the ancient models in the spirit of the sixth principle of Xie He. To paint in the manner of Wu Daozi, therefore, was no less original than for a pianist to play the works of Bach and Beethoven; for what the artist sought was not originality but a sense of identity, both with nature and with the tradition itself. The Western artist particularizes, and his painting is generally the result of a direct examination of what is before his eyes. The Chinese painter generalizes, and his work, ideally, reveals not the particular but the quintessential forms of nature, animated by his élan and by his mastery of the brush. Like the pianist, he must have the language of expression at his fingertips so that no technical impediment, no struggle with form or brushwork, should come between the vision and its realization.

An important part of his training is the study of the old masters. He might make an exact reproduction by tracing (*mu*), he might copy the picture with the original before him (*lin*), or he might freely interpret the manner of the master (*fang*). Paintings in either of the first two categories that passed into the hands of unscrupulous collectors or dealers would often acquire false signatures, seals, and colophons, and the new attribution would then be attested by further colophons. In many cases, such are the vicissitudes through which the painting has passed that the authenticity of an ancient masterpiece can never be proved, and the most that can be said is that a given work is in the style of a certain master or period and *looks* old enough and good enough to be genuine. Sometimes a painting is exposed as a copy by the subsequent appearance of a still finer version. In this most difficult branch of connoisseurship no expert has escaped being deceived; yet the recent tendency in the West toward an excessive caution is not shared by the majority of Chinese and Japanese connoisseurs.

LANDSCAPE PAINTING

THE CLASSICAL IDEAL IN NORTH CHINA

This uncertainty of authenticity applies particularly to the few great landscape paintings of the Five Dynasties and early Song that are generally attributed to such masters as Jing Hao, Li Cheng, Dong Yuan, and Juran, all of whom were working in the tenth century, and Fan Kuan, Xu Daoning, and Yan Wengui (fig. 7.15), who were active into the eleventh. In the hundred years between 950 and 1050, great names succeed one another in what must be looked upon as the supreme moment in classical Chinese landscape painting. Jing Hao, who was active from about 900 to 960, spent much of his life in retirement amid the mountains of eastern Shanxi. An essay attributed to him, the *Bifaji* (Record of brush methods) or *Hua shanshui lu* (Essay on landscape painting), puts his thoughts on the art into the mouth of an old man whom he pretends he met when wandering in the mountains and who gave him a lecture on principles and technique.[6] The old man tells him of the six essentials in painting: the first is spirit, the second rhythm, the third thought, the fourth scenery, the fifth brush, and the sixth ink. This system is more logical than Xie He's (see p. 102), for it proceeds from the concept to its expression, and thence to the composition, truth to nature (scenery), and finally technique. The sage further distinguishes between resemblance (which reproduces the outward, formal aspect of objects) and truth (which involves the inner reality), the synthesis of the two producing a perfect integration of form and content. He seeks a just correspondence of the type of brush stroke with the object depicted. He insists that flowers and trees should be those appropriate to the season, and that people be not larger than trees—not simply for the sake of objective realism, but because only by faithfully reproducing the visible forms of nature can the artist hope to express, through them, their deeper significance. To default in this, therefore, is a sign that the artist has not fully understood how nature operates.

This doctrine of a realism raised to the level of idealism is elaborated in a well-known essay by the eleventh-century master Guo Xi, who combined in his spectacular landscapes the strong drawing and jagged silhouette that we associate

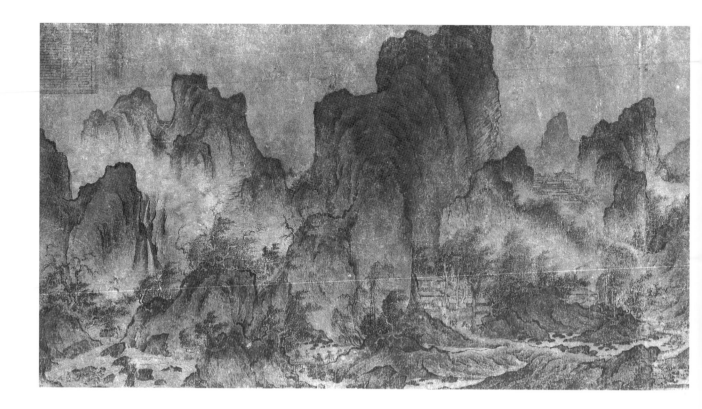

with Li Cheng with a modeling of relief in ink wash that probably derived from the late Tang individualists. His most famous work, the *Early Spring* of 1072 (fig. 7.16), is one of the key monuments of Northern Song painting. Guo Xi was to Song landscape as Wu Daozi had been to Tang Buddhist art—a painter of enormous energy and output who loved to cover large walls and standing screens with monumental compositions. In Guo's *Shanshuixun* (Advice on landscape painting), he insists again and again on the necessity, amounting to an ethical obligation, for the artist to study nature in every aspect—to mark the procession of the seasons, to compare the way the same scene may look at morning and evening, to note and express the unique character of every changing moment, to select with care, to impart movement to water and cloud—for, as he says, "watercourses are the arteries of a mountain; grass and trees its hair; mist and haze its complexion." Indeed, as the painter knows the very mountains to be alive, so must he transmit that life (*qi*) into the mountains that he paints.

PERSPECTIVE

How was it, then, that the Chinese painter, who insisted on truth to natural appearance, should have been so ignorant of even the elementary laws of perspective as the West understands it? The answer is that he deliberately avoided it, for the same reason that he avoided the use of shadows. Scientific perspective involves a view from a determined position and includes only what can be seen from that single point. While this satisfies the logical Western mind, it is not enough for the Chinese painter. Why, he asks, should we so restrict ourselves? Why, if we have the means to depict what we know to be there, paint only what we can see from one viewpoint? The Song dynasty critic Shen Gua took Li Cheng to task for painting "the eaves from below" and thereby putting an arbitrary restriction on his power to view "the part from the angle of totality." "When Li Cheng paints mountains, pavilions, and buildings," Shen writes in his *Mengqi bitan* (Casual writings from the Garden of the Stream of Dreams),

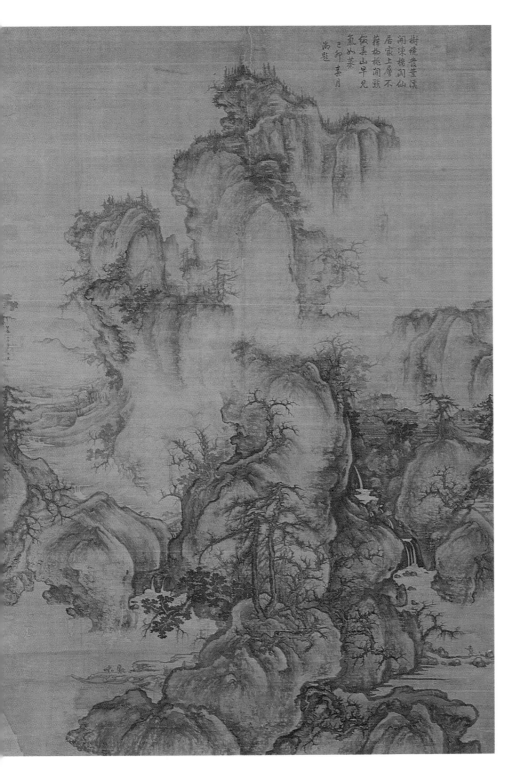

畫緣嵐葉溪
澗凍楼閣仙
居家上層不
藉枯枝簡疏
秋色山早兒
氣如著
己卯秋月
滿甚

FIGURE 7.15 (OPPOSITE)
Yan Wengui (active c. 970–1030).
Pavilion by Rivers and Mountains.
Detail of a handscroll. Ink and light
color on paper. Ht. 32 cm. Northern
Song dynasty. Osaka Municipal Mu-
seum of Fine Art.

FIGURE 7.16 (LEFT) Guo Xi
(c. 1010–c. 1090). *Early Spring*. Hang-
ing scroll. Ink on silk. Ht. 158.3 cm.
Northern Song dynasty, dated equiva-
lent to 1072. National Palace Mu-
seum, Taipei.

he paints the eaves from below. He believes that looking up one perceives the eaves of a pagoda as a person on the level ground and is able to see the beams and rafters of its structure. This is absurd. All landscapes have to be viewed from the angle of totality to behold the part, much in the manner in which we look at an artificial rockery in our gardens. If we apply Li's method to the painting of real mountains, we are unable to see more than one layer of the mountain at a time. Could that be called art? Li Cheng surely does not understand the principle of viewing the part from the angle of totality. His measurement of height and distance certainly is a fine thing. But should one attach paramount importance to the angles and corners of buildings?[7]

The single vanishing point was the problem. A long handscroll requires an infinite number of vanishing points, like the view of suburban gardens seen from a passing train. But for a symmetrical composition, such as the Paradise scene from Cave 172 at Dunhuang (of which a detail is illustrated in fig. 6.13), a single vanishing point would be in order. The artist understands that the receding side of a pavilion must diminish with distance, but the "front face" is always parallel with the picture plane, and each pavilion has its own vanishing point. This does not satisfy the scientific-minded, but for the Chinese it was enough, and it characterized the Chinese handling of this challenge until modern times.

THE AIMS OF THE LANDSCAPE PAINTER

The composition of a Chinese painting is not defined by the four walls of its mount as a European painting is by its frame. Rather, it is an expanse of space in which there may or may not be things. Moreover the images that the artist sets down on paper or silk, although they may be based on sketches done from life, are the distillation of years of looking at nature, expressed in a language of pictorial conventions learned from his master and from the past—a process that was later, quite logically, to be codified in artists' "how-to" manuals such as the *Painting Manual of the Mustard Seed Garden* (see p. 232). Yet however governed by conventions the language may be, it is brought to life in the artist's individual brushwork, while it carries the overtones of symbolic significance—not simply the symbolism of bamboo, pine, or lotus, but, more intangibly, the sense of what a Tang critic called "the image beyond the image," hinting at a meta-

physical truth, inexpressible in words, but made manifest above all in landscape painting.

In the passage I quoted from *Mengqi bitan,* Shen Gua clearly explains the attitude behind the "shifting perspective" of Chinese painting, which invites us to explore nature, to wander through the mountains and valleys discovering fresh beauty at every step. We cannot take in so great a panorama at a glance; indeed, the artist intends that we should not. We would need perhaps days or weeks to walk the length of the stretch of countryside he presents in his scroll; hence, by revealing it to us little by little as we proceed, he combines the element of time with that of space in a four-dimensional synthesis, an effect Western art did not attempt until modern times. The nearest European parallel was not in art but in music, in which the theme unfolds and develops over time. As we unroll as much of the great panorama as we can comfortably pass from right hand to left (never opening it out fully, as is done in museums), we find ourselves drawn unwittingly into the scene spread out before us. The artist invites us to follow him down the winding paths, to wait at the riverbank for the ferryboat, to walk through the village—disappearing from view for a few moments, perhaps, as we pass behind a hill—to reemerge and find ourselves standing on the bridge, gazing at a waterfall, and then perhaps to saunter up the valley to where a monastery roof can just be seen above the treetops, there to rest, fan ourselves after our exertions, and drink a bowl of tea with the monks. At the end of the scroll, the artist will leave us standing at the lakeshore, gazing out across the water to where distant peaks rise through the haze, while an infinity of space stretches above them, carrying us with it beyond the horizon. Or the artist may close the scroll with a rocky tree-clad spur in the foreground, and thus bring us back to earth once more. Only by a shifting perspective, which opens out a fresh view at every turn of the path, is such a journey possible. Indeed, we can only truly appreciate a great Chinese landscape painting if it has this power to send our spirits wandering.

This is not a fanciful intrepretation by a Western observer. The great Guo Xi wrote: "To look at a particular painting puts you in the corresponding mood. You seem in fact to be in those mountains. . . . You see a white path disappearing into the blue and think of traveling on it. You see the glow of the setting sun over level waters and dream of

gazing on it. You see hermits and mountain dwellers, and think of lodging with them. You see cliffs by lucid water or streams over rocks, and long to wander there."[8]

This power of a landscape painting to take us out of ourselves was widely recognized as a source of spiritual solace and refreshment. Guo Xi opens his essay by declaring that it is the virtuous man above all who delights in landscapes. Why the virtuous man in particular? Because, being virtuous (in other words, being a good Confucian), he accepts his responsibilities to society and the state, which tie him down to the urban life of an official. He cannot "seclude himself and shun the world," he cannot wander for years among the mountains, but he *can* nourish his spirit by taking imaginary journeys through a landscape painting into which the artist has compressed the beauty, the grandeur, and the silence of nature, and return to his desk refreshed.

FAN KUAN

The great masters of the tenth and eleventh centuries are sometimes called classical because they established an ideal in monumental landscape painting to which later painters were to return again and again for inspiration. In every case, the attributions to such masters as Jing Hao, Li Cheng, Guan Tong, and Guo Zhongshu are merely traditional. But by a miracle there has survived one masterpiece bearing the hidden signature of the great early Song painter Fan Kuan that is almost certainly an original from his hand.

Born about the middle of the tenth century and still living in 1026, Fan Kuan was a shy, austere man who shunned the world. At first, like his contemporary Xu Daoning, he modeled himself on Li Cheng, but then it came to him that nature itself was the only true teacher, and he spent the rest of his life as a recluse in the rugged Qiantang mountains of Shanxi, often spending a whole day gazing at the configuration of rocks or going out on a winter night to study with great concentration the effect of moonlight upon the snow. If we were to select one painting to illustrate the achievement of the Northern Song landscape painters, we could not do better than to choose his *Traveling amid Mountains and Gorges* (fig. 7.17), in which we see a train of packhorses emerging from a wood at the base of a huge precipice. The

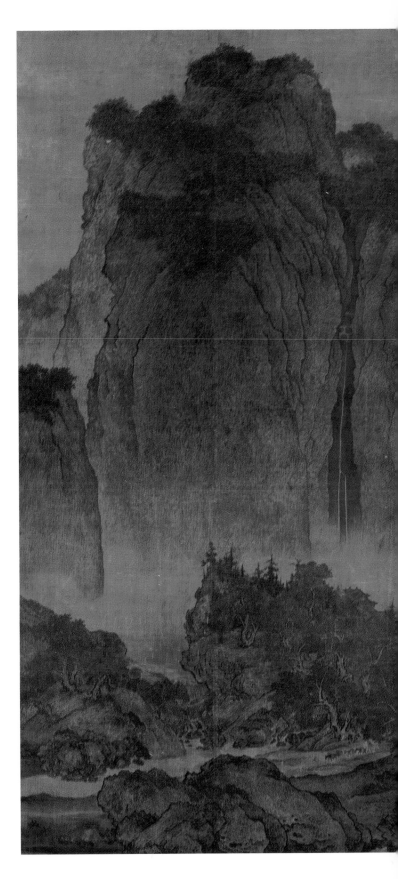

FIGURE 7.17 Fan Kuan (active late tenth to early eleventh century). *Traveling amid Mountains and Gorges.* Hanging scroll. Ink and slight color on silk. Ht. 206.3 cm. Northern Song dynasty. National Palace Museum, Taipei.

composition is still in some respects archaic; the dominating central massif goes back to the Tang dynasty, the foliage retains several early conventions, while the texture strokes (*cun*) are still almost mechanically repeated and narrow in range (their full expressive possibilities were not to be realized for another two hundred years). Yet this painting—on which the long-lost half-hidden signature (fig. 7.18) was rediscovered only in 1958—is overwhelming in its grandeur of conception, in its dramatic contrasts of light and dark in the mist, rocks, and trees, and above all in a concentrated energy in the brushwork so intense that the very moun-

tains seem to be alive, and the roar of the waterfall fills the air around you as you gaze upon it. It perfectly fulfills the ideal of the Northern Song that a landscape painting should be of such compelling realism that viewers will feel that they have been actually transported to the place depicted.

Northern Song realism could take many forms, of which I can include but two more, very different, examples. The handscroll *Autumn Colors on Rivers and Mountains* (fig. 7.19) is painted in a fine line enriched with mineral colors that echo the precise, decorative Tang "green and blue" style. The twelfth-century court painter Zhao Boju (d. c. 1162)

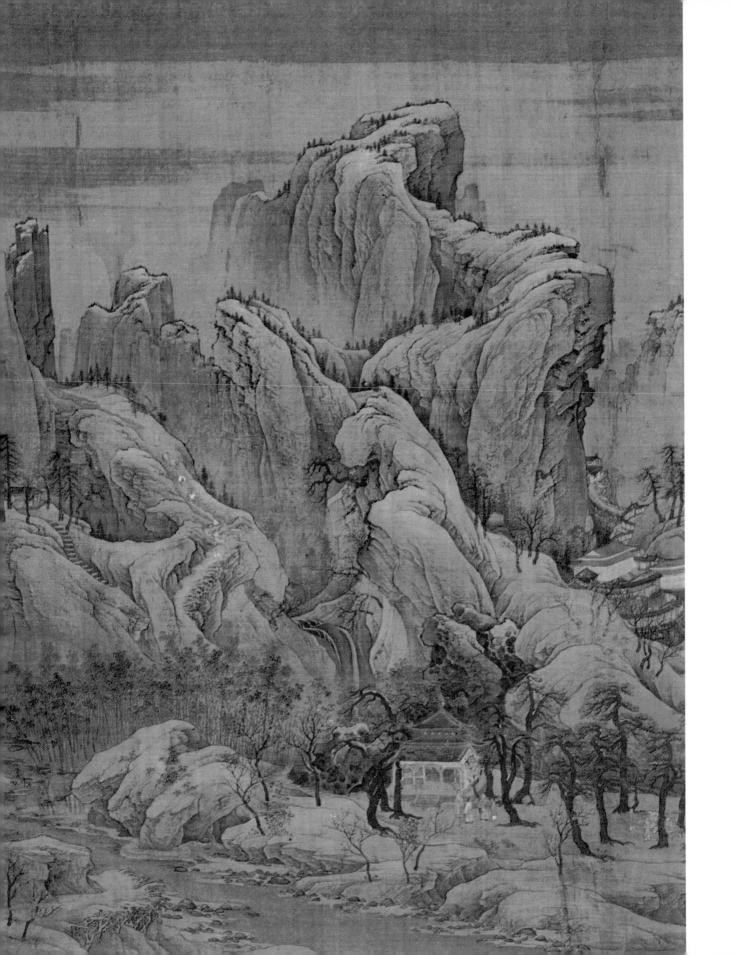

FIGURE 7.20 (RIGHT)
Attributed to Zhang Zeduan
(early twelfth century). *Going Upriver
at Qingming Festival Time.* Detail of a
handscroll. Ink and slight color on silk.
Ht. 25.5 cm. Late Northern or early
Southern Song period. Palace
Museum, Beijing.

FIGURE 7.21 (OPPOSITE)
Attributed to Dong Yuan (tenth cen-
tury). *Scenery along the Xiao and
Xiang Rivers.* Part of a handscroll. Ink
and color on silk. Ht. 50 cm. Early
Song period. Palace Museum, Beijing.

was said to be a master of this archaistic style, and since the Ming dynasty this marvelous work has been attributed to him. But the spectacular conception and the dynamic interplay of forms, as the mountains twist and thrust against each other, combined with exquisitely observed detail, seem more characteristic of the monumental *intimisme* of the Northern Song.[9]

Less visually breathtaking, and far more literal in its realism, is the long scroll that bears the title *Going Upriver at Qingming Festival Time* (fig. 7.20), long thought to depict life on the outskirts of the northern capital.[10] The artist shows an encyclopedic knowledge of the look of houses, shops, restaurants, and boats and of the variety of people of high and low degree who throng the streets. His vision is almost cinematic, as he "tracks" along the riverbank like a movie camera, and in his drawing of riverboats he shows an easy

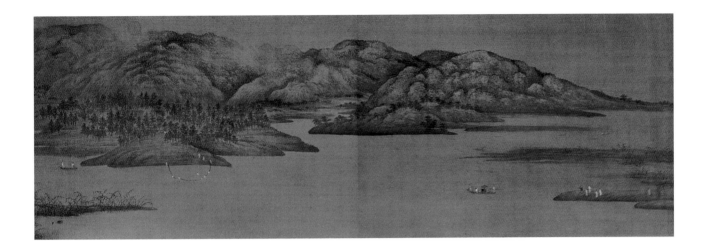

mastery of shading and foreshortening that will not appear again in Chinese painting until the twentieth century.

The Qingming scroll is attributed in a colophon of 1186 to the early-twelfth-century Hanlin scholar Zhang Zeduan. But the authorship and even the subject of this fascinating work are uncertain, for it has been pointed out that none of the customs such as picnics and sweeping the family graves that take place at the Qingming festival are depicted on the scroll, and the phrase *qingming* may simply refer to a time of peace and tranquillity. But even if this is a somewhat idealized rendering of a northern town along a river or canal, it is still a remarkable display of pictorial realism, and perhaps one of the last examples of this kind of painting by a member of the scholar class in the Song dynasty. From now on, the literati were to leave realism to the academicians and professionals, in whose hands it became conventionalized—as, for example, in the painting by the eighteenth-century professional artist Yuan Jiang illustrated in fig 10.8.

DONG YUAN AND JURAN

After establishing the Jin dynasty, the Jurchen, eager to appear civilized and tolerant, attracted to their court many scholars and artists who had remained behind when the remnants of the Song court had fled to the south. As a result many of the paintings produced by Li Shan and other Jin artists continue the northern tradition of monumental realism. Their work forms a link with later masters, such as Tang Di (see chapter 8), who were to revive this tradi-

tion during the Yuan dynasty. These painters were all men of north China, nurtured in a hard, bleak countryside whose mood is well conveyed in the austerity of their style.

The painters of the south lived in a kinder environment. The hills of the lower Yangzi Valley are softer in outline, the sunlight is diffused by mist, and winter's grip is less harsh. In the works connected with the names of Dong Yuan and Juran, both active in Nanjing in the middle decades of the tenth century, there is a roundness of contour and a looseness and freedom in the brushwork that are in marked contrast to the angular rocks and crabbed branches of Li Cheng and Fan Kuan. Shen Gua said that Dong Yuan "was skilled in painting the mists of autumn and far open views" and that "his pictures were meant to be seen at a distance, because their brushwork was very rough." Dong Yuan also, surprisingly, worked in a colored style like that of Li Sixun. Fig. 7.21, a detail of Dong Yuan's scroll depicting scenery along the Xiao and Xiang rivers in Hunan, illustrates the revolutionary impressionism that he and his pupil Juran achieved by means of broken ink washes and the elimination of the outline. In this evocation of the atmosphere of a summer evening, the contours of the hills are soft and rounded and the mist is beginning to form among the trees, while here and there the diminutive figures of fishermen and travelers go about their business. Over the scene hangs a peace so profound that we can almost hear their voices as they call to each other across the water. Here for the first time an element of pure lyricism appears in Chinese landscape painting.

THE PAINTING OF THE LITERATI

Vestiges of Northern Song realism lingered on in the Southern Song Academy and in professional painting even through the Ming and Qing dynasties—as, for example in the landscape by Yuan Jiang illustrated in fig. 10.8—but this apparent realism was a mere convention: the artist was no longer looking at nature with fresh eyes; he was simply concocting pictures in accordance with long-established pictorial and technical conventions. Yet even while a realism based on genuine observation was reaching its climax in the Northern Song period, the seeds of a different notion of the purposes of painting were taking root in the minds of a small circle of intellectuals led by the great poet Su Dongpo (1036–1101), Wen Tong (Su's teacher in bamboo painting, d. 1079), Mi Fu (or Mi Fei, 1051–1107), and the scholar and calligrapher Huang Tingjian (1045–1105).[11] They saw with dismay how court artists were treated as low-grade artisans whose choice of subject and style was closely monitored by officials in the Academy. Distancing himself from this kind of art, Su Dongpo put forward the revolutionary idea that the purpose of painting was not representation but expression. "To discuss paintings in terms of 'form-likeness,'" he wrote, "is to show the understanding of a child." To Su and his circle, the aim of a landscape painter was not to evoke in viewers the feelings they would have if they were actually wandering in the mountains, but rather to reveal to friends something of the artist's own mind and heart. They spoke of merely "borrowing" the forms of rocks, trees, or bamboo in which, for the moment, to find "lodging" for their thoughts and feelings. Of a panorama of the Xiao and Xiang rivers such as that attributed to Dong Yuan, they might say, not "From this you can tell what the scenery of Xiao and Xiang is like," but "From this you can tell what kind of a man Dong Yuan was." Their brushwork was as personal and as revealing of character as was their handwriting.

In their painting, Fan Kuan's passion for the hills and streams gave way to a more urbane, detached attitude, for they avoided becoming deeply involved either in nature or in material things. Above all, they were gentlemen, poets, and scholars first and painters only second; and, lest they be taken for professionals, they often claimed that they were only playing with ink and that a certain roughness or awkwardness was a mark of unaffected sincerity. By choice, they painted in ink on paper, deliberately avoiding the seduction of color and silk. It is not surprising that of all the streams of Chinese pictorial art, the painting of the high officials (*shidafu hua*) and of the literati (*wenren hua*) is hardest to appreciate. The lines that the Song scholar Ouyang Xiu wrote of the poetry of his friend Mei Yaochen would apply equally well to the paintings of Su Dongpo, Wen Tong, or Mi Fu:

> His recent poems are dry and hard,
> Try chewing on some—a bitter mouthful!
> The first reading is like eating olives,
> But the longer you suck on them the better the taste.[12]

Just what brought about this momentous change in the educated man's view of the purposes of art is not clear. The germs of it might be found in the life and work of the Tang poet-painter Wang Wei, regarded by the later literati as the founding father of this tradition of landscape painting; but its emergence as a philosophy of art belongs to the Song and seems to go hand in hand with the tendency, which found its subtlest and most complex expression in the philosophy of the second generation of Neo-Confucians, to unite all phenomena, from natural forces to qualities of mind, in a universal system of relationships that can be grasped through intuition. The very existence of such a synthetic philosophy—the ancient *bagua* (eight trigrams) had been a primitive attempt in the same direction—encouraged thinkers to leap from the object of experience straight to the general, all-embracing principle (*li*) without investigating the object itself. As this approach to knowledge took a stronger hold on intellectuals, it steadily discouraged both scientific investigation and realism in art, while the broadening gulf separating the intellectual elite from the rest of society ensured that henceforth scholars would no longer concern themselves (except in their capacity as administrators) with worldly affairs. It would have been utterly impossible, for instance, for a gentleman in the Yuan, Ming, or Qing dynasty to have painted a scroll like Zhang Zeduan's riverside panorama (see fig. 7.20).

Whatever the causes of this momentous shift in emphasis—and there are many—it is well illustrated in the handful of surviving paintings attributed to members of this small group of Northern Song scholar-painters. The short handscroll illustrated in fig. 7.22 was first attributed

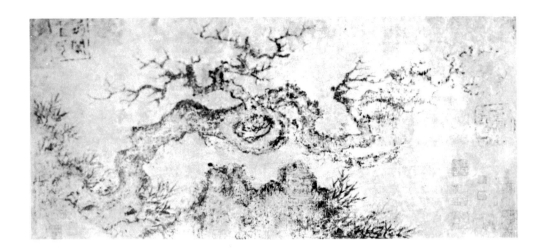

to Su Dongpo in the thirteenth century, though its actual author is unknown. But it is typical of the taste and technique of the eleventh-century scholar-painters in the choice of medium, the dry, sensitive brushwork, the avoidance of obvious visual appeal, and the sense that this is a spontaneous statement as revealing of the artist himself as of what he depicts.

The work of these early scholar-painters was original, not because they strove for originality but because their art was the sincere and spontaneous expression of an original personality. One of the most remarkable of these men was Mi Fu (fig. 7.23), a critic, connoisseur, and eccentric who would spend long evenings with his friend Su Dongpo (whom he first met, probably in Hangzhou, in 1081), surrounded by piles of paper and jugs of wine, writing away at top speed till the paper and wine gave out and the small boys grinding the ink were ready to drop with exhaustion. In painting landscapes, Mi Fu, it is said, abandoned the drawn line altogether, forming his mountains of rows of blobs of wet ink laid on the paper with the flat of the brush—a technique probably derived from Dong Yuan's impressionism and highly evocative of the misty southern landscape that Mi Fu knew so well. This striking Mi-dot technique, as it came to be called, had its dangers, however. In the hands of the master or of his son Mi Youren (1086–1165), who seems to have modified it somewhat (fig. 7.24), it achieved marvels of breadth and luminosity with the simplest of means, but it was very easy to imitate.

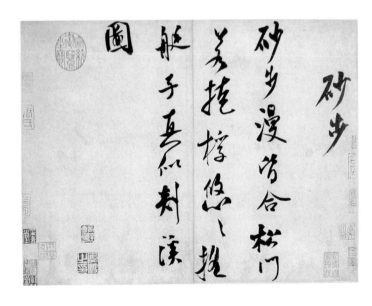

FIGURE 7.22 (TOP) Attributed to Su Dongpo (1036–1101). *Bare Tree, Bamboo, and Rocks.* Handscroll. Ink on paper. Ht. 23.4 cm. Northern Song dynasty. Palace Museum, Beijing.

FIGURE 7.23 (ABOVE) Mi Fu (1051–1107). Part of a poem in *xingshu* (running script). Song dynasty. Palace Museum, Beijing. Courtesy of Liu Zhengcheng.

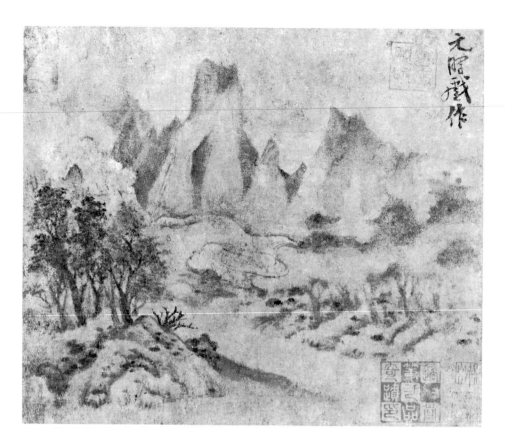

FIGURE 7.24 (RIGHT)
Mi Youren (1086–1165). *Misty Landscape*. Hanging scroll. Ink on paper. Ht. 24.7 cm. Southern Song dynasty. Osaka Municipal Museum of Art (former Abe Collection).

FIGURE 7.25 (OPPOSITE)
Attributed to Emperor Huizong (r. 1101–25). *The Five-Color Parakeet*. Hanging scroll. Ink and color on silk. Ht. 53 cm. Northern Song dynasty. Museum of Fine Arts, Boston; Maria Antoinette Evans Fund. Photo © 2008 Museum of Fine Arts, Boston.

SONG HUIZONG AND THE ACADEMY

So radical was Mi Fu's technique that the emperor Huizong, although he found Mi Fu vastly entertaining as a courtier, would have none of his work in the imperial collection, nor would he permit the style to be practiced at court. It is not known whether an official painting academy ever existed before the Southern Song. Painters at the Tang court had been given a wide variety of civil and military ranks, most of which were sinecures. Wang Jian, a ruler of the Former Shu who died in 918, seems to have been the first to give his painters appointments in his own Hanlin Academy of Letters, and this practice was followed by the Southern Tang emperor Li Houzhou at Nanjing and by the first emperors of the Song. Contemporary writers often speak of distinguished painters in attendance (*daizhao*) in the Yuhuayuan (Imperial Academy of Painting); yet no such institution is ever mentioned in the Northern Song history, and if such a body did exist, it was presumably a subdivision of the Hanlin Academy.[13] After the Song dynasty, the term

daizhao often merely meant a professional artist attached to a temple.

The tradition of direct imperial patronage culminated in Huizong (r. 1101–25), the last emperor of the Northern Song, whose passion for pictures and antiquities blinded him to the perils into which his country was drifting. In 1104 he set up an official School of Painting (Huaxue) in the palace, but in 1110 the school was abolished and painting once more put under the Hanlin Academy. Huizong kept tight control over the painters at court. He handed out the subjects to be painted and set examinations as though the painters were candidates for civil service posts. The theme was generally a line from a poem, and distinction went to the most ingenious and allusive answer. When, for example, he chose the theme "A Tavern in a Bamboo Grove by a Bridge," the winner did not put in the tavern at all but simply suggested it by a signboard set amid the bamboo. Thus, what Huizong required of these artists was not so much academic realism as intellectual agility—the avoidance of the obvious and the play upon ideas that was ex-

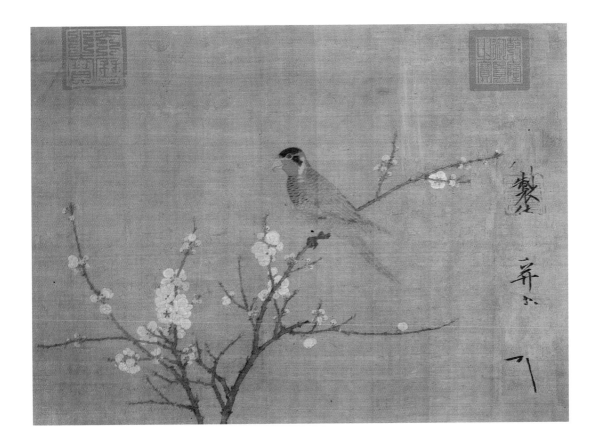

pected also of literary scholars. But the emperor, himself a painter, tolerated no indiscipline in the ranks. He imposed upon his academicians a dictatorship of form and taste as rigid as that of le Brun over the artists working for Louis XIV. The penalty for independence was dismissal. Huizong's pictorial orthodoxy was, together with Neo-Confucian ideas about what constituted "knowledge," a key factor in the almost total abandonment of pictorial realism in landscape painting from the twelfth century onward. For all his talent and enthusiasm, his influence cannot have been beneficial. The imposition of a rigid orthodoxy laid the foundation for a decorative, painstaking "palace style" that was to govern court taste until modern times, while his insatiable and somewhat unscrupulous demands as a collector—demands that no owner could refuse—helped to ensure the destruction, in the disastrous events of 1125–27, of most of the remaining masterpieces of ancient art.

Whenever Huizong produced a masterpiece, the painters in the academy vied with each other in copying it and, if they were lucky, succeeded in having their versions inscribed with the emperor's own cipher. So closely indeed did they model their work on his that it is now almost impossible to disentangle the one from the other, though attempts have been made to do so. It would even be wrong to assume that the better the painting the more likely it is to be from the imperial hand. The pictures associated with his name are for the most part quiet, careful studies of birds on branches—*A Dove on a Peach Tree, Sparrows on Bamboo,* and so on—painted with exquisite precision, delicate color, and faultless placing. Often their beauty is enhanced by the emperor's highly elegant calligraphy, which, we may be sure, was not infrequently applied also as a mark of approval to paintings executed by members of the Academy. Court eunuchs were trained to imitate his hand exactly, and, as with the paintings, it is impossible to determine whether the inscriptions in his "thin gold" script, *shoujin shu,* were actually written by Huizong himself.[14] A typical product of this sophisticated circle is the famous *Five-Color Parakeet* (fig. 7.25), which bears a poem and signature penned by the imperial brush. This exquisitely balanced picture reveals a cer-

tain stiffness (much clearer in the original than in the photograph), an anxiety to be correct at all costs—just the qualities we might expect of a court artist striving to please this most exacting of patrons. The noted Beijing art historian Xu Bangda suggests that the works from Huizong's own hand are in ink on paper and cites as an example the freely and sensitively painted handscroll *A Pond in Late Autumn* in the National Palace Museum, Taipei.

BIRD AND FLOWER PAINTING

The art of flower painting that Huizong and his academicians practiced was not, in origin, wholly Chinese. Buddhist banner paintings brought from India and central Asia were richly set about with flowers, painted in a technique that influenced the late-sixth-century master Zhang Sengyou. Commenting on some of Zhang's paintings in a temple at Nanjing, a Tang author wrote: "All over the gate of the temple 'flowers-in-relief' are painted. . . . Such flowers are done in a technique brought here from India. They are painted in vermilion, malachite greens, and azurite blues. Looking at them from a distance, one has the illusion that they are [carved] in relief, but close at hand they are seen to be flat."[15] Tang Buddhist art is rich in this decorative style of flower painting, but by the tenth century it had become an art in its own right. Later painters loved to animate their flower studies with birds, and thus "birds and flowers" (*huaniao*) became recognized as an independent category in the repertoire.

The tenth-century master Huang Quan is said to have invented a revolutionary technique of flower painting at the court of Wang Jian in Chengdu. He worked almost entirely in delicate transparent washes of color, sometimes laid one over the other—a style, requiring great skill in handling the medium, that is related to the boneless technique we have already encountered in landscape painting. The technique of his contemporary and great rival at Nanjing, Xu Xi, was markedly different, for Xu drew his flowers and leaves swiftly in ink and ink wash, adding only a little color. Huang Quan's style was considered the more skillful and decorative and eventually became more popular with professionals and court painters, while Xu Xi's, because it was based on the free use of brush and ink, found favor among the literati. Huang's son Huang Jucai, among others, successfully combined elements of both styles (fig. 7.26). No

FIGURE 7.26 (ABOVE) Attributed to Huang Jucai (933–993). *Pheasant and Sparrows amid Rocks and Shrubs*. Hanging scroll. Ink and color on silk. Ht. 99 cm. National Palace Museum, Taipei.

FIGURE 7.27 (OPPOSITE) Attributed to Li Tang (c. 1050–c. 1130). *Myriad Trees on Strange Peaks*. Fan. Ink and color on silk. Ht. 24.7 cm. Twelfth century. National Palace Museum, Taipei.

original from the hand of Huang Quan or Xu Xi has survived, but their techniques are still popular with flower painters today.

A comment by the critic Shen Gua on the work of Huang and his son, on the one hand, and Xu, on the other, throws an interesting light on the standards by which this kind of painting was judged in the Song dynasty:

> The two Huangs' flower paintings are marvellous [*miao*] in their handling of colours. Their brushwork is extremely fresh and finely detailed. The ink lines are almost invisible, and are supplemented only by washes of light colours. Their sort of painting you might call sketching from life. Hsü Hsi [Xu Xi] would use his ink and brush to draw in a very broad way, add a summary colouring, and that would be all. With him the spiritual quality is preeminent, and one has a special sense of animation. Chuan [Quan] disliked his technique, called his work coarse and ugly, and rejected it as being without style.[16]

This was the true professional speaking.

LI TANG

When, after the disaster of 1125, the Song shored up the ruins of their house amid the delights of their "temporary" capital at Hangzhou, they set out to recapture the dignity and splendor of the old life at Bianjing. At Wulin, outside the new capital, a formal Academy of Painting (Huayuan) was set up for the first and only time in Chinese history. Venerable masters from the north were assembled there to reestablish the tradition of court painting, and no national catastrophe, it seemed—provided that it was ignored—could disturb the even tenor of their life and art.

The classical northern tradition was transformed and transmitted to the Southern Song by Li Tang, doyen of Huizong's Academy. History credits Li Tang with a monumental style based on the *fupi cun* ("ax-cut texture stroke"), a graphic description of his method of hacking out the angular facets of his rocks with the side of the brush. A powerful landscape in this technique in the National Palace Museum, Taipei, signed and dated equivalent to 1124, may be a later copy, and it is likely that no original from his hand survives today. Perhaps the little fan painting, *Myriad Trees on Strange Peaks* (fig. 7.27), brings us as close to his style as we shall ever get. He was an old man when Bianjing fell,

and most of his work must have perished with the imperial collection. But copies, attributed paintings, and literary sources suggest that his style and influence dominated artistic expression in the twelfth century, making him a vital link between the remote grandeur of the Northern Song masters and the brilliant romanticism of Southern Song painters such as Ma Yuan and Xia Gui.

So much Southern Song landscape painting is lost that it is difficult today to get a clear picture of its variety and range, chiefly because our image of it is dominated by the style favored at court, of which the chief exponents were Ma Yuan and Xia Gui—the so-called Ma-Xia School discussed in the next section. But there were other kinds of painting too. The tradition of Dong Yuan lived on in the south, as it did in the north at the Jin court. A fine example is the handscroll *Dream Journey through the Xiao and Xiang Rivers* (fig. 7.28), painted around 1170 for an old Chan priest by an artist about whom nothing is known except that his surname was Li. The painting combines in a wonderful way grandeur of conception, serenity of mood, sensitivity in the handling of distance through subtle grades of ink tone, and a human dimension in the delicate details of village life that cause us to wonder how many masterpieces of this period by unknown artists have been lost forever. At least the survival of a handful of Southern Song paintings in this style helps us to understand how artists such as Huang Gongwang and Wu Zhen were able to carry the Dong Yuan tradition through the succeeding Yuan dynasty.

FIGURE 7.28 Li (?). *Dream Journey through the Xiao and Xiang Rivers*. Part of a handscroll. Ink on paper. Ht. 30.3 cm. Southern Song dynasty, c. 1170. Tokyo National Museum.

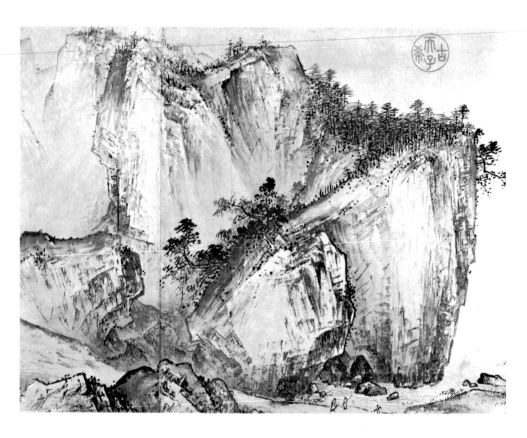

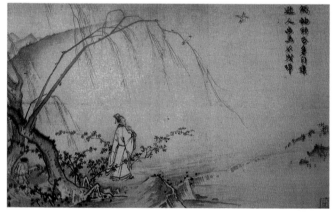

FIGURE 7.29 (ABOVE) Xia Gui (active c. 1200–1230). *Pure and Remote View of Hills and Streams.* Detail of a handscroll. Ink on paper. Ht. 46.5 cm. Southern Song dynasty. National Palace Museum, Taipei.

FIGURE 7.30 (RIGHT) Ma Yuan (active c. 1190–1225). *On a Mountain Path in Spring,* with a poem by Yang Meizi, consort of the emperor Ningzong. Album leaf. Ink and slight color on silk. Ht. 27.4 cm. Southern Song dynasty. National Palace Museum, Taipei.

MA YUAN AND XIA GUI

In Western eyes the work of the Ma-Xia School, with its obvious visual and emotional appeal, came in the early twentieth century to represent the quintessence of Chinese landscape painting—and not only in the West, for this style was to have a profound influence too on the development of landscape painting in Japan. Its language of expression was not altogether new. We have found an anticipation of its spectacular tonal contrasts in Fan Kuan and Guo Xi, its clawlike trees and roots in Li Cheng, its ax strokes in Li Tang. But in the art of Ma Yuan and Xia Gui these elements all appear together, united by a consummate mastery of the brush that would border on mannerism if it were not so deeply infused with poetry. Without this depth of feeling, the style is in itself decorative and easily imitated in its outward aspects—qualities that were to be seized upon by Ming dynasty professional artists and by the painters of the Kanō School in Japan. What is new is the sense of space achieved by pushing the landscape to one side, opening up a vista of limitless distance. There are many night scenes, and the atmosphere is often redolent of a poetic melancholy that hints at the underlying mood of Hangzhou in this age of deepening anxiety.

Ma Yuan became a *daizhao* at the end of the twelfth century, Xia Gui early in the thirteenth. It is not always easy to disentangle their styles. If we say, looking at the *Four Old Recluses* in Cincinnati attributed to Ma Yuan, that his brushwork is bold and fiery, we will find the same quality even more brilliantly displayed in Xia Gui's *Pure and Remote View of Hills and Streams* (fig. 7.29) in the National Palace Museum, Taipei. It is hard to believe that this almost violently expressionistic work was painted by a senior member of the Imperial Academy. Both he and Ma Yuan used Li Tang's ax-stroke *cun* with telling effect; both exploited brilliantly the contrast of black ink against a luminous expanse of mist. All we can say is that of the two, Ma Yuan generally seems the calmer, the more disciplined and precise (fig. 7.30), Xia Gui the expressionist, who may in a fit of excitement seem to stab and hack the silk with his brush. The brilliant virtuosity of his style appealed strongly to the Ming painters of the Zhe School (see chapter 9), and there is little doubt that the great majority of paintings generally attributed to Xia Gui are in fact pastiches by the Ming professional painter Dai Jin and his followers. For there is

in the real Xia Gui a noble austerity of conception, a terseness of statement, a brilliant counterpoint of wet and dry brush, a sparing and telling use of *cun,* that his imitators altogether failed to capture.

CHAN PAINTING OF THE SONG DYNASTY

We have seen earlier in this chapter (pp. 172–73) how the Chan Buddhist painters practiced an outlandish style that seems to be a pictorial metaphor for the irrational nature of sudden enlightenment. The tradition continued through the Song dynasty in the Chan monasteries, but now the distinction between the court painters and the Chan expressionists was not so stark. Chan masters took part in theological debates in the Southern Song court, consorting with officials and scholars. They painted portraits of their patriarchs as meticulously as any court artist. Liang Kai, who had been a *daizhao* under Ningzhong (r. 1195–1224) before he retired to a Chan monastery near Hangzhou, took the courtly style of portrait painting with him. His moving study of the emaciated Śākyamuni emerging from a fruitless period of austerity in the mountains borrows the techniques from the Academy (fig. 7.31), whereas by contrast his painting of Huineng, the illiterate Sixth Patriarch, chopping up bamboo and ecstatically tearing up a Buddhist sūtra (fig. 7.32) is dashed off with all the abandoned wit of caricature.

For to the Chan adept, all nature, all styles of painting, were one. Muqi, a monk living near Hangzhou in the early thirteenth century, expressed the essence of Chan in the serene simplicity of his famous *Six Persimmons*, while in his triptych, *The White-Robed Guanyin, a Crane, and Gibbons* (fig. 7.33), he drew upon the subtle resonance of the finest of Southern Song court art. Whether or not these pictures were painted to hang together is immaterial. What is most striking about these scrolls, and common to all the best Chan painting, is the way in which the artist rivets the viewer's attention by the careful painting of certain key details, while all that is not essential blurs into obscurity, as in the act of meditation itself. Such an effect of concentration and control was only possible to artists schooled in the disciplined techniques of the Academy; the brush style of the literati, for all its spontaneity, was too relaxed and personal to meet such a challenge.

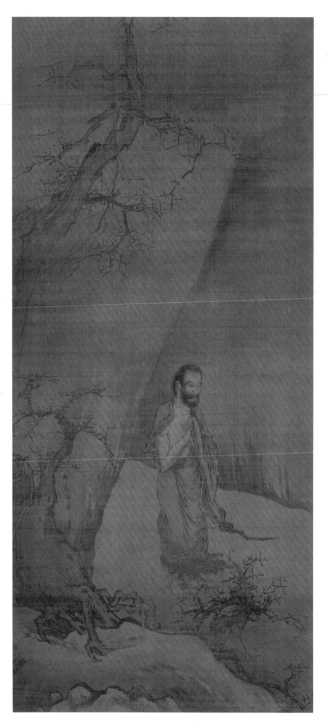

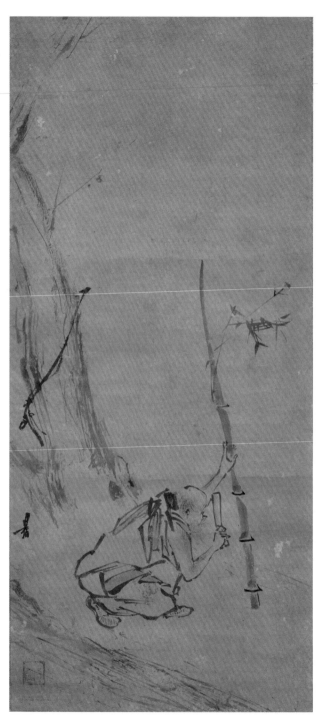

FIGURE 7.31 Liang Kai (c. 1140–c. 1210). *Śākyamuni Returning from the Mountains*. Hanging scroll. Ink and color on silk. 118 × 52 cm. Southern Song dynasty. Tokyo National Museum. Photo: TNM Image Archives.

FIGURE 7.32 Liang Kai. *Huineng Chopping the Bamboo*. Hanging scroll. Ink on paper. 72.7 × 31.8 cm. Southern Song dynasty. Tokyo National Museum. Photo: TNM Image Archives.

FIGURE 7.33 Muqi (active mid thirteenth century). *The White-Robed Guanyin, a Crane, and Gibbons.* Central portions of three hanging scrolls. Ink on silk. Ht. 172 cm. Southern Song dynasty. Daitokuji, Kyoto.

DRAGONS

The influence of the academic attitude toward art in the Song dynasty is revealed in a growing tendency to categorize. The catalogue of the emperor Huizong's collection, *Xuanhe huapu,* for instance, was arranged under ten headings: Daoist and Buddhist themes (which, though less popular than before, still preserved a prestige conferred by tradition); figure painting (including portraits and genre); palaces and buildings (particularly those in the ruled *jiehua* style); foreign tribes; dragons and fish; landscapes; domestic animals and wild beasts (there was a whole school of painters specializing in water buffaloes); flowers and birds; ink bamboo; and vegetables and fruit. The last category requires no special mention, and bamboo I will discuss in chapter 8. But before leaving the subject of Song painting, I must say a word about dragons.

To the man in the street, the dragon was a benevolent and generally auspicious creature, bringer of rain and emblem of the emperor. To the Chan Buddhists he was far more than that. When Muqi painted a dragon suddenly appearing from the clouds, he was depicting a cosmic manifestation and at the same time symbolizing the momentary, elusive vision of truth that comes to the Chan adept. To the Daoists, the dragon was the Dao itself, an all-pervading force that momentarily reveals itself to us only to vanish again and leave us wondering if we had actually seen it at all. "Hidden in the caverns of inaccessible mountains," wrote Okakura Kakuzō,

> or coiled in the unfathomed depths of the sea, he awaits the time when he slowly rouses himself to activity. He unfolds himself in the storm clouds; he washes his mane in the blackness of the seething whirlpools. His claws are in the forks of the lightning, his scales begin to glisten in the bark of rain-swept pine trees. His voice is heard in the hurricane which, scattering the withered leaves of the forest, quickens the new spring. The dragon reveals himself only to vanish.[17]

Cao Buxing in the third century was the first prominent painter to specialize in dragons, but the greatest of all was

Chen Rong, who combined a successful career as an administrator during the first half of the thirteenth century with a somewhat unorthodox technique as a dragon painter. His contemporary Tang Hou tells us that when Chen was drunk he would give a great shout, seize his cap, soak it with ink, and smear on the design with it, afterwards finishing the details with a brush. His celebrated *Nine Dragons* (fig. 7.34), painted in 1244, could well have been executed thus, the dragons with his brush, the clouds with his cap; indeed, on the original we can clearly see the imprint of some textile in the clouds.

CERAMICS

NORTHERN WARES

The art of the Song dynasty that we admire today was produced by and for a social and intellectual elite more cultivated than at any other period in Chinese history. The pottery and porcelain made for their use reflects their taste. Some Tang wares may be more robust, Qing wares more perfectly finished, but the Song have a classical purity of form and glaze that holds a perfect balance between the vigor of the earlier wares and the refinement of the later. Although some of the porcelain for the Northern Song court came from kilns as far away as Zhejiang and Jiangxi, the most famous of the Northern Song *guan* ("official") wares were manufactured in the kilns at Jiancicun near Dingzhou in Hebei, where a white porcelain was already being made in the Sui dynasty. The classic Ding ware is a finely potted, high-fired white porcelain with a creamy white glaze that has a brownish tinge where it runs into the "teardrops" described in early texts. The floral decoration of earlier pieces, such as the masterly tomb pillow illustrated in fig. 7.35, was freely carved in the "leather-hard" paste before firing; later, more elaborate patterns were impressed in the paste from pottery molds. Because the vessels were fired upside down, the rims of bowls were left unglazed and often had to be bound with bronze or silver. Chinese connoisseurs recognize, in addition to the true *bai* ("white") Ding, a fine-grained *fen* ("flour") Ding, a *zi* ("purple," actually soy-sauce brown) Ding, and a

coarse yellowish ("earth") Ding. Varieties of Ding and near-Ding, however, are not always easy to distinguish.

The extensive surveys and excavations of recent decades have made it apparent that not only was one type of ware often made in a number of different kilns, with the inevitable local variations in character and quality, but also that one kiln center might turn out a wide range of products. To take two examples, Koyama Fujio and, more recently, Chinese investigators discovered in the ruins of the Ding kilns white, black, and persimmon-red glazed porcelain, unglazed painted porcelain, and pottery with white slip, with patterns in iron oxide, with carved designs, and with black or buckwheat-brown glaze. While turning out chiefly plain white wares, the Song kilns at Haobi, Tangyinxian, Henan, first investigated in 1955, also produced colored wares, white wares with colored decoration, cups glazed black outside and white inside, a high-quality Jun-type stoneware, and black glazed vases with vertical yellowish ribs in relief, such as the lovely vessel illustrated in fig. 7.36. The value and beauty of the Ding wares lie not merely in

FIGURE 7.34 (OPPOSITE) Chen Rong (active c. 1235–60). *The Nine Dragons.* Detail of a handscroll. Ink on paper. Ht. 46 cm. Southern Song dynasty, 1244. Museum of Fine Arts, Boston; Francis Gardner Curtis Fund. Photo © 2008 Museum of Fine Arts, Boston.

FIGURE 7.35 (ABOVE LEFT) Funerary pillow. Ding ware. Porcelain covered with creamy white glaze. Ht. 15.3 cm. Northern Song dynasty. The Avery Brundage Collection. © Asian Art Museum of San Francisco.

FIGURE 7.36 (ABOVE RIGHT) *Meiping* vase. Stoneware covered with black glaze. Ht. 25.4 cm. From Hebiji, Henan (?). Northern Song dynasty. Formerly in the collection of Mrs. Alfred Clark, Fulmer, Buckinghamshire.

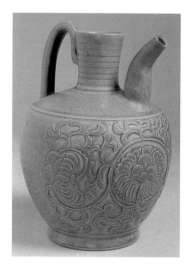

their glaze and decoration but also in the exquisite purity of their shapes, many of which were copied not only in other Song kilns but also in the Korean wares of the Koryŏ period. After the fall of Bianjing in 1127, wares of the Ding type were made at Jizhou in central Jiangxi, probably by refugee potters who had fled to the south.

Since the Song dynasty, Chinese connoisseurs have classed Ding ware as a "classic" ware of the Northern Song, together with Ru ware, Jun ware, and the now legendary Chai ware, which had a glaze "blue like the sky after rain." At some point, the too-fastidious emperor Huizong decided that, presumably because of its "teardrops" and metal rim, Ding ware was no longer good enough for palace use. It has long been thought that kilns were then set up in the capital to make a new palace ware, but they and the ware they produced have never been positively identified. Much more certain is that at the end of the Northern Song, Ru ware (fig. 7.37) was the favorite of the emperor Huizong. This, the rarest of all Song porcelains, has a buff or yellowish-pink body covered with an unctuous bluish-gray glaze tinged with lavender. A Chinese connoisseur described the glaze as being "like lard dissolving, but not flowing," while another noted that it contained agate. The shapes—chiefly bowls, brush washers, and bottles—are of an exquisite simplicity matching the quality of the glaze. For decades the kilns were sought in Ruzhou, where the Jun wares were produced. Finally, in 1986, they were discovered 100

miles (160 km) to the southwest of Kaifeng at Qingliangsi, a temple in Baofeng. By 1988 thirty-seven complete pieces had been excavated there, to add to the sixty-odd known worldwide.[18]

A close cousin of Ru ware, though less perfect in quality, is the well-known Jun ware made not only at Junzhou and Ruzhou, but also at other centers in the neighborhood of Haobi, Anyang, and Zizhou. The finest Jun is of palace quality, and so is sometimes called *guan* Jun by Chinese connoisseurs. The potting is much heavier than that of Ru ware, however, and myriads of tiny bubbles, which burst on the surface of the thick lavender-blue glaze, give it a seductive softness and warmth (fig. 7.38). The Jun potters discovered that spots of copper would oxidize in the glaze during firing to produce crimson and purple splashes, a technique they used with restraint. On later varieties of Jun ware, however—such as the sets of flowerpots and bulb bowls, numbered according to size, that were made in the Ming dynasty at kilns in Dehua and Guangzhou (Canton)—these flambé effects are used with tasteless extravagance.

The "green ware," or celadon, family discussed later in this chapter was essentially a southern tradition, but the Northern Song capital acted as a magnet, drawing crafts and craftsmen up from the Zhejiang-Jiangsu area of the southeast. The beautiful "northern celadon"—a stoneware often richly decorated with carved or molded floral designs under a dull green glaze (fig. 7.39)—was made in several centers, including the large factory at Yaozhou in Tongxuanxian, north of Xi'an. It is possible that some southern potters were sent to work there.[19]

When the Northern Song potters could not produce a pure white ware, they would cover a yellowish, gray, or buff body with a white slip and a transparent glaze. This is what was chiefly done in the so-called Cizhou wares, made not for the court but for general use. The extensive kilns at Cizhou, in southeastern Shanxi near the Hebei border, have given their name to a huge family of north China stoneware of varying quality that was made in many kilns, of which, in addition to Cizhou itself, some of the more important were in Gongxian, Dengfeng, and Haobi in Henan and in Xiuwu (or Zhaozuo), on the Shaanxi-Henan border. The Cizhou wares were either left plain (a cheaper imitation of Ding wares) or decorated in a variety of ways, including free underglaze brush painting (fig. 7.40), incising, stamping,

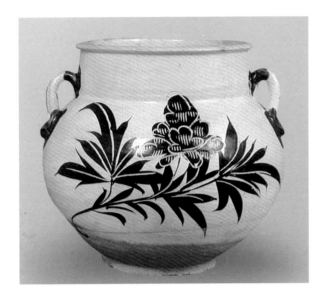

FIGURE 7.40 Jar. Cizhou ware. Stoneware slipped and painted in black under a transparent glaze. Ht. 20.5 cm. Jin dynasty, about twelfth century. Reproduced from *Ceramic Art of the World*, vol. 13 (Tokyo: Shogakukan, 1981).

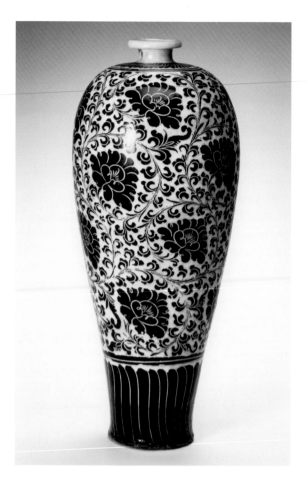

FIGURE 7.41 (RIGHT) *Meiping* vase. Cizhou ware. Stoneware with designs carved through black to white slip under a transparent glaze. Ht. 49.5 cm. From Xiuwu, Henan. Late Northern Song or Jin dynasty. The Avery Brundage Collection. © Asian Art Museum of San Francisco.

FIGURE 7.42 (BELOW) Bowl (side and interior). Cizhou ware. Stoneware decorated with colored enamels over a creamy white glaze. Diam. 9 cm. Jin or Yuan dynasty. The Avery Brundage Collection. © Asian Art Museum of San Francisco.

FIGURE 7.43 (OPPOSITE) Traveler's flask. Stoneware with relief ornament in green enamel over white glaze. Ht. 37.5 cm. North China. Liao dynasty. Private collection, Japan.

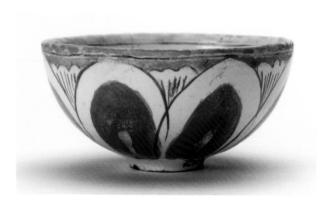

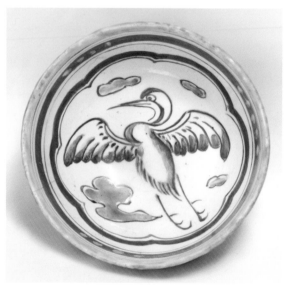

or carving floral designs through a light glaze to a darker slip, or reserving the design on a black glaze over a lighter body or slip, as on the beautiful *meiping* illustrated in fig. 7.41. When the Jin conquered the territory of the Northern Song, many of these kilns continued to operate under their new masters, who developed the novel technique of painting over the glaze and then firing the vessel again at a lower temperature. The results of this process are among the earliest examples of the enameling technique that was to become so popular during the Ming dynasty.

Until the Jin conquered the Liao territory, together with the northern half of the Song domain, the Liao had a flourishing ceramics industry of their own. Liao cities and kiln sites to the north of the Great Wall have yielded fragments of Jun-, Ding-, and Cizhou-type wares and far larger quantities of a distinct local ware that combined something of the sgraffito floral decoration of Cizhou (fig. 7.42) with the three-color glazes and robust—though now often provincial and ungainly—shapes of the Tang dynasty, such as the chicken ewer, pilgrim flask, and trumpet-mouthed vase.[20] The finest Liao and Jin wares are the equal of Song porcelains in elegance, and even the rough grave wares such as the imitation of a leather water flask carried at the saddle (fig. 7.43) have the same unsophisticated charm that we admire in medieval English pottery.

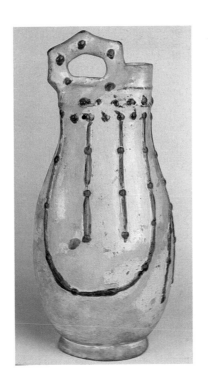

SOUTHERN WARES

Among the most striking of the wares produced in the Cizhou kilns are those with a black glaze, which used to be called Henan *temmoku.* The name forms a link with south China, for it was in the south that tea drinking first became fashionable in the Tang dynasty, and it was discovered that a black glaze effectively showed off the pea-green color of the tea. *Temmoku* is the Japanese equivalent of Tianmu, a mountain near Hangzhou dotted with Buddhist monasteries where Japanese monks often came to stay, taking home with them the tea bowls they had used there. The true *temmoku,* made at Jian'an in northern Fujian as early as the tenth century, consisted almost exclusively of the type of tea bowls that proved so popular in Japan (fig. 7.44). They have a dark stoneware body decorated with a thick, oily iron glaze running to big drops at the foot. The color is basically a very dark brown verging on black, often streaked with blue or steel gray, producing marks known as "hare's fur" or bluish "oil spots" caused by the coagulation of gray crys-

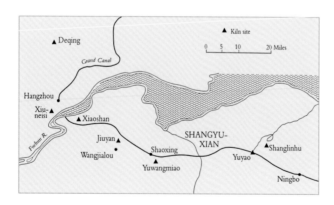

tals. They were imitated at Jizhou in Jiangxi and at other kilns in Fujian in a rather coarse, lusterless ware that is often confusingly called "Kian ware" in older books.

When after a few years the Southern Song court realized that Hangzhou was to be more than a temporary halting place, steps were taken to enlarge the palace and government offices and to set up factories to manufacture utensils for court use that would duplicate as closely as possible those of the old northern capital (map 7.2). According to tradition, the supervisor of parks, Shao Chengzhang, who was in charge of this work, established a kiln near his own office (Xiuneisi) on Phoenix Hill just to the west of the palace, which lay at the southern end of the city. There, according to a Yuan text, the *Zhuogeng lu* of Tao Zongyi, Shao's potters made "a celadon called *neiyao* [palace ware]. Its pure body of exceptional fineness and delicacy, its clear and lustrous glaze, have been prized ever since." The Phoenix Hill area has been repeatedly built over, and the kilns have only recently been discovered. But before long another imperial factory was set up to the southwest be-

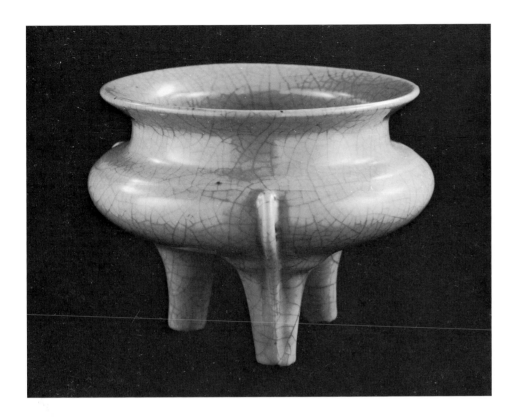

low the suburban Altar of Heaven (Jiaotan). It has become a place of pilgrimage to ceramics enthusiasts, who over the years have picked up quantities of shards of the beautiful "southern *guan*" that graces many Western collections (fig. 7.45). The dark body of this ware is often thinner than the glaze, which is layered, opaque, vitrified, and sometimes irregularly crackled, ranging in color from a pale bluish-green through blue to dove gray. The ware has an air of courtly elegance combined with quietness and restraint that made it a fitting adornment for the Southern Song court.

We should not try to draw too sharp a line between Hangzhou *guan* ware and the best of the celadons made at Longquan in southern Zhejiang. The imperial kilns at Hangzhou made a light-bodied ware in addition to the dark, while Longquan turned out a small quantity of dark-bodied ware as well as the characteristic light gray. It seems certain that the finest Longquan celadons were supplied on official order to the court and could hence be classed as *guan*.

Of all Song stonewares the celadons are probably the most widely appreciated—outside China, at least. The

FIGURE 7.44 (OPPOSITE) Tea bowl. Jian ware. *Temmoku* stoneware with black "hare's fur" glaze. Diam. 12.2 cm. Southern Song dynasty. Ashmolean Museum, Oxford, Gift of Sir Herbert Ingram.

FIGURE 7.45 (ABOVE) Tripod incense burner. Southern *guan* ware. Stoneware with crackled bluish-green celadon glaze. Ht. 12.9 cm. Southern Song dynasty. National Palace Museum, Taipei.

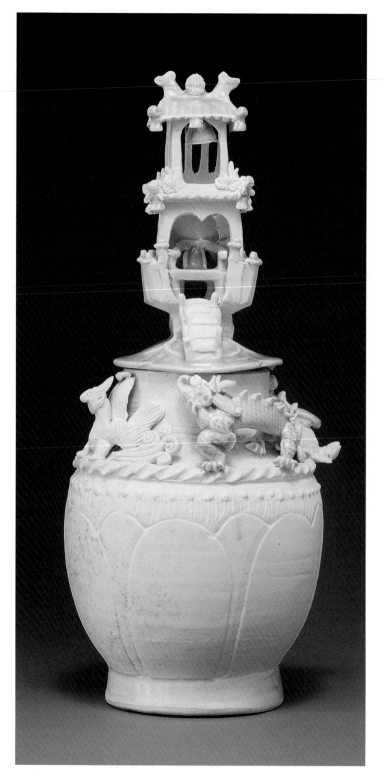

FIGURE 7.46 (ABOVE) *Kinuta*-type vase. Longquan ware. Stoneware with gray-green celadon glaze. Ht. 16.8 cm. Southern Song dynasty. National Palace Museum, Taipei.

FIGURE 7.47 (RIGHT) Mortuary jar. *Qingbai* ware. Ht. 36.8 cm. From Jingdezhen. Song dynasty. Leon Lee Collection, Hong Kong.

name is believed to have been taken from that of Céladon, a shepherd dressed in green who appeared in a pastoral play, *L'Astrée,* first produced in Paris in 1610. These beautiful wares, known to the Chinese as *qingci* ("blue-green porcelain"), were made in a number of kilns, but those of Longquan were the finest, as well as the most abundant, and were, indirectly, the heirs of the Yue wares. The light-gray body of Longquan ware burns yellowish on exposure in the kiln and wears an unctuous iron glaze ranging in color from leaf-green to a cold bluish-green, which is sometimes, though by no means always, crackled. Originally an accidental result of the glaze shrinking more than the body when the vessel cooled after firing, crackle was often exploited for its decorative effect, as in the *ge*-type celadons, in which a closer secondary crackle was also developed.[21] To the finest Longquan celadons, which have a lovely, cloudy blue-green color, the Japanese gave the name *kinuta* ("mallet"; fig. 7.46), perhaps after the shape of a particularly famous vase. Almost every shape appears in the Longquan repertoire. Many are purely ceramic, but we also encounter adaptations of archaic bronze forms, notably incense burners in the form of the three- and four-legged *ding*—a mark of the antiquarianism that was now beginning to develop in Chinese court art and was to have an ever-increasing influence on cultivated taste.

We can trace the development of the Zhejiang celadons through dated pieces well into the Ming dynasty, when the potting becomes heavier, the glaze greener and more glassy, and the scale more ambitious. Celadon, including coarser varieties made in south China, bulked large in China's export trade from the Southern Song onward. Of the over six thousand pieces recovered from a ship destined for Japan that went down off Sinan, in southern Korea, shortly after 1331, most were celadons. The ware has turned up in sites from New Guinea and the Philippines to East Africa and Egypt, while, as every amateur knows, it was much in demand among Arab potentates, partly perhaps because it was believed to crack or change color if poison touched it.

Also exported in large quantities (although originally a purely domestic ware) was a beautiful translucent porcelain with a granular, sugary body and pale bluish glaze. Its respectability in Chinese ceramic history was long doubted because its name in the West used to be *yingqing,* a term for which scholars searched in vain in Chinese works. The name turned out to be a recent invention by Chinese dealers to describe its shadowy blue tint; in fact, its original name, *qingbai* ("bluish white"), occurs frequently in texts going back to the Song dynasty—although Chinese writers are inconsistent, and the term may on occasion, in later periods at least, have meant "blue and white." Fashioned not from clay but from "porcelain stone" (*bai tunzi*) with a high mica content, the body could be potted in shapes of wonderful thinness and delicacy (fig. 7.47). The tradition, which began humbly in the Tang kilns at Shihuwan some miles to the west of Jingdezhen, achieved a perfect balance between living form and refinement of decoration in the Song wares, whose shapes included teapots, vases, cups, and bowls, often with foliate rim and dragons, flowers, and birds molded or incised with incredible lightness of touch in the thin paste under the glaze. Already in the Song dynasty *qingbai* wares were being imitated in many kilns in south China. In 1979 extensive, hitherto unknown, kilns were found in and around Rongxian in Guangxi, about 300 miles (480 km) northwest of Guangzhou, that produced not only *qingbai* but also copies of Ding, Jian, and Yaozhou ware as well as the first copper red and copper green glazes made anywhere in the world.[22] Huge quantities of ceramic wares were exported from south China to southeast Asia, the Indonesian archipelago, and the Philippines, where the presence of *qingbai* celadon or the white wares of Dehua, Fujian, in a grave or archaeological site often provides the most reliable means of dating it.

THE YUAN DYNASTY

During the twelfth century, China had come to uneasy terms with its northern neighbors and, after Chinese custom, civilized them. But beyond them across the deserts of central Asia there roamed a horde that Patrick Fitzgerald called "the most savage and pitiless race known to history"—the Mongols.[1] In 1210 their leader, Genghis Khan, attacked the buffer state of Jin, and in 1215 destroyed the capital at Beijing. In 1227 he destroyed the Xixia, leaving only one-hundredth of the population alive, a disaster by which the northwest was permanently laid waste. Three years later Genghis died, but still the Mongol hordes advanced, and in 1235 they turned southward into China. For forty years the Chinese armies resisted them, almost unsupported by their own government. But the outcome was inevitable, and even before the last Song ruler perished in 1279, the Mongols had proclaimed their dynastic title, calling themselves the Yuan. China was spared the worst of the atrocities that had been visited upon all other victims, for, as an adviser from the Qidan tribe had pointed out, the Chinese were more useful alive—and taxable—than dead. But the wars and breakup of the administration left the Mongols masters of a weak and impoverished empire whose taxpayers had been reduced from a hundred million under the Song to fewer than

sixty million. Although Kublai Khan (r. 1260–94) was an able ruler and a deep admirer of Chinese culture, the Mongol administration was ruthless and corrupt. Seven emperors succeeded one another in the forty years following the death of Kublai.

In 1348 Chinese discontent with the harsh rule of the last Khan broke into open rebellion. For twenty years rival bandits and warlords fought over the prostrate country, which the Mongols had long since ceased to control effectively. Finally, in 1368, the Khan fled northward from Beijing, the power of the Mongols was broken forever, and the short, inglorious rule of the Yuan came to an end. In conquering China they had realized the age-long dream of all the nomad tribes, but in less than a century the Chinese drained them of the savage vitality that had made that conquest possible and threw them back into the desert, an empty husk.

Politically the Yuan dynasty may have been brief and inglorious, but it is a period of special interest and importance in the history of Chinese art—a period when men, uncertain of the present, looked both backward and forward. Their nostalgia is shown in the tendency, in painting as much as in the decorative arts, to revive ancient styles, par-

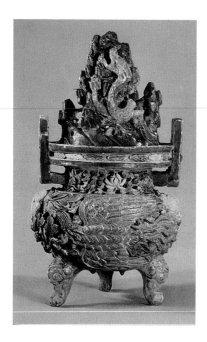

FIGURE 8.1 Incense burner. *Liuli* ware. Molded pottery covered with polychrome lead glaze. Excavated in the remains of the Yuan capital Dadu (Beijing). Yuan dynasty. Palace Museum, Beijing.

MAP 8.1 Sketch map of Dadu in the Yuan dynasty (broken line) compared with Beijing of the Ming and Qing (unbroken line)

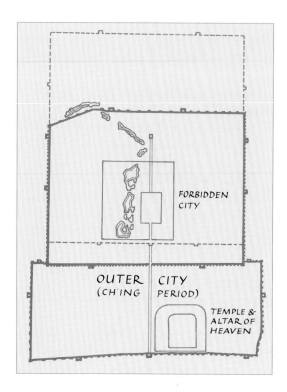

FORBIDDEN CITY

OUTER CITY (CH'ING PERIOD)

TEMPLE & ALTAR OF HEAVEN

ticularly those of the Tang dynasty and Northern Song, which had been preserved in a semifossilized state in north China under the alien Liao and Jin dynasties. At the same time, the Yuan dynasty was in several respects revolutionary, for not only were those revived traditions given a new interpretation, but the divorce between the court and the intellectuals brought about by the Mongol occupation instilled in the scholar class a conviction of belonging to a self-contained elite that was not undermined until the twentieth century and was to have an enormous influence on painting.

In the arts and crafts, the Yuan dynasty saw many innovations, a reaction against Song refinement, and a new boldness, even garishness, in decoration. Some of these changes reflect the taste of the Mongol conquerors themselves and of the non-Chinese peoples, such as Uighurs, Tanguts, and Turks, whom the Mongols had swept up in their *Drang nach Osten* and established as fief-holders and landlords in occupied China—a new and partly Sinicized aristocracy that the dispossessed Chinese gentry, particularly in the south, looked on with a mixture of envy and contempt.

The Mongols dragooned artisans and craftsmen of all the conquered races into their service, organizing them in quasimilitary units. Although there were central Asians, Persians, and even Europeans among them, the dominating influence on the arts was of course Chinese. Yet Marco Polo's description of Kublai's palace at Khanbalik (or Cambaluc, as he called it) and Friar Odoric's account of the Mongol summer palace at Shangdu (Coleridge's Xanadu) show that while the buildings were mostly Chinese in style, the Mongols displayed their new wealth in a lavish use of gold and brilliant colors—the very antithesis of Song taste—while they betrayed their nomad origins in the thick mats, furs, and carpets that covered the floors and the skins that draped the walls of the imperial apartments, giving them the air of an unbelievably sumptuous yurt.[2] The garishly glazed incense burner shown in fig. 8.1, which was excavated from a Yuan mansion in Beijing in 1964, vividly illustrates the demand of the invaders, and of the Chinese traders who profited by the occupation, for objects that were traditionally Chinese in form but showy, even barbaric, in flavor.

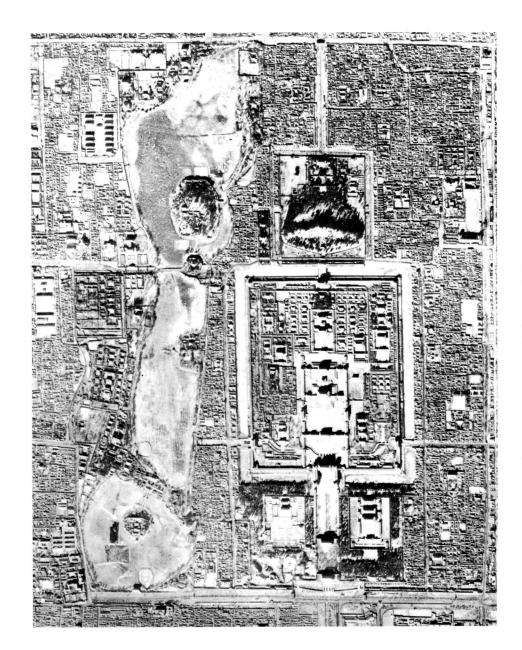

FIGURE 8.2 Aerial photograph of the heart of Beijing, taken by the U.S. Air Force about 1949. Down the center run the lakes Beihai, Zhonghai, and Nanhai; to the right is the moated rectangle of the Purple Forbidden City, with the three halls of state, Sandadian, clearly visible on the north-south axis; while to the south is the main gateway of the Forbidden City, Tiananmen, the Gate of Heavenly Peace. Prospect Hill lies in the rectangle to the north. Since this photograph was taken the city walls have been torn down, the area to the south of Tiananmen has been cleared to make a huge square with the Great Hall of the People on the west side, while new streets, high-rise offices, and apartment blocks have take the place of many of the narrow lanes and courtyard houses of old Beijing.

ARCHITECTURE

Little is left above ground of Kublai's Khanbalik. The city we see today is essentially the creation of the Ming emperor Yongle, who moved the capital back from Nanjing to Beijing in 1421, and of his Ming and Qing successors. The Ming capital, which came to be called the Tartar City after its occupation by the Manchus in 1644, is actually smaller than that laid out by the Mongols, though the total area was greatly increased again when the Manchus created to the south the Chinese City for the native inhabitants. Beijing consists of a city within a city (map 8.1). Surrounded by a wall 15 miles (24 km) long, the Tartar City comfortably holds the Imperial City, with a perimeter of $6\frac{1}{2}$ miles (10.5 km), in the heart of which lies the Purple Forbidden City—the Imperial Palace itself (fig. 8.2). At the extreme southern end of a north-south axis that stretches for $7\frac{1}{2}$ miles (12 km)

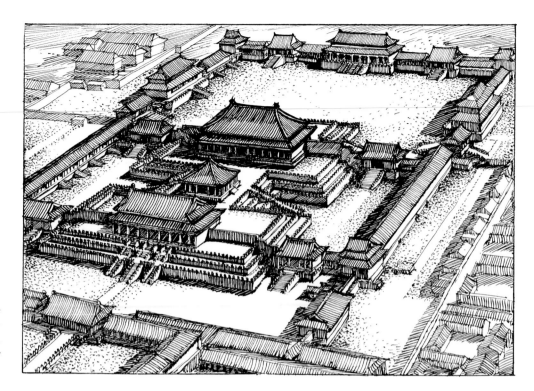

FIGURE 8.3 The three halls of state (Sandadian) of the Forbidden City, looking south. Drawn by T. A. Greeves.

lie the three-tiered marble Jiaotan (Altar of Heaven) and the circular Qiniandian (Hall of Annual Prayers)—the Tiantan (Temple of Heaven), whose blue-tiled roofs are familiar to every visitor to Beijing.

Ancient Zhou ritual, to which the Ming and Qing rulers rigidly conformed, prescribed that the Son of Heaven should rule from "three courts." Accordingly, the heart of the Forbidden City is dominated by three great halls of state, the Sandadian (fig. 8.3), set one behind the other at the climax of the great axis. The first from the south, and the largest, is the Taihedian (Hall of Supreme Harmony), used by the emperor for his grander audiences; it is raised on a huge platform and approached by marble staircases. Behind it lies the waiting hall, Zhonghedian (Hall of Middle Harmony), while beyond is the Baohedian (Hall of Protecting Harmony), used for state banquets. The private apartments, offices of state, palace workshops, and gardens occupy the northern half of this vast enclosure. Not many of the palace buildings we see today are the original structures, however. The Taimiao (Grand Ancestral Shrine) is indeed Ming, having been rebuilt in 1464 after a fire, but the history of the Taihedian is more typical. First built by Yongle in 1427, it was largely rebuilt on the same plan in 1645; a further reconstruction, started in 1669, took thirty years to finish. The Taihedian was again rebuilt in 1765, since when it has been frequently restored and repainted, though so conservative were the Qing architects that it is unlikely that they departed much from the Ming original, itself a cautious repetition of the style of the fourteenth century.

Indeed, from Yuan times onward, Chinese architecture becomes less and less adventurous. Gone are the daring experiments in quadripartite gables, spiral canopies, and dynamic bracketing that give such interest and vitality to Song architecture. Now each building is a plain rectangle. The eaves have become so heavily loaded with unnecessary carpentry that the architect has to place an extra colonnade under their outer edge to support the weight, thus making superfluous the elaborate cantilevered system of brackets and ang, which now shrinks away to a decorative and meaningless frieze or is masked behind a band of scrollwork suspended from the eaves. The splendor of the Forbidden City lies not in its details but, rather, in its rich color (now wonderfully mellowed by age), the magnificently simple sweep of its roofs, and the stupendous scale of its layout. These

buildings were all of timber. A few barrel-vaulted stone or brick temple halls were built in the sixteenth century, but, as before, the use of the vault and dome was largely confined to tombs. A typical example is the tomb of the Wanli emperor in the Western Hills, the excavation of which, completed in 1958, occupied a team of Chinese archaeologists for two full years.

ART UNDER THE MONGOLS

Like other invaders before them, the Mongols supported the Buddhists as a matter of policy. They were particularly attracted to the esoteric and magical practices of the Tibetan Lamaists, but they also, like the Liao and the Jin, patronized the orthodox Buddhist sects and the Daoists. Magnificent wall paintings of about 1320 from the Xinghuasi, a Buddhist temple near Jishan in southern Shanxi, are today in museums in Philadelphia, Kansas City, and Toronto, while still in situ in Shanxi and recently restored are the frescoes, dated to between 1325 and 1358, in the Yonglegong (fig. 8.4), a temple dedicated to the Daoist deity Lu Dongpin. It is interesting to note that the leading painters whose names appear in inscriptions in both these temples were *daizhao*. Once a title reserved for senior court officials (see chapter 7), the term by now was often used for professional temple artists. The Yuan also saw a large output of devotional painting, some of it done by genuine Chan monks such as Yintole, some by professional artists such as Yan Hui, who with his many followers painted both Buddhist and Daoist subjects in the traditional Southern Song manner.

In general, the Mongols viewed with deep suspicion those of the southern gentry who did not take refuge in a monastery or were not seduced into public service. Deprived of their normal source of income, they kept themselves alive by teaching, fortune-telling, medicine, and making use of their special skills, if they had any. Ren Renfa (1254–1327), for example, was an expert in hydraulics and water conservancy as well as a skilled painter of horses. His most famous work was his *Lean and Fat Horse,* symbolizing the plight of the Chinese scholar-official denied promotion, contrasted with the collaborator (often from one of the non-Han tribes) who could rise to high office under the Mongols.

Some of the better-off southerners devoted their enforced leisure to the writing of a new kind of fiction and drama that has permanently enriched Chinese literature.

FIGURE 8.4 Guardian figure. Detail of a wall painting in the Sanxingdian of the Yonglegong temple, Yongxian, Shanxi. Yuan dynasty, between 1325 and 1358.

FIGURE 8.5 Qian Xuan (c. 1235–after 1301). *The Calligrapher Wang Xizhi Watching Geese.* Detail of a handscroll. Ink and color on paper. Ht. 23.2 cm. Yuan dynasty. The Metropolitan Museum of Art, New York; Ex coll.: C. C. Wang Family, Gift of The Dillon Fund, 1973. Photo © 1979 The Metropolitan Museum of Art.

With a few exceptions, the great scholar-painters also put themselves beyond the conqueror's reach. Qian Xuan (c. 1235–after 1301) was typical of the Song loyalists; middle-aged when the dynasty fell, he was forced into retirement, supporting himself as a quasi-professional artist. Two small album paintings, of a squirrel and a sparrow, show him (if indeed they are his) as a sensitive exponent of Song *intimisme,* but in his gentle way he was a revolutionary too. His choice of the archaic Tang style for his charming handscroll of the calligrapher Wang Xizhi watching geese (fig. 8.5), and indeed of the subject itself, may be seen both as a rejection of the Song culture that had betrayed itself and as the beginning of the restoration of the art of a more glorious past that was henceforward to preoccupy the scholar-painters.[3]

It would be strange indeed if so splendid a court as that of Kublai Khan had attracted no painters of talent, and in Qian Xuan's pupil Zhao Mengfu (1234–1322) the emperor found a man ideally suited to bridge the gulf between his regime and the Chinese educated class. Zhao was a descendant of the first Song emperor and had already served the old dynasty in a minor post for several years when Kublai appointed him. His first job was the writing of memorials and proclamations, but he soon rose to the rank of cabinet minister, confidential adviser to the emperor, and secretary to the Hanlin Academy. He often regretted his decision to collaborate, made the more reprehensible by his close family relationship to the Song royal house. Up in the capital, separated from his family and lonely, he wrote to a friend in the south, "The only one who can console me now is my own shadow." Yet it was men of his kind who civilized the Mongols and thus indirectly hastened their downfall. Zhao Mengfu was also a great calligrapher, versed in all the styles from the archaic "big seal" (*dazhuan*) script through the clerical (*li*) style and the standard (*kai*) style to the running (*xing*) draft character.

CALLIGRAPHY

In the previous discussion of calligraphy (see chapter 5), I mentioned Wang Xizhi as a master who was to be a model for later generations. During the Six Dynasties period in north China some of the formal qualities of the old Han *lishu* were preserved in the many Buddhist inscriptions carved on stone steles and rock faces, but in the south the styles of Wang Xizhi and his son Wang Xianzhi were far more fashionable, and it was these styles that took hold at the Sui and Tang courts when China was reunited after four hundred years of division. Tang Taizong was determined to acquire the most famous example of Wang Xizhi's writing still extant, the so-called *Lanting Preface* (see fig. 5.6). He sent an agent to trick its owner, a monk, into parting with it, enjoyed it for the rest of his life, and had it buried with him.

In the liberal atmosphere that prevailed in the reign of Xuanzhong (the "Brilliant Emperor" Minghuang) a wide range of style was practiced. The emperor himself, in writing out the text of the *Classic of Filial Piety* (*Xiaojing*) in 745, appropriately chose a strong and elegant version of the Han *lishu*, but the southern style was always in fashion, while a widely unconventional form of cursive script called *kuang-cao* (crazy *cao*) was practiced by the poet Du Fu's friend Zhang Xu (d. c. 740) and his follower, the monk Huaisu (c. 700–750), among others (fig. 8.6). In this most uninhibited script, characters are run together in a continuous stroke of the brush, scribbled in sweeping gestures bordering on, but not quite arriving at, total illegibility.

The essayist Han Yu (768–824), claiming that the Wang Xizhi style was sterile and artificial, proposed a return to the stern simplicity of the ancient script. This "anti-Wang" trend was personified in the upright Yan Zhenqing (709–785), who played a key role in saving the dynasty at the time of the An Lushan rebellion. His calligraphy (fig. 8.7), which combined the strength of the Han *lishu* with the beauty of the Wang Xizhi *kaishu* and *xingshu* (see fig. 5.3), became a model for later generations.

Through the Song dynasty the two traditions continued side by side, with derivatives from the Wang style dominant, and lovers of Chinese calligraphy can derive great pleasure from identifying how the strands interweave, creating a body of work of extraordinary range and subtlety. The

FIGURE 8.6 Huaisu (c. 700–750). Part of a preface. *Kuangcaoshu* (crazy *cao* script). Tang dynasty. National Palace Museum, Taipei.

維乾元元年歲次戊戌九月庚
午朔三日壬申第十三（叔）銀青光祿
（大）夫使持節蒲州諸軍事蒲州
刺史上輕車都尉丹陽縣開國
侯真卿以清酌庶羞祭于亡姪
贈贊善大夫季明之靈曰
惟爾挺生夙標幼德宗廟瑚璉
階庭蘭玉每慰人心方期戩穀何圖逆賊間釁
稱兵犯順
爾父竭誠常山作郡余時受命亦在平
原仁兄愛我俾爾傳言爾既歸止

閏中秋月

桂彩中秋特地圓況當餘
閏魄澄鮮因懷勝賞初
經月兔使詩人嘆萬年
萬象欽光增皓魄四寰收
夜助嬋娟麟雲清廓心
再豫華嵩與能無賦詠篇

洛神賦 并序
曹子建

黃初三年余朝京師還濟洛川古人有言斯水
之神名曰宓妃感宗玉對楚王神女之事遂作
斯賦其詞曰
余從京域言歸東藩背伊闕越轘轅經通谷
陵景山日既西傾車殆馬煩爾迺稅駕乎蘅皋
秣駟乎芝田容與乎陽林流眄乎洛川於是精
移神駭忽焉思散俯則未察仰以殊觀睹一麗
人于巖之畔迺援御者而告之曰爾有覿於彼者
乎彼何人斯若此之豔也御者對曰臣聞河洛之
神名曰宓妃然則君王之所見無迺是乎其狀若
何臣願聞之余告之曰其形也翩若驚鴻婉若遊龍
榮耀秋菊華茂春松髣髴兮若輕雲之蔽月

great Song poet Su Dongpo (1036–1101), his protégé Huang Tingjian (1045–1105), and the more eccentric painter-poet Mi Fu (1051–1107) tended to favor a fuller, more rounded, and fluent style (see fig. 5.4), whereas Huizong, the last emperor of the Northern Song (r. 1101–1125), practiced a somewhat sharp, elegant, and self-conscious hand that came to be called "thin gold script" (*shoujinshu;* fig. 8.8).

This, then, was the rich and complex tradition—dominated during those centuries by the Wang Xizhi model and its derivatives—that the scholar-gentry of the Yuan dynasty inherited. Around 1300, Zhao Mengfu (fig. 8.9) was the greatest exponent of the southern style, which scholar-painters such as Shen Zhou and Wen Zhengming carried on into the Ming dynasty. Yet each exponent of the art was to interpret it in his own way—no one more acutely than the painter and critic Dong Qichang (1555–1636), who, as we shall see in the next chapter, brought to his writing (fig. 8.10) the same astringent intelligence and force of personality that he displayed in his critical writing and his landscape painting.

FIGURE 8.7 (OPPOSITE TOP) Yan Zhenqing (709–785). Part of a memoir to his brother and nephew, killed by An Lushan. *Xingshu* (running script). National Palace Museum, Taipei. Photo courtesy of Liu Zhengcheng.

FIGURE 8.8 (OPPOSITE LEFT) Song Huizong (r. 1101–1125). Part of a text composed for the Lunar Festival. *Shoujinshu* (thin gold script). Northern Song dynasty. National Palace Museum, Taipei. Photo courtesy of Liu Zhengcheng.

FIGURE 8.9 (OPPOSITE RIGHT) Zhao Mengfu (1254–1322). Part of the *Luoshen fu* (*Fu* prose-poem on the goddess of the Luo River). *Kaishu* (regular script). Photo courtesy of Liu Zhengcheng.

FIGURE 8.10 (LEFT) Dong Qichang (1555–1636). Part of the text of a poem. *Xingshu* (running script). Ming dynasty. Photo courtesy of Liu Zhengcheng.

ZHAO MENGFU

Zhao Mengfu's fame rests not only on his calligraphy, but also on his legendary skill in the art of painting horses. So closely is this court painter to the Mongols identified with pictures of the animal dearest to their hearts that almost any good example with a respectable claim to antiquity used to be attributed to him. But the horse had powerful associations for the Chinese also, as a symbol of virility and endurance, while the legendary Bole, judge of fine horses, was held up to the emperor as a model in choosing men of merit to serve him. Above all it is as a landscape painter that Zhao Mengfu must be remembered. He might, indeed, have said of himself, with Cézanne, "I am the primitive of the way I have discovered."

He occupies a pivotal position in the history of Chinese landscape painting, for, living at a time when the Song tradition had exhausted itself or exploded into Chan gestures with the brush, he united a direct, spontaneous expression of feeling with a deep reverence for the antique. Looking back beyond the orthodox Song styles, he rediscovered the poetry and the brushwork of the long-neglected southern manner of Dong Yuan and Juran. In doing so, he opened the way not only for the next generation of Yuan amateur painters—notably the Four Great Masters discussed in the next section—but for almost all subsequent scholarly landscape painting up to the present day. In his most famous surviving landscape (fig. 8.11), painted to evoke for a friend the ancestral homeland he had never seen, Zhao Mengfu with dry scholarly wit combines references to the quaintly archaic landscape style of the Tang dynasty and to the broad, calm vision of Dong Yuan. In much the same way, his calligraphy represents an elegant, balanced revival of early styles, notably that of Wang Xizhi.

Zhao Mengfu's wife, Guan Daosheng, was an accomplished painter in her own right, chiefly of bamboo. It is often asked why so few women seem to have a place in the history of Chinese art. After all, there were famous women poets and calligraphers, such as Li Qingzhao in the Song dynasty. The reason may be not that women lacked the talent, but that the historical and critical works were written by *wenren* (scholar-gentlemen), most of whom would have heartily endorsed the popular saying *nuzi wu cai bian shi de*—"for a woman to be without talents is synonymous with virtue." Women, they held, could be talented or virtuous; they could not be both, and their husbands preferred them virtuous.[4] An outstanding exception was the eighteenth-century poet and *bon viveur* Yuan Mei, who enjoyed the company of gifted women and encouraged their creative talents.

THE FOUR GREAT MASTERS
OF LANDSCAPE PAINTING

The movement of which Zhao Mengfu was the initiator found its fulfillment half a century later in the Four Great Masters of the Yuan dynasty: Huang Gongwang, Ni Zan, Wu Zhen, and Wang Meng. The oldest was Huang Gongwang (1269–1354), a detail of whose greatest surviving work, *Living in the Fuchun Mountains,* is reproduced in fig. 8.12. Little is known about his career except that for a time he held a minor official post and that he retired to a life of scholarship, teaching, painting, and poetry in his native Zhejiang. His masterwork, finished in 1350, was painted intermittently, as the mood took him, over three years. The treatment is magnificently broad, relaxed, and unaffected, with not the least hint of the decorative silhouette, the "one-corner composition," and other mannerisms of the Southern Song Academy. We feel this is the painter himself speaking from the depths of his heart. Colophons by the Ming painters Shen Zhou and Dong Qichang mention Dong Yuan and Juran as artists who inspired Huang Gongwang, but the spontaneity of his touch shows clearly that he caught the spirit of antiquity without becoming its slave.

This noble simplicity of utterance was carried even further by Ni Zan (1306?–74), a wealthy country gentleman

FIGURE 8.11 (OPPOSITE) Zhao Mengfu. *Autumn Colors on the Qiao and Hua Mountains.* Detail of a handscroll. Ink and color on paper. Ht. 28.4 cm. Yuan dynasty, dated equivalent to 1295. National Palace Museum, Taipei.

FIGURE 8.12 (ABOVE) Huang Gongwang (1269–1354). *Living in the Fuchun Mountains.* Detail of a handscroll. Ink on paper. Ht. 33 cm. Yuan dynasty, dated equivalent to 1350. National Palace Museum, Taipei.

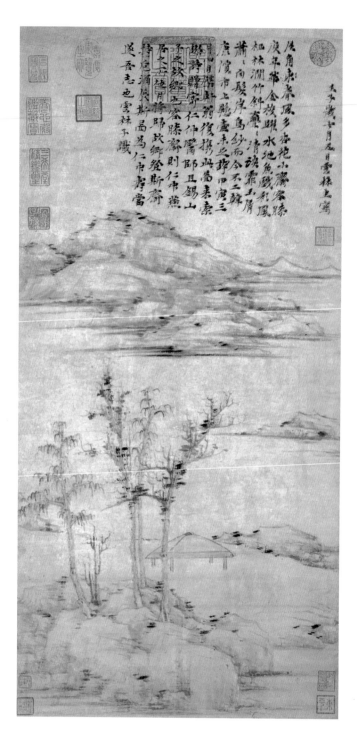

living in Wuxi who, to escape ruinous taxation, spent his later years drifting in a houseboat through the lakes and hills of southeastern Jiangsu, putting up at monasteries and staying with friends. The establishment of the Ming dynasty in 1368 enabled him to return to Wuxi, where he died in peace at the home of a relative. To the Ming *wenren* he was the ideal type of untrammeled scholar-painter. If Huang Gongwang was austere, then what word can we use to describe Ni Zan? A few bare trees on a rock, a few hills across the water, an empty pavilion—that is all (fig. 8.13). The forms are spare and simple. The ink is dry and of an even grayness, touched here and there by sparsely applied *cun*, set down, very black, with the side of the brush; it was said of Ni Zan that "he was as economical of ink as if it were gold." No concessions are made to the viewer; no figures, no boats or clouds enliven the scene, and nothing moves. The silence that pervades the picture is that which falls between friends who understand each other perfectly. The innumerable imitations of his style produced by later artists show clearly how much strength is hidden in his apparent weakness, how much skill in his fumbling with the brush, what richness of content in his emptiness.

A very different type of artist was Wang Meng. He had held office under the Mongols, served as a magistrate after the Ming restoration, was arrested for a slight association with a prime minister executed for alleged treason, and died in prison in 1385. He was a master of a close-knit texture made up of tortuous, writhing lines and a rich variety of *cun* (fig. 8.14); but though he seems to leave nothing out, his touch is sensitive and his composition clear-cut. He is one of the few Chinese painters—Shiqi is perhaps another (see chapter 10)—who, though using a brush technique of restless intensity, can achieve a final effect of repose.

Now for the first time it became natural for the artist, following the example of Qian Xuan and Zhao Mengfu, to find his inspiration not in nature so much as in art itself— a new and indeed revolutionary attitude to painting that was to have a profound influence on later generations. Up until the Yuan, each painter had built upon the achievement of his predecessors in enriching his pictorial vocabulary and drawing closer to nature, as Guo Xi had built upon Li Cheng, Li Tang upon Fan Kuan. Now the succession was broken, as artists began to range back over the whole tradition, reviving, playing variations upon, and painting "in the manner of" the great masters, particularly those of the tenth and

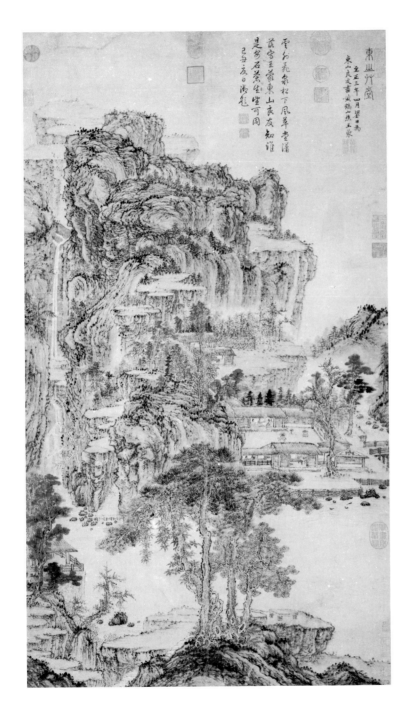

FIGURE 8.13 (OPPOSITE) Ni Zan (1306?–74). *The Rongxi Studio*. Hanging scroll. Ink on paper. Ht. 73.3 cm. Yuan dynasty, dated equivalent to 1372. National Palace Museum, Taipei.

FIGURE 8.14 (LEFT) Attributed to Wang Meng (1308–85). *Thatched Halls on Mount Tai*. Hanging scroll. Ink and color on paper. Ht. 111 cm. Yuan dynasty. National Palace Museum, Taipei.

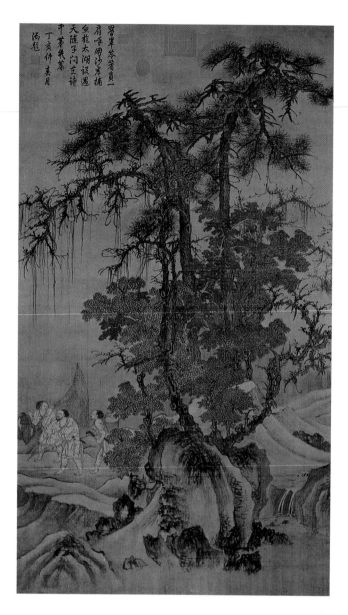

eleventh centuries. Tang Di, for instance (fig. 8.15), revived and transformed the styles of Li Cheng and Guo Xi; Wu Zhen and Huang Gongwang paid tribute to Dong Yuan; while others transformed the tradition of Ma Yuan and Xia Gui into styles that the professionals could practice. If henceforth this "art-historical art," as it has been called, was to be nurtured and enriched by the great tradition, it was also imprisoned within it, and only a strong artistic personality could break free.

With the Yuan scholar-painters, the literary and poetic associations of painting acquired a new value and importance. It became customary for the painters themselves to write a poem or inscription on their paintings not only as an expression of the intimate relationship between poetry, calligraphy, and painting, but also because their paintings were no longer realistic representations of nature, as they had been in the Song, but generalized, even slightly abstract. The inscription helps to fix the purpose or meaning of the painting, as does Wu Zhen's on his quiet, serene, nobly conceived *Central Mountain* (fig. 8.16) in the manner of Dong Yuan, although here he simply gives the date (1336), the title, and his signature. It might be joined by others written by friends and later admirers till the picture was almost obliterated under inscriptions and seals, which, far from ruining it in Chinese eyes, might greatly enhance its value. From then on also, scholar-painters preferred, like the calligraphers, to work on paper, which, besides being a great deal cheaper than silk, was more responsive to the touch of the brush.[5]

BAMBOO PAINTING

It is not surprising that the difficult art of bamboo painting should have found special favor in the Yuan dynasty, for it was a natural subject for the proud and independent *wenren* who lived out their secluded lives far from the Mongol court. To them, indeed, the bamboo was itself a symbol of the true gentleman, pliant yet strong, who maintains his integrity no matter how low the adverse winds of circumstance may bend him. The lithe grace of its stalk and the dashing sword-point of its leaves offered the perfect subject to his brush; but, above all, the painting of bamboo in monochrome ink brought the painter closest to that most difficult of arts, calligraphy. In painting bamboo, the form

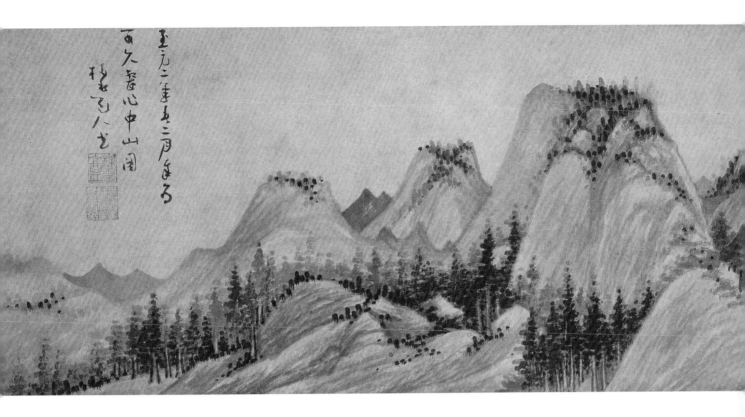

FIGURE 8.16 Wu Zhen (1280–1354). *The Central Mountain.* Detail of a handscroll. Ink on paper. Ht. 26.4 cm. Yuan dynasty, dated equivalent to 1336. National Palace Museum, Taipei.

and place of every leaf and stalk must be clearly delineated: the awkward juncture cannot be hidden in mist as in landscape painting; the gradations from black ink in the near leaves to pale in the distance must be precisely judged; the balance of stalks to leaves, of leaves to empty space, exactly struck. Having achieved this, the painter must still know how the bamboo grows and give to his own the springing movement of the living plant. A great bamboo painting is a virtuoso performance of a very high order.

The art of bamboo painting had first become fashionable in the Six Dynasties, when it was the custom, except when painting on a minute scale, to outline the stem and leaves in ink and fill them with color. This painstaking technique was handed down chiefly by the academicians, though the Song artist Cui Bo and the fourteenth-century master Wang Yuan also used it occasionally. Bamboo painting seems to have gone out of fashion during the Tang dynasty (Huizong had no Tang specimens in his collection), but became widely popular again by the Northern Song,

when its greatest exponents were Wen Tong and the poet and calligrapher Su Dongpo. In the Yuan dynasty several of the great literati, notably Ni Zan and Zhao Mengfu, were accomplished painters of bamboo in monochrome ink. Li Kan (c. 1245–1320), who took as his master Wen Tong, devoted his life to bamboo, which he studied both as an amateur botanist and as a painter (fig. 8.17). His illustrated manual on bamboo, *Zhupu xianglu,* became an essential tool in the hands of every practitioner and provided the starting point for all later writers on the subject.

A more natural and spontaneous rendering of the sub-

ject than Li Kan ever achieved is Gu An's contribution to the collaborative picture illustrated in fig. 8.18. Gu An (c. 1295–c. 1370) was a scholar and official in Suzhou; his friend Zhang Shen, a former governor of Zhejiang, did the old tree, while the calligrapher Yang Weizhen (1296–1370) wrote the wild poem above, in which he speaks of "painting bamboo while drunk"—referring presumably to Gu An's performance.[6] It is a beautiful *jeu d'esprit*, datable before the summer of 1370, when Gu An died; at a later date the aged Ni Zan added to it, on a separate piece of paper stuck on, a long inscription and the rather feeble rock in the lower corner. These additions lack altogether the spontaneity of the rest and spoil the composition, as we can see if we cover over Ni Zan's contribution. Amateurish carelessness could be carried too far.

CERAMICS

It used to be thought that the decorative arts in China declined, if they did not actually come to a standstill, in the Yuan dynasty, but now scholars realize that this was, on the contrary, a period of innovation and technical experiment. In ceramics, for example, techniques such as painting in underglaze red or blue were revived. The northern kilns, except for those at Cizhou and Junzhou, barely survived the Liao, Jin, and Mongol invasions, and now the focus of the ceramic industry shifted permanently to the center and south. The kilns at Longquan and Lishui in Zhejiang continued to produce celadons on a large scale—indeed, production must have increased to keep pace with the demand for exports to the Near East that the *Pax Tartarica* had stimulated.[7] A baluster vase dated 1327 in the Percival David Foundation collection in London is typical of the more baroque preferences of the period, being elaborately and somewhat tastelessly decorated with floral scrolls molded in relief under the glaze. More daring was the technique of leaving the central decorative motif on a dish, such as a dragon, unglazed in relief. Sometimes these reliefs were modeled by hand, but the presence in the Percival David Foundation collection of a celadon dish and a flask bearing identical dragons (the former unglazed and the latter glazed) indicates that molds were also used. It is possible that spotted celadon (*tobi-seiji*) may also have been a Yuan innovation. There are signs, however, that by the mid fourteenth century the quality of Longchuan wares was be-

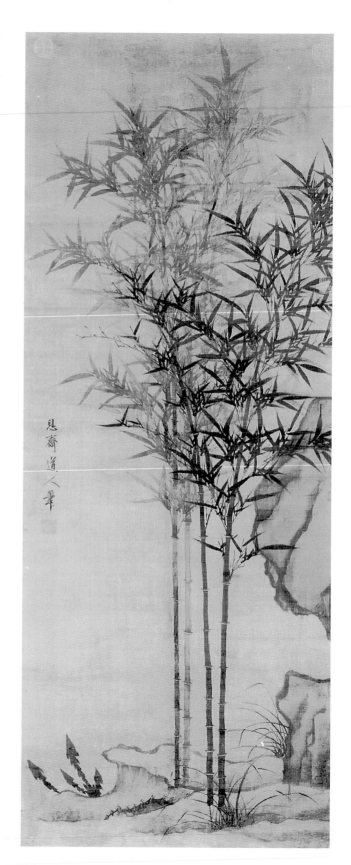

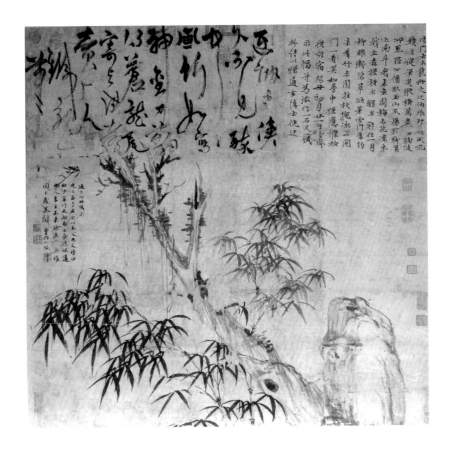

ginning to fall off, probably because of competition from the factories at Jingdezhen in Jiangxi.

There had been kilns in and around Jingdezhen since the tenth century. In 1004 their products were considered good enough to be sent up to the palace at Beijing, but it was not until 1369 that the Yuan court actually set up their own kilns there. Closed down in 1608, the imperial factory was reestablished in the Qing dynasty (1680) under the emperor Kangxi and survived until 1910, when the last court wares were ordered from commercial kilns.

The quantity sent up to Beijing varied enormously: none at all in some years; 440,000 pieces in 1443. Sometimes, to fill a huge order, the imperial kilns cooperated with commercial ones, which could be penalized if their products did not come up to the palace's exacting standards. The Jingdezhen ceramic industry, now mechanized, still flourishes today, and large quantities are produced both for domestic consumption and for export.

During the Song dynasty the finest products of the

Jiangxi kilns had been white porcelains, chiefly *qingbai* ware and an imitation of the northern Ding ware. But by the beginning of the fourteenth century new techniques were already being explored. *Fouliangzhi* (The annals of Fouliang), written before 1322, notes that at Jingdezhen "they have experts in molding, painting, and engraving." Painting we will consider in a moment. Molding and engraving can be seen in the so-called *shufu* ("privy council") wares. It seems likely that the *shufu* was the first ware to be made at Jingdezhen on imperial order. It comprises chiefly bowls and dishes with incised, molded, or slip decoration—generally consisting of flower sprays, lotus leaves, or phoenixes amid clouds—under an opaque white glaze. Sometimes a vessel includes the characters *shufu* or other auspicious words such as *fu* ("happiness"), *shou* ("long life"), or *lu* ("emolument"). Closely related to these vessels are the stem cups, ewers, bottles, and jars whose decoration consists of applied reliefs, often in zones separated by pearl beading, and the figurines, chiefly bodhisattvas, that were used in

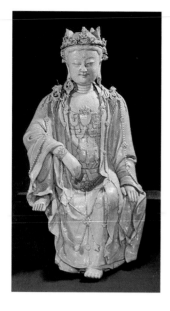

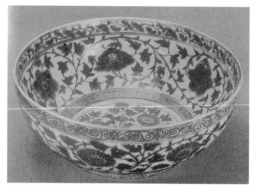

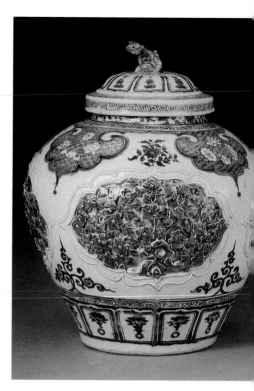

domestic shrines. Several exquisite examples of these *qing-bai* wares, including the Guanyin illustrated in fig. 8.19, have been excavated from Yuan-period sites in Beijing.

Another of the developments at Jingdezhen that may have occurred before the middle of the fourteenth century was painting in copper red under the glaze (fig. 8.20), a technique that had originally been used, somewhat tentatively, in the Tang kilns at Tongquan near Changsha in Hunan. Some of the most attractive Yuan examples are the bottles with graceful pear-shaped bodies and flaming lips decorated with sketchily drawn flower sprays or clouds. During the Ming dynasty the designs were to become more elaborate, but the copper red had a dull, often grayish, color and a tendency to run, and it was consequently abandoned in the fifteenth century in favor of the more manageable underglaze cobalt blue. For a while, attempts were made to combine not only underglaze copper red and cobalt blue but also beading, carving, and openwork. The wine jar illustrated in fig. 8.21, excavated at Baoding in Hebei, is a splendid example of the extravagant blending of techniques so typical of Yuan taste.

In the whole history of ceramics, probably no single ware has been so much admired as Chinese blue and white. Imitated in Japan, Indochina, and Persia, it inspired the pottery of Delft and other European factories; its devotees have ranged from the headhunters of Borneo to James McNeill Whistler and Oscar Wilde, and its enchantment is still at work.

The debate about blue and white is complicated by its early history, which was not continuous. We have seen how a crude blue and white was produced during the Tang dynasty at the Gongxian kilns in Henan, while pieces of poor-quality blue and white dating from the late Song have been discovered in kiln sites in Zhejiang and Jiangxi. Continuous development apparently did not get under way until the early fourteenth century. Even kilns south of Kunming in distant Yunnan produced their variant of the ware, using cobalt from local mines. But from now on the main production was to be at Jingdezhen. Progress must have been rapid to have produced the famous pair of vases in the Percival David Foundation collection in London (fig. 8.22), which were dedicated to a temple in Jiangxi in 1351.

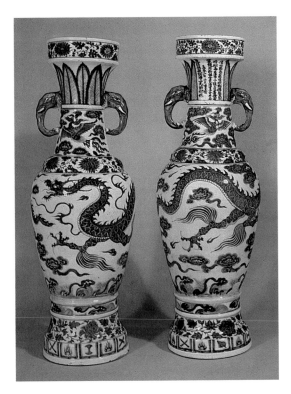

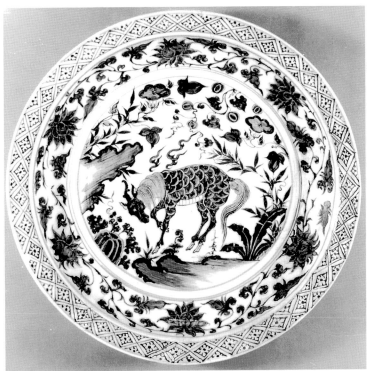

To begin with, at least, the ware had no appeal to connoisseurs. *Ge gu yaolun,* the compendium for collectors of 1387–88, dismissed it, along with the five-color wares, as "very vulgar."

The pieces that can be dated to the Yuan period with confidence include large, boldly decorated dishes (fig. 8.23), pear-shaped vases, ewers and flasks in Near Eastern shapes made for export, bowls, and stem cups. Decoration includes Near Eastern ogival panels and Chinese dragons, lotus and chrysanthemum scrolls, and narrower bands of petals, some of which had already appeared in the Jizhou wares of the Southern Song. By the time the David vases were made, the potters and painters at Jingdezhen had fully mastered their art, and the vases and dishes of the next hundred years are unequaled in splendor of shape and beauty of decoration. The drawing is free and bold, yet delicate, the blue varying from almost pure ultramarine to a dull, grayish color with a tendency to clot and turn black where it runs thickest—a fault that was eradicated by the sixteenth century and cleverly imitated in the eighteenth.

FIGURE 8.19 (OPPOSITE LEFT) Guanyin. White porcelain. *Qingbai* ware. Ht. 67 cm. Excavated in the remains of the Yuan capital, Dadu (Beijing). Yuan dynasty.

FIGURE 8.20 (OPPOSITE CENTER) Bowl. White porcelain decorated with copper red under the glaze. Diam. 40.5 cm. Yuan dynasty. Gemeente Museum Collection, The Hague.

FIGURE 8.21 (OPPOSITE RIGHT) Wine jar. White porcelain decorated with openwork panels and painting in underglaze red and blue. Ht. 36 cm. Excavated at Baoding, Hebei. Yuan dynasty.

FIGURE 8.22 (ABOVE LEFT) Pair of vases dedicated to a temple in Jiangxi in 1351. Porcelain decorated in underglaze blue. Ht. 63 cm. Yuan dynasty. Collection of Percival David Foundation of Chinese Art, London.

FIGURE 8.23 (ABOVE RIGHT) Dish. Porcelain decorated in underglaze blue with a mythical animal amidst plants. Diam. 46 cm. Yuan dynasty, fourteenth century. Sayce Bequest, Ashmolean Museum, Oxford.

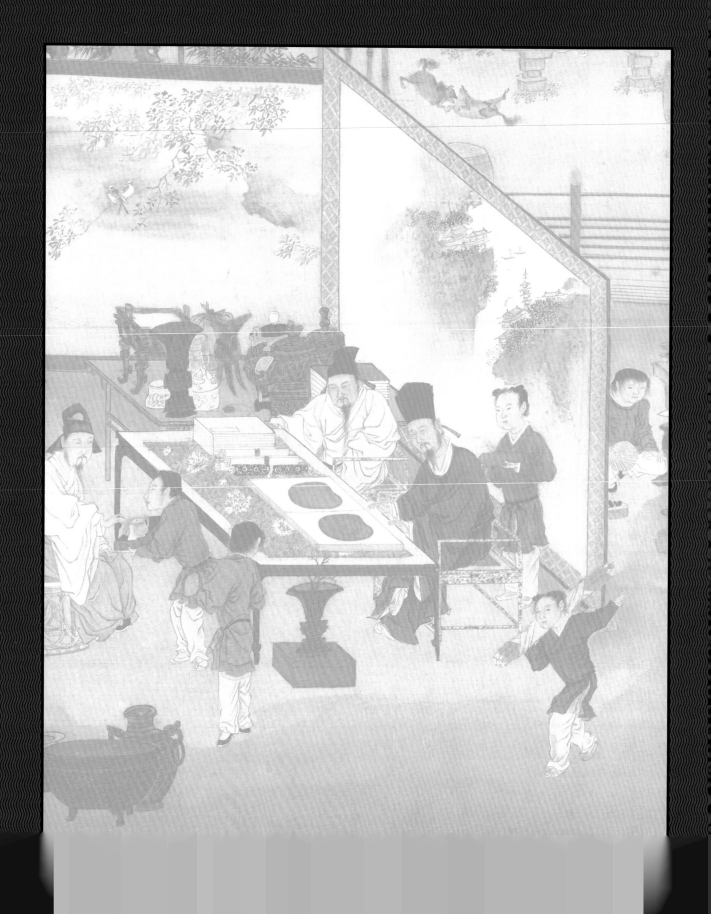

THE MING DYNASTY

The ferment into which central China had sunk as the Mongols lost control of the country was finally resolved in 1368 when Zhu Yuanzhang—in turn shepherd, monk, bandit, warlord, and emperor—sent his armies north to occupy Beijing, from which the last Yuan ruler had fled. Zhu proclaimed himself emperor of the Ming dynasty, set up his capital in Nanjing, and within four years had not only recovered all the territories held by the Tang at the height of its power, but had extended his control over part of Manchuria as well. He built at Nanjing a capital with a city wall 20 miles (32 km) in circumference, the longest in the world, and under him and his successor central and southern China enjoyed a new importance and prosperity. In 1421 the third emperor, the usurper Yongle,[1] moved his capital back to Beijing (fig. 9.1), whence he had received his chief support in his struggle for power, and it was he who rebuilt the city on the scale we see today. But Beijing was a bad site on two counts. It was situated too far to the north of China's new economic center of gravity, the Yangzi Valley, and it was also highly vulnerable: China's northern enemies—now the Manchus—had only to cross the Great Wall to be at the gates of the city. The troubles that beset the Ming dynasty throughout its subsequent history were largely due to the remoteness of the capital from the parts of China that mattered most—the center and south—and to the constant tension along the Great Wall (fig. 9.2), which lay only 40 miles (64 km) from Beijing. Yongle was aggressive and secured the frontier, but his successors were weak and corrupt, the victims of eunuchs, of whom there were said to be as many as seventy thousand in the emperor's service across the country, with immense power not only over the scholar-officials, who were brutally treated, but over the military as well. In fact, the eunuchs' power was one factor in driving the literati from court life and encouraging them, especially in the Jiangnan region, to enjoy their own culture, backed up by a flourishing economy and a class of prosperous merchants and landowners who bought their paintings. Typical was Wang Zhen (d. 1495), a merchant who knew many artists, among them Shen Zhou, and took to the grave with him twenty-four examples of the work of scholar-painters and calligraphers.

In the early fifteenth century Ming China was immensely powerful. Chinese navies roamed the southern seas under Admiral Zheng He, a eunuch in high favor with the emperor. The admiral was not bent on conquest: the Chinese have never—in the past, at any rate—been interested

FIGURE 9.1 (BELOW) Guardian lion in
front of the Taihedian, in the Forbidden
City. Bronze. Ming dynasty, 1427.

FIGURE 9.2 (RIGHT) The Great Wall
at Badaling. Ming dynasty.
Photo by the author.

in stretching their empire beyond the seas. Zheng He's five expeditions between 1405 and 1433 were carried out for the purpose of showing the flag, making alliances, and opening up trade routes, and incidentally collecting curiosities for the entertainment of the court. China had no other interest in the outside world. Before the end of the fifteenth century, however, Vasco da Gama had rounded the Cape of Good Hope; by 1509 the Portuguese were in Malacca and by 1516 in Guangzhou (Canton), and China was finally forced to take account of the Western barbarians by reason of their aggressive conduct around its shores.

The splendor of the Ming court concealed a creeping paralysis. Officials, selected by civil service examinations centered on the stultifying complexities of the "eight-legged essay," became increasingly conservative and conventional in outlook. The energies of savants at court were devoted less to original scholarship than to the preparation of such vast works as the *Yongle dadian,* an encyclopedia in 11,095 volumes compiled between 1403 and 1407. The Song emperors had been men of taste and education, able to inspire the best in their scholars and painters; the Ming emperors were for the most part ruffians, usurpers, or weak victims of court intrigue. As a result, the palace tradition in painting petered out in a frozen academicism, and for significant achievements we must look not to the court but to the scholars, collectors, and amateurs who carried on the tradition that had been established by the independent literati of the Yuan dynasty. If the history of later Chinese painting is to be told, for the most part, in the lives and work of the scholar-gentry—and there are many in China today who would dispute this—then we must focus our attention from now on almost exclusively on the corner of south-

eastern China that embraces southern Jiangsu and northern Zhejiang (map 9.1), a region rich in agriculture, cotton, silk, and thriving cities where most of the material and cultural wealth was now created and enjoyed.

Here, chiefly in and around Suzhou and Wuxi, the landed gentry of the fifteenth century cultivated their estates, digging pools and heaping up artificial hills to create those famous gardens in which scholars, poets, and painters could enjoy the good life.[2] The gardens in Suzhou and Wuxi, with their pavilions and winding paths, their fancy rocks dredged out of the bed of Lake Tai (and often "improved" by rock specialists), have been restored—and in places tastelessly overrestored—for the pleasure of the modern visitor, among them the Garden to Linger In (Liu yuan) and the Garden of the Clumsy Politician (Zuozheng yuan). One of the courtyards of the Garden of the Master of the Fish-

ing Nets (Wangshi yuan; fig. 9.3) was copied with scrupulous care in the Metropolitan Museum of Art, New York, and further enriched with an exquisite group of rocks (fig. 9.4) rescued from an abandoned garden in Suzhou.

In and around Suzhou also were concentrated the great private collections, those, for example, of Xiang Yuanbian (1525–90) and Liang Qingbiao (1620–91), whose seal on a painting, if accepted as genuine, was often all the collector required to attest to its authenticity.[3] It was these and other private collectors in the southeast, rather than the Ming emperors, who preserved the remaining masterpieces of the Song and the Yuan, some of which were to find their way back into the imperial collection in the eighteenth century.

To attach the name of an old master to a painting was to link its owner with the great cultural tradition. As Joan

Stanley-Baker put it, "collecting became a social relationship between famous artists and fame seeking collectors." And it encompassed far more than painting. Collecting included all those "superfluous things" that made life agreeable: old books and rubbings, bronzes, porcelain, jade, lacquer. Naturally the forgers flourished in this world of conspicuous consumption. Moreover, by the late Ming the strict sumptuary laws laid down by the first Ming emperors—specifying exactly what materials, finish, and decoration were permitted on the furniture, dress, ornaments, tableware, and so on of various official ranks and of merchants and artisans—were widely ignored. "Nowadays," laments a late Ming author, "men dress in brocaded and embroidered silks, and women ornament themselves with gold and pearls, in a case of boundless extravagance which flouts the regulations of the state."[4]

The good life meant leisure not only for the practice of the arts, but also for the pleasures of philosophy. Many schools were active in the Ming, most of which were Neo-Confucian with a coloring of Buddhist and Daoist ideas. The Northern Song Neo-Confucians had stressed the importance, in self-cultivation, of the "investigation of things," which included not only the mind and the underlying principles of things, but also phenomena and objects in themselves. By the Ming, however, study of the external world had largely given way to study of such questions as the relationship between mind and principle and between knowledge and action. For a rigorous analysis of things, Ming thinkers such as Wang Yangming substituted a tendency to generalize about them. The painting of the Ming scholars, like their thinking, tended to be more intuitive and conceptualized, as if their predecessors had learned all they needed from the study of the natural world, and now they had only to "borrow" (as Su Dongpo had once put it) mountains and water, rocks and trees, as vehicles for the expression of thought and feeling.

Ming painting consequently does both less and more than that of the Song: less in that it tells us so little about nature as we see it—compare, for example, the landscapes of Shen Zhou and Wen Zhengming in this chapter with

those of Fan Kuan and Zhang Zeduan in chapter 7—and more in that the painting is now made to carry a much richer freight of poetic and philosophical content; or, to put it another way, the artist is saying things that cannot be fully expressed in the conventional language of landscape painting. To help carry that freight—to extend, as the Chinese put it, the idea beyond the pictorial image itself—the painter's inscription became longer and more richly poetic or philosophical in tone. Thus did the art of painting at its upper levels become more and more interwoven with the ideals and attitudes of the elite and more and more remote from the experience of the rest of society.

COLOR PRINTING

This was a great age of art scholarship. Not only the connoisseurs and collectors but also the painters themselves were students of the tradition, often deriving inspiration less from nature than from the works of the old masters, which they studied and copied as an essential part of their artistic activity. The encyclopedic knowledge of the styles of the old masters that amateur painters began to display at about this time was aided by the development of color printing. The earliest color printing known in China—indeed, in the world—is a two-color frontispiece to a Buddhist sūtra scroll dated 1346. Under the Ming, erotic books were illustrated in line blocks using up to five colors. One of the first books to include full-color printing was the *Chengshi moyuan* (Mr. Cheng's miscellany), published in 1606, for which a few of the monochrome illustrations were copied from prints given to the author by the Jesuit missionary Matteo Ricci. The art of color printing reached its peak in the rare group of anonymous seventeenth-century prints known as the Kaempfer Series (fig. 9.5), after an early

collector of them, and in the *Shizhuzhai shuhua pu* (Treatise on the paintings and writings of the Ten Bamboo Studio; fig. 9.6), published in 1633. Thereafter, handbooks on the art of painting as a pastime were to proliferate, the most famous being the *Jieziyuan huazhuan* (Painting manual of the Mustard Seed Garden; fig. 9.7), first published in five parts in 1679, later expanded, and still used as a technical primer by Chinese students and amateurs today.[5]

In the late seventeenth century Chinese color prints reached Japan, stimulating the growth of the art, although full-color printing was not perfected in Japan until the middle of the eighteenth century. In Japan the color print developed as a vital art form in its own right, of which the masters recognized and exploited the very limitations of the medium, whereas in China it was, like so much else, the servant of painting and was always at its best when it most nearly gave the effect of ink and watercolor. After a sad decline in the nineteenth century, the art was revived in the 1920s, and the Rongbaozhai studio in Beijing has become famous both for its decorated letter papers and for its faithful replicas of paintings printed with up to two hundred separate blocks.

COURTLY AND PROFESSIONAL PAINTING

At the Ming court there was no one of Zhao Mengfu's stature to mediate between the academicians and the literati, who kept their distance and made no attempt to influence court art for the better. The Ming emperors, following the Tang model, made the Bureau of Painting a subdivision of the Hanlin Academy, but it was no longer the center of culture and art that it had been in former times. It was set up in the Renzhi Palace within the Imperial City, and a special office under the Directorate of Palace Eunuchs was established to control it. Painters were honored with high military titles (to distinguish them from civil officials!) and treated with great favor. This favor, however, depended upon absolute obedience to a rigid code of rules and regulations. They lived, moreover, in terror of their lives. Under Hongwu, four court painters, including Zhou Wei and Zhao Yuan, were executed for having incurred that savage monarch's displeasure, and it is astonishing that any good work was produced at all. By the time of the Xuande emperor (Xuanzong, 1426–35), who was a painter himself, the lot of the senior court artists had much improved, and they were now given the time-honored rank of *daizhao*. Yet Dai Jin could be dismissed from the emperor's service because he had allegedly painted the garment of a fisherman red, the color reserved for officials at imperial audiences.[6]

Among the most talented of the court painters of the early Ming was Bian Wenjin (c. 1400–1440), who specialized in painting birds and flowers in the careful, decorative, outline-filled-with-color style of the Five Dynasties master Huang Quan. In his day Bian Wenjin was considered one of the three greatest living artists, and indeed his works have a delicacy and perfection of drawing and color that link him rather to Huizong than to any of the host of decorators who turned out paintings by the hundred to adorn the innumerable rooms of the palace. Dominant among these was the late-fifteenth-century painter Lü Ji, whose magnificently decorative compositions, rich in color, definite and precise in form, conservative in style, exactly suited the taste of his imperial patrons (fig. 9.8). In landscape, the models for the professionals were Ma Yuan and Xia Gui, partly because they too had been academicians and partly because the basis of their work, like that of the flower painters, was not self-expression but technique, and technique could be learned. Ni Duan, for example, modeled him-

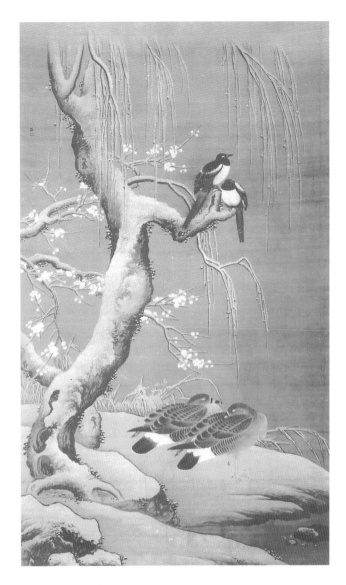

FIGURE 9.8 Lü Ji (late fifteenth to early sixteenth century). *A Pair of Wild Geese on a Snowy Bank*. Hanging scroll. Ink and color on silk. Ht. 185 cm. Ming dynasty. National Palace Museum, Taipei.

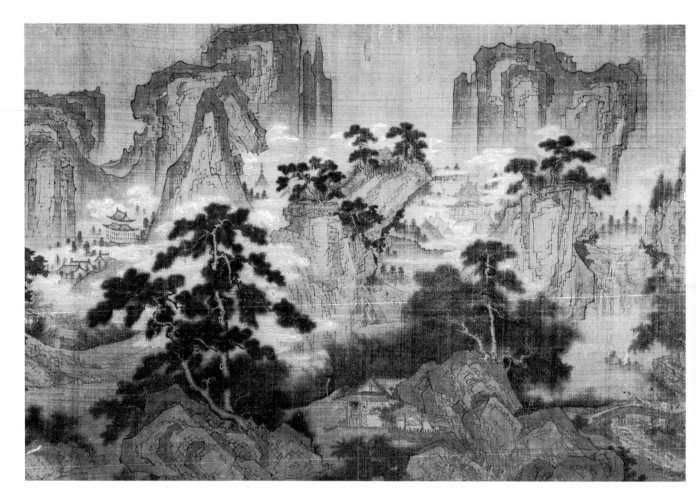

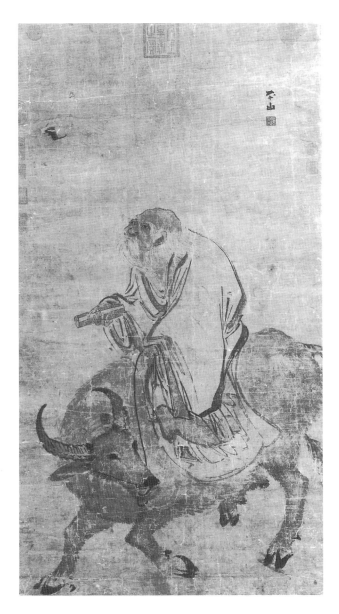

FIGURE 9.11 Zhang Lu (c. 1464–1538). *Laozi Riding on a Water Buffalo.* Hanging scroll. Ink and color on paper. Ht. 114 cm. Ming dynasty. National Palace Museum, Taipei.

self on Ma Yuan, Zhou Wenjing on both Ma Yuan and Xia Gui, Li Zai—who is said to have impressed the great Japanese landscape painter Sesshu—on Ma Yuan and Guo Xi, while Shi Rui, in a beautiful handscroll reproduced in fig. 9.9, skillfully combined the monumental manner of the Northern Song with the rich mineral-blue-and-green coloring of a still older tradition. In most of their works, however, the element of mystery in the Song romantics had hardened into a brilliant eclecticism, its poetry into prose.

Dai Jin (1388–1452), a highly skilled landscapist at the Ming court, was a native of Hangzhou in Zhejiang, where the styles of the Southern Song academy still lingered on in the fifteenth century. After his dismissal and return to Hangzhou, his influence in the area became so wide as to give the name of his province to a loosely connected group of professional landscape painters. The Zhe School, as it was called, embodied the forms and conventions of the Ma-Xia tradition, but treated them with an unacademic looseness and freedom, as, for instance, in the detail in fig. 9.10 from Dai Jin's handscroll, *Fishermen,* in the Freer Gallery. Other outstanding artists of the Zhe School were Wu Wei and Zhang Lu, both of whom specialized in figures in a landscape setting (fig. 9.11). At the end of the dynasty, the Zhe School enjoyed a brief final flowering in the elegant and eclectic art of Lan Ying (1578–1660).

PAINTING OF THE LITERATI

THE WU SCHOOL

During the prosperous middle years of the Ming dynasty, the Wu district of southern Jiangsu and northern Zhejiang was the artistic capital of China and Shen Zhou (1427–1509) its greatest ornament. Because of his prominence he is regarded as the founder of the Wu School, although he was only the chief of a long line of landscape painters in Wu going back to the Tang dynasty. Shen Zhou never took office, but lived in comfortable retirement, a benevolent landlord and member of a circle of scholars and collectors. Under his scholarly teacher Li Jue, he early mastered a wide range of styles, from those of the Southern Song academicians to those of the Yuan recluses. His well-known landscapes in the manner of Ni Zan (fig. 9.12) are extremely revealing of the change that was coming over the literary man's art during the Ming dynasty, for while Ni Zan is almost forbiddingly plain and austere, Shen Zhou is something of

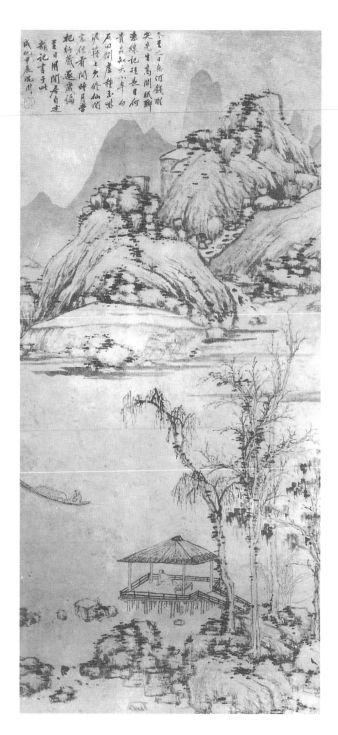

an extrovert who cannot help infusing a human warmth into his paintings. As he said of himself, "Ni Zan is simple, I am complex," and whenever he painted in the manner of that difficult master his teacher would shout at him, "You're overdoing it!"

Shen Zhou was no mere copyist. He distilled a style that is uniquely his own. Whether in long panoramic landscapes, tall mountain scrolls, or small album paintings, his brushwork, seemingly so casual, is in fact firm and confident, his detail crystal clear yet never obtrusive, his figures—like those of Canaletto—reduced to a kind of shorthand yet full of character, his composition open and informal yet perfectly integrated; and when he used color he did so with an exquisite freshness and restraint. It is not surprising that he became so popular not only with the literati of his time, but also with modern connoisseurs. His debt to Huang Gongwang is subtly evoked both in the style of the album leaf illustrated in fig. 9.13 and in the subject, a self-portrait, *Returning Home from the Land of the Immortals,* with, as his companion, a crane who might be the spirit of crazy old Huang himself. Above it Shen Zhou writes:

> With crane and lute aboard, I am homeward bound
> across the lake.
> White clouds and red leaves are flying together.
> My home lies in the very depths of the mountains,
> Among the bamboo, the sound of reading, a tiny couch
> and a humble gate.[7]

Such album leaves are full of natural charm, and only when we compare Shen Zhou with Huang Gongwang or Wu Zhen do we realize that something of their grandeur and breadth of vision has been lost. But it was Shen Zhou who transformed their lofty style into a language that other, less gifted, painters could draw upon.

As Shen Zhou dominated the Wu district in the fifteenth century, so did his follower Wen Zhengming (1470–1559) in the sixteenth. Ten times Wen Zhengming sat for the civil service examinations, and ten times he failed; nevertheless he was called to the capital, where he spent a few unhappy years as a history compiler in the Hanlin Academy before returning in 1527 to Suzhou to devote the rest of his life to art and scholarship. There he systematically collected and studied the works of the old masters, not only the Yuan literati but such classical and academic figures as Li Cheng and Zhao Boju. His studio became an informal academy

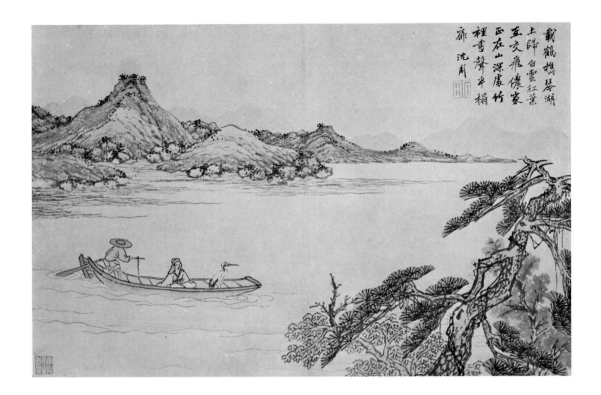

載鶴攜琴湖
上歸台雲紅葉
互次飛儂家
正在山深處竹
裡書聲半榻
廉 沈周

through which he passed on his high standards and encyclopedic knowledge of the history and technique of painting to his many pupils, who included not only his son Wen Jia and his nephew Wen Boren, but also the flower painter Chen Shun (Chen Daofu, 1483–1544) and the fastidious landscapist Li Zhi (1496–1576). Although much of his work is refined and sensitive (fig. 9.14), in his last years Wen Zhengming painted a series of remarkable scrolls of old juniper trees in pure monochrome ink that in their rugged, twisted forms seem to symbolize the noble spirit of the old scholar-painter himself (fig. 9.15).

In chapter 7 we touched on the problem of copies and forgeries of paintings in the Song dynasty. During the Ming and Qing dynasties, particularly in prosperous southern cities such as Hangzhou and Suzhou, rich merchants aimed to acquire gentility by collecting the paintings and calligraphy of masters such as Shen Zhou and Dong Qichang (discussed later in this chapter). The demand for their work was so great that these and other popular artists employed their pupils and assistants as *dai bi* ("substitute brushes") to turn out works in the master's style, to which

FIGURE 9.12 (OPPOSITE) Shen Zhou (1427–1509). *Landscape in the Manner of Ni Zan.* Hanging scroll. Ink on paper. Ht. 138 cm. Ming dynasty, dated equivalent to 1484. The Nelson-Atkins Museum of Art, Kansas City, Missouri. Purchase: Nelson Trust.

FIGURE 9.13 (ABOVE) Shen Zhou. *Returning Home from the Land of the Immortals.* Album leaf. Ink on paper. Ht. 38.7 cm. Ming dynasty. The Nelson-Atkins Museum of Art, Kansas City, Missouri. Purchase: Nelson Trust.

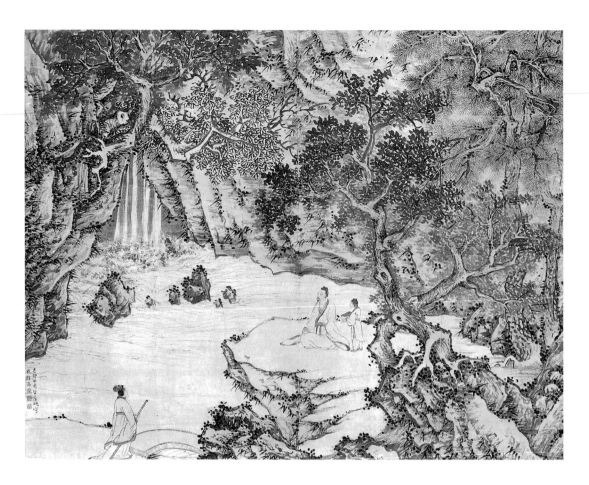

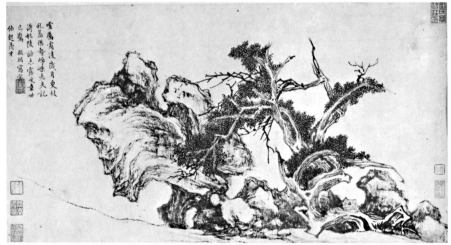

they would add their own signature and seals—a practice that has continued up to the present day. So expert were these *dai bi* that Wen Zhengming could not always tell their work from that of his master, Shen Zhou, while Wen Zhengming himself often used his son Wen Peng as his own *dai bi*.

TANG YIN AND QIU YING

Two painters active in the first half of the sixteenth century cannot be classified as belonging either to the Zhe or to the Wu School. Tang Yin (1479–1523) ruined a promising career when he became involved in a scandal over the civil service examinations. No longer considered a gentleman, he spent the rest of his life between the brothels and wine shops of Suzhou, on the one hand, and the seclusion of a Buddhist temple, on the other, painting for a living. He was a pupil of Zhou Chen and a friend of Wen Zhengming, whose rectitude he admired but could not emulate. His eclectic style drew on many contemporary artists as well as on Li Tang, Liu Songnian, Ma Yuan, and the great Yuan masters. Because of his friendship with Wen Zhengming, he is often classed with the Wu School. But his towering mountains painted in monochrome ink on silk are re-creations of the forms and conventions of the Song land-

scapists, though with a hint of mannerism and exaggeration. *Gentleman Playing the Lute in a Landscape* (fig. 9.16) in the National Palace Museum, Taipei, is a good example of his work at its most refined—scholarly in content, yet highly professional in technique. It is these conflicting qualities in his style and social position that make him so hard to place and have caused a modern Japanese scholar to label him "neo-academic."

Into the same class falls Qiu Ying (c. 1494–c. 1552), who was also born in Wuxian, but of lowly origins, and who was neither court painter nor scholar but a humble and possibly illiterate professional. Idealizing in his pictures the leisurely life of the gentry whose equal he could never be, Qiu Ying was happiest if one of the great literati condescended to write a eulogy on one of his paintings. He is also famous for his long handscrolls on silk depicting with exquisite detail and delicate color such popular themes as the *Lute Song*, life at the court of Minghuang, or the multifarious activities of the ladies of the palace. He was an

FIGURE 9.16 Tang Yin (1479–1523). *Gentleman Playing the Lute in a Landscape.* Detail of a handscroll. Ink and color on paper. Ht. 27.3 cm. Ming dynasty, about 1516. National Palace Museum, Taipei.

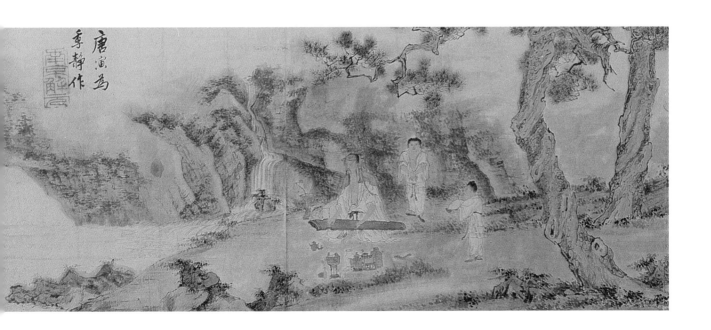

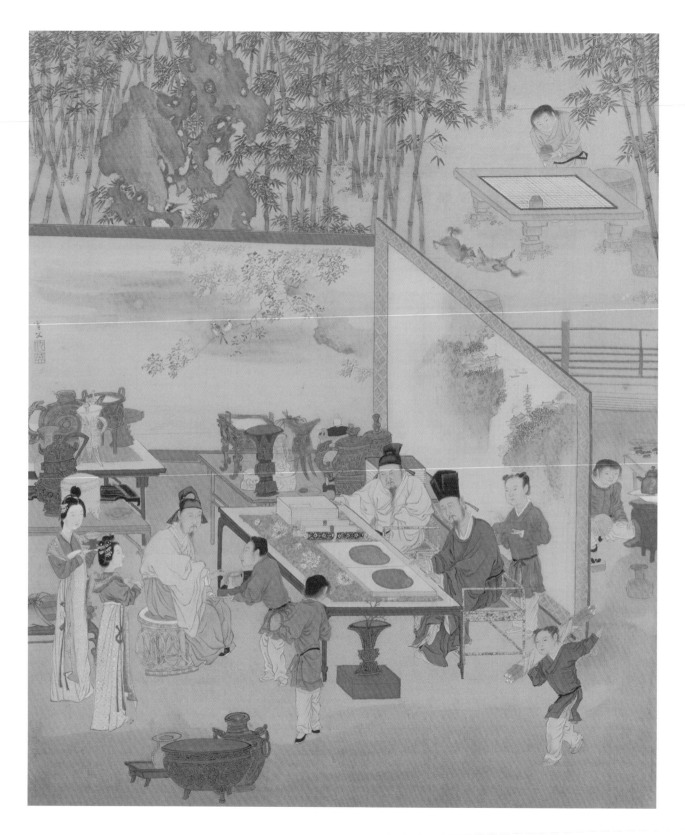

expert copyist of the old masters for his patrons, who in-
cluded the famous collector Xiang Yuanbian. As a land-
scapist he was the last distinguished exponent of the green-
and-blue style, though he worked also in the ink washes of
the Wu School. His delightful pictures, such as his paint-
ing of well-attended gentlemen enjoying their antiques in
a garden (fig. 9.17), are widely appreciated both in China
and in the West, and next to Wang Hui he is probably the
most forged painter in the history of Chinese art.

DONG QICHANG AND THE
NORTHERN AND SOUTHERN SCHOOLS

In the later development of the literary school no man
played a more significant part than the scholar-painter Dong
Qichang (1555–1636), who rose to high office under Wanli.
Not only did he embody in his paintings the aesthetic ideals
of his class, but he also gave them theoretical formulation
through his critical writings. Dong Qichang was a noted
calligrapher and a painter of landscapes in monochrome
ink, but though he worked freely in the manner of the great
masters of the past, he was not content merely to para-
phrase. His creative reinterpretations of earlier styles are
animated by a passion for pure form, an expressive dis-
tortion, that few of his followers understood. They preferred
to take his theories more literally, to the detriment of schol-
arly painting during the ensuing three centuries.

For it is as a critic that Dong Qichang is most famous.
It was he, borrowing an idea first put forward by the poet-
painter Du Qiong in the fifteenth century, who formulated
the theory of the Northern and Southern Schools for the
express purpose of demonstrating the superiority of the
wenren tradition above all others. It was primarily through
landscape painting, he maintained, that the scholar and gen-
tleman expressed his understanding of the working of the
moral law in nature, and hence his own moral worth. The
wenren, indeed, was the only kind of man who could do this
successfully, for only he was free from both the control of
the academy, on the one hand, and the necessity to make
a living, on the other; moreover, being a scholar, his wide

reading in poetry and the classics gave him an under-
standing of the nature of things combined with an epi-
curean nobility of taste that the lower orders of professional
painters could never hope to acquire. In the spontaneous
play of ink and brush, in his freedom to select, omit, sug-
gest, the *wenren* had at his command a language capable
of conveying the loftiest and subtlest concepts.

Dong Qichang called the tradition of the independent
scholar-painter the Southern School because he saw in it
an analogy to the Southern School of Chan Buddhism in
the Tang dynasty, which had held that enlightenment came
of itself, spontaneously and suddenly, as opposed to the
Northern, or gradual, School, which had maintained that
enlightenment could be attained only by degrees, after a
lifetime of preparation and training. To Dong Qichang, all
the great gentleman-painters were members of the South-
ern School, beginning in the Tang dynasty with his hero,
Wang Wei (for a genuine work from whose hand he spent
a lifetime in searching), and passing down through the great
Northern Song masters Dong Yuan, Juran, Li Cheng, and
Fan Kuan, via Mi Fu (another ideal Southern type) to the
four great masters of the Yuan, ending in his own time with
Shen Zhou and Wen Zhengming. To the Northern School
he relegated all academic and court painters, beginning with
Li Sixun and his followers in the green-and-blue style, in-
cluding among them Li Tang and Liu Songnian, Ma Yuan
and Xia Gui. He had some difficulty over Zhao Mengfu (see
fig. 8.11). As a scholar, calligrapher, and landscapist Dong
admired him greatly, but he could never bring himself to
include Zhao among the Southern painters, because Zhao
had compromised himself in the eyes of the literati by tak-
ing office under the Mongols.

This arbitrary scheme has dominated and bedeviled
Chinese art criticism for three centuries, while its obvious
inconsistencies have caused endless confusion. We may
discount Dong Qichang's prejudices and refuse to accept
his classification in individual cases, but his division into
Northern and Southern Schools does in fact represent a just
division between two kinds of painting, the one in its purest
manifestations academic, eclectic, precise, and decorative;
the other free, calligraphic, personal, and subjective. At the
same time, the doctrine of the two schools is a reflection
of the state of late Ming culture and the confusion of val-
ues and doctrines felt by the literati as the corrupt Ming
dynasty was approaching its downfall. Many of the literati

were just playing with art, their work mannered and artificial, without roots in the great tradition. Dong Qichang called the paintings of his contemporaries "shallow" and "bizarre"; his friend the critic Li Zhihua (1565–1635) went even further: "Of late," he wrote, "painting has become disgusting, I feel like vomiting when I unroll a scroll by a contemporary painter."[8] Dong Qichang saw it as his mission to get landscape painting back on the rails again. His follower Wang Yuanqi (1645–1715) was later to say, "he had cleansed the cobwebs from landscape in one sweep."

Central to his philosophy of art was his belief that the great Southern tradition must be not only revived and preserved, but creatively reinterpreted, for only thus could it live. Some of his own paintings exemplify this doctrine, most strikingly, perhaps, his *Dwelling in the Qingbian Mountains* of 1617 (fig. 9.18), in which the stylistic references to Dong Yuan and Huang Gongwang are almost overwhelmed by the writhing distortions of the composition—especially in the central section, which reveals an expressionist's passion for pure form that has led him to be labeled the first modernist. It is hardly surprising that his orthodox followers failed to understand him.

The court by now was hopelessly corrupt and no longer the focus of loyalty or enlightened patronage. Intellectuals withdrew in despair, a few courageous spirits forming semisecret protest groups such as the Donglin Society, with which Dong Qichang was loosely connected. Yet the decay of the dynasty produced no real closing of the ranks, and the literati were often divided and isolated. Suzhou, Songjiang, and Nanjing were only the chief among many centers of artistic activity, and it has been said that there were now as many schools as there were painters.

But, to compensate, the breakdown also loosened traditional restraints upon originality. While many artists still followed in the footsteps of Shen Zhou and Wen Zhengming, others broke free, even if their new direction was only into a highly individualistic, if not willfully perverse, reinterpretation of some aspect of the tradition itself. In Suzhou, for example, Shao Mi and Zhao Zuo turned back to the Northern Song for inspiration, although Shao Mi could show, in his album in the Seattle Museum (fig. 9.19), that he could play with a wide range of the styles of the old masters; Chen Hongshou gave an ironic twist to the ancient figure-painting style that derived from Gu Kaizhi (fig. 9.20); Wu Bin produced fantastic distortions of the

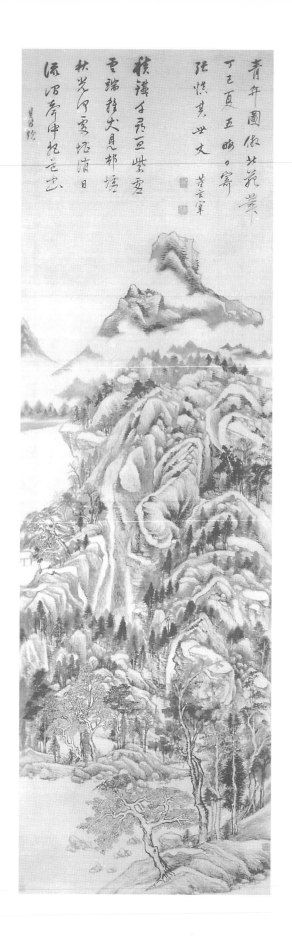

FIGURE 9.18 (OPPOSITE) Dong Qichang (1555–1636). *Dwelling in the Qingbian Mountains,* in the manner of Dong Yuan. Hanging scroll. Ink on paper. Ht. 224.5 cm. Ming dynasty, dated equivalent to 1617. © Cleveland Museum of Art, Leonard C. Hanna, Jr., Bequest.

FIGURE 9.19 (ABOVE) Shao Mi (c. 1620–60). *Landscape.* Album leaf. Ink and color on paper. Ht. 28.8 cm. Ming dynasty, dated equivalent to 1628. Seattle Art Museum, Eugene Fuller Memorial Collection. Photo: Paul Macapia.

FIGURE 9.20 (RIGHT) Chen Hongshou (1599–1652). *Portrait of the Poet Bo Juyi,* in the manner of Li Longmian. Detail of a handscroll. Ink and color on paper. Ht. 31.6 cm. Qing dynasty, dated equivalent to 1649. Charles A. Drenowatz Collection, Museum Rietberg, Zürich. Photo: Wettstein & Kauf.

FIGURE 9.21
Wu Bin (c. 1568–1626). *Fantastic
Landscape*. Hanging scroll. Ink and
light color on satin. Ht. 225 cm.
Ming dynasty, dated equivalent to
1615. Hashimoto Collection,
Takatsuki, Japan.

classic styles of Li Cheng and Fan Kuan (fig. 9.21), whose realism and chiaroscuro effects were for a time influenced by European engravings brought by the first Jesuit missionaries. Some artists defended the Ma-Xia School, and one even went so far as to denigrate the immaculate Ni Zan. In such a chaotic and crumbling world, in which a painter's search for a style, an attitude, a place in the tradition was at the same time a search for his own identity, it is easy to see how a dominating personality such as Dong Qichang could take command of all but the most independent painters and sweep them along behind him down the path to a new orthodoxy.

PORTRAITURE

There never was in China, as there was in the West, a great tradition of portrait painting. Leading masters of figure painting—such as Gu Kaizhi, Yan Liben, and Li Longmian—painted portraits, but probably not from life. Far more important than true likeness in such portraits was their symbolic function. The artist, in any case, worked within a close set of formal and technical restraints. Even so, portraits formal and informal often reveal much about the subject, if we read them carefully. Yan Liben's "portrait" of the long-dead emperor Xuan of the Chen dynasty (see fig. 6.18) does suggest that monarch's air of ineffectual benignity. The detail in fig. 9.22 of an official portrait of the Yongle emperor, for all its frontal stiffness, shows a man powerful, intelligent, and direct, while a self-portrait of Xiang Shengmou (1597–1658), grandson of the great collector Xiang Yuanbian, reveals a man who had suffered much and yet retained in old age his wry sense of humor.[9]

Even those icons of filial piety, the ancestral portraits—often compiled, like a police photofit, by professional artists from eyes, noses, mouths, and so on in an album shown to the relatives of the deceased—are astonishingly realistic, though whether they are true to life of course cannot be known. It seems that the brooding presence of these images, hanging above the family altar, was a constant reminder that the spirit of the recent ancestor hovered, inescapable, over his descendants, guiding their destiny. The more real these images seemed to the living, the greater their power.

From the late Ming onward there is, in some at least of the surviving portraits, a striking change in the rendering

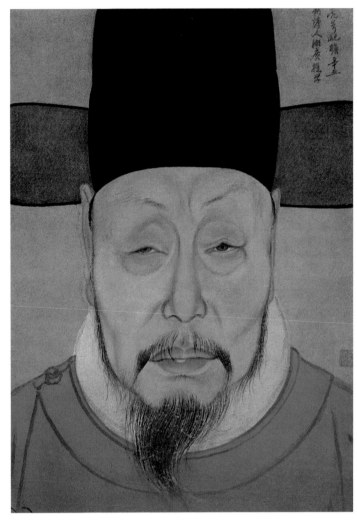

of the face. Hitherto, features and character had been delineated by the subtlest modulations of the line, with barely a hint of shading. But from the early seventeenth century, in the work of Zeng Jing (1564–1647) and his followers, there appears a frank use of shading to emphasize the modeling of the face. Works of this kind include an astonishingly lifelike and indeed unflattering set of unsigned portraits of late Ming officials of Zhejiang province (fig. 9.23)—all painted on paper and almost certainly from life, probably as preliminary studies for more formal portraits on silk—that perfectly match a contemporary critic's description of Zeng Jing's faces, which "would glare or gaze, knit their brows or smile, in a manner alarmingly like real people."[10] Their

FIGURE 9.22 Anon. *Portrait of the Yongle Emperor* (r. 1403–24). Detail of a hanging scroll. Ink and color on silk. Ht. of scroll 220 cm. Ming dynasty. National Palace Museum, Taipei.

FIGURE 9.23 Anon. *One of the Eminent Men of Zhejiang Province.* Probably a sketch from life for an official portrait. Album leaf. Ink and color on paper. Ht. 40.3 cm. Late Ming period. Nanjing Museum.

almost Western look supports the view that the paintings and engravings Matteo Ricci and his Jesuit colleagues brought to China had an influence that spread rapidly among professional painters in the early years of the seventeenth century.

SCULPTURE

To many people "Ming" means not painting—for only recently has Ming painting come to be appreciated outside China—but the decorative arts. Before discussing them, however, I should say a word about sculpture. As Buddhism gradually loosened its hold over the mind and heart of China during the Song and Yuan dynasties, Buddhist sculpture declined. Under the Ming revival, what sculpture lacks in spiritual content it makes up for in vigor—a vigor shown, for example, in the colossal guardian figures of officials,

warriors, and animals that line the "spirit way" leading to the tombs of the Ming emperors outside Nanjing and Beijing (fig. 9.24). The casting of large figures in iron had developed during the Song dynasty as a substitute for the more precious bronze. The finest of these figures have a simplicity and compactness of modeling that makes them extremely impressive. Far greater freedom of movement was possible in ceramic sculpture, which now lent an air of gaiety and splendor to the roof ridges of palaces and temples already glittering with yellow, blue, and green tiles. The boldly conceived figure of a guardian in green- and yellow-glazed terracotta (*liuli;* fig. 9.25), inscribed "Made by Master Ma" and dated equivalent to 1523, is a splendid example of the confident manner in which Ming craftsmen revived and transformed the style of the Tang dynasty. Although these roof ornaments were usually in two colors, they are often called *sancai* (three-color) ware.

FIGURE 9.24 (LEFT) Camel. Stone. From the "spirit way" (*shendao*) to the Ming tombs outside Beijing. Ming dynasty, fifteenth century.

FIGURE 9.25 (BELOW) Yanlewang (Yama). Pottery ridge tile with colored glazes. *Liuli* ware. Inscribed "Made by Master Ma." Ht. 83.8 cm. Ming dynasty, dated equivalent to 1523. With permission of the Royal Ontario Museum, Toronto. © ROM.

TEXTILES

A striking feature of early Ming decorative art is its uniformity. The first Ming emperor, eager to proclaim the splendor and legitimacy of his dynasty, paid enormous attention to correct ritual. The drawing offices under the Board of Works were charged to produce correct, standardized designs for official robes and for the objects used in court ceremonies. Thus, for example, the typical early Ming flamboyantly coiling dragon may appear on court robes, lacquer, cloisonné, or blue and white porcelain.[11] Naturally, the moneyed classes throughout China strove to emulate courtly taste in their decorative arts wherever they could.

The great achievement of the Song weavers had been the perfecting of *kesi,* a form of tapestry woven from silk using a needle as a shuttle (fig. 9.26). This technique had been invented in central Asia, possibly by the Sogdians, improved by the Uighurs, and finally passed on to the Chinese early in the eleventh century. The term *kesi,* translatable as "cut silk," describes the vertical gaps between adjacent areas of color visible when it is held up to the light, but other variants suggest that *kesi* is probably a transliteration of the Persian *gazz* or Arabic *khazz,* referring to silk and silk products.

After the debacle of 1125–27, the art was taken to the Southern Song court at Hangzhou, where a historian records that *kesi* was used for mounting paintings and binding books in the imperial collection. It was also used for robes, for decorative panels, and, most astonishingly, for translating paintings and calligraphy into the weaver's art. We can form some idea of its microscopic fineness when we realize that whereas the finest Gobelins tapestry may have 30 warp threads to the inch (12 per cm), Song *kesi* has about double that, and it also has almost 300 weft threads per inch (116 per cm) of warp, compared with the 56 (22) of Gobelins. In the Yuan dynasty, when trade across central Asia was probably easier than at any other period in history, panels of *kesi* were exported at enormous expense to Europe, where they were incorporated into the vestments of the cathedrals in Danzig, Vienna, Perugia, and Regensburg, while splendid examples have also been found in Egypt. Hongwu, the spartan and ferocious first emperor of the Ming, forbade its manufacture, but it was revived early in the fifteenth century under Xuande.

Little Song *kesi* has survived until today, but we may get

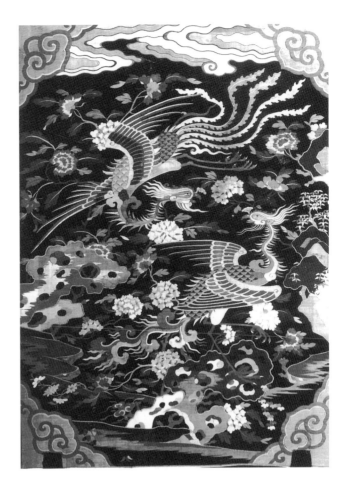

FIGURE 9.26 A pair of phoenixes among peonies and rocks. *Kesi* tapestry hanging. Qing dynasty, sixteenth to seventeenth century. Victoria and Albert Museum, London. V&A Images.

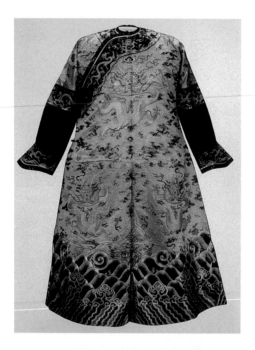

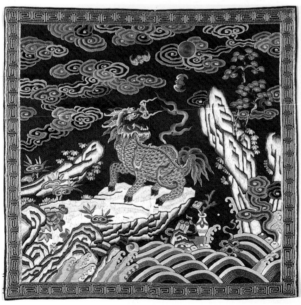

FIGURE 9.27 Dragon robe. Woven silk tapestry. L. 139.8 cm. Qing dynasty. Victoria and Albert Museum, London. V&A Images.

FIGURE 9.28 Mandarin square. Embroidered satin. Ht. 27 cm. Qing dynasty. Victoria and Albert Museum, London. V&A Images.

an impression of the splendor of the weaver's art from the court robes of the Ming dynasty. These include both the ceremonial robes made for the imperial sacrifices and decorated with the "twelve emblems"—sacred symbols that go back to hallowed antiquity and are described in the early Zhou *Shujing* (Classic of history)—and the so-called dragon robes, a term used to describe a long semiformal robe worn by courtiers and officials from Ming times onward, embroidered with a number of motifs, of which the chief and most conspicuous is the dragon (fig. 9.27). If we are to judge from surviving paintings, dragons with three claws had been a principal motif on Tang robes and became an established institution under the Yuan. Strict sumptuary laws introduced in the fourteenth century permitted a robe with four-clawed dragons (*mangpao*) to lesser nobles and officials, while restricting to the emperor and royal princes dragons with five claws. The Ming emperors wore robes decorated with both the dragons and the twelve symbols. Dragon robes became extremely popular under the Qing, when the regulations of 1759 confined the twelve symbols, at least in theory, to the emperor's personal use.

The Ming and Qing official robes were further embellished with "Mandarin squares" (fig. 9.28), badges of rank that had already been used decoratively in the Yuan dynasty and were first prescribed for official dress in the sumptuary laws of 1391. The Ming squares were broad and made in one piece, generally from *kesi* tapestry. The Manchus, who were content with embroidery, used them in pairs back and front, splitting the front panel down the center to fit the open riding jacket. Official regulations prescribed bird motifs (symbolizing literary elegance) for civilian officials, animals (suggesting fierce courage) for the military; the emblems were precisely graded from the fabulous monster *qilin* (for dukes, marquises, and imperial sons-in-law) through the white crane or golden pheasant (for civil officials of the first and second ranks) down to the silver pheasant for the fifth to ninth civil ranks. Military ranks had a corresponding animal scale. Though these woven and embroidered robes vanished from the official world with the passing of the Manchus in 1912, they may still be seen today lending their glitter and pageantry to the traditional theater.

LACQUER

Lacquer, as we have seen, was already a highly developed craft in the Warring States and the Han. At that time, decoration was restricted to painting on a ground of solid color or incising through one color to expose another beneath it. Tang dynasty artisans started the practice of applying lacquer in many layers—to mirror backs, for example—and then, before it had completely hardened, inlaying it with mother-of-pearl.

Although most surviving Song lacquer is in simple shapes in plain dark red, brown, or black, it seems likely that the deep, rich floral and pictorial carving known from signed pieces to have been produced in the Yuan dynasty was already being made before the end of the Song. Another technique invented in the Song and popular in the Yuan, and known by the Japanese name of *guri* ("heart-shaped"), involved cutting scroll patterns in V-shaped channels that revealed the multiple layers of contrasting color. Fig. 9.29 illustrates a thirteenth-century tea-bowl stand covered in black, red, and yellow lacquer carved with *guri* scrolls.

The typical Chinese lacquer of the Ming period was carved in red with rich floral or pictorial designs (*tihong*); either these were modeled in full relief or the background was cut away, leaving the design in flat relief (as on many Han engraved stones). Two styles, one sharp-edged, the other more rounded, can be identified. The polychrome tray illustrated in fig. 9.30 is typical of the elaborate and intricate taste of the seventeenth century. The names of several master craftsmen of the early Ming period are recorded. Nevertheless, lacquer is easy to imitate, and many of the signed pieces of the late Ming period and those bearing Ming reign titles (*nianhao*) may well be later Chinese or Japanese forgeries. Indeed, by the fifteenth century the Japanese had become so expert in lacquerwork that Chinese craftsmen were traveling to Japan to learn the art.

ENAMEL WARES

Two kinds of enamel ware have been practiced in China in recent centuries: cloisonné enamel, which separates areas of pure color by little walls of metal (cloisons), and painting in enamel color. The earliest known reference to cloisonné enamel in China occurs in the *Ge gu yaolun*, a collectors' and connoisseurs' miscellany first published in 1388,

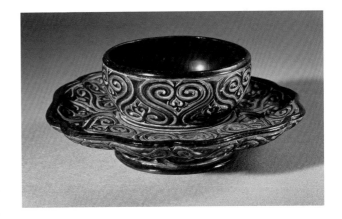

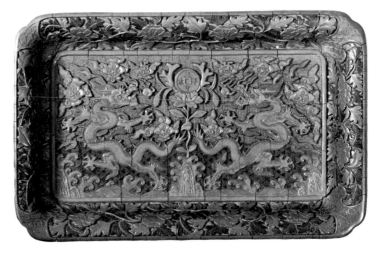

FIGURE 9.29 Stand for a porcelain tea bowl. Covered in black, red, and yellow lacquer and carved with *guri* scrolls. Ht. 6 cm. Southern Song dynasty, thirteenth century. © The Trustees of the British Museum, London.

FIGURE 9.30 Rectangular dish. Red, greenish-black, and yellow lacquer carved with a design of dragons amid clouds and waves. L. 32.2 cm. Ming dynasty, Wanli period, dated equivalent to 1589. National Palace Museum, Taipei.

FIGURE 9.31 (BELOW) Tripod incense burner. Cloisonné enamel. Diam. 19 cm. Ming dynasty, early sixteenth century. Freer Gallery of Art, Smithsonian Institution, Washington, D.C.

FIGURE 9.32 (OPPOSITE TOP) *Zun* wine vessel in the form of a phoenix. Cloisonné enamel. Ht. 34.9 cm. Qing dynasty, eighteenth century. National Palace Museum, Taipei.

FIGURE 9.33 (OPPOSITE BOTTOM) Flask. Porcelain decorated in underglaze cobalt blue. Ht. 47.6 cm. Ming dynasty, early fifteenth century. Palace Museum, Beijing.

where it is referred to as *Dashi* ("Muslim") ware. No authentic examples of fourteenth-century Chinese enamel work have yet been identified, though it is possible that pieces were being made for ritual use in the Lama temples of Beijing during the latter part of the Yuan dynasty.[12]

This art, which permits such rich and vibrant color effects, came into its own in the Ming dynasty, and the oldest positively datable pieces have the Xuande reign mark (1426–35), when the imported craft reached maturity. Ming enamels include incense burners in archaic shapes (fig. 9.31), dishes and boxes, animals and birds, and pieces for the scholar's desk. In early Ming pieces the cloisons are not perfectly filled and the surface has a certain roughness, but the designs are bold, vigorous, and endlessly varied. Unfortunately, as the technique improved these qualities were lost, until we come to the technically prefect yet lifeless and mechanical enamel ware of the time of Qianlong (fig. 9.32). Identical shapes and designs were produced through the nineteenth century, while today the reappearance of these same designs bears eloquent witness to the archaistic revival of traditional arts under the People's Republic.

Making delicate paintings with enamel colors was not practiced in China until it was introduced early in the seventeenth century by the Jesuits, who brought a craftsman, Jean-Baptiste Graveneau, to the capital to train Chinese craftsmen in the art. During the ensuing Qing dynasty the technique was applied to the decoration of porcelain, metalwork, and even glass, while exquisite examples are to be found in the little snuff bottles beloved of Western collectors.

CERAMICS

Porcelain collectors generally agree that a climax of refinement combined with freedom of drawing was reached in the blue and white of the Xuande period (1426–35). In addition to dishes there are stem cups, jars, and flattened pilgrim flasks, in which an earlier tendency to crowd the surface with flowers, waves, tendrils, and other motifs set in ogival panels has given way to a delicate play of lotus scrolls, vines, or chrysanthemums over a white surface. The influence of courtly flower painting on porcelain decoration is evident in the lovely blue and while flask illustrated in fig. 9.33.

The blue and white of each reign has its own character, which the connoisseur can readily recognize. The Xuande

style continued in the Chenghua era, though beside it there now appeared in the so-called palace bowls (fig. 9.34) a new style more delicate and less sure in its drawing and consequently easier for the eighteenth-century potter to imitate. In the Zhengde period (1506–21) there was a great demand among the Muslim eunuchs at court for what were once called "Mohammedan wares"—consisting mostly of brush rests, lamps, boxes, and other articles for the writing table—whose decoration incorporated inscriptions in Persian or Arabic. The pieces of the reign of Jiajing (1522–66) and Wanli (1573–1620) show a change from the old floral decoration to more naturalistic scenes, while in the former reign the Daoist leanings of the court made popular such auspicious subjects as pine trees, immortals, cranes, and deer.

The imperial wares of the Wanli period closely follow those of Jiajing, but there now begins a general decline in quality, the result of mass production and rigidity in the requirements of the palace. The most pleasing and vigorous blue and whites of the last hundred years of the Ming are wares made in the numerous commercial kilns. These are of two kinds: those made for domestic consumption (*min,* literally, "people's"), and the even more roughly modeled and painted export wares, made for sale or barter to the countries of southeast Asia, to which I shall refer again. Soon after 1600 a particular type of thin, brittle Wanli export blue and white began to reach Europe (fig. 9.35). This ware, called *kraak* porcelain because it had formed part of the cargo of two Portuguese carracks captured on the high seas by the Dutch, caused a sensation when it appeared on the market in Holland and was soon being imitated in the painted faience of Delft and Lowestoft. In spite of European potters' intense efforts, however, it was not until 1709 that the Dresden potter Johann Böttger, an alchemist in the service of Augustus the Strong of Saxony, succeeded for the first time in making true porcelain—more than a thousand years after it had been perfected in China.

JINGDEZHEN WARES

By the middle of the fifteenth century Jingdezhen had become the greatest ceramic center in China. It was ideally situated near Poyang Lake, whence its products could go by lake and river to Nanjing and by the Grand Canal to Beijing. An apparently inexhaustible supply of china clay lay in the Machang hills nearby, while just across the river at

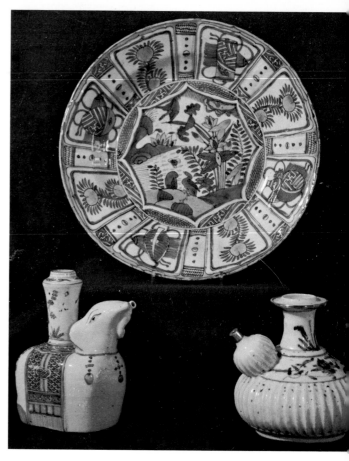

FIGURE 9.34 "Palace" bowl. Porcelain decorated in underglaze cobalt blue. Diam. 15.5 cm. Ming dynasty, Chenghua period (1465–87). Collection of Percival David Foundation of Chinese Art, London.

FIGURE 9.35 Dish (*kraak* ware) with two *kendi* (drinking flasks). Porcelain decorated in underglaze blue. Export ware. Late Ming period. Formerly University Art Museum, University of Singapore.

Hutian was to be found the other essential ingredient in the manufacture of porcelain in this part of China, namely, "china stone" (often called *bai tunzi* when in its prepared form). By this time there had evolved out of the nearly white *qingbai* and *shufu* wares of Song and Yuan a true white porcelain, which was perhaps already being made at the imperial factory for the Hongwu emperor. The most beautiful pieces, however, were those made in the Yongle period, most of which are decorated with motifs incised or painted in white slip under the glaze—a technique aptly called *anhua* ("secret decoration"), for it is scarcely visible unless the vessel is held up to the light. From the technical point of view, the eighteenth-century white glaze is perhaps more perfect, but it lacks the luminous warmth of the Ming surface. In some Yongle bowls the porcelain body is pared down to paper thinness so that the vessel appears to consist of nothing but glaze; these are the so-called bodiless (*tuotai*) pieces. Almost as beautiful are the monochromes produced at Jingdezhen in the Yongle and Xuande periods (fig. 9.36), notably the dishes, stem cups, jugs, and bowls decorated in "sacrificial red" (*baoshihong*) or with imperial dragons under a yellow or blue glaze. The imperial Yongle wares were the first to bear a reign mark on the base.

DEHUA WARES

Jingdezhen, though the largest Ming factory producing monochrome wares, was by no means the only one. A white porcelain was being made at Dehua in Fujian as early as the Song dynasty. The Fujian wares, indeed, form a race apart. They never bear reign marks and are extremely difficult to date accurately, while they range in quality from the finest porcelain with a luminous, warm, and lustrous glaze, with a brownish tint where it runs thick, to the more metallic products of the past hundred years. In addition to vessels, boxes, and ceremonial objects such as incense burners and other bronze shapes, the Dehua potters modeled figurines in white porcelain, a lovely example being the Guanyin from the Barlow Collection at the University of Sussex (fig. 9.37). Here the subtle turn of the body and the liquid flow of the drapery show how much ceramic modeling was influenced by the sweeping linear rhythms of figure painting. From the seventeenth century onward, Dehua ware was shipped from Xiamen (Amoy) to Europe, where, as "blanc-de-Chine," it had a considerable vogue and was widely imitated.

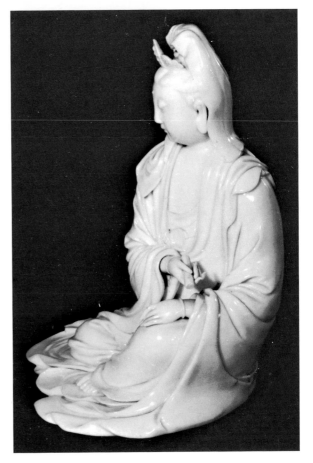

FIGURE 9.36 "Monk's hat" jug. Porcelain covered with *baoshihong* (sacrifical red) glaze. Ming dynasty, Xuande period (1426–35). Qianlong period inscription of 1775 engraved on the base. National Palace Museum, Taipei.

FIGURE 9.37 Guanyin. Fujian Dehua ware. White porcelain. Ht. 22 cm. Early Qing period, seventeenth century. Barlow Collection, University of Sussex.

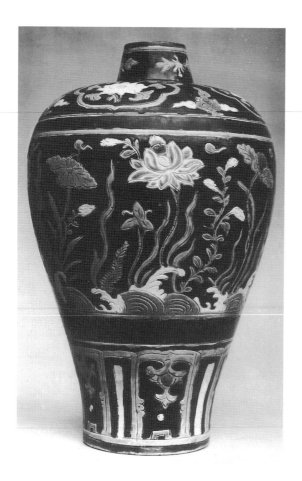

ENAMELED WARES

Robust Ming taste is more typically expressed in the so-called *fahua* ("bounded pattern") wares. The exact origin of this family is not known, though there is reason to believe that it may have been produced in stoneware at Junzhou in Henan, where the kilns were still active in the sixteenth century, while it was also, and more perfectly, made in porcelain at Jingdezhen. Among the colors used, a rich turquoise, dark blue, and aubergine predominate (fig. 9.38). They are thickly applied in bold floral motifs and separated by raised ridges that perform the same function as the cloisonné on Ming enamels. Occasionally the turquoise glaze was used alone, as on a magnificent vase in the Percival David Foundation collection inscribed on the shoulder, "For general use in the Inner Palace." Although this ware follows the range of shapes made earlier in Chun ware—vases, storage jars, flowerpots, and bulb bowls—the vigor of the shapes and the strong, rich-colored glazes show how much closer in feeling Ming art often comes to that of the Tang dynasty than to that of the Song.

Another important family comprises the wares that combine underglaze outline painting in cobalt blue with enamel colors prepared from the material for lead glaze, applied over the transparent glaze and fired again at a lower temperature. In the Xuande and Jiajing era these pieces, called *doucai* ("filled colors"), are lightly potted, the painting—chiefly of vines, flowers, and flowering branches—disposed with perfect taste and subtle balance over the white ground (fig. 9.39). By the Wanli period, the enameled wares, now called *wucai* ("five colors"), are more robustly potted and painted, with the liveliness and vigor of a popular art form.

EXPORT WARES

Besides these exquisite enamels, the sixteenth century saw the appearance of a more full-blooded style, often decorated with genre scenes, chiefly in red and yellow; this style was to be echoed in the *wucai* wares made for export in the south China kilns—known generally by the misleading term "Swatow" ware. No pottery was made at Swatow (modern Shantou in Guangdong), but some of these rough and vigorous porcelains—both blue and white and five-color enamels (fig. 9.40)—were made upriver at Chaozhou and probably at Shima in Fujian, while a kiln producing blue and white export ware has recently been found in Quan-

zhou. Swatow, however, was probably one of the main ports of dispatch.

China's export trade to the Nanhai ("South Seas") was already flourishing in the Song and Yuan dynasties. Early Ming wares, including celadon, Jingdezhen white porcelain, Cizhou, *qingbai,* and Dehua as well as the wide range of wares produced in the newly discovered kilns in Guangxi (see the section on southern wares in chapter 7), have been found in huge quantities over an area extending from the Philippines to East Africa. Most intriguing among their products for export was the *kendi,* often used for feeding babies and old people or for giving medicine, and perhaps for ritual purposes as well. Two typical *kendi* found in Java and Malaysia are shown below the *kraak* dish in fig. 9.35.

These export wares had a profound influence on the native pottery of southeast Asia. Blue and white was successfully imitated not only in Japan (Imari ware), but also in Annam and, less successfully (for the want of cobalt), by the Thai potters at Sawankalok, although the Siamese kilns succeeded in producing a beautiful celadon of their own. Before the end of the Ming dynasty, the Chinese factories were also making porcelain on order for European customers, notably through the Dutch "factory" established at Batavia (Jakarta) in 1602; but this trade, which was to play so great a part in the contacts between Europe and China, we must leave to chapter 10.

THE QING DYNASTY

The Ming dynasty was brought down by the same inexorable laws of decay that had operated on previous occasions in Chinese history: corruption and the power of the eunuchs at court, leading to a breakdown of the administration, large-scale banditry in the provinces, and an enemy on the northern frontier patiently awaiting the opportunity to pounce. In 1618 the Manchu nation was founded on the banks of the bleak Sungari River. Seven years later the Great Khan, Nurhachi, set up his capital in Shenyang (Mukden), calling his new dynasty Qing ("pure") to parallel the Chinese Ming ("bright"). The Manchus' moment came when in 1644 the Chinese general Wu Sangui appealed to them for help to expel the rebel leader Li Zicheng, who had forced his way into Beijing. The Manchus promptly accepted, drove Li out of the city, and, while Wu Sangui was pursuing him into the west, quietly occupied the capital and proclaimed the rule of the Qing dynasty. Their unexpected success left the Manchus momentarily exposed, but Wu Sangui waited ten years before attempting to dislodge them, and by then it was too late. Yet for nearly four decades Wu and his successors held south China, which was not finally secured for the Manchus until the capture of Kunming in 1682. As a result of this long civil war there grew up a bitter hostility between north and south; Beijing became increasingly remote and suspicious, the south ever more rebellious and independent.

It would be wrong, however, to picture the Manchus as barbarous and destructive. On the contrary, they felt an intense admiration for Chinese culture and leaned heavily on the Chinese official class; but the more independent minded of the Chinese intelligentsia remained, as under the Mongols, a potential source of danger to the regime, and the Manchus' trust of the literati did not extend to a sympathetic consideration for the "new thought" of the eighteenth century. They clung to the most reactionary forms of Confucianism, becoming more Chinese than the Chinese themselves and strenuously resisting up to the end every attempt at reform made by the literati, some of whom were responsible and far-seeing men. This hidebound refusal to recognize the inevitability of change eventually brought about the collapse of the dynasty. But for the first century and a half, China basked in the sunlight of its restored power and prosperity, thanks largely to the work of the second emperor, Kangxi (r. 1662–1722; fig. 10.1), who pacified all of China and reestablished the empire's paramount position in Asia.

During the seventeenth century and the first half of the eighteenth, the European powers treated China with enormous respect; admiration for Chinese principles of government filled the writings of the Enlightenment, while its arts gave birth to two waves of *chinoiserie,* the first late in the seventeenth century, the second at the height of the eighteenth. During this period, indeed, China had far more influence upon the thought, art, and material life of Europe than had Europe on China.

Western influence on China was confined to the court, where, ever since the arrival of the Jesuit missionary Matteo Ricci in 1601, the emperors and their immediate entourage of officials and savants had been in close touch with Western art and learning. But apart from Adam Schall's reform of the calendar and Verbiest's ordnance factory, the arts and techniques brought by the Jesuits were treated by all but a tiny minority of scholars as mere curiosities. This was not entirely true of painting, however. Although the literati generally ignored European art, some academicians at court made strenuous efforts to master Western shading and perspective in the interest of greater realism.

The most characteristic intellectual achievement of the Qing dynasty was, like that of the Ming, not creative so much as synthetic and analytical, indeed, in the production of such works as the huge anthology *Gujin tushu jicheng* (1729) and the *Siku quanshu* (an encyclopedia in 36,000 volumes begun in 1773 and completed nine years later), the Qing scholars far surpassed their Ming forebears in sheer industry. Characteristically, also, the latter work was compiled not primarily in the interest of scholarship but as a means of seeking out all books whose contents might reflect upon the legitimacy of the Manchu dynasty. Nevertheless, this enormous compilation contains many otherwise unknown texts and the fruits of much scholarly research. For this was an antiquarian age when men looked back into the past as never before, burrowing into the classics, dabbling in archaeology, and forming huge collections of books and manuscripts, paintings, porcelain, and archaic bronzes. Most famous among the collectors of paintings were Liang Qingbiao, to whom we have already referred, and the salt magnate An Yizhou (c. 1683–c. 1740), many of whose treasures were later acquired by the Qianlong emperor.

Qianlong, who succeeded Yongzheng in 1736, possessed a prodigious enthusiasm for works of art, and in his

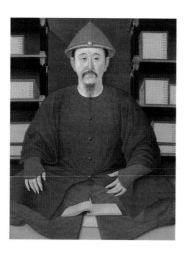

FIGURE 10.1 Portrait of the Kangxi emperor (r. 1662–1722). Detail. Ink and color on silk. Qing dynasty. Palace Museum, Beijing.

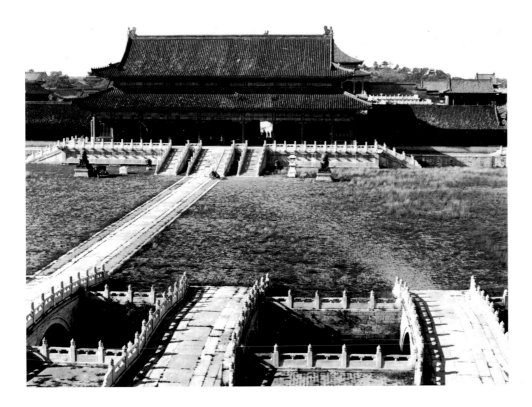

FIGURE 10.2 The Forbidden City, Beijing, looking north from the Wumen to the Taihemen. A corner of the Taihedian is visible beyond. Ming and early Qing dynasties. Photo: Hedda Morrison.

hands the imperial collection grew to a size and importance it had not seen since the days of Huizong.[1] His taste, however, was not always equal to his enthusiasm, and he could not resist the temptation to write indifferent poems all over his most treasured paintings and stamp them with large and conspicuous seals. His abdication in 1795 (because he considered it unfilial to occupy the throne longer than his illustrious grandfather) marked the end of the great days of the Qing dynasty.

To the familiar story of internal dissolution was now added the aggressive advance of the European powers, whose original admiration had given way to hostility, provoked by impatience at irksome trade restrictions. We need not linger over the tragic history of the nineteenth century, the shameful Opium Wars, the failure of the Taiping rebels to regenerate China, and its final abasement after 1900. This was not a time for greatness either in politics or in arts. Though a few of the literati maintained a certain independence of spirit, the educated class as a whole took its lead more and more from the reactionary attitude of the Manchus.

ARCHITECTURE

The architecture of the Qing dynasty was, in the main, a tame and cautious continuation of the style of the Ming (fig. 10.2)—with one notable exception. To the northwest of the capital, the Kangxi emperor laid out an extensive summer palace, in emulation of the great hunting parks of the Han and Liang emperors. It was enlarged by Yongzheng, who gave it the name Yuanmingyuan, and again by Qianlong, who added to many palaces already built in it an assembly of pleasure pavilions designed by the Italian Jesuit missionary and court painter Giuseppe Castiglione (1688–1766) in a somewhat Sinified version of Italian eighteenth-century rococo (fig. 10.3). These extraordinary buildings were set about with fountains and waterworks devised by Father Benoit, a French Jesuit who had familiarized himself with the fountains at Versailles and Saint-Cloud. Every detail down to the furniture was specially designed (much of it copied from French engravings) and the walls hung with mirrors and Gobelins tapestries sent out by the French court in 1767. The total effect must have been bizarre in the extreme.

The heyday of Yuanmingyuan was brief. Before the end

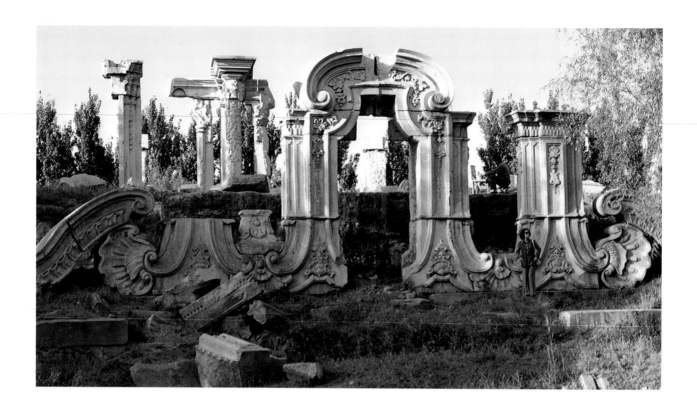

FIGURE 10.3 (ABOVE)
Yuanmingyuan, Beijing. Ruins of the
Belvedere (Fangwaiguan) designed by
Giuseppe Castiglione (Lang Shining,
1688–1766). Qing dynasty. Photo
by the author.

FIGURE 10.4 (OPPOSITE TOP LEFT)
The Summer Palace, Beijing. Late Qing
period, completed 1888.

FIGURE 10.5 (OPPOSITE TOP RIGHT)
Qiniandian (Hall of Annual Prayers),
Beijing. Qing dynasty, 1545; rebuilt
1752, 1889. Photo by the author.

FIGURE 10.6 (OPPOSITE BOTTOM)
Jiao Bingzhen (early eighteenth
century). *Illustrations of Rice and
Agriculture*. Album leaf from the
Gengzhitu. Ink on silk. Qing dynasty.
National Palace Museum, Taipei.

of the eighteenth century the fountains had long ceased to play, and Qianlong's successors so neglected their transplanted Versailles that by the time the Western allies destroyed the foreign-style buildings and looted their treasures in 1860, Yuanmingyuan had fallen into a sad autumnal state of disrepair. But we can obtain some idea of what it looked like in its prime from the engravings made by Castiglione's Chinese assistants in 1786.

The last great architectural achievement—if indeed it deserves the name—of the Manchus was the Summer Palace (fig. 10.4), built by the dowager empress Cixi on the shore of Bohai to the west of the Forbidden City with funds raised by public subscription to construct a navy. Although she was condemned at the time for her extravagance, it has since been observed that had she built a fleet, the Japanese would certainly have sunk it in the war of 1895, whereas the Summer Palace will endure for centuries. Less pretentious and far more appealing among the late-Qing ceremonial buildings is the Qiniandian (Hall of Annual Prayers; fig.10.5), erected near the Altar of Heaven in the southern quarter of the city late in the nineteenth century. Its gleam-

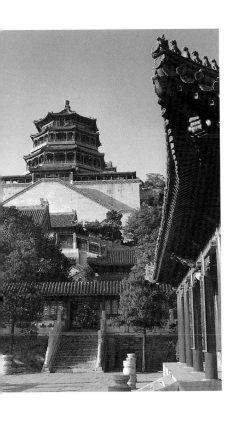

ing marble terraces, its richly painted woodwork, and the deep blue of its tiles dazzle the eye. But we need only glance at the poverty of its detail, its reliance upon paint rather than functional carpentry, to realize that, fairylike as is its total effect, the Hall of Annual Prayers marks the exhausted state of a great tradition, at least until its late-twentieth-century revival.

EUROPEAN INFLUENCE ON COURT ART

In a corner of the Forbidden City, Kangxi set aside a court-yard known as the Qixianggong as a studio and repair shop where Chinese and Jesuit artists and mechanics worked side by side painting, engraving, and repairing clocks and musical instruments. The palace storerooms even today are crammed with unpublished paintings produced in these workshops, many showing Western influence.[2] The court painter Jiao Bingzhen studied perspective there under the Jesuits and embodied what he learned in forty-six illustrations to the famous agricultural work *Gengzhitu* (fig. 10.6), while his pupil Leng Mei is noted for delightful but overly

FIGURE 10.7 (ABOVE) Giuseppe Castiglione. *A Hundred Horses in a Landscape.* Detail of a handscroll. Ink and color on silk. Ht. 94.5 cm. Qing dynasty, dated 1728. National Palace Museum, Taipei.

FIGURE 10.8 (OPPOSITE) Yuan Jiang (early eighteenth century). *Fishing Villages by Riverbanks.* Hanging scroll. Ink and color on silk. Ht. 213.5 cm. Qing dynasty, dated 1707. The Avery Brundage Collection. © Asian Art Museum of San Francisco.

elegant paintings of court ladies, generally in a garden setting, that show some knowledge of Western perspective. Castiglione was already an accomplished painter when he arrived in Beijing in 1715. He soon mastered the academic manner of his Chinese colleagues and proceeded to create a synthetic style that blends a Chinese medium and technique with Western naturalism, aided by a subtle use of shading (fig. 10.7). He was a favorite at court, where his still-life paintings, portraits, and long handscrolls depicting horses in a landscape or scenes of court life signed, very carefully, with his Chinese name, Lang Shining, were greatly admired. He had numerous pupils and imitators, for the decorative realism of his style was particularly suited to the kind of "furniture painting" the palace required in huge quantities to decorate its endless apartments. Castiglione, however, no more affected the general trend of Chinese painting in his time than did the Chinese artists working for the Europeans in Guangzhou and Hong Kong.[3] Zou Yigui (1686–1772), a court artist to Qianlong noted for the painstaking realism of his flower paintings (an art in which he probably influenced the style of his colleague Castiglione), much admired Western perspective and shading. "If they paint a palace or a mansion on a wall," he wrote, "one would almost feel induced to enter it." But he makes it clear that these are mere technicalities, to be kept in their proper place: "The student should learn something of

their achievements so as to improve his own method. But their technique of strokes is negligible. Even if they attain perfection it is merely craftsmanship. Thus, foreign painting cannot be called art."[4]

The most interesting and neglected of the Qing professional painters, however, was the group around Li Yin and Yuan Jiang, both of whom were working in prosperous Yangzhou between about 1690 and 1725, after which the latter became a court painter, as did Yuan Yao (presumed to be Yuan Jiang's son). They are chiefly noted for having given a violent twist to the long-moribund Northern tradition by applying to the style and composition of early Song masters such as Guo Xi the fantastic distortions of the late-Ming expressionists. The blend of fantasy and mannerism in their work can be seen in the meticulously painted landscape by Yuan Jiang illustrated in fig. 10.8.

WENREN HUA

The literati (*wenren hua*) shared none of the academicians' admiration for European painting, for they now felt themselves to be the custodians of a tradition infinitely more precious than anything the West had to offer. Dong Qichang, through the sheer force of his personality, had given a new interpretation to the style of Dong Yuan and Juran, but his less-gifted followers in the Qing dynasty took his injunction to restore the past (*fugu*) too literally, and in the work of many of the hundreds of painters who now appear on the scene, the free, unfettered art of the leading Ming literati froze into a new academicism in which an obsession with style and the repetition of hackneyed themes too often took the place of a direct response to nature. But even if many of the amateur painters played the same tunes over and over again, they played them beautifully, and the enjoyment we derive from this kind of painting comes not from sudden revelation or strength of feeling but from subtle nuances in touch such as those we savor in listening to a familiar piano sonata interpreted by different hands.

To give the impression that all Qing painting is conventional would be utterly misleading. Indeed, the story of the seventeenth century—of the decay and death of the Ming, the Manchu invasion, the civil war and the decades of uncertainty that followed it, and the return to stability under Kangxi—can all be read in the painting of the period, which for this reason is one of the most fascinating and

intensely studied in the history of Chinese art. The Ming loyalists, called Yimin (literally, "people left over"), suffered acutely, for their code forbade their taking or holding office under a new dynasty, most of all an alien one. Some committed suicide, some became destitute, some turned wanderer, monk, recluse, or eccentric, while some even lived to become loyal and contented servants of that remarkable Manchu ruler Kangxi.

Thus, the Yimin responded to the crisis in a number of ways, and there can be no greater contrast than that between, say, the two masters Hongren and Gong Xian.[5] The Anhui monk Hongren (1610–64) faced his predicament by transcending it, expressing an inner serenity of spirit through his sparse, dry landscapes (fig. 10.9)—fragile yet incredibly solid, sensitive yet monumental—that exude an atmosphere of almost unearthly purity reminiscent of Ni Zan. Hongren was one of the first, and certainly the greatest, of the Anhui School of landscape painters, who took their inspiration from the spectacular scenery of Huangshan.[6] A leading twentieth-century reviver of the school was Huang Binhong (see fig. 11.12).

By contrast, the Nanjing painter Gong Xian (1620–89) seems to have been on the run for some years after the fall of the Ming, harried by political enemies and private anxieties. His desolate, prisonlike landscape in the Rietberg Museum, Zürich—in which no life seems possible, nothing stirs (fig. 10.10)—may owe something to the expressive distortions of Dong Qichang, but like other pictures of Gong Xian's middle years it is also symbolic, both of the condition of his native land raped by the Manchus and of his own desperate sense of having, literally, nowhere to turn. Yet his whole career cannot have been so turbulent, for he was also a noted poet, calligrapher, publisher, and art teacher—his pupil Wang Gai was the chief compiler of the *Painting Manual of the Mustard Seed Garden,* mentioned in chapter 9—while the calm, monumental landscapes of his later years suggest that he had found peace at last.

These masters were certainly individualists, but that label is often, and arbitrarily, reserved for three great painters who dominated the art of the early Qing as Hongren and Gong Xian never did. These men are Zhu Da (1626–1705), Shiqi (Kuncan, 1612–73), and Shitao (1642–1707). Zhu Da—or Bada Shanren, as he signed himself in his later years—was a distant descendant of the Ming imperial house who on the advent of the Manchus became a monk. When his father died, so the story goes, he was struck dumb and would only shout and laugh, the butt of the children who ran after his ragged figure in the streets. For a while, around 1680, he was mentally unbalanced. He turned his back not only upon the world but upon the art of painting as practiced in his time. His brush style appears careless and slapdash, and yet, like that of the Chan eccentrics who were his spiritual ancestors, it is incredibly

sure and confident. His landscapes executed in a dashing shorthand (fig. 10.11) carry Dong Qichang's creative distortion of the Southern tradition to a pitch that must have shocked the orthodox disciples of the late-Ming master. Perhaps his peculiar genius shows best in his swift album sketches, in which small angry-looking birds perch in an infinity of space (fig. 10.12), or in his studies of fishlike rocks and rocklike fish drawn in a few brilliant sweeping lines of the brush. This is "ink play" at its most unrestrained; yet it is no mere empty virtuosity, for Bada's deceptively simple style captures the very essence of the flowers, plants, and creatures he portrays.

Shitao and Shiqi are linked by Chinese art historians as the Two Stones (*Er shi*), yet there is no positive evidence that they were close friends. Shiqi, a devout Buddhist who spent all his life as a monk, was in his later years, as abbot of a monastery at Nanjing, an austere and unapproachable recluse. The texture of his landscapes, painted with a dry, scrubby brush, has the groping, almost fumbling, quality that we find in Cézanne, and as in Cézanne this very awkwardness, this refusal to make concessions to the viewer, bears witness to the painter's integrity. Yet the final effect—in the beautiful autumn landscape in the British Museum

FIGURE 10.9 (OPPOSITE) Hongren (1610–64). *The Coming of Autumn.* Hanging scroll. Ink on paper. Ht. 122 cm. Qing dynasty. Honolulu Academy of Arts, Hawaii.

FIGURE 10.10 (ABOVE) Gong Xian (1620–89). *A Thousand Peaks and Myriad Ravines.* Hanging scroll. Ink on paper. Ht. 62.3 cm. Qing dynasty. Charles A. Drenowatz Collection, Museum Rietberg, Zürich. Photo: Wettstein & Kauf.

(fig. 10.13), for example—gives an impression of grandeur and serenity.

Shitao, whose original name was Zhu Ruoji, was a lineal descendant of the founder of the Ming dynasty, which fell when he was still a child. He later joined the Buddhist community on Lushan, but he was no recluse and was never a real monk. In 1657 he went to live in Hangzhou and thereafter spent much of his life wandering about China, visiting sacred mountains in the company of monks, scholars, and painter friends such as Mei Qing. He spent nearly three years in Beijing (where he and Wang Yuanqi collaborated on the picture *Bamboo and Rocks*) and finally settled in Yangzhou, where he severed his monastic vows and, because he had no private income, became a professional, though highly respected, painter. A chronicle of Yangzhou, a city famous for its gardens, says that one of his favorite hobbies was "piling up stones"—i.e., designing gardens, among which his Garden of Ten Thousand Rocks, laid out for the Yu family, was considered his masterpiece. It may be that some of his little album landscapes were actually suggestions for garden designs.

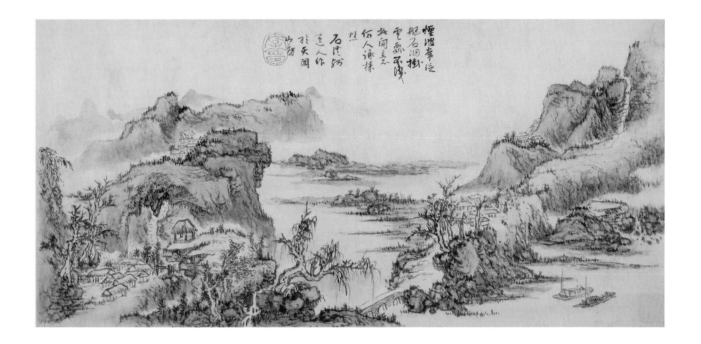

Shitao's aesthetic philosophy is contained in the *Huayulu,* a profound and often obscure document that cannot possibly be summarized in a paragraph, for it is not a statement of a coherent aesthetic theory so much as a series of utterances that touch on reality, nature, man, and art at many levels.[7] Central to Shitao's thinking is the concept of the *yi hua* (literally, "one line" or "one painting"); but the very word *yi* might mean the transcendent "One," the unity of man and nature, or simply "the single," and *hua* either the art of painting, "delineation," or simply "line." Drawing both upon earlier aesthetic theorists going back as far as Zong Bing and Xie He and upon Buddhist and Daoist metaphysics, and not unaware of his own genius, Shitao meditates upon the artist's power to express his sense of oneness with living nature in the unified, uninterrupted flow of inspiration through his brush. While we may not be able to analyze Shitao's thought with any precision, in reading the *Huayulu* we become aware of what the art, and the act, of painting could mean to the inspired practitioner.

In his painting, Shitao justifies his claim in the *Huayulu* that by establishing the *yi hua* he had created a method out

FIGURE 10.11 (OPPOSITE LEFT) Zhu Da (Bada Shanren, 1626–1705). *Landscape in the Manner of Dong Yuan.* Hanging scroll. Ink on paper. Ht. 180 cm. Qing dynasty. Ostasiatiska Museet, Stockholm.

FIGURE 10.12 (OPPOSITE RIGHT) Zhu Da. *Two Birds on a Bough.* Album leaf. Ink on paper. Ht. 31.8 cm. Qing dynasty. Sumitomo Collection, Oiso, Japan.

FIGURE 10.13 (ABOVE) Shiqi (Kuncan, 1612–73). *Autumn Landscape.* Handscroll from a set of landscapes of the four seasons. Ink on paper. Ht. 31.4 cm. Qing dynasty, dated equivalent to 1666. © The Trustees of the British Museum, London.

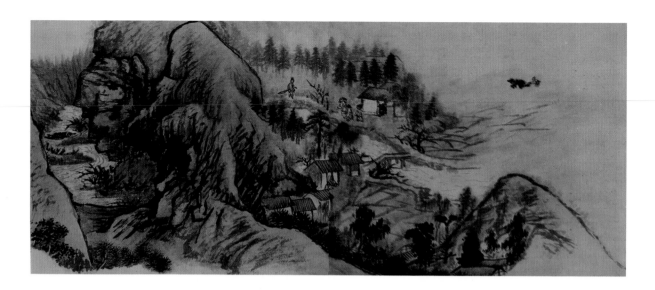

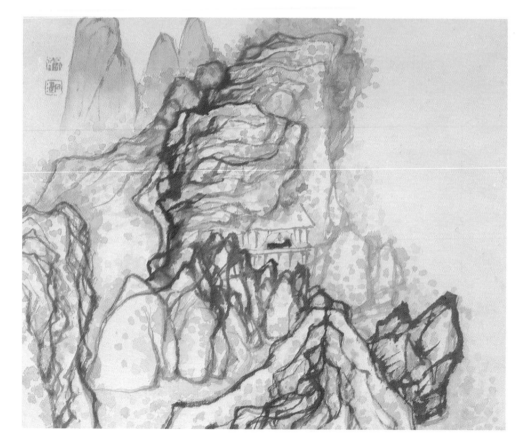

FIGURE 10.14 (ABOVE) Shitao (1642–1707). *The Peach Blossom Spring.* Detail of a handscroll illustrating the story by Tao Yuanming. Ink and color on paper. Ht. 25 cm. This section shows the wandering fisherman, still carrying his paddle, being greeted by the inhabitants of the utopian valley, who had been cut off from the outside world for several hundred years. Freer Gallery of Art, Smithsonian Institution, Washington, D.C., Gift of C. C. Wang and Family.

FIGURE 10.15 (RIGHT) Shitao. *A Man in a House beneath a Cliff.* Album leaf. Ink and color on paper. Ht. 24.2 cm. Qing dynasty. C. C. Wang Family Collection, New York.

of an absence of method. His concept of the ecstatic union of the artist with nature is by no means new, but nowhere in the whole of later Chinese art will we find it expressed with so much spontaneous charm. Whether in a handscroll, such as the delightful illustration to Tao Yuanming's *The Peach Blossom Spring* (fig. 10.14), or in a towering landscape, such as the magnificent view of Mount Lu in the Sumitomo Collection, or in any of his album leaves (fig. 10.15), his forms and colors are ever fresh, his spirit light, his inventiveness and wit inexhaustible.

All these masters, although they drew upon the tradition, developed and enriched it and so touched the heights. At a rather lower level we encounter a host of painters who represent the orthodox stream, flowing down from Shen Zhou, Wen Zhengming, and Dong Qichang, that survived the upheaval and kept its steady, if seldom adventurous, course, growing ever broader and shallower as the Qing dynasty settled into its long stagnation. In the seventeenth century, however, the stream still runs strong in the work of the Six Great Masters of the early Qing dynasty, that is, the Four Wangs, Wu Li, and Yun Shouping. The earliest of the four was Wang Shimin (1592–1680), who had learned to paint from the hand of Dong Qichang himself (fig. 10.16). In his endeavor to achieve the "great synthesis" of style that Dong Qichang had advocated, he compiled albums of famous Song and Yuan compositions. One of these albums, it is recorded, he took with him wherever he went, to serve as his models. "Thus, in his works," wrote the Qing historian Zhang Geng, "every compositional detail, every outline, texture, and ink wash had its origin in an ancient source."[8]

Like his master, Wang Shimin deeply admired the broad, relaxed manner of Huang Gongwang, and his great series of landscapes in the manner of the Yuan recluse, painted in his seventies, are among the noblest achievements of the Qing literati. Wang Jian (1598–1677), his close friend and pupil, was an even more conscientious follower of the Yuan masters. More gifted was Wang Hui (1632–1717), who as a poor student had been introduced to Wang Shimin and became his pupil. He devoted much of his talent to the imitation of early masters, and his huge oeuvre consists chiefly of endless variations on the styles of Dong Yuan and Juran as they had been successively reinterpreted by

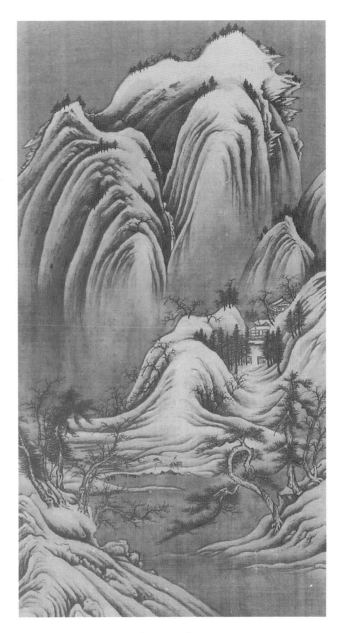

FIGURE 10.16 Wang Shimin (1592–1680) or unknown artist. *Landscape in the Manner of Juran.* A page from the album *Xiao zhong xian da* (In small see big), with a title by Dong Qichang. Ink and light color on silk. Ht. 70.2 cm. Late Ming period. National Palace Museum, Taipei.

Huang Gongwang, Dong Qichang, and Wang Shimin (fig. 10.17). The National Palace Museum, Taipei, also contains a number of clever pastiches of tenth-century and Northern Song landscapes that are almost certainly his work.

Of the four Wangs, Wang Yuanqi (1642–1715) was the most gifted and original. The grandson of Wang Shimin, he rose to high office under the Manchus, becoming chancellor of the Hanlin Academy and vice president of the Board of Finance. He was a favorite of Kangxi, who frequently summoned him to paint in his presence, and he was appointed one of the editors of the great anthology of painting and calligraphy *Peiwenzhai shuhuapu*, published on imperial order in 1708. But Wang Yuanqi was no academician. Although he drew his themes from the Yuan masters, notably Ni Zan, and his curious angular rocks and gaunt trees from Dong Qichang, he had an obsession with form unique in a Chinese painter (fig. 10.18). With deep concentration he would, as it were, pull apart and reassemble the rocks and mountains in his paintings, like a cubist. These are not landscapes to wander in; they are, rather, semi-abstract creations of the painter's mind, totally convincing in their own terms and remote from the mannered distortions of Yuan Jiang and his school.

Yun Shouping (commonly known as Yun Nantian, 1633–90) was the son of a Ming loyalist and consequently had to live in partial obscurity in the Suzhou-Hangzhou region, far from the capital, where he supported himself by his painting and calligraphy. There is a widely held belief that he gave up landscape painting because he felt he could not compete with his friend Wang Hui. But although his flower paintings, chiefly on fans and album leaves, show an exquisite mastery of technique (fig. 10.19), his heart was in the landscape, which he painted with sensitivity often lacking in the work of the brilliant Wang Hui.

Wu Li, born in 1632, is of unusual interest because he came under the influence of the Jesuits, was baptized, and spent six years studying theology in Macao, where he was ordained in 1688, thereafter devoting his life to missionary work in Jiangsu. However, his conversion in no way changed his style of painting. A pupil of Wang Jian and an intimate friend of Wang Hui, he called himself Mojing Daoren, the Daoist of the Inkwell (in the literal sense of Alice's treacle well), continuing, after an unproductive period following his conversion, to paint in the eclectic

FIGURE 10.17 (OPPOSITE) Wang Hui (1632–1717). *Landscape in the Manner of Fan Kuan.* Hanging scroll. Ink and color on paper. Qing dynasty, dated equivalent to 1695. Formerly Huang Pao-hsi Collection, Hong Kong.

FIGURE 10.18 (LEFT) Wang Yuanqi (1642–1715). *Landscape in the Manner of Ni Zan.* Hanging scroll. Ink on paper. Ht. 82 cm. Qing dynasty. Museum für Ostasiatische Kunst, Berlin.

FIGURE 10.19 (BELOW) Yun Shouping (1633–90). *Peony.* Album leaf. Ink and color on silk. Ht. 26.2 cm. Qing dynasty. National Palace Museum, Taipei.

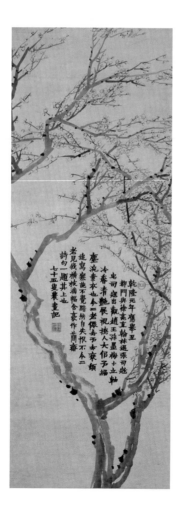

manner of the early Qing *wenren* (fig. 10.20) without a hint of European influence, until his death in 1718.

By the eighteenth century the settled state of China had created a great demand for works of art, notably in such prosperous cities as Yangzhou, at the juncture of the Grand Canal and the Yangzi River. Here, to bear witness to their newly acquired gentry status, salt merchants and other rich traders built up libraries and art collections, entertained scholars, poets, and painters, and expected to be entertained in return. Among the many artists who competed for their patronage, the most talented were a group that came later to be known as the Eight Eccentrics of Yangzhou, whose idiosyncrasies of behavior or technique were, in some cases at least, partly assumed for professional reasons, while they disguised their anti-Manchu sentiments with subtle visual puns. The hallmark of the art of the scholarly and successful Jin Nong (1687–1764) was not so much his deft ink paintings of birds, flowers, or bamboo as his heavy, square calligraphy, derived from Han stone inscriptions, which offers a teasing contrast to the light touch of the brushwork in his *Plum Blossoms* (fig. 10.21). His contemporary Huang Shen (1687–c. 1768), a prolific professional from Fujian, playfully distorted the figure style of Chen Hongshou (fig. 10.22), which was itself already a playful distortion of ancient models; while the art of the equally prolific Hua Yan (1682–c. 1755) is often an airy commentary on the styles of the great masters of Song and Yuan bird and flower painting (fig. 10.23). In many of the works

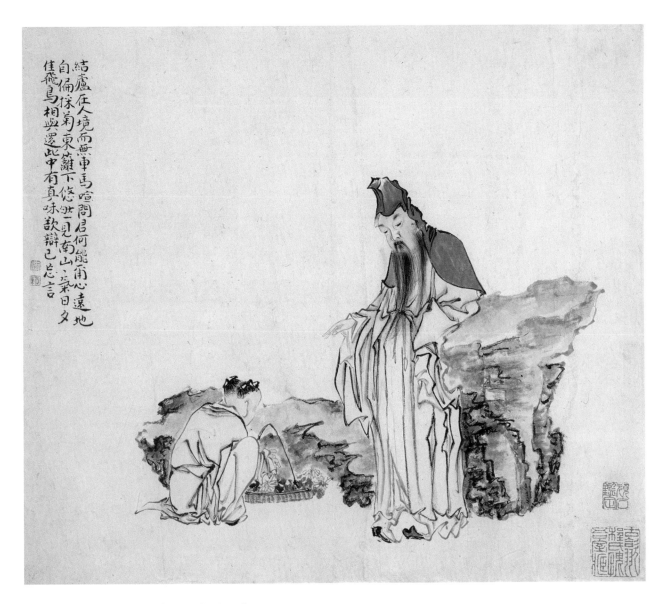

結廬在人境而無車馬喧問君何能爾心遠地
自偏採菊東籬下悠然一見南山氣日夕
佳飛鳥相與還此中有真味欲辯已忘言

FIGURE 10.20 (OPPOSITE TOP) Wu Li (1632–1718).
White Clouds and Green Mountains. Detail of a handscroll.
Ink and color on silk. Ht. 25.9 cm. Qing dynasty. National
Palace Museum, Taipei.

FIGURE 10.21 (OPPOSITE LEFT) Jin Nong (1687–1764).
Plum Blossoms. Hanging scroll. Ink on paper. Ht. 115.9 cm.
Qing dynasty, dated equivalent to 1761. Yale University Art
Gallery, New Haven, Leonard C. Hanna, Jr., B.A. 1913, Fund.

FIGURE 10.22 (ABOVE) Huang Shen (1687–c. 1768).
The Poet Tao Yuanming Enjoys the Early Chrysanthemums.
Album leaf. Ink and color on paper. Ht. 28 cm. Qing dynasty.
Iris & B. Gerald Cantor Center for Visual Arts at Stanford
University; Committee for Art Acquisitions Fund.

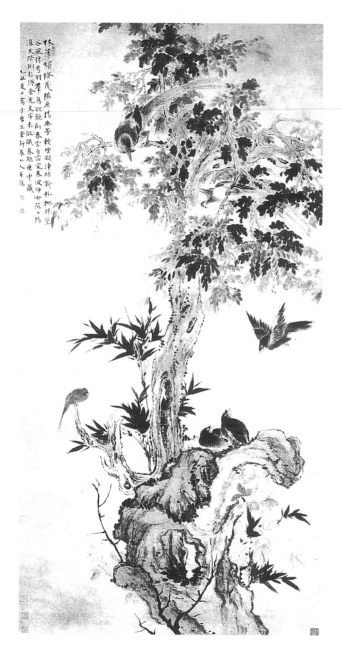

of these professional eccentrics is an appeal to the antique, but their attitude is much less serious than that of their late Ming and early Qing predecessors, and they carry the burden of tradition more lightly. Their purpose, after all, was to entertain. Jin Nong's favorite and most versatile pupil, Luo Ping (1733–99), made a portrait of his friend Yi'an that is a parody of the style of Chen Hongshou, which was itself inspired by Gu Kaizhi; while his oddest and most famous work is an album of ghosts (fig. 10.24) for which the sources are to be found not in the great tradition, but in popular art and—if he is to be believed—in his own experience, for he claimed that he had actually seen them.

Groupings such as the Four Wangs and the Eight Eccentrics of Yangzhou have little foundation in fact. Where, for instance, does individualism stop and eccentricity begin? Were there really just eight eccentrics in Yangzhou? There were many kinds of eccentricity, natural and assumed. Some of these men were friends, others not; some were outstanding, others obscure. But these traditional groupings are helpful, as much to Chinese as to Western readers, in reducing the bewildering number of Qing painters to some sort of order.

The careers of some of the Yangzhou eccentrics point to a change in the status of the so-called amateur painter in China. Ideally, he was a salaried official or a man of means who painted for pleasure in his spare time. But among the Qing gentleman-painters were many—indeed, a majority—who were not officials and had no private income and so were forced (although this was not openly acknowledged) to paint for a living. Wang Hui, for example, painted industriously for the patrons in whose mansions he lodged for months on end; Jin Nong for a time was reduced to decorating lanterns; while competition for the patronage of the Yangzhou salt merchants forced artists such as Jin Nong and Huang Shen to cultivate a deliberate oddity of style to attract their attention. The miracle is that the discipline of the brush still held and that there is still so much sensibility and freshness in their art.

At the opposite extreme to the work of the Yangzhou eccentrics was a kind of painting that I mentioned in chapter 8 as being beneath the notice of the literati who wrote on art: the paintings done by and for women. By the Ming and Qing highly skilled professional artists, many of whose names are unknown, were painting intimate domestic scenes depicting women, often with their servant girls, enjoying themselves in garden, studio, and bedroom. Some of these charming pictures have erotic overtones; many, with little justification, have been attributed to Qiu Ying.[9]

The art of the individualists and eccentrics can be interpreted as their private protest against the academicism of the painting of the time. But as the Qing settled deeper into the stagnation that seems to have been the fate of every long-lived dynasty in Chinese history, the lamp of individualism burned more and more dimly, while a kind of spiritual paralysis seemed to grip the scholar class as a whole. Early-nineteenth-century painters such as Gai Qi (1773–1828), Fei Danxiu (1801–50), and Dai Xi (1801–60) carried on the tradition with little change. By mid century, however, prosperous cities such as Guangzhou, Suzhou, Nanjing, and, after the Taiping Rebellion was quelled, Shanghai nurtured an increase of vigorous market-oriented art. In Shanghai Ren Xiong (1823–57) was the leader of what came to be called Shanghai Haipai, the Shanghai School of Painting, of which the most famous product is that artist's arresting self-portrait of 1857 (fig. 10.25).

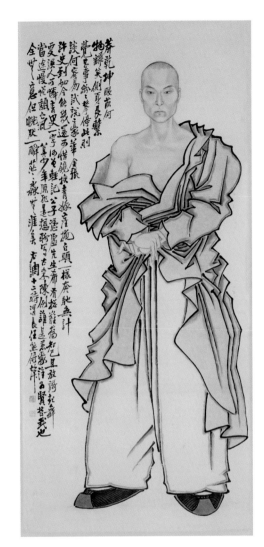

FIGURE 10.23 (OPPOSITE LEFT) Hua Yan (1682–c. 1755). *Birds, Tree, and Rock*. Hanging scroll. Ink and color on paper. Qing dynasty, dated equivalent to 1745. Formerly Huang Pao-hsi Collection, Hong Kong.

FIGURE 10.24 (OPPOSITE RIGHT) Luo Ping (1733–99). *Ghost*. Album leaf mounted on a small handscroll. Ink on paper. Qing dynasty. Huo Baocun Collection, Shanghai.

FIGURE 10.25 (ABOVE) Ren Xiong (1823–57). *Self-Portrait*. Hanging scroll. Ink and color on paper. Ht. 177.4 cm. Qing dynasty. Palace Museum, Beijing.

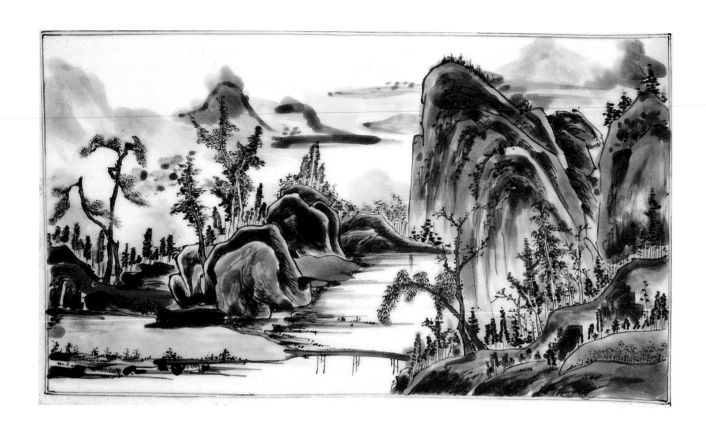

FIGURE 10.26 Tile. Porcelain decorated with a landscape in underglaze blue. Ht. 16.5 cm. Qing dynasty, seventeenth century. Reitlinger Bequest, Ashmolean Museum, Oxford.

CERAMICS

The political disasters that so deeply affected the seventeenth-century painters touched all Chinese society. None except perhaps the poorest peasant was unaffected. Confusion, banditry, and civil war, which had begun after the death of the Wanli emperor in 1620 and was not stilled until well into the reign of Kangxi, wreaked havoc on the ceramics industry at Jingdezhen. Already before the end of the Ming dynasty the imperial wares had sharply declined in both quality and quantity. The reign of Tianqi is noted for a coarse, brittle blue and white prized in Japan as *tenkei* ware, but marked pieces from his successor Chongzhen's era are rare and of poor quality. During these years China lost to Japan the great market it had built up in southeast Asia and Europe, and exports did not fully recover until Wu Sangui had been defeated and south China brought once more under the control of the central government. Consequently the so-called transitional wares of the mid seventeenth century, being for the most part continuations of earlier styles, are not always easy to identify. The most characteristic of

them are strongly built blue and white jars, bowls, and vases decorated with figures in landscapes, rocks, and flowers (especially the "tulip," possibly based on a European motif) in a thick violet glaze that Chinese collectors call "ghost's-face blue" (*guimianqing*) and Western connoisseurs call "violets in milk" (fig. 10.26). Many of them were made primarily for export and, like the export blue and white of Jiajing and Wanli, have a freedom of drawing that gives them considerable appeal.

JINGDEZHEN

No abrupt change at Jingdezhen followed the establishment of the new dynasty. The kilns were still functioning, after a fashion, in the 1650s, and pieces produced during these unsettled years represent, as we would expect, a continuation of the style of the Wanli period. Between 1673 and 1675 Wu Sangui's rebel horde laid waste to Jiangxi, and in the latter year the imperial factories at Jingdezhen were destroyed. They were rebuilt in 1677. In 1682 Kangxi appointed as director of the imperial kilns Zang Yingxuan, a secretary in the Imperial Parks Department. Zang, who arrived early in the following year, was the first of three great directors whose names are linked to this supreme moment in the history of Jingdezhen. It is not known precisely when Zang retired. In 1726 Yongzheng appointed Nian Xiyao, who in turn was succeeded in 1736 by his assistant, Tang Ying, who held the office until 1749 or 1753. Thus, Zang's directorship corresponds roughly to the reign of Kangxi, Nian's to that of Yongzheng, and Tang's to the first years of Qianlong.

Two Chinese works give us useful information on the imperial kilns and their output, though both were written after the factory had begun to decline. Zhu Yan published his *Taoshuo* (Talks on pottery) in 1774, while the *Jingdezhen taolu* (Record of the potteries of Jingdezhen), written by Lan Pu, did not appear until 1815. The most valuable description, however, is that contained in two letters written by the French Jesuit Père d'Entrecolles, who was in China from 1689 to 1741 and had not only influential friends at court but also many converts among the humble artisans in the factories at Jingdezhen. These letters, dated 1712 and 1722, give a vivid picture of the whole process of manufacture, of which he was an intelligent observer.[10] He recounts how the *bai tunzi* ("porcelain stone") and kaolin are quarried and

prepared, and notes the enormous labor involved in kneading the clay. He describes a degree of specialization among the decorators so minute that it is a wonder the painting had any life at all: "One workman does nothing but draw the first color line beneath the rims of the pieces; another traces flowers, while a third one paints. . . . The men who sketch the outlines learn sketching, but not painting; those who paint [i.e., apply the color] study only painting, but not sketching"—all in the interests of absolute uniformity. Elsewhere he says that a single piece might pass through the hands of seventy men. He speaks of the hazards of the kiln and of how a whole firing is often lost by accident or miscalculation. He tells how the emperor would send down Song dynasty *guan*, Ru, Ding, and Chai wares to be copied and describes the gigantic fishbowls ordered by the palace that took nineteen days to fire. The greatest challenge, however, was set by the agents of the European merchants in Guangzhou who demanded openwork lanterns, tabletops, and even musical instruments in porcelain.

WARES OF THE KANGXI PERIOD

The most beautiful Kangxi wares, and those most admired in both China and the West, are the small monochromes, which in their classic perfection of form, surface, and color recapture something of the subtlety and restraint of the Song. The *Taolu* says that Zang Yingxuan's clays were rich, his glazes brilliant, and his porcelain thin-bodied, and that he developed four new colors—eelskin yellow, spotted yellow, snakeskin green, and turquoise blue. He also perfected a mirror black that was often decorated with gold; an exquisite soft red shading to green known as "peach bloom" and used, it seems, for a small range of vases and vessels for the scholar's desk; an "imperial yellow"; and a clear, powder blue, blown on through a bamboo tube and then often painted with arabesques in gold. Powder-blue arabesques were especially admired in France, where it was the fashion to mount them in ormolu. The most splendid effect was a rich red produced from copper, known in Europe as *sang de boeuf* ("oxblood") and in China as *Langyao* (fig. 10.27); several members of the Lang family have been suggested as possible candidates for the honor of having this ware named after them, the most likely being Lang Tingji, who, as governor of Jiangxi from 1705 to 1712, took an active interest in the kilns at Jingdezhen. The glaze,

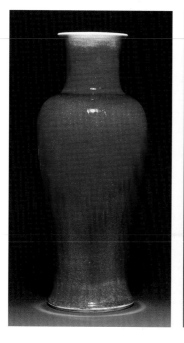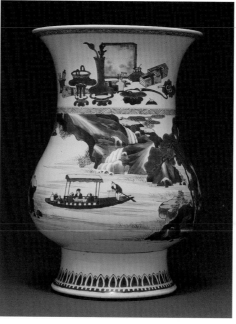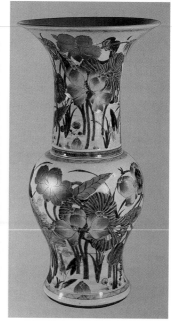

which was probably applied by spraying, runs down the sides of the vase, stopping miraculously short of the foot (a degree of control that was lost in the Qianlong period and has only recently been recovered), while a beautiful effect appears around the rim where the color failed to "develop" and the glaze has a pale greenish tinge. The Kangxi potters also copied the beautiful white "eggshell" bowls of the Yongle period, their version being more flawless than the Ming originals, and made a fine imitation of the classical Ding ware of the Song period as well.

These monochromes appealed chiefly to cultivated taste. Much more widely appreciated were the underglaze blue and enameled wares, for which there was a huge demand both in China and abroad. Most Kangxi blue and white was produced by the mass-production methods of which Père d'Entrecolles gives so depressing a picture. As a result it has a technical perfection combined with a dead uniformity only partly redeemed by the color of the cobalt itself, which has a vivid, intense luminosity never equaled before or since (fig. 10.28). It had a great vogue in Europe in the first half

of the eighteenth century, particularly popular being the "ginger jars" decorated with blossoming prunus on a blue ground reticulated with lines suggesting ice cracks. Thereafter it was largely replaced in favor by the brightly colored enameled wares (fig. 10.29). Between 1667 and 1670 an imperial edict had been issued forbidding the use of the Kangxi *nianhao*. It is not known how long the ban remained in force, but there are comparatively few genuine pieces with the Kangxi mark and a correspondingly large number to which the potters added the fictitious marks of the Ming emperors Xuande and Chenghua.

The great achievement of the potters working under Zang Yingxuan, however, was in the enamels, of which two kinds had been developed by the end of the Ming dynasty: *wucai* ("five colors") enameled over the glaze, and *sancai* ("three colors") applied directly "on the biscuit." In the Kangxi *wucai*, overglaze violet blue replaces the underglaze blue of Wanli, but the dominating color is a transparent jewel-like green that led its European admirers in the nineteenth century to christen it *famille verte* (fig. 10.30). Most

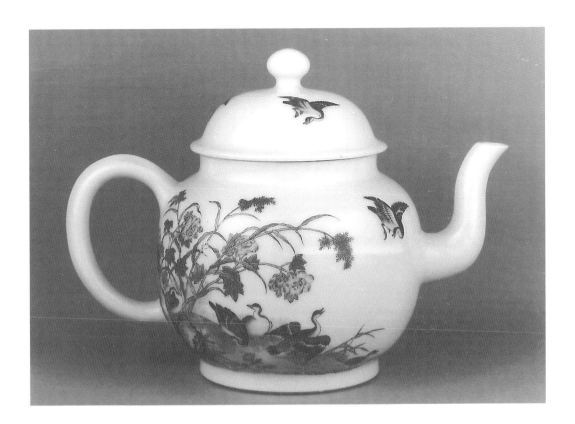

of these pieces are decorated with birds or butterflies amid flowering branches, disposed with an exquisite and subtle sense of balance that strongly suggests these designs were inspired by paintings. The revived *sancai* enamel-on-biscuit was used chiefly for reproductions of archaic bronzes and for figurines of Buddhist and Daoist divinities, children, birds, and animals. Also enameled directly "on the biscuit" is the so-called *famille noire,* whose polychrome floral decoration is set off against a background of a rich black made almost iridescent by being washed over with a transparent green glaze. Until recently this spectacular ware had an enormous vogue among foreign collectors, and, like certain other Qing enamels, it still commands prices out of all proportion to its aesthetic worth. Examples of both *famille verte* and *famille noire* were sometimes adorned with Chenghua reign marks to show how highly their makers regarded them. Toward the end of the Kangxi period, the robust vigor of the *famille verte* began to yield to a new style dominated by a delicate rose pink, which is known in Europe as *famille rose;* the Chinese call it *yangcai* ("foreign

FIGURE 10.27 (OPPOSITE LEFT)
Vase. Langyao porcelain. Ht. 45.1 cm. Qing dynasty, Kangxi period. Seattle Art Museum, Eugene Fuller Memorial Collection. Photo: Paul Macapia.

FIGURE 10.28 (OPPOSITE CENTER)
Vase. Porcelain decorated in underglaze blue. Ht. 34.3 cm. Qing dynasty, Kangxi period. Seattle Art Museum, Eugene Fuller Memorial Collection. Photo: Paul Macapia.

FIGURE 10.29 (OPPOSITE RIGHT)
Vase. Porcelain decorated with overglaze enamel colors. Ht. 45.4 cm. Qing dynasty, Kangxi period. Palace Museum, Beijing.

FIGURE 10.30 (ABOVE) Teapot. *Famille verte* porcelain with enamels in *guyuexuan* style. Ht. 12.9 cm. Qing dynasty, Qianlong period. Collection of Percival David Foundation of Chinese Art, London.

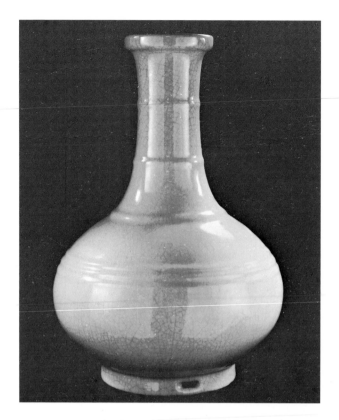

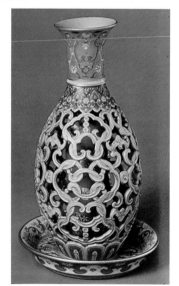

color"), alluding to its invention about 1650 by Andreas Cassius of Leyden, who succeeded in producing a rose red from gold chloride. A saucer dish in the Percival David Foundation collection, dated 1721, must be one of the earliest Chinese examples of the use of this color, which was probably introduced by the Jesuits.

WARES OF THE YONGZHENG PERIOD

The *famille rose* came to its full flowering with the appointment of Nian Xiyao as director of the imperial factories in 1726. Nian's directorship is chiefly famous for its "imitation of the antique and invention of novelties." As a typical example of the former we have his exquisite copies of classical Song wares (fig. 10.31), so perfect that a Ru ware bottle in the Percival David Foundation collection was for many years accepted as a genuine Song piece by the Palace Museum authorities until its carefully concealed Yongzheng mark was discovered. Indeed, many Yongzheng pieces had the reign mark ground away so that they might be passed off as Song when they were illicitly sold out of the palace collection. Nian's "novelties" included the "tea dust" glaze, made by blowing green enamel onto an iron, yellow-brown glaze, an improvement on the exquisite pale blue glaze known in Europe as *clair-de-lune,* and such rococo effects as painting in ink black flecked with gold or in greenish blue flecked with red. Already in 1712 the officials at Jingdezhen had asked d'Entrecolles for curious European objects that might be copied in porcelain and sent to court, and during the Yongzheng period—and increasingly under Qianlong—this taste for extravagant forms and new effects was to absorb the energies of the potters at the cost of real refinement of taste (fig. 10.32). Its most lamentable results can be seen in the decline of *famille rose,* which early in the Yongzheng period had had an exquisite delicacy; it was spoilt by the foreign demand for rich and garish decoration, finally degenerating into the livid salmon pink of the nineteenth century.

WARES OF THE QIANLONG PERIOD

In point of sheer craftsmanship the Qianlong period is supreme, and the finest of the enameled wares produced under the directorship of Tang Ying are unsurpassed. Tang lived and worked with his potters, had complete mastery of their techniques, and was continually experimenting with new effects, reproducing the color and texture of

silver, grained wood, lacquer, bronze, jade, mother-of-pearl, and even cloisonné. He copied Italian faience drug pots, Venetian glass, Limoges enamels, and even Delft painted pottery and Japanese "old Imari" ware, which were themselves copies of late-Ming blue and white. Tang Ying also reproduced all the familiar Song wares (his rather glassy copies of Longquan celadon being particularly fine), while his versions of the robust Guangzhou wares were considered a great improvement on the originals. But the most beautiful of the porcelains produced under his direction are the enameled eggshell vessels and bowls, such as the lovely lavender vase illustrated in fig. 10.33, decorated with mallow flowers and chrysanthemums and bearing a poem believed to be by Tang Ying himself. In recent years, fashion has swung away from these exquisite objects to the more free and vital wares of the Tang and the Song, in which we can see and feel the touch of the craftsman's hand, but nothing can surpass the finest of these Qianlong pieces for sheer perfection of craftsmanship.

The influence of European taste on the decoration of Jingdezhen porcelain, which had been growing since the end of the Kangxi period, is nowhere more clearly seen than in a small and choice group of *famille rose* enameled pieces known as *guyuexuan*.[11] Indeed, many of them are decorated with European scenes, and even the Chinese flower motifs have a foreign quality in the realistic drawing, shading, and handling of perspective. They generally bear poems followed by red seals, while the reign mark on the base is in embossed enamel.

A few words should be said on the subject of the porcelain made for the European market during the seventeenth and eighteenth centuries. Already in the sixteenth century the south China potters were decorating dishes with Portuguese coats-of-arms, and the Dutch trade vastly increased the demand in the seventeenth century. It was the Dutch who chiefly furnished the "porcelain rooms" in the great houses of France and Germany, of which the unfinished Japanese Palace of Augustus the Strong, King of Poland and Elector of Saxony, was the most ambitious. Augustus is reputed to have bartered a regiment of grenadiers for a set of *famille verte* vases.

During the seventeenth century European customers were generally content to receive Chinese pieces decorated in accord with Chinese taste, although by 1635 the Dutch were already forwarding, via Formosa, wooden models of

FIGURE 10.31 (OPPOSITE TOP)
Bottle. Copy of Ru ware. Porcelain covered with bluish-gray crackled glaze. Qing dynasty, Yongzheng period. Collection of Percival David Foundation of Chinese Art, London.

FIGURE 10.32 (OPPOSITE BOTTOM)
Taoping openwork double vase. Porcelain, the inner vessel decorated with underglaze blue, the outer with pierced sides, in *fencai* enamels. Ht. 38.5 cm. Qing dynasty, Qianlong period. National Palace Museum, Taipei.

FIGURE 10.33 (ABOVE) Vase. Porcelain decorated with flowers in *famille rose* enamels. A poem by Tang Ying is on the back. Ht. 19 cm. Qing dynasty, Qianlong period. The Mount Trust, England.

FIGURE 10.34 (ABOVE) "Jesuit china" dish. Porcelain decorated in underglaze blue with a baptism scene, after a European engraving. Diam 27.4 cm. Qing dynasty. © The Trustees of the British Museum, London.

FIGURE 10.35 (OPPOSITE) Chen Mingyuan (active mid seventeenth–early eighteenth century). Brush rest. Yixing ware. Unglazed pottery. L. 10.8 cm. Ming dynasty. The Nelson-Atkins Museum of Art, Kansas City, Missouri. Purchase: Nelson Trust. Photo: Jamison Miller.

the shapes they required. In the eighteenth century Europeans sent out not only specimen shapes such as beer mugs and "vomit pots," but also subjects to decorate pieces that had been sent down to Guangzhou "in the blank" from Jingdezhen. The motifs included armorial bearings, genre scenes, views of great houses, and religious themes such as the baptism, crucifixion, and resurrection of Christ—the so-called Jesuit china (fig. 10.34). We can get some idea of the growth of the trade from the fact that in 1643 no fewer than 129,036 pieces of porcelain were sent to Holland, while the cargo of a single Dutch East Indiaman, the *Geldermalsen*, which went down off Singapore in 1752, contained over 150,000 pieces destined for sale in Amsterdam.[12]

Toward the end of the eighteenth century, however, enthusiasm for things Chinese waned as Europe began to supply its needs from its own porcelain factories. The great days of the export trade were over, and the so-called Nankeen ware (enameled porcelain) of the nineteenth century bears eloquent witness to its decay.

Although the imperial factory continued to flourish until the end of the eighteenth century, its great era ended with the departure of Tang Ying. Thereafter the decline was slow but steady. At first we see an even greater ingenuity and elaboration in the manufacture of such freakish objects as boxes with porcelain chains and perforated and revolving vases. But after the beginning of the nineteenth century the decay is more rapid, and though some of the wares of the reign of Daoguang (1821–50) are of fine quality, the industry suffered a crippling blow when the Taiping rebels sacked Jingdezhen in 1853. Thereafter, there was a revival under Tongzhi (1862–73), and a further revival took place in the twentieth century. Today the factories at Jingdezhen are run on modern industrial lines, but care is being taken to preserve the skills and techniques of the traditional potters.

While the imperial kilns were concentrating on an ever greater perfection of technique, the provincial factories in the south maintained their vigor and vitality. Of the scores of these kilns I can mention only a few. Yixing in Jiangsu specialized in the production of little vessels and other objects made of red stoneware for the scholar's table (fig. 10.35)—most ingeniously fashioned in the form of plants, tree trunks, beetles, rats, and other creatures—and in the manufacture of teapots. The names of many Yixing potters are known because they signed their products.[13] Most famous were Shi Dabin in the late Ming, who made teapots for the famous collector Xiang Yuanbian; Hui Mengchen in the early Qing; and Chen Mingyuan, active in the Kangxi and Yongzheng periods, who was well educated and composed poems that he inscribed on his teapots. The Yixing tradition still flourishes today, and there are many fakes.

Dehua continued to make the fine white porcelain developed in the Ming dynasty. Other provincial wares were made either for local use or for shipment to regions where buyers were less exacting in their demands than the Europeans. This applies particularly to the vulgar but vigor-

ous brown stonewares made at Shiwan (Shekwan), near Foshan (Fatshan) in Guangdong, consisting chiefly of ornamental pieces, figures, and large jars decorated with a thick blue glaze streaked and flecked with gray and green, which since the Ming dynasty have both gratified local taste and been exported in quantity to the Nanhai.

DECORATIVE ARTS: JADE, LACQUER, GLASS

About the year 1680, Kangxi set up workshops in the palace precincts for the manufacture of porcelain, lacquerware, glass, enamel, furniture, jade, and other objects for court use. The porcelain project, intended to replace distant Jingdezhen, was found impracticable and soon abandoned, although palace craftsmen continued to decorate porcelain sent up "in the blank" from Jingdezhen, while the other workshops turned out a variety of decorative arts of superb quality and continued in production for the rest of the dynasty. The finest pieces of jade carving are often assigned, with little reason, to the reign of Qianlong. Carved jade (fig. 10.36) is extremely difficult to date, and work of the highest quality has been produced right up to the present day.

Other factories supplied the needs of the wealthy middle class and of the export market. Beijing and Suzhou, for example, specialized in carved lacquer, Fuzhou and Guangzhou in the painted sort. The Guangzhou products were considered inferior both in China and abroad because they were often made hastily to meet the demands of European merchants, who were permitted to reside in the city only for a few months of the year. The Fuzhou lacquer folding screens and cabinets, with their bold carving and rich colors embellished with powdered gold, were exported not only to Europe but also to Russia, Japan, Mecca, and India. So many were transshipped from the Coromandel Coast of south India that this kind of lacquer became known in eighteenth-century England as Coromandel ware (fig. 10.37).

Kangxi's glass factory turned out a wide variety of colored glass bottles and vases, the specialty being an opaque glass laminated in several contrasting colors through which the designs were carved by the intaglio method. "Snuff bottles" (originally made for medicine in the Song and Yuan dynasties) were carved in glass and painted with enamel colors (fig. 10.38). They were also made in an endless va-

FIGURE 10.36 (ABOVE) Carp leaping out of the water. Carved green and brownish jade. Ht. 16.7 cm. Qing dynasty. National Palace Museum, Taipei.

FIGURE 10.37 (OPPOSITE TOP) "Coromandel" screen. Lacquer on wood, decorated with phoenixes and flowering trees. Ht. 2.75 m. Qing dynasty. Formerly Lu Qinzhai Collection.

FIGURE 10.38 (OPPOSITE BOTTOM) Snuff bottle. Enameled glass inscribed *guyuexuan* on base. Ht. (without stopper) 5.8 cm. Qing dynasty. Collection of Percival David Foundation of Chinese Art, London.

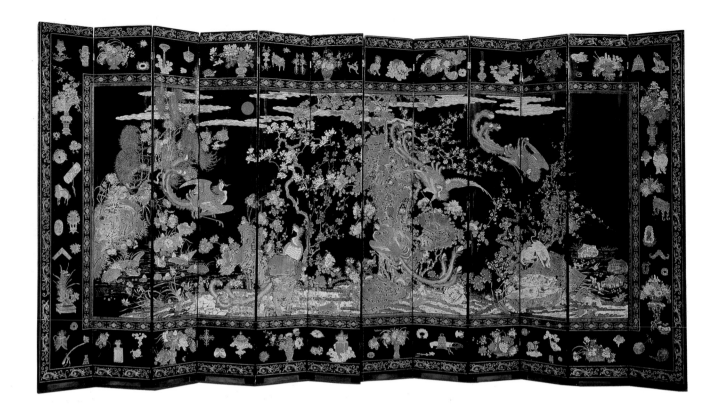

riety of semiprecious substances such as lacquer, jade, crystal, coral, agate, and enamel, all of which were imitated in porcelain at Jingdezhen. In the eighteenth century the art of backpainting on glass was introduced from Europe into China. It was said to have been practiced by Castiglione in Beijing and soon became popular for painting delightful genre scenes on the backs of mirrors. The application of this technique to the decoration of the inside surface of transparent snuff bottles, first attempted about 1887, represents one of the last efforts of the dying arts of the Qing dynasty to venture into new fields.

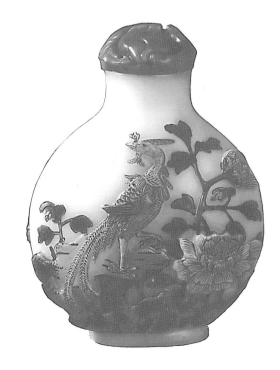

THE TWENTIETH CENTURY
AND BEYOND

Toward the end of the nineteenth century China began to stir once more into life, roused by the aggressive penetration of the Western powers. But it was to be decades before China's response to Western art was anything more than passive or reluctantly imitative. Chinese rulers, unlike their Japanese counterparts of the Meiji period, did not see the arts of Europe as an aid to modernization and reform. If they had any attitude at all toward Western culture, as opposed to Western guns and machines, it was one of hostility and contempt, and the problems of the cultural confrontation were left to take care of themselves.

ARCHITECTURE

From the mid nineteenth century onward, Western-style commercial buildings, schools, and churches were rising wherever the foreigners penetrated. If those put up by the foreigners were bad, the Chinese imitations of them were even worse. A hybrid style combining Chinese and Western elements soon came into being, but well into the present century practicing architects knew too little about traditional building methods to be able to adapt them suc-

cessfully to modern materials. And the results were generally disastrous.[1]

In 1930 a group of architects founded the Chinese Architectural Research Society to remedy this defect and explore new ways of adapting traditional forms to modern needs. The results of their work, and especially that of Henry Killam Murphy, can be seen in government and university buildings put up in Nanjing, Shanghai, Beijing, and elsewhere during the few peaceful years before the Japanese invasion of 1937. Attractive as some of these are, they are still essentially Western buildings Sinicized with a traditional curved roof and enriched with detail translated from timber into painted concrete. These architects had not yet discovered the truth, long since grasped by the Japanese, that the essence of their traditional architecture lies not in the curved roof, lovely as it is, but in the post-and-frame structure, which, unlike the roof, is readily adaptable to modern needs and materials.

After 1949 the need for reconstruction and development on a vast scale was fueled by genuine revolutionary enthusiasm. But the question of architectural style was not so easily solved. In the 1950s Soviet experts promoted the

FIGURE 11.1 (ABOVE)
Dong Dayou (1899–1973).
Shanghai Municipal Government
building. 1933. Photo courtesy
of Wei Te-wen, Taipei.

FIGURE 11.2 (LEFT)
Zhao Dongri (1919–2005) and
Zhang Bo (1911–99). Great Hall of
the People, Beijing. 1959. Photo
courtesy of Wei Te-wen, Taipei.

FIGURE 11.3 (OPPOSITE)
Yang Tingbao (1901–82) and others.
Beijing Library. 1987. Photo courtesy
of Wei Te-wen, Taipei.

inappropriate Stalinist "wedding-cake" style, seen in such buildings as the Military Museum in Beijing, while Chinese preferences were met by the work of architects such as Liang Sicheng, who took over the modernized traditionalism that had been created by Henry Killam Murphy and his colleagues in the 1930s (fig. 11.1). In the era of Mao Zedong (1949–76) Liang was heavily criticized for a style that was both reactionary and costly.

Among the more successful structures of the early postrevolutionary period are the Beijing Workers' Gymnasium (1951) and the Capital Gymnasium (1971), in which a major technical challenge determined the style. The Great Hall of the People on Tiananmen Square, completed in 1959 in the record time of eleven months for the tenth anniversary of the founding of the People's Republic, is undoubtedly the most impressive (fig. 11.2). Although poor in detail, this vast building is notable for the nobility of its proportions as a symbol of the enduring strength of the new China.

The architecture of the 1980s and early 1990s reflected China's new openness to Western movements after the death of Mao and a consequent uncertainty as to what line to follow. Postmodernism is awkwardly combined with a traditional Chinese roof in the Wangfujing Restaurant in Beijing (1989), but in the new wing of the Beijing Library (1987) Yang Tingbao and his associates achieved a truly Chinese modernism by rejecting the picturesque curved roof

and elaborate bracketing of recent dynasties and returning to the straight roofline and frankly stated frame of Han architecture (fig. 11.3), which adapts well to the modern idiom. I. M. Pei's attempt in his Xiangshan Hotel (1982) to create a multistory style based on the domestic architecture of Zhejiang and Anhui produced a beautiful building, which, however, had little influence.

The late 1990s and early years of the twenty-first century have seen a vast expansion of new building thanks to the economic boom, while in the relentless pursuit of profit in the name of development, huge numbers of old buildings have been destroyed. The sense of history that, at the beginning of this book, I suggested has been a unique feature of Chinese civilization has been, for the time being at least, utterly abandoned. Although here and there awareness of this loss has led to the careful rebuilding of traditional structures—usually to meet the demands of the tourist trade—such is the pace of development and so great the amount of money available that China's cities are rapidly acquiring the featureless character of international commercial modernism.

Some of the boldest experiments in creating a new Chinese style were first made in Taiwan, once architects were able to break through the rigid conservatism of the displaced Guomindang authority. Wang Dahong's elegant project of 1961 for a new National Palace Museum was rejected in fa-

FIGURE 11.4 (ABOVE)
Li Zuyuan. Office building,
Taipei. 1990. Photo courtesy
of Wei Te-wen, Taipei.

FIGURE 11.5 (OPPOSITE TOP)
Lu Xiang. The Bridge Museum for
Posters from the Cultural Revolution.
Anren, Sichuan. 2007. Image
courtesy of Atelier Feichang Jianzhu.

FIGURE 11.6 (OPPOSITE BOTTOM)
I. M. Pei (b. 1917). The Suzhou
Museum, garden view. 2007.
Photo: Kerun Ip, courtesy of Pei
Partnership Architects.

vor of an uninspired traditional design, but since then a new freedom and confidence have reflected Taiwan's prosperity and international standing. A fine example of this assurance (possibly influenced by the work of the Japanese architect Kenzo Tange) is the 1990 Hsiangkuo Office Building in Taipei by Li Zuyuan, in which elements of frame, bracketing, and cantilever—all functionally expressed—are wedded to form a structure of great power and conviction (fig. 11.4).

It has taken rather longer in mainland China for contemporary architecture with any conviction to appear. At the time of this writing (spring 2008), the two most "iconic" new buildings in Beijing are considered to be the Olympic Stadium, by the Swiss architects Jacques Herzog and Pierre de Mauron, and the China Central Television headquarters, by Rem Koolhaas and Ole Scheeren, so they are hardly representative of Chinese architecture—although nowadays architects work all over the world, and the nationality of any particular designer is not necessarily significant. The very fact that foreign architects such as these are working in China, however, *is* significant, for it suggests that the government authorities who commissioned them feel the need to show the world how forward-looking and internationally minded China's leaders are.

Yet it is natural to look for works by Chinese architects that do, however indirectly, relate to Chinese tradition. There are many of these on a less spectacular level than the "iconic" works I have referred to. Among them is the project by Lu Xiang for the Bridge Museum for Posters from the Cultural Revolution at Anren in Sichuan (fig. 11.5). The galleries form a bridge over the river, recalling the traditional "inhabited" bridges of south and southwest China—such as the one that stood until recently at Wangjianglou, outside Chengdu—with splayed concrete posts, echoing the old timber supports, to carry the galleries over the river. It would not be surprising if the architect was aware of Arthur Erickson's Museum of Glass (2002) in Tacoma, Washington, which was built across a highway. Yet, even so, Lu Xiang has created a work that has deep roots in local Chinese tradition.

Better known may be I. M. Pei's Suzhou Museum, which opened in 2007 (fig. 11.6). Here the architect shows a sensitivity to the site explained, perhaps, by its proximity to his ancestral home, the mansions at the Shizi Lin (Lion Forest) garden nearby. The museum itself is next door to the Garden of the Clumsy Politician (Zhuozheng Yuan),

which, like the Shizi Lin, is a World Heritage site, part of the Classical Gardens of Suzhou. I. M. Pei clearly loves the clean lines and white walls of his native town, which he here combines with the modern idiom in a work of rare elegance and poetry.

PAINTING

The painting of the last hundred years presents perhaps the most vivid illustration of the tensions between old ideas and new, native styles and foreign, that are shaping modern China. By the nineteenth century, the court painters, once so highly honored, had sunk to a status hardly higher than that of palace servants, and even their names are not known. The literati too were victims of the growing paralysis of Qing culture, and there were few outstanding amateur painters. In the first half of the century Dai Xi (1801–60) and Tang Yifen (1778–1853) were typically orthodox followers of the academic literary style of Wang Hui, while in the more independent atmosphere of the south *wenren hua* took on a more vital, if cruder, character in the ink painting of Xie Lansheng (1760–1831) and the "two Sus"—Su Liupeng (1796–1862) and Su Renshan (1814–50).[2]

But after mid century the greatest change came in Shanghai, for in spite of the ferment of the fall of the Manchus, the Literary Revolution of 1917, and the May Fourth Movement of 1919, Beijing remained conservative in artistic matters. A few members of the Manchu imperial family were painters. The best of them was Pu Xinyu (1895–1963), whose styles of calligraphy and figure and landscape painting, carefully modeled on the Song and Yuan masters, were marked by great refinement and elegance. Late in life, he was a pillar of scholarly orthodoxy in Taiwan.

In Beijing through the first half of the twentieth century, societies of gentleman-painters flourished, and the styles of the Four Wangs were upheld by artists such as Jin Cheng (1878–1926), Chen Hengke (1876–1922), and Xiao Sun (1883–1944). Qi Baishi (1864–1957) came from a peasant background in Hunan to settle in Beijing, where by sheer determination and talent he became a dominant figure in the art world of the 1920s and 1930s. Immensely prolific, he was particularly noted for his birds and flowers, crabs and shrimps, which he reduced to essentials while preserving their inner life (fig. 11.7).

After Chiang Kai-shek moved the seat of government

south in 1926, Beijing became something of a cultural back-water. The political capital was now Nanjing, but the cultural powerhouse was Shanghai. During the thirteen years of the Taiping Rebellion (1851–64), Shanghai had become a place of refuge for painters and rich collectors from the Jiangnan region, while the city was rapidly growing as a center of commerce. Shanghai's newly rich patrons wanted art that was vigorous, colorful, and easy to understand. At the same time, the late decades of the nineteenth century saw a strong movement among the scholarly *jinshi jia*—"metal and stone-ists," as we might call them—to revive the ancient styles of calligraphy preserved in bronze and stone inscriptions. Together these two enthusiasms—for vigorous, colorful paintings and for calligraphy based on ancient models—came together in the work of the leading painters of the Shanghai School, or *Haipai,* such as Zhao Zhiqian (1829–84) and his follower Wu Changshuo (1844–1927), in whose paintings the somewhat emphatic form, bold color, and powerful calligraphy produce an exhilarating effect (fig. 11.8). Among Shanghai figure painters Ren Yi (Ren Bonian, 1840–95) brilliantly brought to life again the archaistic style of the Ming master Chen Hongshou (see chapter 9) and a touch of realism that he had acquired through contact with the Western-style commercial art of Shanghai (fig. 11.9).

This revival of *guohua* ("Chinese painting") is also reflected in calligraphy. Of the many who practiced the art I can mention only one: Yu Youren (1879–1964), who is chiefly noted for his long effort before the Second World War to standardize and simplify the script, in response to the Guomindang's slogan, "New, Fast, Strong, Simple." An example of his *xingshu* in this spirit is shown in fig. 11.10. He spent the last years of his life in Taiwan.[3]

The number of artists in and around Shanghai who carried on the reinvigorated *guohua* is legion, and the Shanghai School still flourishes today.[4] Not all *guohua* artists fit readily into the Shanghai School, however. Fu Baoshi (1904–65) combined a reverence for the monumentality of Northern Song landscape with his admiration for Shitao, whose work he had discovered in Japan and on whom he wrote a book. His landscapes and figure studies combine great delicacy of touch in the brushwork with a lyrical feeling that is lacking in the work of Qi Baishi and of many of the Shanghai School (fig. 11.11).

Perhaps the most gifted landscapist of the first half of

FIGURE 11.8 Wu Changshuo (1844–1927). *Bodhidharma.* Hanging scroll. Ink and color on paper. Ht. 122 cm. 1915. Formerly Mi Chou Gallery, New York.

FIGURE 11.9 (ABOVE) Ren Yi (Ren Bonian, 1840–95). *Three Heroes in a Time of Disor-der.* Two men and a woman who sought to restore order in the late Sui–early Tang period but gave way to Li Shimin, founder of the Tang, when they recognized his superior-ity. Hanging scroll. Ink and color on paper. Undated. Palace Museum, Beijing. Photo courtesy of Wei Te-wen, Taipei.

FIGURE 11.10 (ABOVE RIGHT) Yu Youren (1879–1964). A couplet written in cursive script (*xingshu*). 1940s. Collection of Rongbaozhai, Beijing. Photo courtesy of Liu Zhengcheng.

FIGURE 11.11 (OPPOSITE LEFT) Fu Baoshi (1904–65). *The Song of Mount Lu.* Hanging scroll. Ink and color on paper. Ht. 91 cm. 1944. Charles A. Drenowatz Collection, Museum Rietberg, Zürich. Photo: Wettstein & Kauf.

FIGURE 11.12 (OPPOSITE RIGHT) Huang Binhong (1864–1955). *A Ferry in Sichuan.* Al-bum leaf. Ink and color on paper. Ht. 33.5 cm. 1948. Private collection, Oxford, England.

the twentieth century was Huang Binhong (1864–1955), who spent most of his career teaching, writing, and painting in Shanghai and Beijing and almost single-handedly brought the Anhui School of landscape painting to life again.[5] His early work was orthodox, but such was the strength of his artistic personality that he was able, as Dong Qichang had been, to internalize what he had absorbed from the great Yuan and Ming masters, including Dong Qichang himself, to produce landscapes in his own unique style (fig. 11.12)—many inspired by the scenery of his native Anhui and his beloved Huangshan—that are restlessly alive, intense yet serene, densely textured yet airy, and seemingly unaffected by any conscious references to the past.

The rebirth of *guohua* was an aspect of the rebirth of China after the fall of the Manchus and of a newly awakened pride in Chinese culture. But at the same time, many felt that traditional culture was an obstacle to modernization. A new language had to be found to express new ideas. That language had to come, with modern technology, from the West.

THE MODERN MOVEMENT

After tentative beginnings here and there in the coastal cities, the modern movement in Chinese art was launched in 1916 by the Cantonese artist Gao Jianfu (Gao Lun, 1879–1951), who had recently returned from Japan. While in Tokyo, he had come under the influence of the Nihonga

花烟橋雨

movement, dedicated to the revival of the Japanese tradition by introducing Western techniques such as shading, chiaroscuro, and contemporary subject matter: several of Gao Jianfu's most famous early hanging scrolls depicted tanks and airplanes. The work of the Cantonese School, *Lingnan pai,* as it was called, founded by Gao Jianfu and his brother Gao Qifeng (Gao Weng, 1889–1933), was too Japanese in feeling, however, and too deliberately synthetic to command a wide following, but it showed that the traditional medium could be adapted to modern themes (fig. 11.13). After the Communists came to power in 1949, the style created by the Cantonese School—shorn of its somewhat slickly decorative texture—developed in China

as one solution to the problem of expressing realistic, revolutionary content in the traditional medium.[6]

The first modern art school in East Asia had been founded in 1876 in Tokyo. But apart from the atelier founded in 1867 by the Jesuits at Tushanwan, Shanghai, to train copyists of Western devotional paintings for Catholic churches, no developments took place in China until 1906, when the Nanjing High Normal School and the Beiyang Normal School in Beijing each opened a department of fine art on the Western pattern. They were soon followed in Shanghai by several private studios modeled upon romantic notions of the typical Paris atelier, notions that had been acquired, very much at second hand, from Japanese artists who had studied in France. Soon after the First World War, art schools opened in Beijing and Shanghai, Nanjing and Hangzhou, while the more fortunate students were finding their way to France, where they came under a variety of influences. Whereas Xu Beihong (1895–1953) painted in oils in a conventional salon style, after his return from Europe he painted also in the Chinese medium with a touch of Western realism (fig. 11.14). He was a dominating influence in Nanjing. Liu Haisu (1896–1994), the head of the private Academy in Shanghai, was a devotee of the Post-Impressionists; while Lin Fengmian (1900–1991), as director of the Academy founded in Hangzhou in 1927, was a follower of Matisse (fig. 11.15). All had their devoted students.

Conservatives naturally viewed these developments with horror. To them Western painting (*xihua*) was a threat to the great tradition, and Liu Haisu early in his career was branded as a "traitor in art." By the mid 1930s the French Concession in Shanghai had become a little Montmartre, the center of a transplanted bohemianism that was inevitably out of touch with the feelings and aspirations of the mass of the Chinese people.

Young artists with a social conscience felt that even Lin Fengmian's modernism was no answer to China's acute social problems. Many of these radicals joined the Woodcut Movement that had been launched by the great writer and polemicist Lu Xun (1881–1936) in 1928. The woodcut, Lu Xun maintained, was Chinese in origin, cheap and easy to produce and reproduce, and a valuable tool in mass education. The models he introduced to Shanghai, however, were chiefly European, notably the prints of Käthe Kollwitz, whose work had a great influence. Not all the wood engravers were Communists. Li Hua (1907–94), the best of

FIGURE 11.15 (OPPOSITE) Lin Fengmian (1900–1991). *Autumn Landscape*. Ink and color on paper. Ht. 68 cm. Undated. Reproduction by permission of the Provisional Urban Council from the collection of the Hong Kong Museum of Art.

FIGURE 11.16 (ABOVE) Li Hua (1907–94). *Refugees*. Woodcut. About 1939.

現實圖

FIGURE 11.17 (ABOVE) Ding Cong (Xiao Ding, b. 1916). *Today's Reality*. Satirical handscroll. Ink and color on paper. 1946. Location unknown.

FIGURE 11.18 (OPPOSITE) Zhang Daqian (Chang Dai-chien, 1899–1983). *Panorama of Mount Lu*. Detail of a mural in portable scroll format. Ink and color on silk. Ht. 178 cm. 1981–83. National Palace Museum, Taipei.

them, long remained uncommitted (fig. 11.16). But in the 1930s and early 1940s many slipped away to the Communist base at Yan'an, where Mao Zedong was laying the foundation for the total political control of the arts that he implemented after "Liberation" in 1949.

In the meantime, all doubts about the place of the artist in modern Chinese society were resolved by the Japanese attack on Beijing in July 1937. Three years of steady retreat brought painters and intellectuals close to the heart of the real China, as yet little touched by the hybrid culture of the Treaty Ports. Ties with Paris were cut; oil paints were hard to obtain; and many Western-style artists, including Wu Zuoren, Pang Xunqin, and Lin Fengmian, took up the Chinese brush to depict the people and landscape of the western provinces. At the same time, social satirists such as Ding Cong (Xiao Ding, b. 1916) and the cartoonist Liao Bingxiong (1915–2006), who had begun the war doing anti-Japanese propaganda, were now turning their satire against the Nationalist government and corruption on the home front (fig. 11.17).

The last years before the fall of the Guomindang were a time of increasing confusion and anxiety. Yet the art world in the big cities revived, and leading artists such as Qi Baishi, Huang Binhong, and Fu Baoshi were producing some of their finest work. The Sichuan *guohua* artist Zhang Daqian (Chang Dai-chien, 1899–1983), who had spent two years copying the wall paintings at Dunhuang, was establishing his reputation as a master of many styles, expert forger, and colorful and mischievous personality.[7] When the Communists came to power, he settled in South America, then in California, his work of this period showing his response to the challenge of Abstract Expressionism. For much of his career he had been a clever and eclectic artist. Only in his last years did he attain the status of a true master in his handscroll *Ten Thousand Li of the Yangzi River* and, finest of all, the great unfinished panorama of Mount Lu (fig. 11.18), on which he was working at the time of his death in Taipei.

Although in the postwar years artists once again hoped to get to Europe, few succeeded. Among those who did were three of Lin Fengmian's most gifted pupils. Zao Wou-ki (Zhao Wuji, b. 1921) settled in Paris in 1948, where, after coming under the influence of Paul Klee, he developed into an Abstract Expressionist of great distinction, although his abstractions, painted with free calligraphic gestures in oils or acrylics, are still Chinese in their suggestions of landscapes (fig. 11.19). Chu Teh Chun (Zhu Dequn, b. 1920), who also settled in Paris, has a reputation second only to that of Zao Wou-ki. Wu Guanzhong (b. 1919) after five years in Paris returned to Beijing in 1951 to teach at the Central Academy, where he was attacked for his admiration for Cézanne and for his nude paintings, which he was forced to destroy.

Like many artists of his kind, he was to suffer severely in the coming years. Perhaps the most remarkable metamorphosis took place in the art of Tseng Yu-ho (Zeng Youhe, b. 1923). A competent academic painter in the manner of her master, Pu Qin, cousin of Pu Xinyu, in postwar Beijing, she settled in Honolulu, where she came under the influence of modern Western art. She was also able to revive and reinterpret the styles of earlier masters in the scholarly tradition, as in her Hawaiian landscape (fig. 11.20) in the manner of the seventeenth-century individualist Gong Xian (see fig. 10.10).

From the establishment of the People's Republic in October 1949, the Communist Party took total control of art education and of the lives, work, and thoughts of the artists themselves.[8] The Central Academy, nominally under Wu Zuoren but controlled by Yan'an-trained Party apparatchiks, became the model for regulated art schools across the country. From 1949 to 1958 Soviet influence dominated all fields, and oil painting was taught at the Central Academy by, among others, the Moscow academician Konstantin Maksimov.

The art of these years, although conditioned by Marxist-Maoist ideology, was experimental in a technical sense, when artists were called upon to depict realistically subjects that had no place in the traditional repertory. Even more important for the future of Chinese art was the fact that peasants and workers were now encouraged to take up the brush and depict the world they knew, thus ending, for a few years at least, the old elitism associated with "fine art" and broadening immeasurably the social base from which art could spring. In 1958 the authorities launched the nationwide "peasant art movement," focusing particularly on the peasant painters of Bixian county in Zhejiang. Professional artists from the cities were assigned to help the peasants improve their technique. Some genuine talent was discovered, and the best of the peasant paintings of this era have an unaffected spontaneity that these amateur artists often lost when they became more technically accomplished.

The mobilization of skills for the task of socialist reconstruction and mass education in the doctrines of Marxism-Maoism was total. All forms and media, traditional and modern, played their part, and there were striking developments in the woodcut and color print, while serial pictures, or strip illustrations—some drawn by leading artists such as Cheng Shifa (1921–2007; fig. 11.21)—sold by the

millions. Equally popular were the traditional New Year pictures pasted to the doors of peasants' houses, which now carried a political or ideological message.

As for *guohua,* cultural leaders were divided as to whether it was bourgeois and reactionary or adaptable to revolutionary needs. The reformers of *guohua* won the battle, and while old masters such as Qi Baishi and Huang Binhong were left to go on painting in their own way, masters of the next generation, such as Zhu Qizhan (1892–1996), Fu Baoshi, and Pan Tianshou (1897–1971; fig. 11.22), were under great pressure to dedicate their art to the revolution by painting scenes of reconstruction, dam building, and peasant life or by illustrating in a traditional landscape a line from a poem by Mao Zedong. The vast majority of *guohua* painters—so

long as they did not stray from the path of orthodoxy, which in any case few were tempted to do—were given financial security and status by membership in the provincial painting academies and in the local branches of the Artists' Association controlled by the Ministry of Culture.[9]

Within the limits tolerated by the Communist cultural officials—and in spite of bewildering changes in policy as the controls were loosened (in the Hundred Flowers Movement of 1956–57, for example) and tightened (in the Anti-Rightist Campaign and the Great Leap Forward of 1958–62)—some fine work was produced in these years, notably by Li Keran (1907–89; fig. 11.23) in Beijing and Pan Tianshou, who taught *guohua* in the Hangzhou Academy.[10]

While Chinese artists in the People's Republic worked

under erratic ideological control, those living in Hong Kong and Taiwan had a better fate.[11] Until the Japanese occupation of Taiwan ended in 1945, leading painters such as the traditionalist Chen Jin (1907–98) and the oil painter Li Shiqiao (1908–95) had studied in Tokyo and Kyoto. The Japanese connection was broken in the postwar years, only to resume in the 1980s. While the Guomindang government long remained obstructively conservative in all cultural matters, during the 1960s, when American influence was strong, they could not prevent a few daring artists—including Liu Guosong (b. 1932; fig. 11.24), Zhuang Zhe (b. 1934), and other members of the Fifth Moon group—from developing an entirely new kind of *guohua,* stimulated by the New York School of Abstract Expressionism. At about

the same time, the In Tao and Circle groups in Hong Kong, led by Lui Show Kwan (Lu Shoukun, 1919–75), took advantage of the liberal climate of the colony to develop along similar lines.

By the 1980s vigorous movements reflecting every possible variant of modernism were flourishing in Taiwan and Hong Kong. When the work of these artists was finally permitted to be shown in the People's Republic, it demonstrated to young artists starved of outside stimuli how painting could be both contemporary in style and Chinese in feeling. In the meantime, a handful of Chinese artists in southeast Asia, notably Cheong Soo Pieng (Zhong Sibin, 1917–83) in Singapore, were responding to the exotic beauty of the tropics with a formalist style refreshingly free from the

FIGURE 11.23 (RIGHT)
Li Keran (1907–89). *Playfulness in Autumn.* Hanging scroll. Ink and color on paper. Ht. 68.5 cm. 1982. Photo courtesy of Lucy Lim.

FIGURE 11.24 (BELOW)
Liu Guosong (b . 1932). *Rocks and Water.* Ink and color on paper. L. 91 cm. 1966. Private collection, Oxford, England.

FIGURE 11.25 (LEFT) Liao Xinxue (1901–58). *Athlete*. Bronze. Life size. 1946.

FIGURE 11.26 (BELOW) Ye Yushan with a team of sculptors from the Sichuan Academy of Fine Arts. Detail of *The Rent Collection Courtyard*. Clay. Life size. 1965. In the courtyard of a former landlord's mansion at Dayi, Sichuan.

influence of Gauguin. The time was passing when the work of Chinese artists living abroad was unacceptable on the mainland while it was being recognized as a uniquely Chinese contribution to the increasingly international character of modern art.

SCULPTURE

As we have seen in earlier chapters, sculpture was never classed with painting and calligraphy as a fine art in China. It was the work of artisans for the adornment of buildings and tombs. In the 1920s and 1930s few art students were interested in the subject, although several who studied in Europe became accomplished figurative sculptors, notably Hua Tianyou (1902–86) and Liao Xinxue (1901–58; fig.

11.25), who returned from Paris in 1947 with bronze, silver, and gold medals from the Salon d'Automne. But sculpture as an expressive art form still had no place in China, and the few commissions that came their way were for monuments and portraits.

When the Communists came to power, the demand for sculpture and sculptors rapidly increased. Soon the masters and their pupils were executing vast statues of Mao Zedong, revolutionary martyrs, and Soviet-style heroic groups of soldiers, peasants, and workers for public places. Sculptors were encouraged to lose their individuality in anonymous group projects such as *The Rent Collection Courtyard* (fig. 11.26), completed in 1965.[12] A dramatic tableau of life-size figures in clay plaster, this much-admired work recreated around the courtyard of a rapacious former land-

lord in Sichuan a harrowing scene that had been only too familiar to the local tenant-framers before "Liberation."

Until recently, the most interesting modern Chinese sculpture was created not in the People's Republic, but in Hong Kong by Cheung Yee (Zhang Yi, b. 1936) and Van Lau (Wen Lou, b. 1933) and their followers, and in Taiwan by Yuyu Yang (Yang Yingfeng, b. 1926) and his pupil Ju Ming (Zhu Ming, b. 1938), whose huge *taiji* figures cast in bronze show a brilliant synthesis of Chinese tradition with Western semi-abstract form (fig. 11.27).

DECORATIVE ARTS AND CERAMICS

Chinese decorative arts and crafts have always been traditional in design, and those of the twentieth century are no exception. Against this conservatism, the painter and designer Pang Xunqin (1906–85), who had studied in Paris, began in the 1940s a long single-handed campaign, producing designs for a wide range of crafts that were mod-

ern and yet rooted in his profound study of ancient motifs (fig. 11.28). Few people were interested in his work; not until 1956 was he able, with the support of Premier Zhou Enlai, to establish in Beijing the Arts and Crafts Institute, Gongyi Meishu Xueyuan, later absorbed into Qinghua University, to put his ideas into effect. But even here, he and his staff and students were subject to great pressure to produce, not new designs, but purely traditional textiles, lacquer, cloisonné, and jade and ivory carving to boost the tourist and export trade. The mass of the uneducated or semi-educated public preferred these traditional styles also. It is not surprising, therefore, that the development of a truly contemporary language of Chinese craft design has been so slow and uncertain.

In the first half of the nineteenth century the ceramics industry had declined steadily, to be dealt a crippling blow when the Jingdezhen factories were destroyed during the Taiping Rebellion of 1851–64. But they recovered, and in 1889, 868 pieces were ordered for the wedding of the emperor Guangxu (1873–1908). The industry grew under the patronage of the empress dowager and is still flourishing today. By the early 1990s twenty thousand workers at Jingdezhen were providing large quantities of all the popular traditional wares for both the domestic and the export markets. Recently a phenomenon new to China has appeared: the studio potter—a growing band of artist potters, both men and women, whose best work rivals the finest produced in Japan and the West.

ART IN CHINA SINCE THE 1960s

Although by Western standards the culture of the early 1960s was limited and conformist, it became the target of the Great Proletarian Cultural Revolution of 1966–76, launched by Mao Zedong chiefly to destroy the Communist Party apparatus that had sidetracked him and, in the process, to crush "bourgeois" trends in education, scholarship, and the arts. Universities and art schools were closed, museums shut their doors, and in June 1966 publication of all art and archaeology journals abruptly ceased.[13] Such exhibitions as took place at all were promoted by Mao's wife, Jiang Qing, who with his encouragement exercised a fanatical tyranny over cultural life. Almost everyone engaged in these activities, including all the mainland artists I have mentioned in this chapter, was criticized for "revisionist"

attitudes, and many, labeled as "Rightists," were publicly disgraced, sent as virtual slaves to farm or factory, or driven to madness or suicide.

To remove all trace of elitism in the arts, the peasant art movement was accelerated. This time, the focus of Jiang Qing's attention was the work of peasants in Huxian county, Shaanxi, which became a model for the whole country. A slight relaxation occurred in 1972–73, when the archaeological journals reappeared and Premier Zhou Enlai was able to bring back some artists to decorate hotels and public buildings at the time of President Nixon's visit to Beijing, but afterwards even tighter controls were imposed.

With the death of Zhou Enlai on January 8, 1976, it seemed to the artists that dark night had descended. On April 4, the day of the Qingming Festival honoring the spirits of the dead, a vast crowd gathered on Tiananmen Square to mourn Zhou and to protest against the oppression wrought by Mao and the notorious Gang of Four, of which Jiang Qing was one. Although police dispersed the protesters, this first truly spontaneous demonstration since "Liberation" was the occasion for an outpouring of art and poetry expressive of feelings more widely shared than any since the May Fourth Movement of 1919.[14]

After the death of Mao on September 9, 1976, and the arrest of Jiang Qing and the rest of the Gang of Four a month later, the thaw slowly set in, although more than two years passed before all artists branded as revisionists and Rightists were cleared. So paralyzed had they become by years of control that no one dared to break ranks until 1979, when a handful of brave young amateur artists, encouraged by the short-lived Democracy Movement, mounted the first unauthorized art exhibition since 1949. Calling themselves the Stars (*Xingxing*), the group—led by Wang Keping (b. 1949), Ma Desheng (b. 1952), and Huang Rui (b. 1952)— hung their work on the railings of a public park in Beijing. This and a second show in the following year contained satirical painting and sculpture such as had not been seen in China since the Communists came to power.[15] Even if the people who saw these exhibitions did not understand all the works, they overwhelmingly approved—so much so that further exhibitions of the sort were banned, and the Stars dissolved. Although in future the authorities would from time to time crack down hard, the Stars' exhibitions were a turning point, and the trend toward greater freedom for

the arts seemed irreversible. However, in the uncertain po-
litical climate of the 1980s and 1990s, all the leading Stars,
and a number of other independent artists, sought freedom
abroad. Wang Keping, for instance, settled in Paris, where
in 1994 he created the joyous *Vie* (Life), illustrated in fig.
11.29.

The Stars' exhibitions and other gestures of artistic inde-
pendence during 1979–81—the Beijing Spring, as it came
to be called—were the prelude to a decade of astonishing
activity. China's doors were opening fast, and for the first
time since "Liberation" all but the oldest artists encountered,
simultaneously, not only contemporary Western art in all
its complexity, but also the whole tradition of non-Chinese
arts and letters, including historical, theoretical, and criti-
cal writing. This wealth of new ideas and forms stimulated
through the 1980s an urgent desire to explore and experi-
ment with every possible style and technique. Hundreds
of young artists emerged on the art scene, and it would be
impossible in these few paragraphs to do more than give
an impression of the main trends.[16]

Realism was not abandoned, but it took new forms as
artists for the first time felt free to tell the truth. Soviet Re-
alism was put to the task of depicting the horrors of the
Cultural Revolution, as, for example, in Chen Conglin's
powerful *Snow on X Month, X Day, 1968,* while a talented
group of artists based in Sichuan—including He Duoling
(b. 1948), Luo Gongliu (b. 1916), and Ai Xuan (b. 1947)—
were depicting the landscape and life on the Tibetan
Plateau with a realism both meticulous and poetic that owed
more to Andrew Wyeth than to Soviet art (fig. 11.30). Sym-
bolic paintings that expressed the desire for freedom,
knowledge, or science drew upon Western artists ranging
from Salvador Dalí to Norman Rockwell, while the more
disturbing aspects of modern Chinese life, notably the
sense of alienation felt by the creative artist in a society grow-
ing ever more materialistic, used images from German Ex-
pressionists and the Surrealists, including Max Ernst and
René Magritte. These artists of the New Wave, as it came to
be called, were inevitably condemned by the Party both for
their "negative" attitude and for borrowing heavily from the
West. But the best of them did not look on themselves as
imitators. To them, it was necessary to borrow and adapt
these foreign forms and styles because there were no words
in the traditional language of Chinese painting to express
their feelings.

The climax and collapse of the New Wave came at the
end of this extraordinary decade, first with the ill-advised
Nudes exhibition of November 1988—ill-advised both be-
cause the work was uneven, ranging from salon-style
nudes to clumsy Abstract Expressionism, and because the
huge crowds it drew were motivated chiefly by curiosity and
prurience. Even more controversial was the long-delayed
avant-garde exhibition of February 1989, which included
daring installations, some of which were deliberately in-
tended to shock. When an artist fired two pistol shots into
her installation *Conversation*—life-size figures isolated in

FIGURE 11.31 (RIGHT)
Wang Guangyi (b. 1956). *Workers, Peasants, Soldiers, and Coca-Cola.* Poster. Color on paper. Ht. 98.8 cm. 1992. Collection of David Tang, Hong Kong. Photo courtesy of Hanart TZ Gallery, Hong Kong.

FIGURE 11.32 (OPPOSITE)
Xu Bing (b. 1955). *Tian Shu* (A book from the sky). Installation. 1988. Also produced in book form (four volumes) in a limited edition of 100 copies.

telephone booths unable to communicate with each other—the authorities decided they had had enough. The exhibition was closed down and a rigid censorship of future shows imposed.[17]

If the artistic movement seemed to lose momentum, the desire for more freedom and democracy did not. It culminated in the monthlong peaceful occupation of Tianamen Square through May and early June 1989 by tens of thousands of men and women, chiefly but by no means all young, protesting the dismissal of Hu Yaobang, the liberal prime minister driven from office by Deng Xiaoping. In what might have been the final provocation, students of the Central Academy of Art erected a styrofoam statue some 30 feet (10 m) high, called "The Goddess of Democracy." Four days later, on the night of June 4, the tanks rolled in. The statue was crushed, and many demonstrators and people living in nearby streets were killed or injured. For their actions that day the art students and their supporters, who included a number of leading artists, were victimized. Later, the academy's valuable site in the city center was sold to developers, and the academy moved to the outer suburbs.

At this time the light seemed to go out. Many leading artists in the modern movement sought freedom and safety abroad, to what seemed then to be the permanent impoverishment of contemporary Chinese art. Official exhibitions, however, continued and expanded, giving recognition to hundreds of young artists from the provinces. The standard, particularly in oil painting, was rising, and the range of subjects and styles permitted—so long as they were not seen as attacks on the regime and its ideology—was very wide.

Some of the more adventurous artists who had decided to stay in China were now painting two kinds of picture: one "safe" kind for exhibition at home, another, more daring, to be shown abroad. In 1994, for example, the Hanart TZ Gallery in Hong Kong mounted a major exhibition of recent avant-garde art from the People's Republic that in-

cluded bitterly satirical painting in the manner of the German Expressionists of the Weimar period as well as a new kind of Pop art, influenced by Andy Warhol, in which sacred icons of the Mao era, including Mao himself, were presented with the logos of Coca-Cola and other well-known products of Western capitalism (fig. 11.31), thus reducing Maoist, and indeed all political, iconography to the level of commercial art.

In one work, the impulse of protest and satire is raised far above the political level, although it was at least partly the controlled political climate of Communist China that inspired it. Xu Bing's *Tian Shu* (A book from the sky; fig. 11.32), created in 1987–88, consists chiefly of long sheets of paper on which are printed thousands of individual characters that look at first glance like a difficult text in classical Chinese. But each of these characters, cut one by one from wooden blocks and printed by hand after the manner of ancient Chinese books, is illegible—a pure invention of the artist. Thus did Xu Bing mock the meaninglessness of the deluge of printed matter, wall posters, and propaganda to which the Chinese had been so long subjected; he also suggests, by the immense labor of the undertaking, the futility of human effort in a rigidly controlled society. When later this extraordinary work was exhibited in the West, detached from its Chinese context, Western critics and students admired and studied it as a commentary, of universal significance, on language, truth, and meaning.

An exhibition of the work of the American artist Robert Rauschenberg in Beijing stimulated the birth of the avantgarde in China in the following years, and calligraphy took on many new and experimental forms, ranging from the expressionist to the truly abstract. A leader of this movement was Gu Gan (b. 1942), whose discovery of the art of Kandinsky, Klee, and Miró led to his developing a new style of semiabstract calligraphy that had a powerful influence on the movement that flourishes today (fig. 11.33).

The get-rich-quick ideal encouraged by Deng Xiaoping under the guise of "capitalism with Chinese characteristics" was by the early 1990s rapidly taking hold, changing the whole climate in which the arts were created. The art market was growing rapidly, with new Chinese entrepreneurs now buying paintings for investment and as gifts that would appreciate in value. The auction houses flourished, and many artists were inevitably tempted to produce works

that would sell. Even a painter of the integrity of Wu Guan-zhong, now an old master, was, in spite of himself, earning huge sums for his oils and *guohua* works. Political pressures apart, the Chinese art world was coming to look more and more like that of the West.[18]

The old debate between *guohua* and *xihua*—traditional Chinese and Western painting—was not resolved; indeed it never would be, and it is precisely the dynamic interaction of the Chinese with the Western modes of painting that has produced the extraordinary richness and range of modern Chinese art. Although among lesser artists there is still a great deal of imitation—as indeed there is in the West—the major figures such as Wu Guanzhong, Wang Huaiqing (b. 1944), Luo Zhongli (b. 1948), and Mao Lizhi (Zhang Zhunli, b. 1950), to name but a handful out of hundreds, were taking what they wanted from the West strictly on their own terms (figs. 11.34 and 11.35). Wu Guanzhong, who had lived in Paris from 1945 to 1950, was persecuted in the Mao years for his admiration of Cézanne. Yet he continued to paint, even when condemned to work as a farm laborer, moving easily from oils to the Chinese medium, creating a style that, in the spirit of his master, Lin Feng-mian, combines East and West with a wholly natural lyricism (see fig. 11.34). At the same time other artists, such as the woman painter Yang Yanping (b. 1934), who later

settled in the United States, and Chu Ge (Yuan Dexing, b. 1931) in Taipei, were digging deep into the roots of Chinese art, finding in the ancient pictographs and the motifs of bronze, lacquer, and jade decoration an inexhaustible store of symbolic forms to reinterpret in the language of modern art. Chinese art of the 1990s exuded a sense of vitality, sophistication, and inner confidence that seemed to foretell the dominant role that China would play on the world scene in the twenty-first century. These qualities are vividly present in *The Moon Is Bright and the Stars Are Few,* by the Beijing woman artist Shao Fei (b. 1954), who combines elements of folk art and children's paintings, with a touch of Picasso, in a work that is anything but naive.

But by the early years of the twenty-first century this forward-looking mood of the recent past was giving way to cynicism, as many successful artists set out to mock the very market they exploited. It seemed that they could do anything so long as it attracted attention and was not a direct attack on the Communist Party, whose power, although often hidden, was as absolute as ever. A single exhibition, such as one of the now fashionable biennales in Shanghai, Guangzhou, or Chongqing, might contain conceptual art (e.g., Wu Shanzhuan, b. 1960), satirical art (Fang Lijun, b. 1963; Yue Minjun, b. 1962), performance and body art (Zhang Huan, b. 1963), installations (Liu Wei, b. 1965), computer-generated art (Yan Lei, b. 1965), abstract calligraphy (Gu Gan, b. 1942), and much else. Yue Minjun's *Freedom Leading the People* (fig. 11.37), a parody of Delacroix's *Liberty Leading the People* of 1830, is a biting satire on a controlled society in which material prosperity gives no more than a semblance of happiness.

Among the hundreds, if not thousands, of artists who have attained some kind of recognition are a handful whose work is likely to be remembered. In this book I can give but one more example. Cai Guoqiang (b. 1957) is chiefly noted for his spectacular installations and performances using gunpowder and fireworks as his medium. But he achieved a more substantial effect in his installation *Reflection;* for this he used the skeleton of a fishing boat dug out of the sand on a Japanese beach, which he engulfed in a huge quantity of white shards from the refuse heaps of the Dehua porcelain kilns in Fujian (fig. 11.38). The work is said to symbolize China's export trade in ceramics. Much more significant is that it is a striking creation in itself, of which the form is more arresting than the concept.

Artists have recently found mutual support in a new

FIGURE 11.33 (OPPOSITE)
Gu Gan (b. 1942). The character *shou*
(long life) attended by the long-life sym-
bols of bird and turtle. Ink and color on
paper. Ht. 93 cm. 1990. Private collec-
tion, Oxford, England.

FIGURE 11.34 (TOP) Wu Guanzhong
(b. 1919). *Grand Residence*. Ink on
paper. Ht. 70 cm. 1981. Collection of
the Birmingham Museum of Art, Alabama.
Museum purchase with funds from the
Acquisitions Fund and Mr. and Mrs.
L. Paul Kassouf.

FIGURE 11.35 (LEFT) Wang Huaiqing
(b. 1944). *Unassembled*. Oil on canvas.
Ht. 144.7 cm. 1994. Courtesy Robert A.
Hefner III Collection, Oklahoma City.

phenomenon—artists' communities such as Dashanzi on the outskirts of Beijing, an almost abandoned factory complex (No. 798, or Qijiuba) they took over together with bookshops and trendy restaurants, which has become a showcase for the avant-garde and proof of the tolerance of the city authorities. In this world, aesthetic values and the idea of beauty play little part, and there has been much confusion in people's minds regarding what is and is not "art." It is hardly surprising that the gulf between the avant-garde and the rest of society has grown ever wider. Meanwhile beyond this charmed circle art goes on much as before. While brush painting flourishes—ranging from the subtle semi-abstract landscapes of Wucius Wang (b. 1936) to the striking ink portraits of Qu Leilei (b. 1952)—the huge output of *guohua* reflects the cultural self-confidence of the new generation of urban Chinese and acts as a counterweight to the international movement in contemporary art.

How, one might ask, can an art world of such vitality and complexity prosper except in an atmosphere of political freedom? That the arts in China today enjoy greater freedom than they have in the past half century and more is unde-

niable. But that freedom has limits, and it is well to remember that the rein on artistic freedom in China is far older than the restrictions imposed by Mao and his heirs. The belief that the individual must put loyalty and responsibility to the group, be it the family or the state, before his or her personal freedom is deeply rooted in Chinese traditional culture. The overall purpose is to achieve social harmony. Only when that harmony breaks down—at the decay of a dynasty or in time of intolerable oppression—does individualism speak with a strong voice.

We should not, then, expect to find in today's China, except in the case of rarely gifted or eccentric artists, the anti-establishment stance taken by many artists in the West and considered as the mark of a vital culture. We may expect to see in the years to come some tension between artist and authority, the artist pressing against, while he or she partly accepts, the restraints that the regime, or society as a whole, imposes on personal freedom. But it was within those restraints that most of the great Chinese art of the past was produced, and it is from within them also that great art may come in the future.

NOTES

CHAPTER I: BEFORE THE DAWN OF HISTORY

1 This is not in fact an ancient legend. In early times the Chinese had no creation myths at all, believing, rather, in a self-generated cosmos. Indeed, Frederick Mote (*Intellectual Foundations of China* [New York, 1971], 17–19) follows Derk Bodde in suggesting that this myth may even be of non-Chinese origin. Nevertheless, that it became so well accepted suggests that it filled a need at least at the popular level.

2 Carbon-14 dates in this book are corrected according to the chronology of the bristlecone pine, but even so they should be treated with caution.

3 For a convenient summary, see Kwang-chih Chang, *The Archaeology of Ancient China*, 4th ed. (New Haven, 1986).

4 Li Wenrui, ed., *Top 100 New Archaeological Discoveries of China, 1990–99* (Beijing, 2002), 1: 156–64.

5 Chang, *Archaeology*, 157.

6 See S. Howard Hansford, *A Glossary of Chinese Art and Archaeology*, rev. ed. (London, 1961), 31.

7 Ibid.

CHAPTER 2: THE EARLY BRONZE AGE

1 See L. Carrington Goodrich, "Archaeology in China: The First Decades," *Harvard Journal of Asiatic Studies* 17, no. 1 (1957): 5–15.

2 For a useful survey of the Xia question and of the state of knowledge of Shang culture, see Robert W. Bagley, *Shang Ritual Bronzes from the Arthur M. Sackler Collection,* vol. 1 (Washington, D.C., and Cambridge, Mass., 1987).

3 See Jessica Rawson, "Shang and Western Zhou Designs in Jade and Bronze," *International Colloquium on Chinese Art History, 1991, Proceedings: Antiquities, Part 1* (Taipei, 1992), 73–105.

4 See Robert W. Bagley, "Panlongcheng: A Shang City in Hubei," *Artibus Asiae* 39, no. 3/4 (1977): 165–219.

5 See Robert W. Bagley, "An Early Bronze Age Tomb in Jiangxi Province," *Orientations* 24, no. 7 (July 1993): 20–36.

6 See Robert W. Bagley, ed., *Ancient Sichuan: Treasures from a Lost Civilization* (Seattle and Princeton, 2001).

7 Translated by David N. Keightley.

8 See Shelagh Vainker, *Chinese Pottery and Porcelain: From Prehistory to the Present* (London, 1991), 27.

9 S. Howard Hansford, *The Seligman Collection of Oriental Art,* vol. 1 (London, 1957), 9.

10 Max Loehr, "Bronze Styles of the Anyang Period," *Archives of the Chinese Art Society of America* 7 (1953): 42–48.

11 K. C. Chang, *Art, Myth, and Ritual: The Path to Political Authority in Ancient China* (Cambridge, Mass., and London, 1983), 65.

12 Mizuno Seiichi, *Bronzes and Jades of Ancient China* (Tokyo, 1959), 9.

13 Passage translated by A. C. Soper from E. Biot, *Le Tcheou-li, ou Rites de Tcheou* (Paris, 1851), 555–56.

14 For a lucid discussion of the Fufeng hoard and other early Zhou hoards, and of the changes in belief and ritual in Western Zhou exemplified in the decoration of the bronzes, see Lothar von Falkenhausen, *Chinese Society in the Age of Confucius (1000–250 B.C.): The Archaeological Evidence* (Los Angeles, 2006), 30–41. As the sets of bronzes in these hoards are incomplete, it has been suggested that their owners had taken their most precious vessels with them on their flight to the east.

15 Arthur Waley, trans., *The Book of Songs* (London, 1937), 182–83.

16 A number of scholars have discussed the Mingtang, particularly the one built by Wang Meng (A.D. 9–23) on the Zhou dynasty model to proclaim the restoration of Confucianism. See, for example, Nancy S. Steinhardt, *Chinese Traditional Architecture* (New York, 1986), 70–77; and Wu Hung, *Monumentality in Early Chinese Art and Architecture* (Stanford, 1995).

17 Slightly adapted from Bernhard Karlgren, *A Catalogue of the Chinese Bronzes in the Alfred F. Pillsbury Collection* (Minneapolis, 1952), 105. The last sentence makes it clear that the vessels were made for ritual use and not for burial.

18 In the light of recent discoveries, it is no longer possible to use the *Zhouli* as a guide to the symbolic use of jade *before* the Zhou dynasty. Excavations of Neolithic sites have shown that the *bi* disk and *cong* tube were widely used down the eastern part of China, but not always in the same burial sites; graves in the Liangzhu site of Yaoshan, for example, yielded many *cong*, but no *bi* at all. The importance of the *Zhouli* is that the ritual and symbolic meanings it codified for certain jades were carefully followed in later dynasties.

19 For the growth in the number and variety of mortuary jades, see Jessica Rawson, *Chinese Jade from the Neolithic to the Qing* (London, 1995), section 24, 314–20.

CHAPTER 3: EASTERN ZHOU AND THE PERIOD OF THE WARRING STATES

1 For good illustrations of this tomb and of some of its contents, see *China Pictorial*, no. 1 (1986): 14–17.

2 Arthur Waley, in *An Introduction to the Study of Chinese Painting* (London, 1923), 21–23, first pointed out the importance of Chu culture in the emergence of both creative art and a consciousness of the power of the artistic imagination. David Hawkes discussed the contribution of Chu in his *Ch'u Tz'u: The Songs of the South* (Oxford, 1959). Their assessment has since been amply confirmed by excavations not only in Changsha, which was a relatively unimportant town, but also in Jiangling, the Chu capital, and in Xinyang. The discovery in 1980 near Chengdu in Sichuan of timber tombs similar to those at Changsha and Jiangling shows how far the influence of Chu had spread by the Western Han period.

3 See *Wenwu*, no. 7 (1979): 1–52; *China Reconstructs*, no. 5 (1979): 28–31.

4 Zhongshan was ruled by the Di tribe, nomads who settled briefly in Hebei before their defeat by the state of Yan in 296 B.C.

5 For a survey of Warring States bronze style, see Jenny F. So, "New Departures in Eastern Zhou Bronze Design: The Spring and Autumn Period" and "The Inlaid Bronzes of the Warring States Period," in Wen Fong, ed., *The Great Bronze Age of China: An Exhibition from the People's Republic of China* (New York, 1980), 249–320.

6 *Guanzi* 4.14, translated by L. S. Yang in "Economic Justification for Spending," *Harvard Journal of Asiatic Studies* 20 (June 1957): 43.

7 For a detailed study of the subject, with particular reference to the set in the Marquis of Zeng's tomb, see Lothar von Falkenhausen, *Suspended Music: Chimes and Bells in the Culture of Bronze Age China* (Berkeley, 1993).

8 For a good survey of the subject, see the exhibition catalogue by Emma Bunker, Bruce Chatwin, and Ann Farkas, "*Animal Style*" Art from East to West (New York, 1970).

9 Hawkes, *Ch'u Tz'u*, 108. The term *xibi*, indicating the Western origin of these buckles, may be derived from the Turkic-Mongol word *sarbe*.

10 The Jiangling discoveries, including the textiles, are well illustrated in *Jiangling Yutaishan Chu mu* (Chu tombs at Yutaishan, Jiangling) (Beijing, 1984).

11 A forerunner of glass, "Egyptian faience," has been found in Western Zhou graves of about 950 B.C. True glass, identified as Chinese by its high lead and barium content, is found in the form of "eye beads" in aristocratic burials of about 475 B.C. The earliest Chinese glass vessels yet found come from the tomb of Liu Sheng, c. 113 B.C. (see chap. 4). See Peter Hardie, "The Earliest Glass in China," *Transactions of the Oriental Ceramic Society* 52 (1987–88): 84.

CHAPTER 4: THE QIN AND HAN DYNASTIES

1 See Wu Hung, "A Sanpan Shan Chariot Ornament and the Xiangrui Design in Western Han," *Archives of Chinese Art* 37 (1984): 38–59.

2 Whether all these apparently Buddhist motifs were made by practicing Buddhists is doubtful. Many may have been bor-

rowed for use in local worship, along with Daoist and other folk religious motifs, by people who had no idea what Buddhism was. A few of them, such as the seated figure from Jiading in fig. 4.4, seem to be unambiguously Buddhist (although the precise date of this figure is uncertain). For a survey of the evidence, see Wu Hung, "Buddhist Elements in Early Chinese Art," *Artibus Asiae* 47 (1986): 263–352.

3 David Hawkes, trans., *Ch'u Tz'u: The Songs of the South* (Oxford, 1959), 105–7. Hawkes suggests that this poem may have been written in 208 or 207 B.C.

4 The full report on the excavation of Tomb No. 1 is *Changsha Mawangdui yihao Han mu*, 2 vols. (Beijing, 1973).

5 Ann Paludan, *The Chinese Spirit Road: The Classical Tradition of Stone Tomb Statuary* (New Haven, 1991), esp. chap. 2.

6 For a well-illustrated survey of the tomb pits and their contents, see China Travel and Tourism Press, ed., *The First Emperor's Terracotta Legion* (Beijing, 1988).

7 For Segalen's vivid account of his discoveries of Han sculpture (intended above all, as he wrote, for artists), see Eleanor Levieux, trans., *The Great Statuary of China* (Chicago, 1978).

8 For a thorough analysis of the meaning of the Wu Liang reliefs, see Wu Hung, *The Wu Liang Shrine: The Ideology of Early Chinese Pictorial Art* (Stanford, 1989). See also Cary Liu, ed., *Recarving China's Past: Art, Archaeology, and Architecture of the "Wu Family Shrines"* (Princeton, 2005).

9 Translation by Arthur Waley, *An Introduction to the Study of Chinese Painting* (London, 1923), 30–31.

10 *Hanshu*, chap. 25, trans. A. C. Soper, "Literary Evidence for Early Chinese Painting," unpublished paper cited in Laurence Sickman and A. C. Soper, *The Art and Architecture of China*, rev. ed. (London, 1971), 67.

11 Wu Hung notes that after death was certain, the relatives had a name banner—the term he uses is *ming jing*—painted to identify the deceased. It was hung first in front of the mourning hall, then beside the temporary grave, to represent the dead and receive the gifts and homage of the family, after which it was placed over the body in the coffin. See Wu Hung, "Rethinking Mawangdui," *Early China* 17 (1992): 1–24.

12 Bernard Karlgren, "Early Chinese Mirror Inscriptions," *Bulletin of the Museum of Far Eastern Antiquities* 6 (1934): 49. Some private manufacturers put the name of the Imperial Workshop on their mirrors to increase their value. See Wang Zhongshu, *Han Civilization*, trans. K. C. Chang et al. (New Haven, 1982), 107.

13 Schuyler Van R. Cammann, "The 'TLV' Pattern on Cosmic Mirrors of the Han Dynasty," *Journal of the American Oriental Society* 68, no. 4 (1948): 160–61.

14 Since the discovery of the suit illustrated in fig. 4.41, several more have been found, of which the finest is that of another member of the Han imperial family, Liu Wu, a feudal "king" of Chu who died in 165 B.C. and was buried, like Liu Sheng, in a tomb cut deep into a hillside near Xuzhou, in Jiangsu. His jade suit was made from four thousand extremely thin jade plaques sewn together with gold thread. The tomb also contained jade belts with gold buttons weighing 13½ ounces (383 g), objects of gold, silver, copper, jade, lacquer, and iron, and 176,000 coins. For a brief report, see *The Times* (London), Jan. 16, 1996.

15 As fresh discoveries vastly increase the number of known kilns—only a few of which are mentioned in this book—the problem of nomenclature becomes more and more acute. But until Chinese ceramic experts produce a new definitive classification, it would not be helpful to the reader to depart too far from accepted names for well-known wares. For a list of kilns, see Yukata Mino and Patricia Wilson, *An Index to Chinese Kiln Sites from the Six Dynasties to the Present* (Toronto, 1973). For a more up-to-date (though incomplete) list with illustrations of shards in color, see the *Catalogue of the Exhibition of Ceramic Finds from Ancient Kilns in China* (Hong Kong, 1981).

CHAPTER 5: THE THREE KINGDOMS AND THE SIX DYNASTIES

1 Beautifully translated by Ch'en Shih-hsiang in *Literature as Light Against Darkness*, rev. ed. (Portland, Me., 1952).

2 These renderings of the six principles are from Arthur Waley, *An Introduction to the Study of Chinese Painting* (London, 1923), 72; Alexander Soper, "The First Two Laws of Hsieh Ho," *Far Eastern Quarterly* 8 (Aug. 1949): 412–23; and Shio Sakanishi, *The Spirit of the Brush* (London, 1939), 51.

3 William B. Acker, *Some T'ang and Pre-T'ang Texts on Chinese Painting* (Leyden, 1964), xxx.

4 There are a number of delightful stories about Gu Kaizhi in his official biography and in that fascinating collection of gossip, *Shishuo xinyu*, available in English as *Shih-shuo Hsin-yü: A New Account of Tales of the World*, trans. Richard Mather (Minneapolis, 1976). See also Ch'en Shih-hsiang's *Biography of Ku K'ai-chih*, Chinese Dynastic Histories Translations, no. 2 (Berkeley, 1953), and Shane McCausland, *Gu Kaizhi and the Admonitions Scroll* (London, 2003).

5 For more on "transmitting the spirit" of the painted subject, see Mary H. Fong, "'Chuanshen' in Pre-Tang Human Figure Painting: As Evidenced in Archaeological Finds," *Oriental*

Art 39, no. 1 (Spring 1993): 4–19. Illustrations of the wall paintings in the tomb of Lou Rui are published in *China Pictorial,* no. 6 (1983): 21–23.

6 For background material on the subject, see A. Foucher, *La Vie du Bouddha* (Paris, 1949); Arthur Wright, *Buddhism in Chinese History* (Stanford, 1959); and, for translations of the key texts in a paperback edition, Dwight Goddard, ed., *A Buddhist Bible* (Boston, 1970).

7 Wu Hung, "What Is Bianxiang? On the Relationship Between Dunhuang Art and Dunhuang Literature," *Harvard Journal of Asiatic Studies* 52, no. 1 (June 1992): 137.

8 The motive was frankly admitted in an edict of one of the barbarian rulers of the Later Zhao (c. A.D. 335): "We were born out of the marches," he declared, "and though We are unworthy, We have complied with our appointed destiny and govern the Chinese as their prince . . . Buddha being a barbarian god is the very one we should worship." Arthur Wright, "Fo-t'u-t'eng, a Biography," *Harvard Journal of Asiatic Studies* 2 (1948): 356.

9 See Laurence Sickman and A. C. Soper, *The Art and Architecture of China,* rev. ed. (London, 1971), 89.

10 See Michael Sullivan and Dominique Darbois, *The Cave Temples of Maichishan* (London, 1969).

11 See Lukas Nickel, ed., *Return of the Buddha: The Qingzhou Discoveries* (London, 2002).

12 The caves were first documented in 1907 by Sir Aurel Stein, who took away a large collection of manuscripts and paintings from a sealed storeroom. In the following year the French Sinologist Paul Pelliot systematically photographed and numbered the caves. His numbers, totaling nearly 300, are familiar to older Western readers and appear in my text in parentheses preceded by the letter *P.* A second system of numbering was used by the noted Chinese painter Zhang Daqian (Chang Dai-chien; see chap. 11), who with his assistants copied some of the paintings in 1942–43. A third system was adopted by the Dunhuang Research Institute, which since 1943 has been preserving, recording, and publishing the paintings. This organization, long headed by the Paris-trained painter Chang Shuhong (1904–94), has now identified 402 caves and niches, and the Dunhuang Research Institute's numbering is generally accepted today.

13 This sculpture is fully discussed and illustrated in Ann Paludan, *The Chinese Spirit Road: The Classical Tradition of Stone Tomb Statuary* (New Haven, 1991), chap. 4, "The Period of Disunion."

14 For a useful summary of the different clay bodies of north and south China ceramics, see Shelagh Vainker, *Chinese Pottery and Porcelain: From Prehistory to the Present* (London, 1991), app. 1, 218–19.

CHAPTER 6: THE SUI AND TANG DYNASTIES

1 In addition to Nancy Steinhardt's *Chinese Traditional Architecture* (New York, 1986) and *Chinese Imperial City Planning* (Honolulu, 1990), a richly illustrated source is Liu Dunzhen, *Zhongguo gudai jianzhu shi* (A history of ancient Chinese architecture) (Beijing, 1980).

2 The northern group of caves at Longmen constitutes a monument to the politics of filial piety by the emperor Taizong and his empress. This complex was based on the Binyang caves, which were themselves sponsored as a filial act in the Northern Wei. The South Binyang Cave was finished to match the Central Binyang Cave by Li Tai in 641, the Jingshansi was sponsored by Lady Wei around 658, and the North Binyang Cave was finished and the Qianxisi commissioned to match it by the emperor Gaozong in the late 650s. See Amy McNair, "Early Tang Imperial Patronage at Longmen," *Ars Orientalis* 24 (1994): 65–81.

3 For more on Anyue, see Gu Meihua, ed., *China's Grand Buddhas* (Shanghai, 1994), 92–93.

4 The demands of Mahāyāna Buddhism for the endless multiplication of icons, diagrams, spells, and texts probably inspired the rapid development of block printing during the Tang dynasty. The earliest dated printed text yet discovered is a Buddhist charm on paper of A.D. 770, found at Dunhuang by Sir Aurel Stein and now in the British Museum. It is likely, however, that the Chinese and Tibetans had been experimenting with block printing since the middle of the sixth century. Moreover, the use of seals in Shang China and the practice of taking rubbings of inscriptions engraved on stone (made possible by the Han invention of paper) point to the existence of printing of a sort at a far earlier date.

5 For landscape vignettes in Dunhuang Cave 323, see Michael Sullivan, *Chinese Landscape Painting,* vol. 2, *The Sui and T'ang Dynasties* (Berkeley, 1980), figs. 11, 21, and 13.

6 See Kohara Hironobu, "Tung Ch'i-ch'ang's Connoisseurship in T'ang and Sung Painting," in Wai-kam Ho, ed., *The Century of Tung Ch'i-ch'ang, 1555–1636* (Kansas City, 1992), 1: 86–88.

7 Zhang Zao's contribution to the evolution of Tang landscape style and technique is discussed in my *Chinese Landscape Painting,* 2: 65–69.

8 The excavation is reported in detail, with good drawings, in *Wenwu,* no. 10 (1988), 1–86. For color illustrations of the most

important finds, see also *China Reconstructs* (Nov. 1987), 50–55, and *China Pictorial*, no. 10 (1987), 9–15.

9　Anonymous, *Ahbār as-Sīwa i-Hind* (The story of China and India), trans. and ed. by Jean Sauvaget (n.p., 1948), vol. 16, section 34.

10　By 1987 archaeologists had located Sui and Tang kilns that had produced white ware in at least twelve districts (*xian*) in Hebei, Henan, Shaanxi, Shanxi, Anhui, and Jiangxi. See Christine Ann Richards, "Early Northern White Wares," *Transactions of the Oriental Ceramic Society* 49 (1984/85): 58–77.

11　Rosemary Scott, "A Remarkable Tang Dynasty Cargo," *Transactions of the Oriental Ceramic Society* 67 (2002–3): 13–26; and Zhang Pusheng, "New Discoveries from Recent Research into Chinese Blue and White Porcelain," *Transactions of the Oriental Ceramic Society* 56 (1991–92): 38. The huge quantities of blue and white of the early Ming period unearthed at Yangzhou all came from Jingdezhen.

12　See T. S. Y. Lam, *Tang Ceramics: Changsha Kilns* (Hong Kong, 1990).

13　Yao Tsung-i, "A Short Account of Chinese Tomb Pottery Figures," in *Chinese Tomb Pottery Figurines* (Hong Kong, 1953), 9.

14　See *Wenwu*, no. 7 (1972), 33–41. I am grateful to Qiqi Jiang for drawing my attention to this reference.

15　From *The Compendium of Deities of the Three Religions (San jiao soushen dazhuan)*, quoted in Lu Xun, *A Brief History of Chinese Fiction*, trans. Yang Xianyi and Gladys Yang (Beijing, 1959), 21–22.

CHAPTER 7: THE FIVE DYNASTIES AND THE SONG DYNASTY

1　The purpose of this manual—to lay down rigid regulations for all dimensions in public and official buildings—is well brought out in Else Glahn, "Chinese Building Standards in the 12th Century," *Scientific American* 244 (May 1981): 132–41.

2　Laurence Sickman and A. C. Soper, *The Art and Architecture of China*, rev. ed. (London, 1971), 192.

3　See Huang Xiufu, *Yizhou minghua lu* (Record of famous painters of Yizhou [Sichuan]), esp. the introduction to his classification of painters, in which he defines the "untrammeled" class.

4　*Huajian* (The mirror of painting), Zhongguo hualun congshu ed. (Beijing, 1959), 22.

5　For a reconstruction of the paintings in this hall based on the research of Ogawa Hiromitsu, see Scarlett Jang, "Realm of the Immortals: Paintings Decorating the Jade Hall of Northern Song," *Ars Orientalis* 22 (1992): 81–97.

6　Jing Hao's essay is translated in Susan Bush and Hsiao-yen Shih, eds., *Early Chinese Texts on Painting* (Cambridge, Mass., 1985), 145–48.

7　This passage is slightly adapted from Tsung Pai-hua, "Space-Consciousness in Chinese Painting," trans. Ernst J. Schwartz, *Sino-Austrian Cultural Association Journal* 1 (1949): 27. Chinese theorists distinguish three kinds of perspective in Chinese painting: *gao yuan* ("high distance") depicts the mountains as they would be seen by someone who was looking upward from below; *shen yuan* ("deep distance") presents a bird's-eye view over successive ranges to a high and distant horizon; *ping yuan* ("level distance") involves a continuous recession to a rather low horizon, such as we often find in European landscape painting.

8　Guo Xi, *Lin quan gao shi* (The lofty message of forest and stream), edited by Guo Si in 1117. Translated in Bush and Shih, *Early Chinese Texts on Painting*, 153.

9　Xu Bangda has suggested that this scroll was the work of an academician at the court of Huizong. See Thomas Lawton's review of Xu's book *Gu shuhua wei e kaobian* (Examination and identification of ancient calligraphy and painting) (Suzhou, 1984), in *Ars Orientalis* 17 (1987): 186.

10　For Roderick Whitfield's pioneering studies of the scroll, see his "Chang Tse-tuan's Ch'ing-ming shang-ho t'u," in *Proceedings of the International Symposium on Chinese Painting, June 18–24, 1970, Taipei* (Taipei, 1972), 351–90. More recent studies casting doubt on the authorship of the scroll and on the interpretation of the title, by Yvon d'Argencé and Hsiao Ch'iung-jui, are summarized in Valerie Hansen, "The Mystery of the Qingming Scroll and Its Subject: The Case against Kaifeng," *Journal of Sung-Yüan Studies* 26 (1996): 183–200.

11　A valuable work on these scholars' attitude to painting is Susan Bush, *The Chinese Literati on Painting: Su Shih (1037–1101) to Tung Ch'i-ch'ang (1555–1636)*, Harvard-Yenching Institute Studies no. 27 (Cambridge, Mass., 1971).

12　Quoted in Yoshikawa Kojiro, translated by Burton Watson, *Introduction to Sung Poetry* (Cambridge, Eng., 1967), 37.

13　On the complicated history of the Song painting academy, see Wai-kam Ho, "Aspects of Chinese Painting from 1100 to 1350," in Wai-kam Ho, Sherman E. Lee, Laurence Sickman, and Marc E Wilson, eds., *Eight Dynasties of Chinese Painting* (Cleveland, 1980), xxv–xxx.

14　See Hui-shu Lee, "The Emperor's Ghost-Writers in Song Dynasty China," *Artibus Asiae* 64 (2004): 61–101.

15 This passage has been slightly adapted from Naito Tōichirō, *The Wall-Paintings of Hōryūji*, trans. William Acker and Benjamin Rowland (Baltimore, 1941), 205–6. Although the temple in question was burned down at the end of the Liang dynasty and the connection with Zhang Sengyou is legendary, there is little doubt that this technique was practiced in sixth-century wall painting.

16 Quoted in Osvald Sirén, *Chinese Painting: Leading Masters and Principles* (London, 1956), 1: 175.

17 Okakura Kakuzō, *The Awakening of Japan* (n.p., 1905), 77.

18 See Wu Tung and Denise Leidy, "Recent Archaeological Contributions to the Study of Chinese Ceramics," in *In Imperial Taste: Chinese Ceramics from the Percival David Foundation* (Los Angeles and San Francisco, 1989), 93.

19 Recent excavations at Yaozhou show that already in the Tang dynasty the kilns were producing, in addition to celadons, three-color tomb figurines and Cizhou-type wares painted in brown and black. For a convenient summary of the findings, see Brian McElney, "Recent Discoveries from the Yaozhou Kiln Site," *Oriental Art* 41, 1 (Spring 1995): 20–24.

20 In an important discovery of the 1980s, archaeologists found in Longquanwu, in the northern suburbs of Beijing, the remains of twelve kilns that had produced a wide range of Liao-type wares from the late tenth to the thirteenth century. See Shelagh Vainker, *Chinese Pottery and Porcelain: From Prehistory to the Present* (London, 1991), 86–87.

21 Legend has it that there were two kilns at Longquan, one supervised by the elder brother (*ge*), the other by the younger (*di*), but they have not been found. Ceramic technologists have recently suggested that the *ge* wares were simply a variety of southern *guan* and that the distinctive color and pronounced crackle were due to the position in which these pieces were stacked in the kiln. See Rosemary Scott, "Guan or Ge Ware? A Re-examination of Some Pieces in the Percival David Foundation," *Oriental Art* 39, no. 2 (Summer 1993): 22.

22 It used to be thought that all the exported *qingbai* came from Jingdezhen or from kilns in Fujian. But with the discovery of the Jiangxi kilns, the whole question of the source of these wares will have to be reconsidered. See Rosemary Scott and Rose Kerr, "Copper Red and Kingfisher Green Porcelains: Song Dynasty Technological Innovations in Guangxi Province," *Oriental Art* 39, 2 (Summer 1993): 25–33.

CHAPTER 8: THE YUAN DYNASTY

1 See Patrick Fitzgerald, *China: A Cultural History* (London, 1935).

2 See Sir Henry Yule, trans., *The Travels of Marco Polo* (London, 1905). Every year doubts grow about whether Marco Polo was ever in China at all. It has been suggested that he wrote himself into an account based on the travels of his father and uncle, who only got as far as Karakorum. See Susan Whitfield, "Exploring Marco Polo," *Britain-China*, no. 3 (1994) and no. 1 (1995); and Dr. Frances Wood, *Did Marco Polo Go to China?* (London, 1995).

3 Overviews by American scholars of the character and extent of the Yuan "revolution" and the subsequent history of Chinese painting can be found in articles by James Cahill, Robert Harris, and Jerome Silbergeld in *Archives of Chinese Art* 55 (2005): 17–39.

4 For a good introduction to the subject of Chinese women painters, see Marsha Weidener et al., *Views from Jade Terrace: Chinese Women Artists, 1300–1912* (Bloomington, Ind., 1988).

5 What and why the Chinese write on paintings is discussed in my short book *The Three Perfections: Chinese Painting, Poetry and Calligraphy*, rev. ed. (New York, 1999).

6 For a discussion of this painting, see James Cahill, *Hills Beyond a River: Chinese Painting of the Yüan Dynasty, 1279–1368* (New York, 1976), 175–76.

7 Between 1976 and 1982 Korean archaeologists recovered 9,639 pieces of late Song and Yuan celadon from a ship wrecked off the island of Sinan. The finds included a number of "baroque" baluster vases, together with an inscription of 1225 relating to the Tōfukuji Temple in Kyōto, their probable destination. See Tokyo National Museum, *The Sunken Treasures off the Sinan Coast* (Tokyo, 1983).

CHAPTER 9: THE MING DYNASTY

1 Yongle, following the example of his father, Hongwu (Zhu Yuanzhang, r. 1368–98), is not, properly speaking, the name of the emperor, but an auspicious title that he gave to his reign period as a whole, thus doing away with the old system of choosing a new era name every few years. The custom continued through the Qing dynasty. Kangxi, for example, is the title of the reign period of the emperor Shengzu, Qianlong that of Gaozong. But because these reign titles have become so well known in the West, I shall continue to use them in this book.

2 Not all the owners of these gardens were scholar-gentlemen. Many gardens were created for wealthy merchants and landlords who needed guidance in matters of design and good taste. It was chiefly for them that Ji Cheng published in 1631 his *Yuanye*, now accessible to the Western reader in a well-

illustrated translation by Alison Hardie, *The Craft of Gardens* (New Haven, 1988). For a broader survey of the subject, see Maggie Keswick's *The Chinese Garden: History, Art and Architecture* (London, 1978).

3 The art world of the Jiangnan region from the Yuan dynasty onward was the subject of a workshop held in Kansas City in 1980. The collected papers were later published in Chutsing Li, ed., *Artists and Patrons: Some Social and Economic Aspects of Chinese Painting* (Lawrence, Kans., 1989).

4 The quotations in this paragraph are cited by Craig Clunas in his illuminating study *Superfluous Things: Material Culture and Social Status in Early Modern China* (Cambridge, Eng., 1991), 68, 154.

5 A good introduction to early color printing is Jan Tschichold's *Chinese Colour Prints from the Ten Bamboo Studio* (London, 1970), which includes an account of the Chinese technique of color printing with multiple blocks.

6 There are several versions of the incident that caused Dai Jin's dismissal, which may have been prompted by the court painters' jealousy of this new arrival in the palace studios. The eunuch who had recommended him was executed. See the chapter on Dai Jin in James Cahill, *Parting at the Shore: Chinese Painting of the Early and Middle Ming Period, 1368–1580* (New York, 1987), esp. p. 46.

7 Adapted from Richard Edwards, *The Field of Stones: A Study of the Art of Shen Zhou* (Washington, D.C., 1962), 40.

8 In an important study of Dong Qichang, Wai-kam Ho quotes this devastating comment by Dong's friend Li Zhihua on the paintings of the late-Ming literati. See Wai-kam Ho and Judith G. Smith, eds., *The Century of Tung Ch'i-ch'ang, 1555–1636* (Kansas City, Mo., and Seattle, 1992), 1: 21. Dong Qichang thought that Shen Zhou and, to a lesser degree, Wen Zhengming were the last legitimate links in his orthodox Southern lineage.

9 This self-portrait is reproduced as plate 115 (with a detail in color as color plate 15) in James Cahill, *The Distant Mountains: Chinese Painting of the Late Ming Dynasty* (New York and Tokyo, 1982).

10 For a study of Zeng Jing, in which this passage from Jiang Shaoshu's *Wusheng shishi* (History of silent poetry [i.e., painting]) is quoted, see Cahill, *Parting at the Shore*, 213–17.

11 See Margaret Medley, "Imperial Patronage and Early Ming Porcelain," *Transactions of the Oriental Ceramic Society* 55 (1990–91): 29–42.

12 See Sir Percival David, trans. and ed., *Chinese Connoisseurship, "The Ko Ku Yao Lun": The Essential Criteria of Antiquities* (London, 1971), 143–44.

CHAPTER 10: THE QING DYNASTY

1 The catalogue of the Qianlong collection, *Shiqu baoji*, was completed in three volumes between 1745 and 1817. Buddhist and Daoist works were catalogued separately. A survey made by the Palace Museum in 1928–31 showed the vast scale of the collection: 9,000 paintings, rubbings, and specimens of calligraphy; 10,000 pieces of porcelain; over 1,200 bronze objects; and a large quantity of textiles, jades, and minor arts. By then some of the finest pieces had been sold or given away by the last Manchu emperor, Puyi, during the twenty years following the Revolution of 1911. All but a fraction of the rest were shipped to Taiwan by the Guomindang government in 1948.

2 See Wu Hung, " 'Emperor's Masquerade': Costume Portraits of Yongzheng and Qianlong," *Orientations* 26, no. 7 (July–Aug. 1995): 25–41. This issue contains several important articles by members of the Palace Museum staff on the court paintings in the collection, many of which had never been published.

3 For a discussion of the European impact on Chinese art, see my *Meeting of Eastern and Western Art,* rev. ed. (Berkeley, 1989); Cecile Beurdeley and Michel Beurdeley, *Giuseppe Castiglione: A Jesuit Painter at the Court of the Chinese Emperors,* trans. Michael Bullock (London, 1972); and Yang Boda, "Castiglione at the Qing Court: An Important Artistic Contribution," *Orientations* 19, no. 10 (Nov. 1988): 44–51.

4 Europe at this time felt much the same way about Chinese art. "In Painting," wrote Alvarez de Semedo in 1641, "they have more curiositie than perfection. They know not how to make use of either *Oyles* or *Shadowing* in the Art. . . . But at present there are some of them, who have been taught by us, that use *Oyles,* and are come to make perfect pictures." Joachim von Sandrart, in his *Teutsche Akademie* (1675), expressed a similar view. See my article "Sandrart on Chinese Painting," *Oriental Art* 1, no. 4 (Spring 1949): 159–61. The quotation from Zou Yigui is from the section on Western art in his miscellany, *Xiaoshan huapu.*

5 See, for example, the essays in James Cahill, *The Restless Landscape: Chinese Painting in the Late Ming Period* (Berkeley, 1971). Hongren and Gong Xian have both been the subject of studies; see Jason C. Kuo, *The Austere Landscape: The Paintings of Hung-ren* (Taipei, 1990); and Jerome Silbergeld, "Political Symbolism in the Landscape Painting and Poetry of Kung Hsien (c. 1620–1689)," Ph.D. diss., Stanford University, 1974.

6 The Anhui School was the subject of a seminal exhibition in Berkeley; see James Cahill, ed., *Shadows of Mt. Huang: Chinese Painting and Printing of the Anhui School* (Berkeley, 1981).

7 For a translation of and commentary on this difficult text, see Pierre Ryckmans, *Les "Propos sur la peinture" de Shitao* (Brussels, 1970). Among many studies of Shitao, especially important is the section devoted to him in Marilyn Fu and Shen Fu, *Studies in Connoisseurship: Chinese Paintings from the Arthur M. Sackler Collection in New York and Princeton* (Princeton, 1973), part 4.

8 Zhang Geng, *Guochao huachenglu*, quoted by Wen Fong in *Images of the Mind: Selections from the Edward L. Elliott and John B. Elliott Collection of Chinese Calligraphy and Painting at the Art Museum, Princeton University* (Princeton, 1984).

9 See James Cahill, "Paintings Done for Women in Ming-Qing China?" In *Nan Nü* (Leiden, 2006), 8: 1–54.

10 The letters were originally published in the Jesuit miscellany *Lettres édifiantes et curieuses*, vols. 12 and 16 (1717 and 1724), reprinted in S. W. Bushell, *Description of Chinese Pottery and Porcelain: Being a Translation of the T'ao Shuo*, and translated in part by him in his *Oriental Ceramic Art* (New York, 1899). Soame Jenyns quotes some interesting passages in his *Later Chinese Porcelain*, 4th ed. (London, 1971), 6–14.

11 The various theories about the origin and meaning of *guyue-xuan* are discussed in Jenyns, *Later Chinese Porcelain*, 87–95.

12 See C. J. A. Jory, *The Geldermalsen: History and Porcelain* (Groningen, 1986).

13 K. S. Lo's valuable study, *The Stonewares of Yixing: From the Ming Period to the Present Day* (Hong Kong, 1986), gives a long list of known Yixing potters and notes that their names were used, long after their death, by their descendants and successors.

CHAPTER II: THE TWENTIETH CENTURY AND BEYOND

1 So far no comprehensive history of Chinese architecture has appeared in the West to match Liu Dunzhen's richly illustrated *Zhongguo gudai jianzhu shi* (A history of traditional Chinese architecture) (Beijing, 1980). Different aspects of the subject are covered in the works listed under architecture in Books for Reference and Further Reading.

2 For many years Western scholars held to the view that Chinese art went into a decline at the end of the eighteenth century from which it never recovered, so little was written about more recent trends. My *Chinese Art in the Twentieth Century* (1959), long out of date and out of print, was superseded by *Art and Artists of Twentieth-Century China* (Berkeley, 1996). In the meantime, an increasing number of Western schol-

ars and students are turning their attention to modern Chinese art. For reasons of space, only a few of the works published in recent years can be included in Books for Reference and Further Reading.

3 See Gordon Barrass, *The Art of Calligraphy in Modern China* (Berkeley, 2002), 22–23.

4 A comprehensive range of *guohua* over 150 years is presented in Robert H. Ellsworth, Keita Itoh, Lawrence Wu, Jean Schmitt, Caron Smith, and James C. Y. Watt, *Later Chinese Painting and Calligraphy, 1800–1950*, 3 vols. (New York, 1986). On the Shanghai School, see James Han-hsi Soong, "A Visual Experience in Nineteenth-Century China: Jen Po-nien (1840–1895) and the Shanghai School of Painting," Ph.D. diss., Stanford University, 1977; and Stella Yu Lee, "Art Patronage of Shanghai in the Nineteenth Century," in Chu-tsing Li, ed., *Artist and Patrons: Some Social and Economic Aspects of Chinese Painting* (Lawrence, Kans., 1989).

5 A good introduction to this artist is Gerald C. C. Tsang, Christina Chu, and Wang Bomin, *Homage to Tradition: Huang Binhong* (Hong Kong, 1995).

6 For an overview of the Cantonese School, see Ralph Croizier, *Art and Revolution in Modern China: The Lingnan (Cantonese) School of Painting, 1906–1951* (Berkeley, 1988). Croizier's estimate of how far the Lingnan painters attained their ideal is aptly expressed in his quotation from Robert Browning: "Ah, but a man's reach should exceed his grasp. / Or what's a heaven for?"

7 The achievement of this controversial figure in modern Chinese art was celebrated in a major exhibition at the Sackler Gallery in Washington in 1991. See Shen C. Y. Fu and Jan Stuart, *Challenging the Past: The Paintings of Chang Dai-chien* (Washington, D.C., and Seattle, 1991).

8 To understand the full impact of Communist ideology and organization on art and artists during the Mao years, see Julia F. Andrews, *Painters and Politics in the People's Republic of China, 1949–1979* (Berkeley, 1994). See also Ellen Johnston Laing, *The Winking Owl: Art in the People's Republic of China* (Berkeley, 1988).

9 The story of how one *guohua* artist fought an intermittently triumphant battle against the political establishment is told in Jerome Silbergeld and Gong Jisui, *Contradictions: Artistic Life, the Socialist State, and the Chinese Painter Li Huasheng* (Seattle, 1993).

10 Li Keran has been the subject of a study by Wan Qingli, *Li Keran pingzhuan* (Taipei, 1995). Major parts of it appeared in English translation in the Taipei journal *Han mo*, nos. 26 (1992, 3.1) and 43 (1993, 8.1).

11 In addition to the relevant chapters in my *Art and Artists of Twentieth-Century China,* the modern movement in Taiwan and Hong Kong is covered in the essays by Martha Su Fu and Wucius Wong in Mayching Kao, ed., *Twentieth-Century Chinese Painting* (Hong Kong and Oxford, 1988).

12 The complete tableau is reproduced in *Rent Collection Courtyard: A Revolution in Sculpture.* Supplement to *China Reconstructs* (1967).

13 In chapter 5 of *Painters and Politics,* Andrews fully documents the effects on art of the Great Leap Forward of 1957–59 and the Cultural Revolution.

14 For the art and poetry of Tiananmen 1976, see Geremie Barmé and John Minford, eds., *Seeds of Fire: Chinese Voices of Conscience* (Hong Kong, 1986).

15 The Stars' achievement is commemorated in Chang Tsong-zung (Johnson Chang), ed., *Xingxing shi nian* (The Stars' ten years), with text in English and Chinese (Hong Kong, 1988).

16 Younger artists who came to prominence in the early 1980s are cited in Joan Lebold Cohen, *The New Chinese Painting, 1949–1986* (New York, 1987). On the New Wave movement, see Gao Minglu's essay in Chang Tsong-zung, ed., *China's New Art, Post-1989, with a Retrospective from 1979–1989,* with contributions by Lang Shaojun, Nicholas Jose, Geremie Barmé, et al. (Hong Kong, 1993).

17 This somewhat sensational exhibition is fully illustrated and documented in Chang Tsong-zung, *China's New Art.*

18 Artistic developments in the mid 1990s are covered in the catalogue *The First Academic Exhibition of Chinese Contemporary Art, 1996–7,* presented by China Oil Painting Gallery and *Art Gallery Magazine* (Beijing, 1996). That this ambitious exhibition was canceled by the authorities the day before it was due to open (Dec. 31, 1996) showed that in spite of the apparent relaxation, political control could still stifle artistic expression.

BOOKS FOR REFERENCE AND FURTHER READING

GENERAL REFERENCES

CHINA

Dawson, Raymond, ed. *The Legacy of China*. Oxford, 1964.

Ebrey, Patricia. *China: Cambridge Illustrated History*. Cambridge, 1996.

Fitzgerald, C. P. *China: A Short Cultural History*. 3rd rev. ed. London, 1961.

Hucker, Charles O. *China's Imperial Past: An Introduction to China's History and Culture*. Stanford, 1975.

Needham, Joseph. *Science and Civilisation in China*. 15 vols. Cambridge, Eng., 1954–.

Spence, Jonathan. *The Gate of Heavenly Peace: The Chinese and Their Revolution, 1895–1980*. New York, 1981.

CHINESE ART

Hansford, S. Howard. *A Glossary of Chinese Art and Archaeology*. Rev. ed. London, 1961.

Lee, Sherman E. *A History of Far Eastern Art*. Rev. ed. New York, 1973.

Rawson, Jessica, ed. *The British Museum Book of Chinese Art*. London, 1992.

Sickman, Laurence, and A. C. Soper. *The Art and Architecture of China*. Rev. ed. London, 1971.

Sullivan, Michael. *Art and Artists of Twentieth-Century China*. Berkeley, 1996.

———. *A Biographical Dictionary of Modern Chinese Artists*. Berkeley, 2006.

———. *Chinese and Japanese Art*. London, 1966.

———. *The Meeting of Eastern and Western Art*. Rev. ed. Berkeley, 1989.

Thorpe, Robert L., and Richard E. Vinograd. *Chinese Art and Culture*. New York, 2001.

Wu Hung. *Monumentality in Early Chinese Art and Architecture*. Stanford, 1995.

EXHIBITIONS AND GENERAL COLLECTIONS

Cahill, James, ed. *Shadows of Mt. Huang: Chinese Painting and Printing of the Anhui School*. Berkeley, 1981.

Fontein, Jan, and Tung Wu. *Unearthing China's Past*. Boston, 1973.

Hearn, Maxwell K. *Splendors of Imperial China: Treasures from the National Palace Museum, Taipei*. New York, 1996.

Hobson, R. L., and W. P. Yetts. *The George Eumorfopoulos Collection*. 9 vols. London, 1925–32.

Lee, Sherman E., and Wai-kam Ho. *Chinese Art under the Mongols: The Yuan Dynasty (1279–1368)*. Cleveland, 1969.

Nelson Gallery, Atkins Museum of Fine Arts, Kansas City, and Asian Art Museum of San Francisco. *The Chinese Exhibition: A Pictorial Record of the Exhibition of Archaeological Finds from the People's Republic of China*. Kansas City, Mo., 1975.

Pope, John A., Aschwin Lippe, James Cahill, and Chuang Shang-yen, eds. *Chinese Art Treasures*. Washington, D.C., 1961.

Rawski, Evelyn, and Jessica Rawson. *China: The Three Emperors, 1662–1795*. London, 2005.

Royal Academy of Arts. *The Chinese Exhibition: A Commemorative Catalogue of the International Exhibition of Chinese Art in 1935–1936*. London, 1936.

Watt, James C. Y., et al. *China: Dawn of a Golden Age, 200–750 A.D.* Metropolitan Museum of Art Series. New York, 2004.

Whitfield, Roderick. *The Art of Central Asia: The Stein Collection in the British Museum*. 3 vols. Tokyo, 1982–85.

PERIODICALS

Archives of Asian Art (formerly, *Archives of the Chinese Art Society of America*). New York, 1945–.

Ars Orientalis. Washington, D.C., and Ann Arbor, 1954–.

Artibus Asiae. Dresden, 1925–40; Ascona, Switzerland, 1974–.

Arts of Asia. Hong Kong, 1971–.

Bulletin of the Museum of Far Eastern Antiquities. Stockholm, 1929–.

Early China. Berkeley, 1975–.

Oriental Art. Oxford, 1948–51; new series, 1955–.

Orientations. Hong Kong, 1970–.

Transactions of the Oriental Ceramic Society. London, 1921–.

ARCHAEOLOGY

Andersson, J. G. *Children of the Yellow Earth*. London, 1934.

Chang, Kwang-chih. *The Archaeology of Ancient China*. 4th ed. New Haven, 1986.

———. *Studies in Shang Archaeology*. New Haven, 1986.

Ho, P'ing-ti. *The Cradle of the East*. Chicago, 1976.

Li Chi. *Anyang*. Seattle, 1977.

———. *The Beginnings of Chinese Civilization*. Seattle, 1957.

Rawson, Jessica. *Ancient China: Art and Archaeology*. London, 1980.

Yang, Xiaoneng, ed. *The Golden Age of Chinese Archaeology: Celebrated Discoveries from the People's Republic of China*. Washington, D.C., and New Haven, 1999.

ARCHITECTURE

Boyd, Andrew. *Chinese Architecture and Town Planning*. London, 1962.

Liang Ssu-ch'eng. *A Pictorial History of Chinese Architecture*. Ed. Wilma Fairbank. Cambridge, Mass., 1984.

Paludan, Ann. *The Imperial Ming Tombs*. New Haven, 1981.

Pirazzoli-T'Stevens, Michèle. *Living Architecture: Chinese*. London, 1972.

Sirén, Osvald. *The Imperial Palaces of Peking*. 3 vols. Paris and Brussels, 1926.

Steinhardt, Nancy S. *Chinese Imperial City Planning*. Honolulu, 1990.

———. *Chinese Traditional Architecture*. New York, 1986.

Wu Hung. *Monumentality in Early Chinese Art and Architecture*. Stanford, 1995.

Yu Zhouyun. *Palaces of the Forbidden City*. Trans. Ng Mau-Sang, Chan Sinwai, and Puwen Lee. Consultant ed. Graham Hutt. London, 1982.

BRONZES

Bagley, Robert W. *Shang Ritual Bronzes from the Arthur M. Sackler Collection*. Vol. 1. Washington, D.C., and Cambridge, Mass., 1987.

Barnard, Noel. *Bronze Casting and Bronze Alloys in Ancient China*. Canberra and Nagoya, 1961.

Fong, Wen, ed. *The Great Bronze Age of China: An Exhibition from the People's Republic of China*. New York, 1980.

Karlgren, Bernhard. *A Catalogue of the Chinese Bronzes in the Alfred F. Pillsbury Collection*. Minneapolis, 1952. Karlgren also published many important articles in the *Bulletin of the Museum of Far Eastern Antiquities* (Stockholm).

Kerr, Rose. *Later Chinese Bronzes*. London, 1990.

Loehr, Max. *Chinese Bronze Age Weapons*. Ann Arbor, 1956.

———. *Ritual Vessels of Bronze Age China*. New York, 1968.

Ma Chengyuan. *Ancient Chinese Bronzes*. Hong Kong and Oxford, 1986.

Pope, J. A., Rutherford Gettens, James Cahill, and Noel Barnard. *The Freer Chinese Bronzes*. 2 vols. Washington, D.C., 1967, 1969.

Rawson, Jessica. *Western Zhou Bronzes from the Arthur M. Sackler Collection*. 2 vols. Washington, D.C., and Cambridge, Mass., 1990.

Watson, William. *Ancient Chinese Bronzes*. 2nd ed. London, 1977.

Yang Hong. *Weapons in Ancient China*. New York and Beijing, 1992.

CALLIGRAPHY

Barrass, Gordon S. *The Art of Calligraphy in Modern China*. Berkeley, 2002.

Chiang Yee. *Chinese Calligraphy*. London, 1954.

Driscoll, Lucy, and Kenji Toda. *Chinese Calligraphy*. 2nd ed. New York, 1964.

Ecke, Tseng Yu-ho. *Chinese Calligraphy*. Philadelphia, 1971.

Fu, Shen, Marilyn Fu, Mary G. Neill, and Mary Jane Clark. *Traces of the Brush: Studies in Chinese Calligraphy*. New Haven, 1977.

Ledderose, Lothar. *Mi Fu and the Classical Tradition of Chinese Calligraphy*. Princeton, 1979.

Tsien Tsuen-hsuin. *Written on Bamboo and Silk: The Beginnings of Chinese Books and Inscriptions*. Chicago, 1962.

CERAMICS

Ayers, John. *The Baur Collection*. 4 vols. London, 1968–74.

Carswell, J. E. A. Maser, Mudge Maser, and J. McClure. *Blue and White: Chinese Porcelain and Its Impact on the Western World*. Chicago, 1985.

Donnelly, P. S. *Blanc de Chine: The Porcelain of Tehua in Fukien*. London, 1969.

Garner, Sir Harry. *Oriental Blue and White*. 3rd ed. London, 1970.

Hobson, R. L. *A Catalogue of Chinese Pottery and Porcelain in the Collection of Sir Percival David Bt*. London, 1934.

Hughes-Stanton, P., and R. Kerr. *Kiln Sites of Ancient China*. London, 1982.

Jenyns, Soame. *Later Chinese Porcelain*. 4th ed. London, 1971.

———. *Ming Pottery and Porcelain*. London, 1953.

Kerr, Rose. *Chinese Ceramics: Porcelain of the Qing Dynasty, 1644–1911*. London, 1986.

Krahl, Regina. *Chinese Ceramics in the Topkapi Saray Museum, Istanbul*. 3 vols. London, 1986.

Li He. *Chinese Ceramics: The New Standard Guide*. London, 1996.

Lo, K. S. *The Stonewares of Yixing: From the Ming Period to the Present Day*. Hong Kong, 1986.

Medley, Margaret. *The Chinese Potter: A Practical History of Chinese Ceramics*. Oxford, 1976.

———. *T'ang Pottery and Porcelain*. London, 1981.

———. *Yuan Porcelain and Stoneware*. London, 1974.

Tregear, Mary. *Song Ceramics*. Fribourg and London, 1974.

Vainker, Shelagh. *Chinese Pottery and Porcelain: From Prehistory to the Present*. London, 1991.

Valenstein, Suzanne G. *A Handbook of Chinese Ceramics*. 2nd ed. New York, 1989.

Watson, William. *Pre-T'ang Ceramics of China: Chinese Pottery from 4000 B.C. to A.D. 600*. London, 1991.

———. *T'ang and Liao Ceramics*. London, 1984.

Yukata, Mino. *Freedom of Clay and Brush through Seven Centuries in Northern China: Tz'u-chou Type Wares, A.D. 960–1600*. Indianapolis and Bloomington, 1980.

CRAFTS

Beurdeley, Michel. *Chinese Furniture*. Tokyo, 1979.

Cammann, Schuyler. *China's Dragon Robes*. New York, 1952.

Clunas, Craig. *Chinese Furniture*. London, 1988.

———. *Superfluous Things: Material Culture and Social Status in Early Modern China*. Cambridge, Eng., 1991.

David, Sir Percival, trans. and ed. *Chinese Connoisseurship, "The Ko Ku Yao Lun": The Essential Criteria of Antiquities*. London, 1971.

Feddersen, Martin. *Chinese Decorative Art*. London, 1961.

Garner, Sir Harry. *Chinese and Japanese Cloisonné Enamels*. London, 1962.

———. *Chinese Lacquer*. London, 1979.

Gyllensvärd, Bo. *Chinese Gold and Silver in the Charles Kempe Collection*. Stockholm, 1953.

Hall, R. *Chinese Snuff Bottles*. 4 vols. Hong Kong, 1987–91.

Kao, Mayching, ed. *Chinese Ivories from the Kwan Collection*. Hong Kong, 1990.

Lam, Peter Y. K., ed. *2000 Years of Chinese Lacquer*. Hong Kong, 1993.

Ledderose, Lothar. *Ten Thousand Things: Module and Mass Production in Chinese Art*. Princeton, 2000.

Lee Yu-kuan. *Oriental Lacquer Art*. New York, 1990.

Simmons, Pauline. *Chinese Patterned Silks*. New York, 1948.

Wang Shixiang. *Chinese Classic Furniture*. Hong Kong and London, 1986.

GARDENS

Ji Cheng. *The Craft of Gardens*. Trans. Alison Hardie. New Haven, 1988.

Keswick, Maggie. *The Chinese Garden: History, Art and Architecture*. Rev. by Alison Hardie. Cambridge, Mass., 2003.

Liu Dunzhen. *Suzhou gudian yuanlin* (The ancient gardens of Suzhou). Nanjing, 1978. Text in Chinese, but richly illustrated with photographs, plans, and drawings.

Sirén, Osvald, with Bo Gyllensvärd. *Gardens of China*. New York, 1949.

JADE

Born, Gerald M. *Chinese Jade: An Annotated Bibliography*. Chicago, 1992.

Forsyth, Angus, and Brian McElney. *Jade from China*. Bath, 1994.

Hansford, S. Howard. *Chinese Jade Carving*. London and Bradford, 1950.

Laufer, Berthold. *Jade: A Study in Chinese Archaeology and Religion*. New York, 1912.

Loehr, Max. *Ancient Chinese Jades from the Grenville L. Winthrop Collection*. Cambridge, Mass., 1975.

Rawson, Jessica, with Carol Michaelson. *Chinese Jade from the Neolithic to the Qing*. London, 1995.

Watt, J. C. Y. *Chinese Jades from the Han to the Ch'ing*. New York, 1980.

PAINTING

Andrews, Julia C. *Painters and Politics in the People's Republic of China, 1949–1979*. Berkeley, 1994.

Bush, Susan. *The Chinese Literati on Painting: Su Shih (1037–1101) to Tung Ch'i-ch'ang (1555–1636)*. Cambridge, Mass., 1971.

Bush, Susan, and Christian Murck, eds. *Theories of the Arts in China*. Princeton, 1983.

Cahill, James. *Chinese Painting*. New York, 1960.

———. *The Compelling Image: Nature and Style in Seventeenth-Century Chinese Painting*. Cambridge, Mass., 1982.

———. *Hills Beyond a River: Chinese Painting of the Yüan Dynasty, 1297–1368*. New York, 1976.

———. *The Restless Landscape: Chinese Painting in the Late Ming Period*. Berkeley, 1971.

Chang Tsong-zung. *China's New Art, Post-1989, with a Retrospective from 1979–1989*. Hong Kong, 1993. Includes contributions by Lang Shaojun, Nicholas Jose, Geremie Barmé, et al.

Clapp, Anne de Courcey. *The Painting of Tang Yin*. Chicago, 1991.

———. *Wen Cheng-ming: The Ming Artist and Antiquity*. Ascona, Switzerland, 1975.

Clunas, Craig. *Elegant Debts: The Social Art of Wen Zhengming*. London and Honolulu, 2004.

Cohen, Joan Lebold. *The New Chinese Painting, 1949–1986*. New York, 1987.

Edwards, Richard. *The Art of Wen Cheng-ming (1460–1559)*. Ann Arbor, 1975.

———. *The Field of Stones: A Study of the Art of Shen Zhou*. Washington, D.C., 1962.

Ellsworth, Robert, Keita Itoh, Lawrence Wu, Jean Schmitt, Caron Smith, and James Watt. *Later Chinese Painting and Calligraphy, 1800–1930*. 3 vols. New York, 1986.

Fong, Wen. *Beyond Representation: Early Chinese Painting and Calligraphy, 8th to 14th Century*. New York, 1992.

Fong, Wen, Alfreda Murck, Shou-chien Shih, Pao-chen Ch'en, and Jan Stuart. *Images of the Mind: Selections from the Edward L. Elliott Family and John B. Elliott Collections of Chinese Calligraphy and Painting at the Art Museum, Princeton University*. Princeton, 1984.

Fu, Marilyn, and Shen Fu. *Studies in Connoisseurship: Chinese Paintings from the Arthur M. Sackler Collection in New York and Princeton*. Princeton, 1973.

Fu, Shen C. Y., and Jan Stuart. *Challenging the Past: The Paintings of Chang Dai-chien*. Washington, D.C., and Seattle, 1991.

Group for the Authentication of Ancient Works of Chinese Painting and Calligraphy. *Illustrated Catalogue of Selected Works of Ancient Chinese Painting and Calligraphy*. 12 vols. Beijing, 1986–93.

Gulik, R. H. van. *Chinese Pictorial Art as Viewed by the Connoisseur*. Rome, 1958.

Ho, Wai-kam, ed. *The Century of Tung Ch'i-ch'ang, 1555–1636*. 2 vols. Kansas City, Mo., and Seattle, 1992.

Kao, Mayching, ed. *Twentieth-Century Chinese Painting*. Hong Kong and Oxford, 1988.

Kuo, Jason C. *The Austere Landscape: The Paintings of Hung-jen*. Taipei, 1990.

Laing, Ellen Johnston. *The Winking Owl: Art in the People's Republic of China*. Berkeley, 1988.

Lawton, Thomas. *Chinese Figure Painting*. Washington, D.C., 1973.

Li, Chu-tsing. *A Thousand Peaks and Myriad Ravines: Chinese Painting in the Collection of Charles A. Drenowatz*. 2 vols. Ascona, Switzerland, 1974.

———. *Trends in Modern Chinese Painting*. Ascona, Switzerland, 1979.

Loehr, Max. *The Great Painters of China*. Oxford, 1980.

Sickman, Laurence, ed. *Chinese Painting in the Collection of John M. Crawford, Jr.* New York, 1962.

Sickman, Laurence, Wai-kam Ho, Sherman Lee, and Marc Wilson. *Eight Dynasties of Chinese Painting: The Collections of the Nelson Gallery–Atkins Museum, Kansas City, and the Cleveland Museum of Art*. Cleveland, 1980.

Silbergeld, Jerome. *Chinese Painting Style: Media, Methods, and Principles of Form*. Seattle, 1982.

Silbergeld, Jerome, and Gong Jisui. *Contradictions: Artistic Life, the Socialist State, and the Chinese Painter Li Huasheng*. Seattle, 1993.

Sirén, Osvald. *Chinese Painting: Leading Masters and Principles*. 7 vols. London, 1956, 1958.

Sullivan, Michael. *The Birth of Landscape Painting in China*. Berkeley, 1961.

———. *Chinese Landscape Painting*. Vol. 2, *The Sui and T'ang Dynasties*. Berkeley, 1980.

———. *Modern Chinese Artists: A Biographical Dictionary*. Berkeley, 2006.

———. *The Night Entertainments of Han Xizai: A Scroll by Gu Hongzhong*. Berkeley, 2008.

———. *Symbols of Eternity: The Art of Landscape Painting in China*. Stanford, 1978.

———. *The Three Perfections: Chinese Painting, Poetry and Calligraphy*. Rev. ed. New York, 1999.

Suzuki Kei. *Comprehensive Illustrated Catalogue of Chinese Painting*. 5 vols. Tokyo, 1982.

Tan Chung, ed. *The Dunhuang Art through the Eyes of Duan Wenjie*. New Delhi, 1994.

Weidner, Marsha, Ellen Johnston Laing, Irving Yucheng Lo, Christina Chu, and James Robertson. *Views from Jade Terrace: Chinese Women Artists, 1300–1912*. Bloomington, Ind., 1988.

Wu Hung. *The Double Screen: Medium and Representation in Chinese Painting*, Chicago, 1996.

Yang Xin, Richard M. Barnhart, Nie Chongzheng, James Cahill, Lang Shaojun, and Wu Hung. *Three Thousand Years of Chinese Painting*. New Haven and Beijing, 1997.

SCULPTURE

Howard, Angela Falco, Li Song, Wu Hung, and Yang Hong. *Chinese Sculpture: The Culture and Civilization of China*. New Haven, 2006.

Mizuno Seiichi and Nagahiro Toshio. *Unko sekkutsu: Yun-kang, the Buddhist Cave Temples of the Fifth Century A.D. in North China*. 16 vols. Kyoto, 1952–55.

Paludan, Ann. *The Chinese Spirit Road: The Classical Tradition of Stone Tomb Statuary*. New Haven, 1991.

Priest, Alan. *Chinese Sculpture in the Metropolitan Museum of Art*. New York, 1954.

Rudolph, Richard. *Han Tomb Art of West China*. Berkeley, 1951.

Segalen, Victor. *The Great Statuary of China*. Trans. Eleanor Levieux. Chicago, 1978.

Sirén, Osvald. *Chinese Sculpture from the Fifth to the Fourteenth Centuries*. 4 vols. London, 1925.

Sullivan, Michael, and Dominique Darbois. *The Cave Temples of Maichishan*. Berkeley, 1969.

Wu Hung. *The Wu Liang Shrine: The Ideology of Early Chinese Pictorial Art*. Stanford, 1989.

MAPS AND ILLUSTRATIONS

INDEX

Beijing: aerial view, 209; architecture, 259–61, 287, 288, 289, 290; artists' communities, 317; color printing, 232; exhibitions, 310–12, 313; invasions of, 207–8, 300; kilns, 223; as Ming capital, 227. *See also* Forbidden City, Beijing

Beijing Library, 289

Beijing Spring, 311

Beijing Workers' Gymnasium, 289

Beiyaocun, Luoyang, Henan, 41, 42

bells, 17, 52, 54, 55

belt hook, 55–56

Benoit, Father, 259

bi disks, 13, 33, 62–63, 94

Bian Wenjin, 233

bianhu flask, 52, 53

Bianjing (modern Kaifeng), 163, 165, 167, 189, 198

Bifaji (Record of brush methods), 175

bird and flower painting: "relief style" of, 142; Song, 187, 188–89; Ming, 233, 234, 251; Qing, 262, 272, 274; twentieth-century, 292

bixie (guardian creatures), 158–61, 211, 228, 246

Bizhentu (Battle array of the brush), 86

black pottery culture, 10

blanc-de-Chine, 253

blue and white ware: Tang and Song, 205, 224; Yuan, 224–25; Ming, 251–52, 254–55; Qing, 270, 276, 277, 278; Tang, 155, 156. *See also specific wares*

bodhisattvas, 112, 117, 118, 119, 122, 138, 139, 223. *See also* Guanyin

bodiless *(tuotai)* ware, 253

bone carvings, 33–34. *See also* dragon bones; oracle bones

boneless style of painting, 144, 149, 151, 188

Book of Songs (Shijing), 35, 36, 59, 65, 95

Boshan xianglu (fairy mountain incense burner), 89

Böttger, Johann, 252

bo-type bell, 52, 54

Bridge Museum for Posters from the Cultural Revolution (Sichuan), 290, 291

bronzes: dating of, 27, 29, 166; decoration of, 32; Shang, 15–16, 17, 18–20, 23, 25–32; Western Zhou, 35, 38–39; Warring States, 49–56, 58, 60–61; Han, 51, 68, 69, 76, 77, 78, 79, 80, 89–93; Buddhist, 113, 120, 138; Six Dynasties, 113; Tang, 152; Song, 166; twentieth-century, 308. *See also* ritual vessels

Buddha: images, 113–16, 118–21, 123, 124, 138, 139, 140, 144, 168, 170, 193, 194; life, 111–13

Buddhism: Han, 69, 93, 320–21n2; Six Dynasties, 110–13; Tang, 120, 133, 135, 137–42; Liao, 167–68; Song, 165; Tibetan, 211; Yuan, 211; Ming, 230, 246. *See also* Buddhist art; Buddhist cave shrines; Chan (Zen) Buddhism

Buddhist art: arrival of, 113–15; auspicious motifs in, 223–24; changes in, 110; color printing, 231; foreign influences on, 123, 141–42; Liao architecture, 167–68. *See also* Buddhist painting; Buddhist sculpture

Buddhist cave shrines: construction, 114–19; pottery figures, 168, 169; relief sculpture, 116, 117–19, 138; wall paintings, 123–24, 125, 141, 143, 144–45

Buddhist doctrine, 110–13, 141, 165

Buddhist painting: Six Dynasties, 107, 109, 123–24, 125; Tang, 141–45, 146, 188; Five Dynasties, 172–73; Song, 173, 193; Yuan, 211

Buddhist sculpture: arrival of, 113–15; funerary, 125–27; Liao, 168, 169; Song-Yuan, 170–71; time phases: first, 115–16; second, 117–20; third, 120–23; fourth, 137–40

burial suit, jade, 93–94, 95, 321n14

Burma, jadeite of, 11

Cai Guoqiang, 314, 317

Cai Yong, 85, 87

calligraphy: definition and development, 42, 85; handbook, 86; Han, 85–86, 104, 213; Six Dynasties, 103–4, 105, 213; Tang, 104; Song, 104, 195, 213, 215; Yuan, 212, 213–15; Qing, 272; twentieth-century, 292, 293, 300, 313. *See also* scripts; writing

camels, 158, 159, 246

Cammann, Schuyler, 93

Cantonese School *(Lingnam pai)*, 296–97

Cao Buxing, 123, 195–96

Cao Yi, 86

Cao Zhi, 106, 107

Cao Zhongda, 142

caoshu (grass script), 86, 104

Capital Gymnasium (Beijing), 289

Cassius, Andreas, 280

Castiglione, Giuseppe (Lang Shining), 259, 260, 262, 285

cave shrines. *See* Buddhist cave shrines

celadon: precursors to, 25, 42, 58, 97; Six

Dynasties, 129; Tang, 156; Song, 203, 205; Yuan, 222–23; Ming, 255; Qing, 281. *See also* northern celadon; *specific wares*

Central Academy of Art, 300, 303, 312

ceramics: copies of, 277, 280–81; dating of, 205; Neolithic, 3–11, 13; Shang, 23–25; Western Zhou, 41–42; Warring States, 56, 57, 58; Han, 56, 75, 77, 78, 83, 96–97; Three Kingdoms, 100; Six Dynasties, 101, 127–29; Tang, 133, 151, 153–61; Northern Song, 156, 196–201; Liao-Jin, 199–201; Southern Song, 156, 201–5; Yuan, 208, 222–25; Ming, 251–55; Qing, 223, 253, 276–84; twentieth-century, 308–9. *See also* blue and white ware; celadon; glazes; porcelain; *specific wares*

Cézanne, Paul, 102, 216, 265, 300, 314

Chai ware, 198

Chan (Zen) Buddhism, 142, 168, 172–73, 193, 195, 211, 241

Chang, K. C., 8, 29

Chang Ch'ung-ho, 104, 105

Chang Dai-chien (Zhang Daqian), 300, 301

Chang, Shuhong, 322n12

Chang'an (city), 66, 68–69, 70, 99, 131–33, 136, 137, 151, 155

Chao Mei, 94

Chen Conglin, 311

Chen Hengke, 292

Chen Hongshou, 242, 272, 274, 293

Chen Jin, 305

Chen Mingyuan, 283

Chen Rong, 196

Chen Shun (Chen Daofu), 237

Cheng Shifa, 303–4

Cheng Wang (Zhou Gong), 34

Chengdi (Han emperor), 80

Chengdu, Sichuan, 72, 163, 165, 173, 188

Chenghua (Ming emperor), 278, 279

Chengshi moyuan (Mr. Cheng's miscellany), 231

Cheong Soo Pieng (Zhong Sibin), 305, 307

Cheung Yee (Zhang Yi), 308

Chiang Kai-shek, 292–93, 300

chime stone, 33

chimera, stone, 125

China Central Television headquarters, 290

Chinese Architectural Research Society, 287

Chinese National Research Institute (Academia Sinica), 15

Chongzhen (Ming emperor), 276

Chu (state), 45, 48, 56, 58–59, 61, 320n2

146, 147; Tang tomb, 137; Yuan paintings, 216; Zhou burial, 48, 49

Hōryūji Kondō Cycle of wall paintings, 143–44

Hsiangkuo Office Building (Taipei), 290

Hu Hai (Qin emperor), 66

hu vessels, 39, 50, 56, 61, 89, 96, 97

Hu Yaobang, 312

Hua shanshui lu (Essay on landscape painting; Jing Hao), 175

Hua shanshui xu (Preface on landscape painting; Zong Bing), 105

Hua Tianyou, 307

Hua Yan, 272, 274

Huainanzi (Prince Nan of Huaian), 67, 87

Huaisu (monk), 213

Huang Binhong, 264, 295, 300, 304

Huang Chao, massacre in South China, 135

Huang Gongwang, 189, 217, 220, 236, 242, 269–70

Huang Jucai, 188–89

Huang Quan, 188–89, 233

Huang Rui, 310

Huang Shen, 272, 273, 275

Huang Tingjian, 104, 184, 215

Huangdao ware, 156, 157

Huangdi (Yellow Emperor), 15, 16

huaniao. See bird and flower painting

Huayulu (Shitao), 267, 269

Hui Mengchen, 283

Huineng (Sixth Patriarch), 193, 194

Huizong (Song emperor), 25, 107, 146, 147, 165, 166, 186–88, 195, 198, 214, 215

Hundred Flowers Movement (1956–57), 304

Hundred Schools of philosophy, 46

hunting and fishing, 55, 70, 83, 96–97, 109, 259

Huxian county, Shaanxi, 310

ibex, 32

Imperial Academy (founded 136 B.C.), 69

Imperial Academy of Letters (Hanlinyuan), 134

Imperial Academy of Painting (Yuhuayuan), 186, 189, 193. *See also* Hanlin Academy of Letters

imperial ceramic factory. *See* Jingdezhen, Jiangxi, kilns

Imperial Workshop (*Shangfang*; Han), 87

incense burner, 250

inscriptions, 20, 21, 38, 42, 220. *See also* calligraphy; scripts

installation art, 313, 314

intaglio technique, 284

ivory carvings, 33

jade: Neolithic, 3, 8, 10, 11–13; Shang, 33–34; Western Zhou, 40; Warring States, 62–63; Han, 93–94, 95; Qing, 284–85

Jade Gate, Yumen, 95

Jade Hall, 173

jadeite, 11

Japan: Beijing attacked by, 300; blue and white ceramics, 255, 276; Buddhist sculpture, 120; color printing, 232; *guri* (heart-shaped) technique, 249; Kanō School, 193; landscape painter Sesshu of, 235; modern art school, 297; Nihonga movement, 295–96; pagodas, 114; Taiwan occupied by, 305; Zen Buddhism, 172, 173. *See also* Nara, Japan, monasteries

Jātaka tales, 117, 118, 124

Jesuit china, 282

Jesuits, 258, 259, 261, 270, 277, 280, 297

jia ritual vessel, 27, 30

jiaguwen (small ancient script), 42

Jiajing (Ming emperor), 252, 254

Jian ware, 202

Jiancicun, Hebei, kilns, 196–97

Jiang, Princess, 84–85

Jiang Qing, 309–10

Jiangxi kiln sites, 156, 196, 198, 202, 224, 225, 252, 277

Jiao Bingzhen, 261

jiehua (ruled line) architectural painting, 195

Jieziyuan huazhuan (Painting Manual of the Mustard Seed Garden), 178, 232, 264

Jin Cheng, 292, 324–25n2

Jin Nong, 272, 274, 275

Jin ware, 201

Jincun, 48–49, 51–52

Jing Hao, 175, 179

Jingdezhen, Jiangxi, kilns, 155, 156, 204, 223–25, 252–55, 276, 277, 283, 309

Jingdezhen taolu (Record of the potteries of Jingdezhen; Lan Pu), 277

Jingdi (Han emperor), 76, 77

Jingtu (Pure Land) School of Buddhism, 141–42

Jinniushan man, 2

jinshi jia ("metal-and-stone-ists"), 293

Jique Palace, Xianyang, Shaanxi, 65, 66

Jiu Tangshu (Old Tang history), 161

Jiuyan kilns, 97

Ju Ming (Zhu Ming), 308

jue vessel, 16

Jun ware, 156, 197–99

Juran, 173, 175, 183, 216, 241, 263, 269

Kaempfer Series, 231–32

Kaifeng (old Bianjing), 163, 165, 167, 189, 198

kaishu (standard or regular script), 104, 212, 213, 214

Kang Senghui, 123

Kangxi (Qing emperor), 223, 257, 258, 259, 261, 263, 270, 276, 277, 284, 324n1 (chap. 9)

Kangxi ware, 277–80, 281

Kanishka (king of Kushans), 111, 113

Karasuk, Siberia, 31–32

Karlgren, Bernhard, 51–52

kendi drinking flasks, 252, 255

kesi tapestry, 247–48

Kian ware, 202

kilns, northern and southern compared, 127–29. *See also specific locations*

kinuta celadon, 204, 205

Klee, Paul, 300

knives and daggers, 31–32, 33

Kollwitz, Käthe, 299

Koolhaas, Rem, 290

Korea, lacquer of, 86–87

Koslov expedition, 95

Koyama, Fujio, 197

kraak ware, 252, 255

kuangcaoshu (crazy draft script), 213

Kublai Khan, 207–9, 212

kui dragon, 29, 30

kui pitcher, 10, 11

Kuncan (Shiqi), 218, 264, 265–66, 267

Kushans (Indian culture), 69, 111, 113

lacquer: comparison of, 249; Neolithic, 10; Warring States, 59, 60, 249; Han, 86–88, 249; Six Dynasties, 107; Ming, 249; Qing, 284–85

Lan Pu, 277

Lan Ying, 235

landscape painting: birth of, 105–10; classical ideal of, 175–76, 179; composition in, 178–79, 269; perspective in, 176–78; Han, 83–84; Six Dynasties, 105–10; Tang, 144, 145, 148–49, 151; Five Dynasties, 175–85; Song, 175–85; Southern Song, 189, 192, 193; Yuan, 216, 217–20; Ming, 230–31, 233–44; Qing, 262–74; twentieth-century, 293–95

Qinglian'gang (Dawenkou) culture, 8, 9, 13
Qingming Festival, 182–83, 310
Qingzhou, Shandong, 120
Qionglai, Sichuan, Wanfosi, Buddhist sculpture from, 123
Qishan, Shaanxi, 35
qitou (guardian creatures), 158–61, 211, 228, 246
Qiu Ying, 239–41, 258, 275
Qu Leilei, 317
Qu Yuan, 48
que pillars, 80–81

Rauschenberg, Robert, 313
realism, pictorial: Northern Song, 166, 175–76, 180–83; Southern Song, 184; Qing, 258, 262; twentieth-century, 293, 294, 297, 303–4, 311
reign titles and marks *(nianhao)*, 249, 251, 253, 278, 279, 281
relief sculpture: Han, 72, 80–83; Buddhist, 116, 117–19, 126, 140; Song, 171, 172; Tang, 137, 140, 142
religious beliefs, 20, 34, 38, 68–69, 84, 133. *See also* Buddhism; Confucianism; Daoism; Hinduism
Ren Renfa, 211
Ren Xiong, 275
Ren Yi (Ren Bonian), 293, 294
Rent Collection Courtyard, The, 172, 307–8
rhinoceros, 77
Ri Di, 84
Ricci, Matteo, 231, 246, 258
ritual vessels, 25–32, 38–39, 166. *See also* bronzes; *specific vessel types*
Rockwell, Norman, 311
Rongbaozhai studio, 232
Rongxian, Guangxi, kilns, 205
Ru ware, 198, 199, 279, 280

Śākyamuni Buddha. *See* Buddha
sancai (three-color) ware, 155, 161, 168, 169, 246, 278–79
Sanxingdui, Sichuan, 19, 20, 23, 31, 40
Sawankalok (Thai potters), 255
scapulamancy, 10
Schall, Adam, 258
Scheeren, Ole, 290
scholar-painters: Song, 184–85; Yuan, 211–12, 218; Ming, 227, 228–29, 230–31, 235–44; Qing, 258–59, 260, 261. See also *wenren* (scholar-gentlemen) tradition

School of Painting (Huaxue, Song), 186–88
scripts: *caoshu* (grass script), 86, 104; *dazhuanshu* (big seal script), 42, 212; *guwen* (ancient script), 42; *jiaguwen* (small ancient script), 42; *kaishu* (standard or regular script), 104, 212, 213, 214; *kuangcaoshu* (crazy script), 213; *lishu* (clerical script), 43, 86, 104, 212, 213; *shoujinshu* (thin gold script), 187, 214, 215; *xiaozhuanshu* (small seal script), 42, 43; *xingshu* (running script), 86, 103, 185, 212, 213, 214, 293, 294
sculpture: didactic tradition in, 171–72; funerary, 125–27, 137–38; Shang, 23; Western Zhou, 36–38; Han, 67, 74, 75–83; Six Dynasties, 125–27; Tang Buddhist, 138, 139; Five Dynasties, 168–72; Song, 168–72; Ming, 228, 246; twentieth-century, 307–8, 312. *See also* Buddhist sculpture; figurines; relief sculpture
secret color *(mise)* ware, 156, 157
secret decoration *(anhua)* technique, 253
Segalen, Victor, 81
Semedo, Alvarez de, 325n4 (chap. 10)
Seres (the Silk People), 95
Seven Sages of the Bamboo Grove, 125, 126, 127
shading technique, 245, 262, 296
Shang dynasty: architecture, 18, 20–23; bronzes, 15–16, 17, 18–20, 23, 25–32; ceramics, 23–25; jade, 33–34; pictograph, 25; pottery, 23–25; social structure, 19–20; textiles, 58–59
Shang Yang, 65, 66
Shangfang (Imperial Workshop, Han), 87
Shanghai, 275, 287, 288, 293, 297
Shanghai School *(Haipai)*, 275, 293
Shanglinhu kilns, 156
Shangyuxian kilns, 129
Shanhaijing (Classic of hills and seas), 67, 87
Shanshuixun (Advice on landscape painting), 176
Shao Chengzhang, 202
Shao Fei, 314, 316
Shao Mi, 242, 243
shen dao (spirit road), 75, 246
Shen Gua, 176, 178, 183, 189
Shen Zhou, 215, 217, 227, 230–31, 235–36, 237, 239, 241, 242, 269
Shenyang (Mukden), 257
Shi Dabin, 283
Shi Ke, 172, 173

Shi Rui, 234, 235
Shihuangdi (Qin emperor), 25, 42, 65–66, 74, 75, 76, 77, 82
Shiqi (Kuncan), 218, 264, 265–66, 267
Shitao, 264, 265, 266, 267–69
Shizhaishan, Yunnan, 89–90
Shizhuzhai shuhua pu (Treatise on the paintings and writings of the Ten Bamboo Studio), 232
Shōsōin Repository, Nara, 152
shoujinshu (thin gold script), 187, 214, 215
shufu (privy council) ware, 223, 253
Shujing (Classic of History), 35, 65, 248
Shuowen jiezi (dictionary), 11–12
Sichuan, twentieth-century, 290, 291, 311
Sickman, Laurence, 84–85, 116, 170–71
Siku quanshu (encyclopedia), 258
silk painting: Zhou and Warring States, 48, 60; Han, 60, 87, 88, 95–96; Six Dynasties, 106; Tang, 144–45, 146, 147; Five Dynasties, 173, 174; Song, 188–89; Northern Song, 177, 179, 180–83; Southern Song, 192, 194, 195; Yuan, 220, 222; Ming, 234, 240; Qing, 258, 262, 263, 269, 271, 272. *See also* textiles
Silk Road, 66–67, 95
Sima Jinlong, 107, 109
Sima Xiangru, 70
Singapore, 305, 306
Six Dynasties: aesthetics, 102–3; architecture, 113–14; bamboo painting, 221; Buddhism, 110–13; Buddhist art, 113–15; Buddhist painting, 107, 109, 123–24, 125; Buddhist sculpture, 115–23; calligraphy, 103–4, 105, 213; ceramics, 101, 127–29; Confucianism, 109; Daoism, 100–102; funerary sculpture, 125–27; lacquer, 107; landscape painting, 105–10; political context, 99–100; wall paintings, 108, 109, 123–24, 125
Six Great Masters, 269
snuff bottles, 283
Song dynasty: architecture, 136, 167–68; calligraphy, 104; ceramics, 156; lacquer, 249; landscape painting, 175–85; Ming compared with, 228; political context, 163–66; sculpture, 168–72; textiles, 247. *See also* Northern Song dynasty; Southern Song dynasty
Song Huizong. *See* Huizong
Song Yu, 48
Song Yun, 113
Soper, Alexander, 102, 114

TEXT 9.5/13 Scala

DISPLAY Priori Sans

SPONSORING EDITOR Deborah Kirshman

ASSISTANT EDITOR Eric Schmidt

PROJECT EDITOR Sue Heinemann

EDITORIAL ASSISTANT Lynn Meinhardt

COPYEDITOR Amy Klatzkin

INDEXERS Margie Towery and Marcia Carlson

DESIGNER Nicole Hayward

PRODUCTION COORDINATOR Sam Rosenthal

COMPOSITOR Integrated Composition Systems

PRINTER AND BINDER Friesens